D1091769

In Pursuit of Heavenly Harmony

In Pursuit of Heavenly Harmony

Paintings and Calligraphy by Bada Shanren
from the Estate of Wang Fangyu and Sum Wai

JOSEPH CHANG AND
QIANSHEN BAI

CATALOGUE
STEPHEN D. ALLEE

Freer Gallery of Art
Smithsonian Institution
Washington, D.C.
in association with
Weatherhill, Inc.

Wang Fangyu and Sum Wai.

© 2003 Smithsonian Institution
All rights reserved.

Published by the Freer Gallery of Art, Smithsonian
Institution, Washington, D.C., in association with
Weatherhill, Inc.

HEAD OF PUBLICATIONS Lynne Shaner
EDITOR Gail Spilsbury
DESIGNER Kate Lydon

COVER *Lilac Flowers* and *Calligraphy,* 1690,
cat. entry 3, p. 43.
ENDPAPER Detail, *Rubbing of the "Holy Mother
Manuscript,"* 1698, cat. entry 17, p. 93.
HALF-TITLE PAGE Detail, *Lilac Flowers* and
Calligraphy, 1690, cat. entry 3, p. 43.
TITLE PAGE Detail, *Lotus,* ca. 1665, cat. entry 1,
p. 33.
PREFACES Detail, *Landscape after Ni Zan,*
ca. 1703-1705, cat. entry 33, p. 141.
CATALOGUE DIVIDER PAGE Detail, *Falling Flower,*
ca. 1692, cat. entry 5, p. 46.
CHINESE DOCUMENTATION DIVIDER PAGE Detail,
Scripture of the Inner Radiances of the Yellow Court,
1684, cat. entry 2, p. 39.
APPENDICES DIVIDER PAGE Detail, *Lotus and
Ducks,* ca. 1696, cat. entry 9, p. 67.

NOTE Dimensions are given in centimeters; height
precedes width precedes depth. All catalogue entries
are by Bada Shanren (1626–1705).

Library of Congress Cataloging-in-Publication Data

Chang, Joseph.
 In pursuit of heavenly harmony: paintings and
calligraphy by Bada Shanren / by Joseph Chang and
Qianshen Bai; catalogue by Stephen D. Allee.
 p. cm.
1. Zhu, Da, 1626–1705--Exhibitions. 2. Calligraphy,
Chinese--History--Ming-Qing dynasties, 1368-1912-
-Exhibitions. 3. Wang,
Fangyu, 1913–1997--Art collections--Exhibitions.
4. Sum, Wai--Art
collections--Exhibitions. 5. Calligraphy--Private
collections--Washington, D.C.--Exhibitions. 6.
Calligraphy--Washington,
D.C.--Exhibitions. 7. Freer Gallery--Exhibitions. I.
Zhu, Da, 1626–1705. II. Bai, Qianshen. III. Allee,
Stephen D. IV. Title.
ND1457.C56 Z483 2003
745.6'19951'092--dc21
2002012387

Printed in China

BOARD OF THE FREER AND SACKLER GALLERIES
Mrs. Hart Fessenden, *Chair of the Board*
Mr. Richard M. Danziger, *Vice Chair of the Board*
Mr. Jeffrey P. Cunard
Mrs. Mary Patricia Wilkie Ebrahimi
Mr. George J. Fan
Dr. Robert S. Feinberg
Dr. Kurt A. Gitter
Mrs. Margaret M. Haldeman
Mrs. Richard Helms
Mrs. Ann R. Kinney
Mr. H. Christopher Luce
Mrs. Jill Hornor Ma
Mr. Paul G. Marks
Ms. Elizabeth E. Meyer
Mrs. Constance C. Miller
Mrs. Daniel P. Moynihan
Mr. Frank H. Pearl
Dr. Gursharan Sidhu
Mr. Michael R. Sonnenreich
Mr. Abolala Soudavar
Professor Elizabeth ten Grotenhuis
Mr. Paul F. Walter
Ms. Shelby White

HONORARY MEMBER
Sir Joseph Hotung

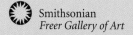

Smithsonian
Freer Gallery of Art

Contents

Foreword

THE SEVENTEENTH CENTURY WAS one of the most eventful and traumatic periods in the history of China. The first half of the century witnessed the irreversible deterioration and collapse of the last native Chinese dynasty, the Ming (1368–1644), and the subsequent invasion and conquest of China by Manchu forces from the northeast, who established the Qing dynasty (1644–1911) in its place. The second half of the century saw the Manchu conquerors consolidate the territory and institutions of their new empire and move towards a political and cultural reconciliation with the Chinese people they now ruled. These events had a profound impact on the life and art of Bada Shanren (1626–1705), a descendant of the Ming imperial house and one of the most celebrated Chinese artists of the period.

Bada Shanren won the praise and admiration of his contemporaries primarily as a calligrapher, and calligraphic techniques and the manipulation of brush and ink were also the foundation of his approach to painting. As a painter, he developed an idiosyncratic visual vocabulary full of personal symbolism and artistic gesture that make his deceptively simple works endlessly intriguing. The lack of ornament and seemingly guileless innocence of Bada's paintings appeal to the modern eye, but while his spontaneous, almost abstract, brushwork may appear rather playful, many paintings also reveal a troubled psychological edge to his character and an innately dark outlook on his own fortunes and the condition of the world at large. Three hundred years later, Bada's works continue to exert a powerful influence on many modern and contemporary Chinese painters.

Wang Fangyu (or Fred Fangyu Wang, 1913–1997), who taught Chinese language for many years at Yale University, was the foremost collector and one of the most prominent modern scholars of painting and calligraphy by Bada Shanren. Together with his wife, Sum Wai (1918–1996), he devoted much of his private life to the collection and study of Bada's life and art, focusing almost exclusively on this artist for more than half a century. Prior to his demise, Professor Wang's was the most comprehensive private collection of calligraphy and painting by Bada Shanren anywhere in the world.

Through the kindness and generosity of Wang Fangyu's son, Mr. Shao F. Wang, the Freer Gallery of Art was selected as the permanent repository for twenty paintings and works of calligraphy by Bada Shanren that Professor Wang had personally identified as the core of his collection. Thanks to the generous financial support of the E. Rhodes and Leona B. Carpenter Foundation, in 1998 the Freer was also able to purchase twelve additional works of calligraphy and one painting by Bada Shanren from Wang Fangyu's estate. These acquisitions were facilitated by the support and encouragement of the important New York art dealer Mr. Robert H. Ellsworth, who was both a student and a longtime friend of Professor Wang. The following year, Shao Wang also donated his father's research archives, comprising some nineteen hundred items, to the archives and slide library of the Freer. The quality and significance of these works of art, complemented by Professor Wang's research materials, have made the Freer Gallery of Art the most important center for the study and exhibition of Bada Shanren's art outside the People's Republic of China.

It is our hope that the publication of this catalogue will provide a thanks and memorial to Professor Wang Fangyu in the manner he would have most appreciated — by making accessible to a broader public the art and personality of Bada Shanren.

JULIAN RABY
DIRECTOR
FREER GALLERY OF ART AND
 ARTHUR M. SACKLER GALLERY
SMITHSONIAN INSTITUTION
WASHINGTON, D.C.

Acknowledgments

BADA SHANREN (1626–1705), AN eccentric monk-painter of late seventeenth-century China, has twice been the focus in recent years of major exhibitions and scholarly symposia, first in China and then in the United States. In October 1986, the Symposium to Commemorate the 360th Anniversary of Bada Shanren's Birth was organized in Nanchang, the artist's home-town; and in 1991, the Yale University Art Museum held the exhibition, *Master of the Lotus Garden: The Life and Art of Bada Shanren,* and also published an accompany-ing book of the same title.

Although I was unable to attend the 1986 Nanchang symposium, I wrote a study on Bada's landscapes and sent it to Professor Wang Fangyu of Yale University for his comments, which were very encouraging. That was how we became acquainted, and for the next ten years, Professor Wang and I continued to exchange and discuss research materials on Bada. Following Wang Fangyu's death in 1997, many major museums throughout the United States, including the Freer Gallery of Art, competed to receive the bequest of Bada Shanren's painting and calligraphy from Wang Fangyu's collection, for it represented the best authenticated and most comprehensive selection of artworks by Bada ever assembled in private hands. Although I did not then know Wang Fangyu's son, Mr. Shao F. Wang, we gradually became acquainted over months of commu-nication about this bequest, and eventually he decided that the Freer Gallery of Art should become the repository for the group of twenty works his father had designated as the core of his collection. Heartwarmingly, my friendship with the late professor has now been extended to Shao and his family as well, whom I wish to thank for their extraordinary kindness and generosity. Shao also made available a further selection of twelve calligraphic works and one painting from his father's collection, which the museum acquired with funds provided by the E. Rhodes and Leona B. Carpenter Foundation, whose generous financial support continues to enhance the holdings and activities of the museum.

Unlike the in-depth study *Master of the Lotus Garden,* this exhibition catalogue has been prepared with the general public in mind and focuses primarily on the thirty-three works acquired by the Freer Gallery of Art from the former collection of Wang Fangyu and his wife, Sum Wai. It is our hope that through this simple introduction, the life and art of the mysterious Bada Shanren can be rendered more accessible to a wider Western audience. In pursuing this end, I have been extremely fortunate to collaborate with two close colleagues, Bai Qianshen, assistant professor of Chinese art at Boston University, and Stephen D. Allee, research specialist in Chinese literature and history at the Freer Gallery of Art and Arthur M. Sackler Gallery. Professor Bai is a specialist in Chinese calligraphy, concentrat-ing on the seventeenth century, and has published a number of important articles on Bada's calligraphy and seals. He particu-larly wishes to extend his appreciation to his friend Matthew Flannery for helping to prepare his manuscript for the essay in this volume. Stephen Allee is a specialist in Chinese literature and a gifted translator. His passion for Chinese painting and callig-raphy is surpassed only by his rigorous training in Chinese literature, which is self-evident in the numerous translations and comprehensive notes he prepared for the catalogue section of this book. I also wish to thank two former summer interns, Veronica de Jong, University of Kansas, and Wen-shing Chou, University of Chicago, who helped to assemble and prepare the initial documents for the book. In addition, the authors would like to thank the Min Chiu Society, Hong Kong, which gener-ously donated funds for the acquisition of the electronic version of *Siku quanshu* (The complete imperial library of the Qing

dynasty), which greatly enriched the contents of various notes and entries.

For the multitude of tasks related to bringing the Wang bequest into the Freer Gallery's collection and producing the Bada Shanren catalogue and exhibition, my colleagues throughout the museum—in Membership and Development, Collections Management, Conservation and Scientific Research, Publications, Photography, Design and Production, Public Affairs and Marketing—all deserve my deepest gratitude. I owe special thanks to Gu Xiangmei, Chinese painting conservator, who heroically remounted ten works and treated the rest of this important acquisition with her usual skill and care, and to the Henry Luce Foundation, whose grant for the Chinese Painting Conservation Program supported these efforts. I would also like to thank the following individuals: Lynne Shaner, head of the publications department, who oversaw the entire project with unflagging persistence; Gail Spilsbury, senior editor, who worked with the authors with the utmost patience and a pleasant manner; Kate Lydon, art director, who prepared a beautiful design for the book; Rachel Faulise, for detailed production coordination and design assistance; Suzanne Crawford, who did an excellent job proofreading the layouts; Victoria Agee for preparing a complex

index; John Tsantes, head of the photography department, who managed the photography element of the book; John Wang, who documented Bada Shanren's various seals and signatures and proofread the book's Chinese portions; and Carol Huh, my curatorial assistant, who efficiently handled the untold administrative aspects of the project.

The eminent Beijing scholar Wang Shiqing and his wife, Shen Shiyin, spent a month in the Freer library in late 1999, sorting the archive of research materials on Bada Shanren assembled by the late Wang Fangyu and subsequently donated to the museum by Shao Wang. They then wrote an analytic report on this substantial archive, for which the authors are extremely grateful.

There have been numerous requests to view Bada's artworks ever since this acquisition joined Freer's collection four years ago. We continue to warmly welcome scholars and students who wish to study these works and their archives and/or contribute to our growing understanding of this great yet mysterious master.

JOSEPH CHANG
ASSOCIATE CURATOR
 OF CHINESE ART
FREER GALLERY OF ART AND
 ARTHUR M. SACKLER GALLERY

Prefaces

Straddling
Two Worlds

IN KEEPING WITH THE OLD
Chinese curse, my father, Wang Fangyu,
lived in interesting times. He witnessed his-
toric upheaval in China that included the
changing of governments and a calamitous
tide of events. These experiences shaped
what my father became. He was a scholar
literati from old Chinese society. Once,
when I almost succeeded in failing at
college, I asked my cerebral father what it
took to be a scholar, to which he brusquely
retorted in traditional Chinese fashion,
"Twenty years' studying by a cold window!"

Born in 1913 to a prominent and well-
to-do family, my father was the third of five
children and the youngest son. The large
family compound in Beijing held the
trappings of success, including objects of
fine art. Wang Fangyu grew up in this cul-
tured environment where scholarship was
highly prized. His calligraphy lessons began
at age three.

Wang Fangyu was prepared for a career
in government service as a member of the
scholarly gentry, but this possibility evapo-
rated as a result of historic events. It is true,
what they say about the fittest—they have
a remarkable ability to survive. Wang
Fangyu not only survived, he thrived.

Life is about playing to our best advan-
tage the mahjongg tiles each of us draws.
From turbulent China, Wang Fangyu came
to the United States and flourished.
Flexibility helped him; in China he taught
English, and in the United States he taught
Mandarin Chinese. In either situation the
guiding principle was the same: Be the best
at what you do, for that is the surest deter-
minant of success.

To extend his academic credentials
beyond the bachelor of arts degree earned
at Furen University (Beijing) in 1936, my
father went to New York City to study at
Columbia University Teachers College. A
year later, in 1945, he joined the Yale
University faculty and embarked on an
academic career that lasted another thirty-
three years (twenty years at Yale and thirteen
more at Seton Hall University where he
rose to become the Dean of the Department
of Asian Studies). Professional success came
quickly and steadily. He won numerous
awards based on his academic achievements
in the field of teaching Mandarin, including
a Teacher of the Year award. His textbooks
and reference materials on teaching the
Chinese language are still in use today.

Throughout this career that many
people would consider a full-time endeavor,
my father was able to explore other interests,
such as applying computers to the teaching
of Chinese, a pioneering initiative at the
time. Concurrently, he also exercised his
traditional scholar-literati mentality through
a growing collection of art.

One of my father's earliest students was
Mr. Robert Hatfield Ellsworth, collector
and dealer extraordinaire. In Mr. Ellsworth,
my father found a kindred spirit and a
mutual appreciation for Chinese antiquities
that became the basis for a wonderful
friendship lasting nearly five decades. In the
classroom, work focused on Mandarin
Chinese; yet, both teacher and student were
also thinking about Chinese fine art. It was
from this condition of "wandering" that
my father gave Mr. Ellsworth his Chinese
name, An Siyuan (he whose mind is far

away). It was Mr. Ellsworth who gave my father the courage to propose to my mother, Sum Wai, and the two married in 1955.

Through Mr. Ellsworth, my father met my godmother, Ms. Alice Boney, doyenne of Asian art dealers. Aunt Alice was a strong-willed lady whose grace was exceeded only by her love and knowledge of Orientalia. Through Aunt Alice my father began collecting objects and paintings in the United States. Once, he was reunited with an object of great sentimental value — a large yellow porcelain dish. The piece was considered a precious family heirloom despite a modest fracture that could only be detected by listening to the ceramic tone after tapping the dish in a particular way. During the turbulence of the Japanese invasion and the Chinese revolution, the Wang family was forced to sell off their antiquities, including this dish. On a visit to Aunt Alice's Park Avenue apartment in the 1960s, Wang Fangyu saw the dish again. Aunt Alice was very proud of this object and asked my father his opinion of it. He smiled and said that the dish was magnificent but damaged. Aunt Alice inquired how he knew, because she had not found any damage. My father demonstrated by tapping the dish and having her listen to the tone.

Calligraphy and painting were his true joy. Wang Fangyu's connoisseurship opened many doors that included meeting and becoming a confidant of Zhang Daqian, the renowned painter and collector. It is interesting to note that many of the Bada

Shanren paintings and calligraphies now residing at the Freer Gallery of Art came to my father from Zhang Daqian, who was the subject of a Sackler Gallery exhibition, *Challenging the Past: The Paintings of Chang Dai-Chien,* in 1991. Among other activities, Zhang would take pride in deceiving "knowledgeable" collectors with his own forgeries. This activity also served the practical purpose of raising funds to support an extravagant lifestyle. Zhang Daqian favored my father for his scholarship and appreciation of Chinese paintings, particularly those by Bada Shanren. Zhang Daqian could have sold these Bada Shanren works to most any of a number of avid collectors, but chose my father because Zhang believed the pieces belonged where they would be best appreciated and understood. Some of my most precious memories are of Zhang Daqian visiting our home, painting, enjoying life, and talking about works of art.

Wang Fangyu and Zhang Daqian in Hong Kong, 1955.

Wang Fangyu spent the last years of his life in the same Upper East Side Manhattan apartment building as his other great friend, C. C. Wang, collector and painter. These events are truly a sign of the blessings of the United States—that two kindred spirits representing the best qualities of traditional China, after crossing an ocean, a continent, and over eight decades, would choose this country as home. For only in America did Wang Fangyu believe he could achieve what he did, as a scholar, collector, and artist. In C. C. Wang, Wang Fangyu had a peer with whom long and deep discussions of painting, calligraphy, and collecting would result in a quiet joy and serenity known only to a privileged few.

I was never quite sure how to react when my father retired from academia upon writing my last college tuition check. Retirement is such a constricting concept. For my father, retiring resulted in the freedom to enthusiastically pursue a bold new endeavor. New, yet not so new. In the true spirit of the scholar literati, he embarked upon another activity: calligraphy. But not just the calligraphy of his youth; rather, Chinese calligraphy that tweaked the traditionalists, of which he himself was one. This third expertise of his took him to new levels of connoisseurship, where perhaps he felt closer to those artists whose works he had collected with such singular success. Once, when I asked my mother why she chose my father, she replied, "Because he writes so well." Her words implied Wang Fangyu was both cultured and refined, with an astute appreciation of the arts. Together, my parents achieved much. Sum Wai

provided emotional support and addressed the practicalities of day-to-day life. Through her caring and management Wang Fangyu was able to pursue his artistic passions, both collecting and creating, and Sum Wai admired both. My father readily acknowledged never making a significant acquisition without my mother's approval, and hers was the opinion he also most valued regarding his calligraphy. Together they enjoyed over forty years of happiness. Sadly, a testament to the happiness of those four decades was that after Sum Wai's death in 1996, Wang Fangyu was often despondent in the last year of his life.

Yet until the very end, my father was a fortunate man. To turn one's avocation into one's vocation is a blessing. The common thread, around which his multiple fields of expertise were joined, was passion. That he was able to constructively leverage that passion for Chinese culture, history, and language was the most elegant and purest sign of his successful life.

I always found fascinating Wang Fangyu's search in nature for the "unbalanced balance." In *tiandao,* or "the way of nature," my father achieved this "unbalanced balance" with his collection, his calligraphy, and his life. From my father I learned of a passion that can magnify the preciousness of each moment. For him, that passion produced a full life, well lived.

In the spirit of Zhang Daqian and the lineage of connoisseurs, my father believed that his collection was meant to serve two purposes: first, to be available for future generations to enjoy; and second, to further advance the scholarship and understanding

of the works. He acknowledged his own societal debt to the United States and was fully aware that the way he led his life and his accomplishments were possible only in this country. Given the meticulous effort on the part of both my parents to amass the collection, it was their wish that it remain together in the United States. In his will my father assigned me the task of finding a suitable institution to house it.

I chose the Freer Gallery of Art for several reasons. First, the Freer, together with the Sackler Gallery, form the national museum of Asian art for the United States. The Freer has fulfilled its august role by making accessible a broad and wonderful array of Asian artifacts for the enjoyment of all. Second, this gift from my family represents a meaningful enhancement to the collection of Chinese paintings already present at this extraordinary museum. The Freer can now be viewed as the destination institution in the United States for those artists and scholars interested in Bada Shanren. We hope that, as such, items from this gift will not only be on display for general viewing but also will be augmented by other objects. Third, it is hoped that the Bada Shanren calligraphies donated by my family, and those purchased by the E. Rhodes and Leona B. Carpenter Foundation, will combine with the marvelous gift of 260 Chinese calligraphies from Mr. Ellsworth, along with pieces previously acquired by this institution, to make the Freer the single richest public museum for this revered Chinese art form. I cannot help but note the symmetry and personal comfort that comes from having pieces from both my father and his student, Mr. Ellsworth, serve as cornerstones of this effort.

My family and I are very grateful to the Freer Gallery of Art and its staff for the care and attention paid to these works, my parents' life effort.

SHAO WANG

A Scholar, a Dealer, and Mahjongg

SHAO WANG'S ALLUSION TO LIFE and the mahjongg tiles each of us draws says it all, as the game includes luck. Knowing what I wanted to do with my life made it easier. Having a neighbor in Connecticut who was a famous art dealer was a great card to be dealt. He gave me a job in 1948. His name was Frank Stoner, and besides being my teacher, he was a past president of the British Antique Dealers' Association and the most respected dealer in English and European ceramic works of art in his day. I went to work one morning with a green-glazed covered vase, which I had bought at the Sloan-Kettering Thrift Shop for $8.00, and proudly announced it was late Ming. "How do you know?" he asked, and the next thing I knew, I had been invited to meet and have drinks with Alice Boney, who was to become Shao Wang's godmother. She settled the controversy: I was right. Alice became my friend and introduced me to the Chinese art world of the day and later to my friend Fred (Wang Fangyu).

After our friendship of approximately one year, Alice decided that I should go to graduate school to study Chinese. From the friends and acquaintances that I had already met through her, she selected Alan Priest, Laurence Sickman, Schuyler Cammann and Langdon Warner to write letters of recommendation for me to attend Yale.

Upon my arrival at this illustrious institution, I met Wang Fangyu (Fred) who was to be my teacher for the next two years. We got to know each other quite well, and after three months Fred asked to come with me when I covered the country dealers after school. The next stage in our friendship included Alice and New York City. We covered the auctions as well as the shops. When we started our escapades into the Chinese art world, Fred had only one painting—a Qi Baishi of shrimp. This exhibition of Bada Shanren shows how all his life Fred played his tiles with geniuses.

Classes started at eight A.M. and finished at twelve P.M.; five days a week I struggled to become a scholar. After twelve o'clock I became what I am: a dealer. Within six months of my meeting Fred, we closed the classes at eleven a.m. whenever there were sales in New York City at Parke Bernet, Spaniermans, or O'Riley Brothers. Trade was beginning to get its grasp on us. Fred and I had many wonderful adventures. He was collecting for himself; I was buying to earn a living.

In the summer following my first year of graduate school, I took a student's tour to China. When I returned home and started my second year at Yale, I realized that Fred was not suited to a single life. He needed more than just a friend with whom to chase

Wang Fangyu and Robert Ellsworth.

after treasures. He was having an ongoing correspondence with a lady in Hong Kong. After my second year of Yale, our hunting and studying and fun was to come to an end. I convinced Fred to propose to the lady in Hong Kong — Sum Wai — and physically helped him push the letter into the mailbox. Then, I was drafted into the army and a two-year separation followed. After my military stint, the Chinese language was dead, and I went into business seriously, where I have been ever since.

We met frequently whenever I found something I knew Fred would like to see. The year I bought A. W. Barr's painting collection from his daughter Edna, we saw a great deal of each other. By 1964, I had a rather grand gallery on East 58th Street. Fred didn't get into town so often then. However, when an interesting painting or a new addition to my nineteenth and twentieth century material showed up, we caught up. By the end of the 1960s, I was going to Hong Kong at least three times a year and he always came to see what I had acquired.

Through our mutual interest in Qi Baishi I met a wonderful gentleman in Hong Kong who sold me some of my prize paintings. After a few years of friendship, he brought out to show me the number one love of his life — rubbings of Chinese calligraphy. Some of these were in my exhibition at the Palace Museum in Beijing, including one volume of the *Chunhuage tie* (tenth-century, Chinese calligraphy rubbings). Fred was with me when I bought it at Christie's. Moments after, and setting a new world's record for rubbing (mine), in raced a Chinese dealer from Hong Kong. He headed for Fred and asked, "How much did it go for?" Then, "Who bought it — he had to be a Chinese." Fred and I were standing together and he said, "Yes, my friend An Siyuan bought it."

I was invited by the mainland government to do business with their Beijing arts and crafts in 1979. I bought and sold from their warehouses. I did an auction for them at Christie's in 1981, and there were three old friends involved — Fred, Alice, and myself. When the powers-that-be decided to dress up Liulichang, the almost ancient antiques district of Beijing, I made it possible for two painting galleries to be redone by buying a great many nineteenth- and twentieth-century calligraphies that are now in the Freer Gallery collections. Export licenses automatically appeared for anything I wished to purchase. There were approximately three hundred calligraphies. When Fred saw what I had brought home from this trip, he finally agreed that I didn't need to read Chinese to understand calligraphy.

From time to time, Fred would check in to see how the collection was progressing. When he moved to New York City, we saw more of each other. At this time, age and space became a factor in his life, so he sold me many of the most important runs of research publications in his personal library, including perhaps the only complete run since the beginning of publication of the Shanghai quarterly *Duoyun* (Art Clouds Quarterly). He knew they were safe with me, and if he needed to check something out, they would always be available for his perusal.

When we first met, trade and scholarship did not often mix. Our friendship was built on the blend of both. Fred was mostly a scholar with a little trade thrown in, and I was the reverse. We both benefited from each other's friendship in many ways, for many years. I know he will be smiling and amused that this most unusual mixture for the 1950s is well represented by us at the Freer more than fifty years later. In the United States, there is no comparable institution to the Freer that offers students access to a bequest as important as Fred's. I am proud to be included with my friend in the list of benefactors of the Freer. I am extremely grateful to have lived long enough to see this happen. Fred unquestionably played his tiles well. I am indebted to Lady Luck for dealing me an ace in my friend Fred — Wang Fangyu.

AN SIYUAN — BOB ELLSWORTH

Remembering
Fangyu

I OWE MY SPECIAL FRIENDSHIP with Fangyu entirely to Chinese painting and calligraphy. When Zhang Daqian came to the United States in the 1950s and brought with him a group of paintings and calligraphy by Bada Shanren, it was through my introduction that Fangyu acquired many of these works and established the foundation of his collection.

Fangyu was a typical scholar, which can be seen for example in the unusual name he chose for his studio, The Hut for Eating Chicken Feet (Shijizhilu). This name alludes to a passage in the ancient Chinese text *The Springs and Autumns of Master Lü*, which says: "A good scholar is like the King of Qi eating chicken feet; he must eat many thousand before he has had enough"; to which a commentary adds: "The word 'chicken feet' (zhi) means the heel of the chicken foot; this statement is a metaphor for the scholar who explores numerous paths, then determines which is best." In just this manner, Fangyu urged himself on indefatigably, achieving mastery through his studies in a broad range of subjects. He devoted his life to teaching Chinese language and literature, and possessed a profound knowledge of philology, literature, and history, using various scholarly methodologies such as textual criticism and comparative analysis in both his research and collecting. He persevered in this for several decades, and aside from the works in his own collection, he also arranged to visit collections of Bada's works all over the world, gaining broad knowledge and extensive visual

experience. Over the years, he published several dozen scholarly articles about Bada in all kinds of publications, both Chinese and Western, in which he addressed one by one the age in which Bada lived, his names and sobriquets, his seals, his language and writing, and the authenticity of works attributed to him, quoting copiously from numerous texts and tracing things back to their source. In 1984, Fangyu edited the *Bada Shanren lunji* (An anthology of essays on Pa-ta-shan-jen), and in 1990 he and Richard M. Barnhart, professor of Chinese art history at Yale University, coauthored the monograph *Master of the Lotus Garden: The Life and Art of Bada Shanren (1626–1705)*. At the same time, they mounted an exhibition of Bada's works and held an international scholarly conference, which caused great excitement both at home and abroad and was the culmination of Bada studies in our time. As a result, Bada Shanren became one of the best-known Chinese painters in the world. Fangyu's achievements in researching and introducing Bada will never perish, for he was undoubtedly the foremost scholar of Bada Shanren in our time and the one who most profoundly understood him.

For decades, I have repeatedly emphasized "brush and ink" (bimo) in my connoisseurship of Chinese painting and calligraphy, that to be able to recognize the differences in how individual artists use brush and ink is the key to connoisseurship. The brush and ink of a Chinese painting are like the voices we are born with, each has its own inimitable quality. Once you recognize this unique voice, it is no longer difficult to

C. C. Wang and Wang Fangyu.

differentiate the look of an individual artist or to distinguish original works from copies and authentic works from fakes. I was extremely fortunate to have had a bosom friend like Fangyu with whom I could sit side by side and intimately discuss such things, for he was one of the very few people outside China who understood this.

Fangyu was also known internationally for his calligraphy. Although Chinese painting and calligraphy were certainly not his area of professional expertise, Fangyu had an astute mind and was an excellent scholar, and based on his erudite knowledge of the written language, he incorporated the unique linear qualities of Chinese calligraphy and his own aesthetic of ink tonality into his historical analysis and interpretation of individual characters. He often selected just one or two characters and fused their structural elements with the fluidity of line and variations of ink tonality to create what he called works of "dancing ink." This approach inspired people to look at Chinese calligraphy from a different point of view and brought them to a new appreciation of its aesthetic qualities.

After Fangyu retired, he devoted even more of his time to studying Chinese painting and calligraphy, and whenever we had the opportunity, we would get together to discuss things. Over many painstaking years, Fangyu became especially famous for his collection of works by Bada Shanren and Qi Baishi, and when we came across works by either of these two masters, we would always take great delight in discussing them, talking for long hours and forgetting to go home. In 1994, Fangyu moved from New Jersey to an apartment in Manhattan to become my neighbor in the same building, making it more convenient for us to discuss painting and calligraphy. After that, with just a phone call or by walking a few steps, we could easily bring each other paintings to view and discuss at length. The feelings of this kind of friendship, where "we enjoyed rare paintings together and mutually examined their uncertain meanings," were no less than the pleasures of the Peach Blossom Spring.

In the autumn of 1997, an unexpected failure of heart surgery took the life of Wang Fangyu. Alas, he is gone, and in one night of autumn wind, heaven and man are forever parted. Fangyu took with him many great unfinished plans for articles and exhibitions, and while the world lost a great expert on Bada Shanren, I suddenly lost a dear friend with whom I can no longer enjoy our intimate conversations. Until this day, whenever I think back, my heart and mind still ache with pain. I have written this short account to express my grief and record it here for those who carry on after us.

C. C. WANG

Maps

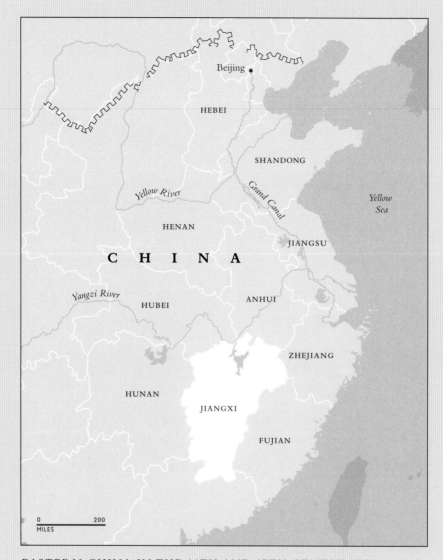

Beijing

HEBEI

SHANDONG

Yellow River

Grand Canal

HENAN

C H I N A

*Yellow
Sea*

JIANGSU

Yangzi River

HUBEI

ANHUI

ZHEJIANG

HUNAN

JIANGXI

FUJIAN

0 200
MILES

EASTERN CHINA IN THE 16TH AND 17TH CENTURIES

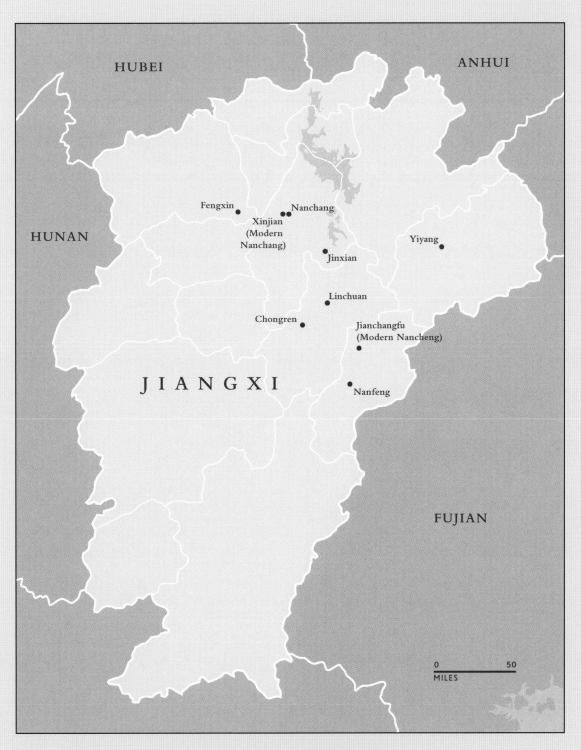

HUBEI

ANHUI

HUNAN

Fengxin •

• Nanchang

Xinjian
(Modern
Nanchang)

Yiyang •

• Jinxian

JIANGXI

• Linchuan

Chongren •

Jianchangfu
(Modern Nancheng)

FUJIAN

• Nanfeng

0 ——— 50
MILES

JIANGXI PROVINCE IN THE 16TH AND 17TH CENTURIES

个山小像

The Life and Painting of Bada Shanren

JOSEPH CHANG

Who was Bada Shanren (1626–1705)? Much about him remains a mystery. His name is a pseudonym and means Eight Eminence Mountain Man, a term that might be puzzling to the uninitiated but is a household name to scholars in the field of Chinese painting and calligraphy. Identified positively as one of the many descendants of the Ming imperial prince Zhu Quan (1378–1448)—the seventeenth son of the dynasty founder and the first prince of Nanchang, Jiangxi—Bada's origins remain elusive. During his lifetime, he adopted about a dozen different pseudonyms, some with slight variations. The name Zhu Da never appeared in Bada's signatures or seals but became associated with him in 1720, fifteen years after his death, and is still widely known today. More recent scholarship on Bada's genealogy remains inconclusive; some studies have attempted erroneously to establish Bada Shanren's lineage as the crown prince of the last emperor of the Ming dynasty (1368–1644).[1] While the riddle of Bada's life continues to generate prodigious scholarly activity, Bada's true identity has yet to be revealed.

BEFORE THE FALL OF THE MING DYNASTY, 1626–1644

Bada Shanren was born into a literary and artistic family that for generations had cultivated poets, calligraphers, painters, seal carvers, and art historians, including Bada's father and grandfather.[2] Most scholars are convinced that the poet, calligrapher, painter, and seal carver Zhu Duozheng (1541–1589) was Bada's grandfather. Although Bada never met his grandfather, Zhu Duozheng's talents influenced his development as an artist. Bada's father Zhu Moujin (died 1644) was a deaf-mute painter who had learned from his own father and capably rendered the styles of mid–Ming Wu School masters Shen Zhou (1427–1509), Wen Zhengming (1470–1559), Lu Zhi (1496–1576), and Zhou Zhimian (late 16th–early 17th century). Raised in such an environment, Bada began writing poetry at the age of seven and later became accomplished in calligraphy, seal carving, and painting.[3] As an imperial descendant, Bada most likely received a classical education. He took the civil service examination in his late teens, passed the first-level test in the early 1640s, and was said to be a brilliant student. Little else has been recorded about his youth.

In 1644, on the 19th day of the third lunar-month (April 25), the last Ming emperor committed suicide when a rebellious peasant army sacked the capital, Beijing. Reportedly, Bada Shanren's father died shortly afterwards. That same year, on the second day of the fifth lunar-month (June 6), the nomadic Manchus from the northeastern frontier seized the capital and established the last dynasty of the Chinese empire, the Qing (1644–1911).

SEEKING SHELTER IN BUDDHIST TEMPLES
AND EPISODES OF MADNESS, 1645–1680

In 1645, a year after assuming power, the Qing army fought its way into Bada Shanren's hometown, Nanchang, Jiangxi, causing Bada to flee and take refuge in the Fengxin mountains, west of Nanchang. In 1648, at age twenty-two, Bada found shelter in a temple and

FIG. 1 *Portrait of Geshan,* by Huang Anping (act. late 17th century), China, Qing dynasty, 1674. Hanging scroll, ink on paper, 97 x 60.5 cm. Bada Shanren Memorial Museum, Nanchang. From Wang Zhaowen, ed., *Bada Shanren quanji* (Complete works of Bada Shanren) (Nanchang: Jiangxi meishu chubanshe, 2000), 1:v.

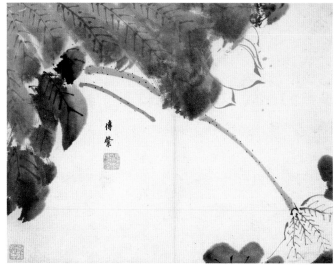

became a Buddhist monk. Just as many artists who created pseudonyms for either artistic or symbolic expressions, Bada adopted many Buddhist names for himself, including the better-known ones, such as Xuege, Chuanqi, Ren'an, Fajue, and Geshan. Bada remained a monk-painter for more than thirty years.

Being a gifted individual from an educated family, Bada quickly learned the Buddhist teachings, exceeding his peers' expectations. In 1653, he became a disciple of the prominent Chan master Yingxue Hongmin (1607–1672) of the Caodong sect. Three years later, at age thirty, Bada replaced his master and became abbot of the Lantern Society (Dengshe) at Jiegang, Jinxian, southeast of Nanchang. Bada's earliest surviving works date to this period.

Bada's earliest extant work, *Flower Studies,* an album of twelve paintings and three leaves of calligraphy, dated 1659–60, is in the collection of the National Palace Museum, Taipei. Heavily permeated with Chan connotations—unfamiliar even to most sinologists—Bada's inscriptions in this work are puzzling. This trait remained generally true for his later works as well. As for Bada's early paintings, his chosen subjects and indistinct brushwork recall the style of the mid–Ming Wu School masters, including Shen Zhou, Chen Shun (1483–1544), and Xu Wei (1521–1593). However, Bada's compositions are constantly unique. He tends to leave the center of most paintings void, with the elements of the imagery dangling from the picture frame or often outside the frame (fig. 2).[4] This feature is even more obvious in Bada's *Lotus* album (cat. entry 1, leaf 8; fig. 3) painted a few years later, circa 1665, and now in the Freer Gallery of Art's collection. Fragmentary images give many of Bada's paintings an incomplete look, evoking a sentiment that the world is imperfect in the eyes of this former prince who was living clandestinely under a foreign regime.

Little is known about Bada's activities and associates during the 1660s, except that he was painting; however, from the beginning of the 1670s, historical records indicate that Bada's social circle had expanded from fellow Buddhist disciples to worldly Qing officials. In the summer of 1671, Bada Shanren made the acquaintance of Qiu Lian (1644–1729), a poet from Zhejiang and the son-in-law of the incumbent Xinchang magistrate Hu Yitang (died 1684), who later was posted to the same official position in Linchuan, Jiangxi, from 1677 to 1680. A close friendship soon developed among the three men and other members of the social elite through their participation in literary gatherings and the exchange of poems.[5] Ironically, at about the same time that Bada developed these new friendships, his Buddhist mentor Yingxue passed away. These two significant events may have contributed to his gradual move toward the secular world.

Bada's old friend Huang Anping (active late 17th century) painted the mysterious former prince in a monk's robe after the two happened to meet on the seventh day of the fifth lunar-month (June 10) in 1674. Bada clearly treasured this image of himself—titled *Portrait*

FIG. 2 *Ink Flowers,* leaf 10 from *Flower Studies,* by Bada Shanren (1626–1705), China, Qing dynasty, 1659–60. Album of fifteen leaves, ink on paper, 24.5 x 31.5 cm. National Palace Museum, Taipei.

FIG. 3 *Lotus,* leaf 8, from *Lotus,* cat. entry 1.

of Geshan (see fig. 1; see p. xx)—for he wrote autobiographical references on it six times between 1674 and 1678 that reveal his torment in choosing between the sacred and secular spheres.[6] Bada Shanren asked his fellow disciple Rao Yupu (17th century) to add an inscription on the portrait in 1677. In his informative statement, Rao acknowledges that Bada received praise for his discipline and creativity in whatever he pursued. Rao also writes about Bada's wish to be regarded as a painter and poet henceforward. On Rao's inscription, Bada made an impression with a personal seal that reads, *Xijiang Yiyang wangsun* (Descendant of the Yiyang Prince of Jiangxi; see Bai, fig. 12, p. 23), revealing openly, for the first time, his imperial lineage. It had become evident that Bada Shanren was ready to return to the secular world under his former imperial identity.

Perhaps, the challenge of reentering secular society after being a Buddhist monk for more than thirty years caused Bada to suffer a nervous breakdown the summer and autumn of 1678.[7] His mental health further declined in late 1680. Shao Changheng (1637–1704), a scholar from Jiangsu who met Bada in 1690, described a period when Bada "went mad, suddenly laughing aloud, or crying sadly all day long. One evening he tore off his monk's robes and burned them. On a walk back to Nanchang, Bada madly strolled alone, going from one shop to another in the city. . . . He was recognized by no one, until found by a certain nephew who took him home and kept him there. After a long while, Bada eventually recovered."[8]

Can Bada Shanren's so-called madness be detected in his works? Based on Hans Prinzhorn's characterizations of schizophrenic artists, published in 1922, art historian James Cahill argues that "Bada in his best and strongest works is not merely reflecting whatever disorder still afflicted him, but is drawing on remembered states of mental aberration to create the aberrant forms and structures of his paintings—one might adapt [William] Wordsworth's famous formulation for poetry to speak of this as 'madness recollected in semi-sanity.'"[9] It may be impossible to prove that Bada went mad during this period of his life. However, accounts written by his contemporaries Qiu Lian, Shao Changheng, Long Kebao (17th century), and Chen Ding (17th century) express either suspicion or outright certainty that Bada's "madness" was feigned for ulterior motives. Shao, in his "Biography of Bada Shanren," opined:

> There are many who know [Bada] Shanren, but there is none who truly knows [Bada] Shanren. . . . What is he supposed to do? By acting suddenly mad, or suddenly mute, he can conceal himself and be the cynic he is. Some say he is a madman, others say a master. These people are so shallow for thinking they know [Bada] Shanren. Alas!"[10]

FROM MADNESS TO MARRIAGE AND BEYOND: THE DONKEY YEARS, 1680–1684

For unknown reasons, Bada Shanren painted landscapes only after he had renounced monkhood and returned to secular life. His first dated landscape painting appeared in 1681 (fig. 4), and was signed with a changed name, *lü* (donkey) followed by a seal with the same Chinese character (see appendix, seals, no. 7). While the composition and brushwork appear ordinary, Bada's inscription is typically difficult to interpret. Although the writing is calm, a strong sense of sadness can be detected in it. Equally mysterious is why the landscape subject, after the first dated one of 1681, did not resurface in his works until the late 1680s or early '90s.

It is unclear whether or not Bada Shanren married before the fall of the Ming dynasty. He may have married later on, however, for several contemporary accounts relate that concerned friends encouraged him to marry after his so-called madness in late 1680. Furthermore, several works of the early 1680s, bearing the *lü* signature or seal, seem to share similar obscure references to Bada's unhappy marriage. Whatever the case, the marriage was short-lived, and more specific messages about it were expressed through the writings on his paintings and works of calligraphy between late 1682 and 1684. A recently discovered painting, *Crab-Apple*

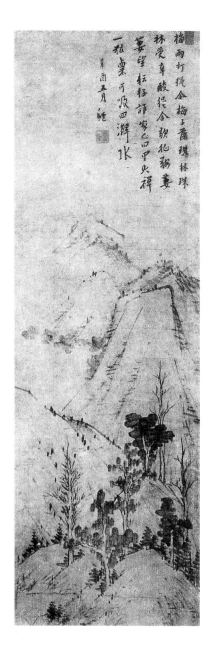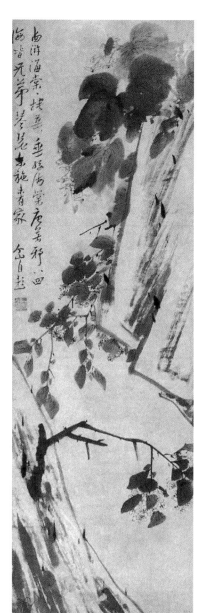

FIG. 4 *Landscape,* by Bada Shanren (1626–1705), China, Qing dynasty, 1681. Hanging scroll, ink on paper, dimensions unavailable. Collection unknown, from *Taishan Canshilou canghua* (Paintings in the collection of the Broken Stone Tower of Taishan). 40 vols. Shanghai: Xiling yinshe, 1926–29.

FIG. 5 *Crab-Apple Flowers,* by Bada Shanren (1626–1705), China, Qing dynasty, ca. 1682–84. Hanging scroll, ink on paper, 119.5 x 38.5 cm. Private collection, New York.

Flowers (fig. 5), further supports the theory that Bada had a brief, unsuccessful marital experience. Datable to early 1684—owing to its unrestrained writing style—Bada's inscription on *Crab-Apple Flowers* refers to irreconcilable differences between the spouses. The artist's seal, *hefu,* or "What promise did I break?" underscores the probability of an unhappy ending.[11]

Bada's paintings and calligraphy from this period (1680–84) are characterized by a preference to use the side of the brush, forming flat, angular, and sharp-ended strokes. The most frequently used signatures and seals bear the *lü* character, a Chan reference not only to his former monkhood but also to his recognition of "impossibility" in life.[12]

SUDDEN RETURN TO THE MUNDANE WORLD, WIELDING BRUSH AND INK, 1684–1705

A new pseudonym, "Bada Shanren," made its first appearance, in both signature and seal, in 1684. The album *Scripture of the Inner Radiances of the Yellow Court* (cat. entry 2), dated on the first day of the seventh lunar-month (August 11), in the Freer Gallery's collection, bears the artist's earliest dated signature of Bada Shanren known to date (see appendix, signatures, no. 2). The signature is also followed by a seal with the *lü* character (see appendix, seals, no. 7). The Freer album provides an important link in the artist's transitional period from the *lü,* or

"donkey," years to those that followed, during which Bada rose to become one of the best-known artists in the history of later Chinese painting.

Sheshi, To Be Involved in Affairs, 1684–1693

Bada Shanren's adoption of a new pseudonym that he used for the rest of his life suggests that he not only came to terms with his broken marriage but also made peace with himself and his life. He continued to socialize with and create artworks for monks, Qing officials, and scholars. While flat and angular brushwork still distinguished his paintings and calligraphy in the latter part of the 1680s, Bada was gradually holding his brush upright to use more of the resilient vertical fine tip *(zhongfeng)* instead of holding it at a slant and using the side of the brush top *(cefeng)*. A fine example of his work using a slanted brush and the side hair is the album leaf *Pine Tree* (fig. 6), datable to circa 1688–89, in the Freer Gallery of Art's collection. This work illustrates the characteristics of broad and flat brushwork executed to form the angular, twisted contours of the objects depicted. By holding the brush upright, the well-rounded hair and fine tip tend to create more linear and even brushstrokes. Two album leaves in the Freer's collection, *Lilac Flowers* and *Calligraphy* (cat. entry 3), dated 1690, provide a compelling comparison for the two very different techniques. Holding the brush upright allows the arm (and not the wrist) to manipulate the brush more freely and swiftly. As a result, Bada's signature and facing inscription in running-cursive script appear more solid and fluid.

Other than a handful of landscapes, Bada's favorite subjects during this period were birds, flowers, bamboo, lotus, melons, plants, fish, ducks, insects, cats, and chickens. Such a broad range of interests is unusual when compared to his contemporaries. What intrigued him to try his brush on such variety? Records reveal that in the beginning of his secular life Bada painted for his own enjoyment and gave away his works. Yet his need for income and his growing recognition as an artist among the social elites led him to become a professional painter in the late 1680s.[13] Judging from extant dated works, Bada became increasingly active from 1690 onward.[14]

An unusual term, *sheshi,* meaning "to be involved in affairs," repeatedly appears in Bada's dated paintings and seal impressions between 1690 and 1693.[15] Four works in the Freer Gallery's collection alone testify to Bada's frequent usage of this imaginative term: *Bamboo, Rocks, and Small Birds,* dated 1692, (cat. entry 4); *Falling Flower, Buddha's Hand Citron, Hibiscus,* and *Lotus Pod,* also dated 1692, (fig. 7 and cat. entry 5, leaves 1, 2, and 4) all bear

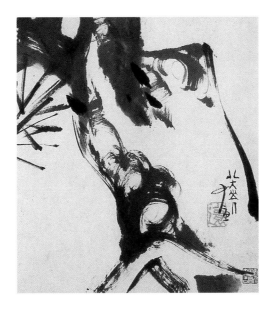

FIG. 6 *Pine Tree,* leaf k, from *Flowers and Birds,* by Bada Shanren (1626–1705), China, Qing dynasty, ca. 1688–89. Album of eleven leaves, ink on paper, 25.5 x 23 cm. Freer Gallery of Art, Smithsonian Institution, Washington, D.C., F1955.21j.

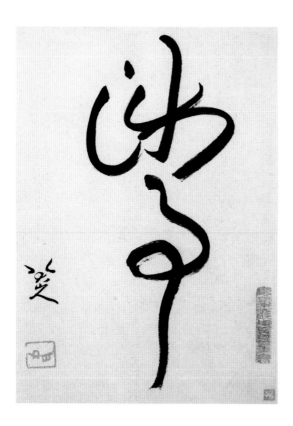

FIG. 7 *Sheshi* (To be involved in affairs), detail from *Falling Flower,* leaf 1 of *Falling Flower, Buddha's Hand Citron, Hibiscus,* and *Lotus Pod,* cat. entry 5.

sheshi in Bada's inscriptions. A seal impression of *sheshi* (see appendix, seals, no. 15) can also be identified in the lower right corner of *Buddha's Hand Citron.* Bada explained why he came up with this term in one of the three inscriptions that he wrote on the Shanghai Museum's *Birds and Fish,* dated 1693: "[One must] repeatedly climb [the mountains] to be free from fear, struggling for competence. In writing, too, [one] must be free from fear in order to be competent; the same holds true for painting. Therefore, when it comes to painting, I respectfully call it *sheshi.*"[16]

Based on these precepts, Bada's vision becomes clear: he intended to immerse himself in brush and ink and to be fearless and competent in creating paintings that portrayed a variety of objects. Bada's growth in this direction was paralleled by his change in format from the small, intimate album and handscroll formats to the large, powerful hanging scroll, such as *Bamboo, Rocks, and Small Birds* mentioned above.

In Pursuit of Antiquity, 1693–1700

Already an accomplished painter and calligrapher by adolescence, by the early 1690s, Bada Shanren had been creating with brush and ink for more than half a century. He knew the age-old theory of shuhua tongyuan—that calligraphy and painting are of the same origin—and that little difference exists in how these sister arts are comprehended or created. The year 1693 marked a period of great importance in Bada's aesthetic evolution. In a missing album, Landscapes and Calligraphy, consisting of eight leaves and dated 1693, Bada unmistakably stated his philosophical views on four of the leaves. First, literary talents are equivalent to the calligraphy and painting of the world (leaf 6); second, the essence of art should not be judged by likeness to an object, but by the emotions and intelligence the art embodies (leaf 2); and third, painting and calligraphy are to be created using the same methods (leaves 5 and 8).[17]

Both landscapes on the second and the fifth leaves share certain unusual qualities in their landscape elements: boundlessness and indefiniteness. Whereas the hanging cliff in the upper right corner of leaf two and the slope in the lower left of leaf five are both edgeless, stretching the landscapes to indefinite remoteness, the contours of trees and rock formations are

often indistinguishable, creating a world that is only beginning to emerge. In his lengthy inscriptions, Bada subtly advocated the importance of emotions and intelligence in an artwork over any likeness it represented. This was a time when Bada seriously contemplated art and its meaning in his life. Technically, he reemphasized that the methods of painting should be united with those of calligraphy, and vice versa. With this revelation, Bada Shanren's art reached new heights.

At the same time, he delved further, and seemingly indiscriminately, into study of the old masters of calligraphy. From ancient steles to works by the great Ming master and theorist Dong Qichang (1555–1636), Bada diligently and thoroughly studied them all (cat. entries 6, 17, 20, 31, and 32). In painting, especially the landscapes, he faithfully followed the doctrine of the Southern School literati painting, arbitrarily established by Dong. This framework emphasized that paintings by men of letters should employ the methods of writing ancient scripts, but at the same time should achieve self-expression through pure calligraphic brushwork characterized by intuition and spontaneity.[18] Of all Dong's immediate followers, it is Bada who offers the best examples for interpreting Dong's theory and practice.

In the *Grieving for a Fallen Nation* album (ca. 1693–96; cat. entry 8), although the four landscape leaves are not inscribed with specific stylistic sources, they generally recall the familiar yet distinctive manners of the Four Great Masters of the Yuan dynasty (1279–1368): Huang Gongwang (1269–1354; leaf 3); Wu Zhen (1280–1354; leaf 2); Ni Zan (1306–1374; leaf 1); and Wang Meng (1308–1385; leaf 4), all distinguished painters in Dong Qichang's Southern School lineage.[19] Bada was completely at ease in displaying the wonder of brushwork from Ni Zan's simplicity to Wang Meng's complexity. The combination of abstract brushwork and ambiguous spatial relationships resulted in charming and illusive landscapes in this exquisite album. Bada's capability of handling brush and ink reached the realms of *linli qigu* (ever-changing, eccentric, and antique) as described by his distant cousin, Shitao (1642–1707), a fellow prince-painter.[20] These "ever-changing and eccentric" qualities are best seen in Bada's large paintings of lotuses and birds, such as *Lotus and Ducks* (ca. 1696; cat. entry 9) in the Freer Gallery's collection. The contrast of solid and loose between the long and upward-lifting lotus stalks—as if they were "written" in the manner of seal script—and the broad and hanging lotus leaves—splashes with wild-cursive strokes of multi-layered ink tonality—is truly ever-changing in execution. The upward, expressive gaze of the juxtaposed ducks (fig. 8) bears a quality of human emotions.

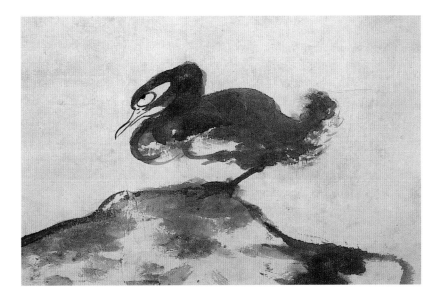

FIG. 8 Detail, *Lotus and Ducks,* cat. entry 9.

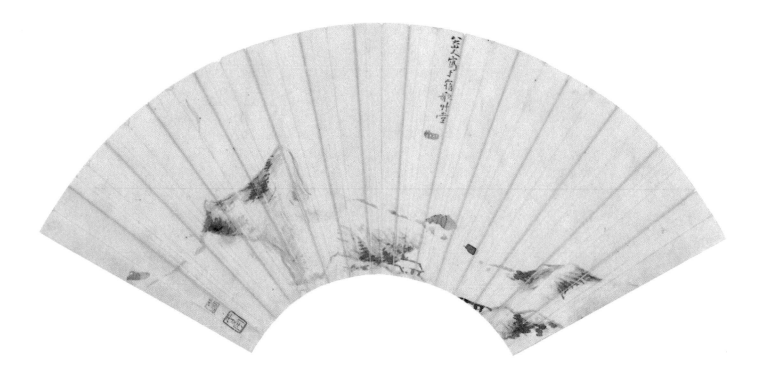

FIG. 9 *Landscape,* by Bada Shanren (1626–1705), China, Qing dynasty, ca. 1705. Fan mounted as an album leaf, ink on paper, 18 x 50 cm. Private collection, New York.

Bada devoted more of his talents toward calligraphy and landscape painting from this point on. The prose and poetry by the old masters that Bada chose to write are frequently about dwelling in nature (cat. entries 10, 13, 22, 25, and 28) or landscape paintings (cat. entries 11, 14, 15, 16, and 18). The following lines, written by the renowned Tang poet Du Fu (712–770; cat. entry 16) are among those most frequently quoted by artists reflecting on the ideal circumstances for creating landscape paintings:

Ten days to paint a river,
 five days to paint a rock,
An expert does not suffer feeling pressed or hurried. . . .

Bada echoes these lines. Yet in reality, he needed to produce art for income at the expense of pure creativity. When the scholar Wang Yuan (1648–1701) traveled to Nanchang in 1698 and met with Bada, he wrote to another painter, Mei Geng (1640–1722), in Xuancheng, Anhui Province, that Bada was "a true master. His arts go far beyond those of his peers. But he is poor and has to make a living by selling his calligraphy and painting, therefore, socializing with society is simply inevitable. Indeed, it is a shame."[21]

Bada's *Album after Dong Qichang's "Copies of Ancient Landscape Paintings"* (ca. 1697; cat. entry 12) reinterpreted Southern School masters such as Dong Yuan (died 962) (leaf 1, 5), Zhao Mengfu (1254–1322; leaf 2, 3), Huang Gongwang (leaf 4), and Ni Zan (leaf 6), through the filter of Dong Qichang's own interpretation. Bada not only followed Dong's copy of ancient landscapes, he also faithfully copied Dong's inscription on each leaf, including the signatures, except for the first leaf, where he left his own mark with a seal impression. When Bada was young, Dong Qichang was rather influential in terms of calligraphy; as Bada matured, Dong continued to be influential, but in terms of painting. Bada's *Album after Dong Qichang's "Copies of Ancient Landscape Paintings"* is his ultimate homage to the Ming dynasty's great master Dong Qichang, and exemplifies Bada's personal pursuit of antiquity in the great tradition of Chinese landscape painting.

Seeking Solitary and Heavenly Harmony, 1701–1705

Starting in the year 1701, a new studio name, *Wuge caotang* (Hut for Sleeping Alone and Waking to Sing) appears in Bada Shanren's inscriptions and was used until his death in 1705.[22] Although it has been reported that in 1702 Bada was a member of the Donghu Calligraphy and Painting Society (Donghu shuhua hui), which was formed mostly by local artists, he also sought a solitary life in old age.[23] A local scholar, Liang Fen (1641–1729), wrote to Bada in 1704, stating that he had not heard from Bada in four years.[24] It is evident that Bada's social activities diminished during the last years of his life. The year of *jiashen* (1704) lacked a dated work by Bada. It is also possible that because the Ming dynasty ended in the same cyclical year of *jiashen* (1644), after a sixty-year cycle, it was simply too painful for Bada to record that particular date.

Taking into account both Bada's new studio name and Liang Fen's concern about the artist's seclusion, it seems probable that Bada intended his last years to be solitary. This chosen behavior complements Ni Zan's landscape style as described by Dong Qichang on the last leaf of Bada's *Album after Dong Qichang's "Copies of Ancient Landscape Paintings"*: "The paintings of Ni Yu [Ni Zan] are plain and natural, and have none of the helter-skelter vulgarity of common painters" (cat. entry 12, leaf 6). On another album leaf by Bada, *Landscape after Ni Zan* (ca. 1703–5; cat. entry 33), in the Freer collection, the artist himself remarks: "Ni Yu painted like a celestial steed bounding the void or white clouds emerging from a ridge, showing not a speck of mundane vulgarity. I drew this [painting] in my spare time."[25] The absolute simplicity of the composition and the contour of trees and rocks outlined by the smooth dry brushstrokes present a landscape from a pure and lofty mind.

Bada had long been interested in the writings of the ancient philosopher Zhuangzi (ca. 369–ca. 286 B.C.E.) as shown in the Shanghai Museum's *Birds and Fish* scroll.[26] On another late landscape, Bada wrote: "[This is] what Zhuangzi meant by 'harmonizing with a touch of heaven.'"[27] This abbreviated inscription refers to Zhuangzi's idea of how a man can live out his years simply by following the laws of nature as expressed in Zhuangzi's "Discussion on Making All Things Equal": "Harmonize them all with the Heavenly Equality, leave them to their endless changes, and so live out your years."[28] It was this kind of simple and harmonious relationship between man and nature that Bada was seeking in the latter part of his life.

A small fan, *Landscape* (ca. 1705; fig. 9), painted in his last studio called the Hut for Sleeping Alone and Waking to Sing, illustrates well Bada's secluded later life. There is not a soul in sight in the wilderness, only a tiny hut, almost invisible, situated on a low hill and separated from the distant mountains by the rising clouds behind it. The rising clouds, depicted only with the void, remind us of Bada's earlier remark on *Landscape after Ni Zan* (cat. entry 33), which partially reads: "White clouds emerging from a ridge, showing not a speck of mundane vulgarity." The only link to the mundane world is a small bridge leading from the hut's lower right side. The characteristic pale and dry brushstrokes of Bada's lofty and elusive later years define the tranquil and timeless nature in which heavenly harmony is supposed to be found.

NOTES

1 For detailed accounts of Bada Shanren's genealogy and identity, see Wang Shiqing, "Bada Shanren de shixi wenti" (The problem of Bada Shanren's genealogy), *Duoyun* (Art Clouds Quarterly) 27 (April 1990): 97–100; Wang Fangyu and Richard M. Barnhart, *Master of the Lotus Garden: The Life and Art of Bada Shanren (1626–1705)* (New Haven: Yale University Art Gallery and Yale University Press, 1990), 23–32. For the theory that Bada Shanren was the heir of the last Ming emperor, see Wei Ziyun, *Bada Shanren zhi mi* (The riddle of Bada Shanren) (Taipei: Liren shuju, 1998).

2 Wang Shiqing, "Bada Shanren de jiaxue" (The family education of Bada Shanren), in *Gugong wenwu yuekan* (National Palace Museum Monthly) 96 (March 1991): 68–85.

3 Chen Ding, "Bada Shanren zhuan" (The biography of Bada Shanren), in Wang Fangyu, ed., *Bada Shanren lunji* (An anthology of essays on Pa-ta-shan-jen) (Taipei: Guoli bianyiguan Zhonghua congshu bianshen weiyuanhui, 1984) 1:531–32.

4 For *Flower Studies,* see Wang Zhaowen, ed., *Bada Shanren quanji* (Complete works of Bada Shanren) (Nanchang: Jiangxi meishu chubanshe, 2000) 1:3–17. For another album, *Flowers,* in the Shanghai Museum, that shares similar characteristics, 1:18–27.

5 For Bada's acquaintances, see Wang Shiqing, "Bada Shanren de jiaoyou" (Bada Shanren's circle of friends), in ibid., 5:1094–1119.

6 For the inscriptions on *Portrait of Geshan,* see Wang and Barnhart, *Master of the Lotus Garden,* 37–41.

7 For Bada's madness, see Wang Shiqing, "Bada Shanren de bingdian wenti" (The problem of Bada Shanren's madness), in *Da Gong Bao,* July 1, 1984.

8 For Shao Changheng's "Bada Shanren zhuan" (The biography of Bada Shanren), see Wang Fangyu, ed, *Bada Shanren lunji* 1:527–28.

9 James Cahill, "The 'Madness' in Bada Shanren's Paintings," in *Ajia bunka kenkyu* (Asian culture studies) 17 (March 1989), 119–43.

10 Zhang Zining (Joseph Chang, "Bada Shanren shanshuihua de yanjiu" (Researches on the landscape paintings of Bada Shanren), in *Gugong wenwu yuekan* (National Palace Museum Monthly) 97 (April 1991): 87–115.

11 For detailed accounts of Bada Shanren's marriage, see Wang and Barnhart, *Master of the Lotus Garden,* 50–55.

12 Rao Zongyi, "Chanseng Chuanqi qianhou qi minghao zhi jieshuo" (Interpretations of the various pseudonyms of the Chan monk Chuanqi), *Duoyun* (Art Clouds Quarterly) 15 (October 1987): 150–53.

13 On Bada's becoming a professional artist, see Rao Zongyi, "Zhilelou cang Bada Shanren shanshuihua ji qi xiangguan wenti" (Landscape paintings by Bada Shanren in the Zhilelou collection and related issues), in *Ming yimin shuhua yanjiu taolunhui jilu* (Proceedings of the symposium on paintings and calligraphy by Ming i-min). *Zhongguo wenhua yanjiusuo xuebao* (Journal of the Institute of Chinese Studies) 8, no.2 (December 1976): 507–15; English summary, 516–17.

14 Wang Shiqing, "Qingchu huayuan bajia huamu xinian" (Dated paintings by eight masters in the early Qing dynasty: part 3) *Xin meishu* (New arts) 20, no.3 (1999): 74–78.

15 Hui-shu Lee, "Bada Shanren's Bird-and-Fish Painting and the Art of Transformation," *Archives of Asian Art* 44 (1991): 6–26.

16 For *Fish and Birds* in the Shanghai Museum, see Wang Zhaowen, ed., *Bada Shanren quanji* 2:268–73; for a discussion of *sheshi,* see Hui-shu Lee, "Bada Shanren's Bird-and-Fish Painting," 8–9.

17 For a reproduction of this album, see Wang Zidou, comp., *Bada Shanren shuhua ji* (Collection of calligraphy and painting by Bada Shanren) (Beijing: Renmin meishu chubanshe, 1983) 2:38–53; for discussion of the significance of this album and Bada Shanren's landscapes, see also note 10, especially pages 96–99.

18 For discussion of Southern School painting and its practice, see Wen C. Fong, "Tung Ch'i-ch'ang and Artistic Renewal," in *The Century of Tung Ch'i-ch'ang, 1555–1636,* ed. Wai-kam Ho (Kansas City: Nelson-Atkins Museum of Art, 1992) 2:43–54.

19 For works by the Four Great Yuan Masters, see James Cahill, *Hills Beyond a River: Chinese Painting of the Yuan Dynasty, 1279–1368* (New York: Weatherhill, 1976), 68–74; 85–127.

20 For Shitao and Bada Shanren, see Jonathan Hay, *Shitao: Painting and Modernity in Early Qing China* (Cambridge: Cambridge University Press, 2001), 126–31.

21 Hu Zhe and Jin Ping, "Mei Geng nianpu" (The chronology of Mei Geng), *Duoyun* (Art Clouds Quarterly) 53 (December 2000): 294–320.

22 Wang and Barnhart, *Master of the Lotus Garden,* 253.

23 For the Donghu Calligraphy and Painting Society, see Huang Du, "Luo Mu nianpu" (The chronology of Luo Mu), *Duoyun* (Art Clouds Quarterly) 25 (June 1990): 122–27.

24 Hu Yi, "Bada Shanren xinkao" (New discoveries on Bada Shanren), in *Bada Shanren yanjiu* (Studies on Bada Shanren), ed. Bada Shanren Jinianguan (Nanchang: Jiangxi renmin chubanshe, 1986), 303–14.

25 For Bada Shanren's final tribute to Ni Zan, see Wen C. Fong, "Stages in the Life and Art of Chu Ta (1626–1705 C.E.," *Archives of Asian Art* 40 (1987): 20.

26 See Hui-shu Lee, "Bada Shanren's Bird-and-Fish Painting."

27 Wang and Barnhart, *Master of the Lotus Garden,* 189–91.

28 For Zhuangzi's "Discussion on Making All Things Equal," see Burton Watson, trans., *The Complete Works of Chuang Tzu* (New York: Columbia University Press, 1968), 36–49.

多暇日山水契真

成九江臨戶牖三峽

宅遐意生筵含萬里

荒含樂鏡清詠歌

春遇迢迤論以義

The Calligraphy and Seals of Bada Shanren

QIANSHEN BAI

FROM BADA'S EARLY LEARNING TO THE FORMATION
OF THE BADA STYLE OF CALLIGRAPHY

For centuries before the time of Bada Shanren, calligraphy had been regarded as one of the most important achievements in Chinese art. A calligrapher was obliged to follow the prescribed sequence of strokes that make up each character while arranging the characters in a fixed format—usually vertical columns—so that the flow of his brush sketched a sequential path that was believed to have a temporal dimension akin to music. Because calligraphy is nonrepresentational and because it is affected by individual skill, style, and imagination, it is seen as a spontaneous product of hand, mind, and feeling and therefore has long been viewed by art critics and scholars as "a delineation of the mind" *(xinhua)*. Calligraphy is thus seen as an act of the "whole being," representative of one's personality, and an important means of self-cultivation and self-expression. Since in Chinese art theory a civilized mind produces civilized calligraphy, an individual's achievement in calligraphy is viewed as an index to his degree of self-cultivation.

Because good calligraphy was regarded as a reflection of a high level of self-cultivation and cultural achievement, calligraphy was the principal art that every member of the educated elite felt obliged to study. Because it was practiced, appreciated, and collected mainly by the literati, Lothar Ledderose has defined Chinese calligraphy as an "art of the elite."[1]

Calligraphy, unlike painting, is nonrepresentational. There have long been stories of calligraphers whose achievements were inspired by watching natural phenomena, but in reality, the foundation of calligraphic learning and creation has been the copying of ancient masterworks, and it has been through the diligent study of ancient masterworks that calligraphers have acquired skill and competence.

Bada's extant, early calligraphic works bear out this learning process, for they demonstrate that, in establishing his own idiosyncratic style, he first thoroughly studied various ancient masters.[2] An album of painting and calligraphy executed in 1659 (when Bada was thirty-three) now in the collection of the National Palace Museum (Taipei) is the earliest extant work by Bada. Its several calligraphy leaves and inscriptions on paintings are invaluable for studying Bada's early work. The album uses several different script types, including the running, cursive, clerical, clerical-cursive, and regular-script types, and these types were written in the styles of several ancient masters, demonstrating Bada's solid, extensive training in calligraphy.

The second leaf of this album is a painting of a taro root (fig. 1), on which Bada inscribed a poem describing an old man on Mount Hongya (a mountain in Xinjian county in Jiangxi) baking a taro root in winter as a treat for his guests. Although the poem may allude to the plain life Bada led in a Buddhist monastery, its elaborate regular-script calligraphy faithfully follows the style of the Tang master Ouyang Xun (557–641). Ouyang is famous for his rigid application of various rules in executing strokes and constructing character structures (fig. 2). Like Ouyang's calligraphy, every stroke in Bada's leaf is carefully executed, character structures are well balanced, and the overall composition of the

Detail, *Poem by Sun Ti,* ca. 1698, cat. entry 18.

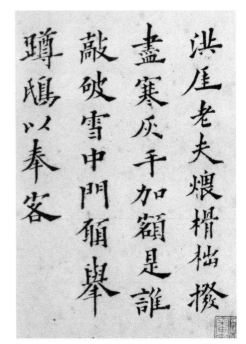

twenty-eight-character inscription is neat and orderly. As a Zen monk of the Caodong sect, often Bada laced his poetry with humor, but the calligraphy on this painting is serious, even ritualistic, showing that calligraphy has its own aesthetics, and that these do not always relate to the literary content of its texts. Thus, the aesthetics of a calligraphy can be enjoyed separately from its text or, alternatively, can be appreciated in terms of the possible tension between its calligraphic style and the literary theme of its presented text.

Three characters in this leaf are worth noting: the second character of the first column and the first and last characters of the second column (Chinese is written from top to bottom and in columns from right to left). The last stroke in each of these three characters is horizontal, with its right end given a distinctive upward flip, a characteristic of clerical script, a precursor of regular script. This feature is interesting because, during Bada's time, or, more precisely, since the Tang dynasty (618–907) onward, horizontal strokes in regular script tended to rise slightly from left to right, while their right ends were usually cut at a diagonal that slanted toward the lower right, as we can see in the work of Ouyang Xun (see fig. 2). This slanted ending, created by downward diagonal pressure from the brush, was in one sense an improvement over the horizontals in clerical script, for it better accords with the convention of writing characters from top to bottom because it sends the brush in the direction of subsequent strokes below, speeding the pace of writing.

Thus, the upward flick at the right ends of horizontal strokes in pre-Tang calligraphy eventually was replaced by the blunter, downward-pointing terminus of post-Tang regular script. Bada, by introducing outdated upward flicks into his horizontal strokes, alluded to ancient styles and introduced an archaic flavor into his calligraphy. This strategy of incorporating elements of ancient writings into calligraphy to lend it an archaic flavor was a common practice among calligraphers in the last half of the seventeenth century.

In contrast to Ouyang Xun's rigid brush method, leaves three and fifteen present a much livelier style of calligraphy that shows that Bada also was influenced by Chu Suiliang (596–658), another Tang calligraphy master (fig. 3). In Chu's "Preface to the Sacred Teachings" (*Shengjiao xu*), written in 653, commonly taken as his best work in regular script (fig. 4), the application of the so-called press-and-lift (*ti'an*) technique is more visible than it is in Ouyang's work. This technique is heavily dependent on the structure of the typical calligraphy brush, which has a tuft usually made from sheep, weasel, or rabbit fur. It is cone-shaped, and its tip is pointed. Pressing and lifting the brush, especially on absorbent paper,

FIG. 1 Detail, *Taro Root,* leaf 2 from *Flower Studies,* by Bada Shanren (1626–1705), China, Qing dynasty, 1659–60. Album of fifteen leaves, ink on paper, 24.5 x 31.5 cm. National Palace Museum, Taipei.

FIG. 2 Detail from *Jiuchenggong liquanming* (Inscription on the Sweet Wine Spring in the Jiucheng Palace), by Ouyang Xun (557–641), China, Tang dynasty, 632. Rubbing mounted as an album, ink on paper, dimensions unavailable. From Yang Renkai, ed., *Sui Tang Wudai shufa* (Calligraphy of Sui, Tang, and Five dynasties), vol. 3 of *Zhongguo meishu quanji: Shufa zhuankebian* (A comprehensive selection of Chinese art: calligraphy and seal carving) (Beijing: Renmin meishu chubanshe, 1989), 38, pl. 21.

FIG. 3 *Poem* in regular script, leaf 15 from *Flower Studies,* by Bada Shanren (1626–1705), China, Qing dynasty, 1659-60. Album of fifteen leaves, ink on paper, 24.5 x 31.5 cm. National Palace Museum, Taipei.

produces a great variety of stroke widths because, when the brush is pressed, the stroke becomes wider, and when lifted, thinner. In Chu's model and Bada's leaves, a horizontal stroke usually begins with a firm downward press. As the brush moves to the right to make the body of the stroke, it is slightly raised, then is pressed again at the end, leaving the middle section of the stroke thinner than at either end. Viewers of this technique get the impression that the brush dances as it moves, creating a rhythm akin to that of music and dance. That is why critics say of beautiful calligraphy that "the brush sings, and ink dances."

Besides use of the press-and-lift technique, Bada's calligraphy in Chu's style has other features. For instance, vertical strokes always begin with a sophisticated start and continue in graceful curves. Because they are relatively thin, they make a work seem more spacious and

FIG. 4 Detail from *Shengjiao xu* (Preface to the sacred teachings), by Chu Suiliang (596–658), China, Tang dynasty, 653. Rubbing mounted as an album, ink on paper, measurement unavailable. From Yang Renkai, ed., *Sui Tang Wudai shufa* (Calligraphy of Sui, Tang, and Five dynasties), vol. 3 of *Zhongguo meishu quanji: Shufa zhuankebian* (A comprehensive selection of Chinese art: calligraphy and seal carving) (Beijing: Renmin meishu chubanshe, 1989), 68, pl. 33.

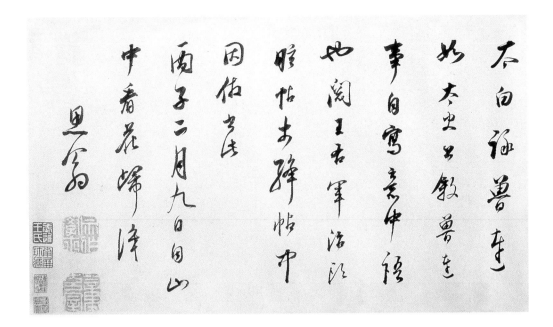

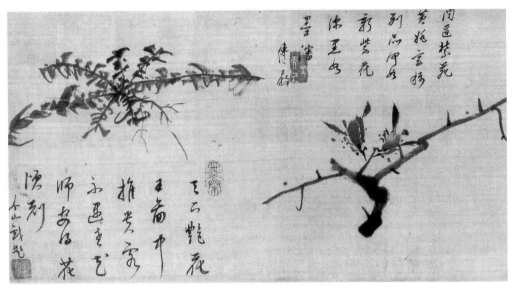

FIG. 5 Detail from *Three Works after Wang Xizhi,* by Dong Qichang (1555–1636), China, Ming dynasty, 1636. Handscroll, ink on paper, 25.1 x 305.1 cm. Freer Gallery of Art, Smithsonian Institution, Washington, D.C., purchase F1982.3.

FIG. 6 Detail from *Flowers,* by Bada Shanren, China, Qing dynasty, ca. 1671. Handscroll, ink on paper, 22 x 192.5 cm. Palace Museum, Beijing.

relaxed. Sometimes, character structures (particularly of the fifth character in the first column from right) are purposely unbalanced, their unstable structures diminishing the ritualistic orientation of regular-script writing and giving it a lively, individualistic flavor.

Different types of linear strokes and character structures convey different meanings and emotions and provoke different feelings. Bada's calligraphy in running and cursive scripts in the 1660s and the 1670s convincingly demonstrates that he closely followed the style of the late Ming master Dong Qichang (1555–1636) (fig. 5). No one occupied a more central position in seventeenth-century calligraphy than Dong. The richness and broad variety of his calligraphy prevents a comprehensive discussion here of the scope of his training and achievement. But in a larger historical framework, Dong's calligraphy followed the so-called model book tradition that had been founded on the elegant, graceful art of Wang Xizhi (ca. 303– ca. 361 C.E.) and by the Tang dynasty had become codified. Not only are Dong's models drawn from this elegant tradition, but his personal style is also innately graceful and refined.

There is an undated handscroll (it likely dates from around 1671) of flowers by Bada in the collection of the Palace Museum (Beijing) whose running-cursive script bears striking resemblance to the calligraphy of Dong Qichang (fig. 6). Precisely and delicately executed, the strokes have an effortless flow, and those that change direction bend in round rather than

FIG. 7 Detail from *Scroll for Zhang Datong,* by Huang Tingjian (1045–1105), China, Song dynasty, 1100. Handscroll, ink on paper, 34.1 x 552.9 cm. Art Museum, Princeton University, gift of John B. Elliott (1992.22).

FIG. 8 *Copy of Eulogy on the Virtue of Wine,* by Bada Shanren (1626–1705), China, Qing dynasty, undated. Handscroll, ink on paper, 25.7 x 531.1 cm. Shanghai Museum.

in angular turns, making the brush movement fluid and elegant. In addition, the characters are widely spaced, which creates a relaxed, easy atmosphere throughout the work. The second half of the seventeenth century was extremely turbulent, but during his stay in a Zen Buddhist monastery about this time, Bada managed to achieve a relatively tranquil mental state through his use of Buddhist practices; at the least, he was in a peaceful mood when he wrote this handscroll of flowers.

However, there was an abrupt change in Bada's style in the late 1670s when he sought inspiration from the calligraphy of Huang Tingjian (1045–1105), a master of the Northern Song dynasty (960–1127). Huang's running-script calligraphy is characterized by an elongated character structure that has a dense concentration of strokes at its core, from which elongated strokes radiate to the structure's periphery (fig. 7). Huang's strokes were often written with a purposely trembling hand, yielding strokes with uneven edges and frequent changes in brush direction. A handscroll executed by Bada around 1680, now in the collection of the Shanghai Museum, is the best-known example of Bada's calligraphy in Huang's style (fig. 8). The text of this scroll by the wine-loving scholar Liu Ling of the Western Jin dynasty (265–317 C.E.) is entitled "Eulogy on the Virtue of Wine" (*Jiude* song) a work that defends and praises indulgence in alcohol.

As in Huang's calligraphy, the character structures in this scroll are often elongated with long strokes stretching from the center. It would appear that Bada's brush had a stiffer tuft than Huang's, and he wielded it swiftly. The pointed tip of his brush left many sharp stroke ends, especially beginnings. He reduced the vibration of brush movement, making strokes more straightforward and much more angular than Huang's. Though the text is about wine, Bada may have written this scroll when sober. Even so, there are striking variations in character size in this calligraphy. Four of its columns contain only two large characters each, compared to four or five characters in each of the remaining columns. In retrospect, already associated with Bada's incorporation of Huang Tingjian's style were hints of the dramatic changes that were to transform his later style.

Bada Shanren made his final name change in 1684. Not only did he use "Bada Shanren" until his death, but it became his best-known name to posterity. It was also in this year that he began to practice a distinguished calligraphic style of his own that later became known as "Bada ti," or Bada style. Although his calligraphic works before 1684 showed something of his idiosyncratic character forms, they also contained the clearly identifiable stylistic traits of

BAI

17

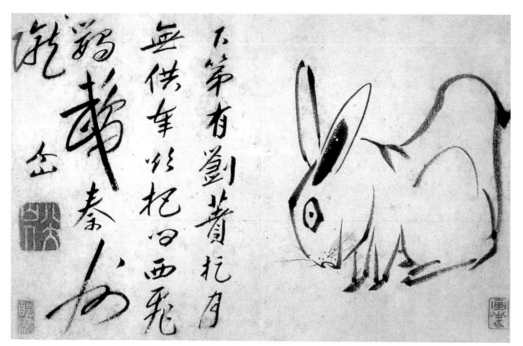

FIG. 9 *Rabbit,* album leaf, by Bada Shanren (1626–1705), China, Qing dynasty, undated. Album of nine leaves, ink on paper, 23.8 x 37.8 cm. Chen Family Collection, Singapore. From Wang Zhaowen, *Bada Shanren quanji* (Complete works of Bada Shanren) (Nanchang: Jiangxi meishu chubanshe, 2000), 1:64.

such specific ancient masters as Ouyang Xun, Chu Suiliang, Dong Qichang, and Huang Tingjian, among others. After 1684, this was no longer the case, so dramatic were Bada's stylistic innovations, and we may treat 1684 as marking the maturity of Bada's calligraphy.

The earliest extant work that bears the signature "Bada Shanren" is an album formerly in the collection of Wang Fangyu, that Bada made in the fall of 1684 (see appendix, signatures, no. 2). Its text is the *Scripture of the Inner Radiances (Neijing jing).* Copying Buddhist and Daoist sutras, or scriptures *(xiejing),* has a long tradition in China. Copying is not only a matter of transmitting religious teachings; it is an activity that accumulates religious virtue. One may copy the holy texts personally, especially on such special occasions as the birthday of Shakyamuni. Or, should one have more money than time, one might commission scribes to do the copying. This practice is often aimed at a specific goal; for instance, blessing ailing parents in hope of a cure.

Bada's objective in copying the *Scripture of the Inner Radiances* remains unclear. He may have been studying Daoism at this time because, in the colophon he attached to his copy of the *Scripture,* he briefly mentions some of the similarities and differences between Daoist and Buddhist teachings, which suggests that these were a current topic of study for him. Although Bada had been a Buddhist monk for many years, he and many other intellectuals of the seventeenth century were also deeply interested in Daoism. While religious texts usually are accorded the dignity of regular script, Bada's copy is a mixture of the regular and running scripts. Even so, one can sense a seriousness in his style. Some strokes are connected to each other, showing a degree of informality, but few characters interconnect, making the work fairly easy to read, as with regular script. And while character structures tilt to the right, lending them a lively, asymmetric balance, the sutra has none of the dramatically elongated characters or brushstrokes characteristic of Bada's "Ode on the Virtue of Wine" in the style of Huang Tingjian, which was discussed above.

Are there clues as to what may have inspired Bada to include elements of running script in his transcription of the *Scripture of the Inner Radiances?* In his colophon to this work, Bada mentions two points that may be relevant. One is that he refers to Buddhist sacred teachings *(Shengjiao).* A closely related text, the "Preface to the Sacred Teachings" *(Shengjiao xu)* of the Tang period, exists in several engraved versions, one of which was carved in running script and thus may have served as precedent for Bada's approach. The second point is that his colophon notes that his transcription of the *Scripture of the Inner Radiances* follows the

calligraphic manner of the Two Wangs (Wang Xizhi and his son Wang Xianzhi, 344–388 C.E.), although the stylistic relationship of the *Scripture of the Inner Radiances* to the style of the Two Wangs is a loose one. What makes the Two Wangs relevant is that the one famous engraved version of "Preface to the Sacred Teachings" (Bada's possible inspiration for writing sacred documents in running script) was commissioned by a Buddhist monk Huiren (active ca. 7th century), in which all the characters were taken by Huiren from Wang Xizhi's running-script writings. Thus, there were two factors behind Bada's writing a sacred text in running script in the style of Wang Xizhi, and Bada mentions connections to both of them in his colophon.

It appears that during this period Bada became deeply interested in exploring a new spatial dimension. In a painting album of 1684 now in the collection of the Chen family in Singapore, both Bada's paintings and inscriptions show his interest in "surface."[3] Taking the leaf with a rabbit as example (fig. 9), it can be seen that the minimized depiction of the rabbit demonstrates no interest in the depth of the painted object. The brushwork of this painting's inscription also tends toward flatness, lacking three-dimensional effects that could have been achieved by applying the so-called centered-tip technique, in which the tip of the moving brush is kept in the middle of the strokes being written. Character structure in this inscribed poem is no longer elongated, but the two extra-large characters in the third column are so eye-catching that one pauses to ponder why the artist adopted such a dramatic fashion of writing. However, Bada's interest in "surface" lasted only about five years. It was followed by a new exploration, this time into depth.

STUDY OF ANCIENT EPIGRAPHY AND BADA'S LATE CALLIGRAPHY

Bada, toward the end of the 1680s, gradually developed a vigorous style whose archaic flavor was strongly reminiscent of ancient seal and clerical calligraphy. There are two album leaves in the former Wang Fangyu collection that bear a painting of a quince and an inscription in running cursive by the artist.[4] This inscription's appearance is less dramatic than that in the Chen family album of 1684. But what is of interest here is the work's brush movement, which was executed by an evenly pressed brush, resulting in lines of generally uniform width. This technique is polar to that used in the work in Chu Suiliang's style discussed above, where the constant use of the press-and-lift technique continuously varied the width of the line. In the present work, the even pressure of the brush makes the strokes firm and round. Although the even-pressure technique seems less complicated than that of press-and-lift, it takes great skill to execute with a calligraphy brush, which naturally lends itself to variations in brush pressure. Despite this hidden difficulty, the strokes in this work are vital and richly substantial, qualities that characterize Bada's calligraphy from the late 1680s to his death.

The stylistic innovation of Bada's use of even brush pressure may have had several sources. Wen C. Fong argues that during this period Bada was interested in reconstructing what he thought had been the appearance of the calligraphy of Wang Xizhi, the sage calligrapher of the Eastern Jin dynasty (317–420).[5] Yet, there was another possible influence of his new style. In the former Wang Fangyu collection, there is a rubbing of a cursive work (mounted as a handscroll) entitled *Shengmu tie* (Holy Mother Manuscript) by the Tang dynasty monk calligrapher Huaisu (ca. 725–ca. 799). Bada must have treasured this rubbing. This is evident because the rubbing bears his seals (showing that he possessed it), and because he took the trouble to make a transcription of Huaisu's cursive text that today is part of the rubbing handscroll (see appendix, seals [in order of appearance], nos. 19, 22, and 18 [identical impression]). Huaisu's calligraphy in the rubbing was made with the same evenly pressed brush as in Bada's late style and may have helped inspire it.

The third possible source for Bada's plain, round calligraphy may have been ancient inscriptions on metal and stone objects. Attempts to draw inspiration and arrive at historical

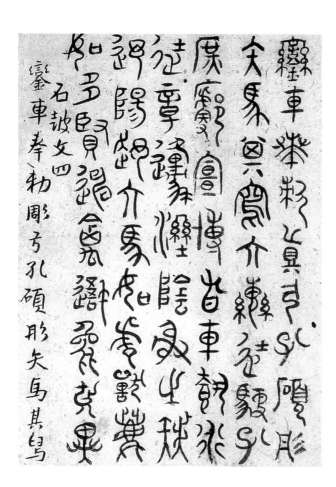

FIG. 10 Detail from *Copy of the Stone Drum Inscriptions,* by Bada Shanren (1626–1705), China, Qing dynasty, 1694. Album leaf, ink on paper, 17 x 8.3 cm. Nanjing Museum.

accuracy regarding the past from these artifacts had much to do with the new intellectual trends of the second half of the seventeenth century.[6] The tragedy of dynastic transition in 1644 forced many leading figures of the loyalist movement in the early Qing to rethink the causes of the rise of the Manchus at the expense of the Ming. Increasingly, empirical research was aimed at more accurately understanding the classics and history. This transition in the intellectual climate had significant influence on the art of calligraphy. As ancient epigraphs, which were regarded as original textual sources for studying the classics and history, became gradually more important in the formation of the new intellectual discourse, the calligraphic roughness and primitiveness of these sources were also appreciated and advocated by a number of leading calligraphers. Searching for steles and collecting rubbings of ancient steles and artifacts became an important part of cultural and intellectual life. Use of the epigraphical seal and clerical scripts exceeded that of the previous dynasties in both quantity and quality. Theoretical discussions of epigraphical calligraphy were also unprecedentedly frequent. But in the seventeenth century, the emergence of a competing style modeled on the plain, rough epigraphs on ancient bronzes and stone artifacts wrought by anonymous artisans caused a revolution in calligraphic taste.

Fu Shan (1606–1684/85), a northern philosopher, calligrapher, and leading theorist of this new taste, persistently advocated that ancient epigraphs in clerical and seal scripts should be the primary sources of calligraphic innovation. He claimed that "unless one practices seal- and clerical-script calligraphy, even if one has studied calligraphy for thirty-six thousand days, in the end, one is still unable to comprehend the key source of this art."[7]

Beginning probably in the 1680s and extending throughout the 1690s, Bada studied ancient epigraphs. A key piece of evidence testifying to Bada's interest in epigraphy is his album of calligraphy from 1694 entitled *Copy of the Stone Drum Inscriptions and the Stele at Mount Goulou,* now in the collection of the Nanjing Museum. It is one of the few surviving works of Bada's seal-script calligraphy (fig. 10).[8] The "Stone Drum Inscriptions" *(Shigu wen)*

FIG. 11 Detail from *Stone Drum Inscriptions,* China, Eastern Zhou dynasty (771–221 B.C.E.). Rubbing, ink on paper, 40 x 62.6 cm. Collection of Robert E. Ellsworth.

are ten odes engraved on ten gumdrop-shaped stone monuments commemorating a hunting event during the Warring States Period (475–221 B.C.E.). The inscriptions on these drums are written in the so-called great-seal script (fig. 11). The characters of this early script type retain pictorial elements, character structures favor symmetry, and strokes have a constant brush pressure that gives them the same width. Bada's copy of these inscriptions is a spontaneous interpretation. It includes his copies of eight of the ten odes in the same calligraphic style and script type as the original, and each copy is followed by his research notes in small characters. While Bada's copy of the inscriptions is rather casual, the curving lines were executed in even brush pressure, but many strokes have an unpolished, rough appearance that resembles the original ruined inscriptions on the stone drums. Thus, the overall flavor of Bada's copy is plain, archaic.

More importantly, Bada not only studied and practiced ancient inscriptions in seal script during this period, he also endeavored to incorporate the method and flavor of seal script into his calligraphy in other scripts. A magnificent hanging scroll of cursive-script calligraphy executed by Bada around 1699 manifests this effort (see cat. entry 22). In this work, strokes do not begin and end with sharp termini but with the blunt and rounded termini that result from the hidden-tip method. In this work, the brush moves vigorously against the surface of the paper. Although there is hardly a press or a lift when writing the strokes in this work, the brush encounters resistance, and some strokes show the roughness and varied ink tones of a drying brush. Bada's brush method also creates three-dimensional effects. There is little dramatic action in this kind of writing, but it achieves richness through simplified forms, the solidity of rounded strokes, and variations in ink tonality.

Calligraphic works of the Ming and Qing dynasties sometimes consisted of sets of hanging scrolls rather than of a single scroll. Depending on available space, these sets usually numbered from four to twelve scrolls in even-numbered increments. A work by Bada in this format (formerly in the collection of Wang Fangyu) comprises four hanging scrolls (see cat. entry 28).[9] The text of each scroll is a cursive transcription of a Tang poem. The four scrolls can be taken as a set because they are consistent in text and style; yet, because each bears a complete poem and Bada's signature and seals, they can also be hung individually. What interests us here is that, like the hanging scroll discussed above, many of the strokes are round and solid because the pressure on the brush was kept relatively even. While some

strokes are ink-saturated, others are dry, leaving streaks of white that create an effect termed by calligraphers "flying white."

Seventeenth-century calligraphers' increasing interest in ancient epigraphy was amplified by a rising passion for seal carving. Seal script had long since become archaic, having been used only rarely in everyday writing since the Han dynasty (206 B.C.E.–220 C.E.). Since the Spring and Autumn (770–476 B.C.E.) and early Warring States periods, however, seal carving and seal script had maintained an intimate relationship, since the legends of most seals were cast or carved in seal script. Late-Ming-literati seal carving was no exception. The preference shown for seal script resembles the attitude of some prestigious Western universities that continue to print their diplomas in Latin to show their pride in a long tradition. Originally the ordinary writing of the Shang (1600–1050 B.C.E.) and Zhou (1050–221 B.C.E.) dynasties, seal script, once dropped from common use, acquired through its later obscurity an aura of antiquity that lent authority to seals, which already were often symbols of political, economic, and cultural power. To be able to carve and read seals, the literati studied seal script. In the seventeenth century, carving and reading seals became an important, if limited, means of access to ancient scripts and led to a greatly increased interest in ancient scripts and in the pursuit of an archaic flavor in calligraphy. Thus, in studying ancient epigraphy even as he was actively engaged in seal carving, Bada followed a cultural trend of his time.

BADA SHANREN'S SEALS

Closely related to calligraphy is an art in which Bada engaged throughout his life: seal carving. We know from Chen Ding's (17th century) biography of Bada that he was good at it.[10] The record was further confirmed by a recently discovered letter that Bada wrote to a Mr. Juanshu (active late 17th century), in which the aged artist told his friend that he had designed a seal for him but had asked a famous seal carver to do the engraving.[11] Bada's signature dates this letter to the 1690s; probably by this time Bada was too old to carve seals by himself, but still made seal designs and had someone else carry out the actual carving.

Bada's involvement with seal carving was no accident; his family had a tradition of seal carving. His grandfather Zhu Duozheng (1541–1589) was a friend of He Zhen (1535–1604), the foremost seal carver of the late Ming, a period that witnessed the first heyday of seal carving as a literati art. Seal carving has existed in China for more than two thousand years. Since the thirteenth century, it has been customary for artists to affix their seal impressions to their calligraphies and paintings. A calligraphic work is not usually viewed as complete until pressed with the artist's seal; even when there was no signature, there was usually a seal impression. By the late sixteenth century, seal carving was emerging as an independent art form. When the Italian missionary Matteo Ricci (1552–1610) arrived in China in the late sixteenth century, he was impressed by the wide use of seals in daily and artistic life:

> *The use of seals for stamping objects is well known and very common here. Not only letters are safeguarded with a seal but they are affixed to private writings, poems, pictures, and many other things. . . . As a rule, they are made of some more or less precious materials, such as rare wood, marble, ivory, brass, crystal or red coral, or perhaps of some semiprecious stone. Many skilled workmen are engaged in making these seals and they are regarded as artists rather than artisans, because the characters engraved upon the seals are very old forms, not in common use, and high esteem is always accorded to those who display any knowledge of antiquity.*[12]

It was in the late sixteenth and early seventeenth centuries, long after calligraphy and painting had already become an indispensable part of literati life, that seal carving became a flourishing form of artistic expression for the literati.

The rise of the literati seal-carving movement was made possible by the reintroduction of soft stones as the medium of choice in the second half of the sixteenth century.[13] The permanent establishment of soft stone as the primary medium for seal carving was revolutionary in the history of Chinese seal carving. As James Watt has pointed out, "the necessary condition for the birth of this new art form, or rather the transformation of an ancient artistic craft into a medium of literati expression, was the use of soft stones (or soapstone) for seal carving."[14] Thereafter, the metal, jade, and ivory previously used by seal carvers was rapidly replaced by soft stone. Exploiting to the full the intrinsic nature of soft stone, seal carvers applied chisels in an increasingly spontaneous manner, leaving gashes and cuts that allowed viewers to trace the process of carving and thus to appreciate the carver's skill. Natural breaks and cracks created by this more spontaneous execution added to their seals a flavor of antiquity. Seal carving had reached a new level of sophistication.

Like works by most of his contemporaries, the majority of Bada's paintings and calligraphy, except his letters, bear his seals. Thus far, scholars have described ninety or so different seals used by Bada from the 1650s to his death, some having identical legends.[15] These seals can be divided into several categories: name seals, phrase seals, and pictorial seals. A distinctive cultural phenomenon in China is that "the Chinese literati assumed a number of personal names, in addition to the formal name they acquired at birth. The formal name was reserved for official and ceremonial use, and employed as a form of address only by one's superiors. Among their friends and in their writings and art, the literati referred to themselves by one or more style names *(zi)*, chosen to reflect a particular character or virtue, or poetic names *(hao)*, which might call to mind certain abilities, desires, or a memorable event."[16]

According to Wang Fangyu's study, Bada used about twenty different names over his life, "many of which provide important insight into his self-image."[17] Bada also used a number of seals that bear phrases or sayings of self-expression. Few pictorial seals are found among Bada's seals. An album leaf in the former Wang Fangyu collection given to the Freer Gallery of Art bears one such seal (see appendix, seals, no. 10). Its irregularly shaped impression contains the image of a mountain *(shan)* and the Chinese character for "mountain." The shape is derived from the image of real mountains. The last two characters "Shanren" in "Bada Shanren" mean "Mountain man," so this seal, although nominally pictorial, may have served as a signature seal.

To modern readers, Bada is a riddle. He never used formal names except his Buddhist names, such as Chuanqi and Fajue. Modern scholarship shows that Bada's original name was likely to have been Zhu Tonglin, but he never used this on his paintings, calligraphies, or seals.[18]

Bada habitually concealed his identity. Part of this cover-up was a series of names he used to mask himself from public exposure. That Bada used so many different name seals and phrase seals may reflect identity crises that he faced during a period of social dislocation. Bada once impressed a seal reading "Descendant of the Yiyang Prince of Xijiang" *(Xijiang Yiyang wangsun)* on his own portrait (fig. 12). The portrait had been painted for him by a friend in 1674, at a moment in his life when he was considering leaving the Buddhist temple and reentering the secular world. During this period, the last serious challenge to Qing rule in China seemed to be on the verge of success, and the generals who led the so-called War of the Three Feudatories held out the promise of a Ming restoration.[19] As Richard M. Barnhart notes, "This is apparently the only time in his life after 1645 that Bada openly identified himself as a prince of the fallen Ming house."[20] He even placed his seal in the imperial position, at the top center of the painting. But by the end of the 1670s, the promised restoration had failed.

Bada's phrase seals sometimes provided readers with specific, concrete information about his problems. For instance, "Control madness" *(Chedian)* was a seal Bada began to use around

FIG. 12 Impression of Bada Shanren's seal *Xijiang Yiyang wangsun* (Descendant of the Yiyang Prince of Xijiang). From Wang Zhaowen, ed., *Bada Shanren quanji* (The complete works of Bada Shanren) (Nanchang: Jiangxi meishu chubanshe, 2000) 4:910.

1678, when he was suffering from purported madness (fig. 13). Scholars have long pondered whether Bada was mad. Some scholars have drawn a curious parallel between Bada Shanren and van Gogh, for both men were artists of extraordinary originality and both experienced episodes of madness.[21] Yet, Barnhart writes that "while van Gogh has come to be the almost inevitable paradigm of the insane artist, Bada Shanren may not ever have been really mad. Possibly at a few periods of his endangered and troubled life he feigned insanity as the best means by which he could maintain his life and safety. In doing so, he would have been following an old tradition."[22] This point is supported by Wang Fangyu's convincing argument that Bada Shanren's madness was likely feigned madness *(yang kuang),* rather than a true mental disease.[23] However, our present concern is not whether Bada Shanren was suffering from mental disease or how serious it may have been, but why he reported his madness in his work. A physical problem was turned into an artistic expression that had profound meaning.

FIG. 13 Impression of Bada Shanren's seal *Chedian* (Control madness). From Wang Zhaowen, ed., *Bada Shanren quanji* (The complete works of Bada Shanren) (Nanchang: Jiangxi meishu chubanshe, 2000) 4:910.

The dynastic change reduced many literati, especially those in elite positions, to lifestyles, social stations, or reputations that were much lower than they had been. This forced them to redefine their socio-political roles as they coped with a rapidly changing world. From about 1692 to 1699, Bada used another two-character seal, *Gui'ai* (fig. 14). According to Jiang Zhaoshen's research, these two characters refer to two kinds of grass. *Gui,* polygala in Latin, is a medical herb that has another Chinese name, *yuanzhi,* or great ambition. Also, long tradition in Chinese literature has associated *wangsun,* princes, with *fangcao,* fragrant grass.[24] Contrarily, *ai,* moxa, is a grass that since ancient times has been regarded as common or vulgar. By combining princely polygala and humble moxa in making a phrase seal, Bada implicitly indicated his identity shift from an imperial Ming prince with great ambitions to a painter of inferior status.

FIG. 14 Impression of Bada Shanren's seal *Gui'ai* (Polygala and moxa). See appendix, seals, no. 19.

No seal stones used by Bada have survived; there remain only their impressions on his works. For this reason, we are not sure which among these imprinted seals were carved by Bada. It is very likely that Bada carved, or at least designed, some of his own seals because a number of them share some of the idiosyncratic features of his calligraphy. During Bada's time, the ancient seals made in the Han dynasty were firmly canonized as the primary models for modern seal carvers. By the late Ming, many Han seals had suffered the depredations of time (fig. 15). These qualities of decay now became so aesthetically desirable that seal carvers attempted to reproduce them in their works. The seal critic Shen Ye (active ca. second half of the 16th century) relates some amusing anecdotes:

FIG. 15 Impression of a Han seal, China, Han dynasty, 206 B.C.E.–220 C.E. Bronze. Dr. Paul Singer Collection of Chinese Art of the Arthur M. Sackler Gallery, Smithsonian Institution, Washington, D.C., RLS1997.48.2031.

> When Wen Peng [1498–1573] made a seal, he put the seal in a box upon completing its carving and asked a young attendant to shake it all day. When Chen Taixue [active ca. 16th century] carved a seal, he threw the stone seal on the ground several times until parts of it were broken, giving it an antique flavor.[25]

A considerable number of Bada's seals followed this new trend. Take, for example, a seal impression reading "Immortality is achievable" *(Ke de shenxian)* that Bada frequently used from 1686 until his death (fig. 16). This seal was carved in a spontaneous manner, leaving gashes and cuts that allowed viewers to trace the process of carving. Some strokes are deliberately broken, and one area of the ground between two strokes is marred. This damage contributes an antique feel to the work. Whereas the structure of the seal "Immortality is achievable" is well balanced, another of Bada's seals, reading *Fu xian* (fig. 17; its exact connotation is unclear), follows a different Han model: all its vertical lines lean to one side; together with the gashed lines, this seal attempts to create a casual, naive, primitive flavor.

As in his calligraphy, Bada's seals reflect his stylistic diversity. Besides the mode of Han ruination discussed above, some of Bada's seals were carved with extraordinary precision and clarity. For instance, the seal *Ren'an* (fig. 18; Bada's studio name), which first appeared in

FIG. 16 Impression of Bada Shanren's seal *Ke de shenxian* (Immortality is achievable). See appendix, seals, no. 18.

FIG. 17 Impression of Bada Shanren's seal *Fu xian*. From Wang Zhaowen, ed., *Bada Shanren quanji* (The complete works of Bada Shanren) (Nanchang: Jiangxi meishu chubanshe, 2000) 4:911.

FIG. 18 Impression of Bada Shanren's seal *Ren'an* (one of Bada's pseudonyms). From Wang Zhaowen, ed., *Bada Shanren quanji* (The complete works of Bada Shanren) (Nanchang: Jiangxi meishu chubanshe, 2000) 4:910.

FIG. 19 Impression of Bada Shanren's "slipper" shaped seal. See appendix, seals, no. 16.

1672, is carved in a careful and delicate manner. Stylistically speaking, it follows the tradition that developed after the Yuan dynasty (1279–1368). The two characters in small seal script are well structured and placed, and each line is meticulously and gracefully executed, lending the work a refined elegance.

Thanks to scholarly endeavors over the past four decades, it is now possible to identify the characters in most of Bada's seals. Nevertheless, Bada's seals often present us with more problems than solving questions about his identity and intentions. Often, the exact meanings of Bada's seals remain elusive. Take, as an example, the "slipper" seal that Bada used most frequently late in his life (fig. 19). Many scholars tend to read this seal as "Bada Shanren" because it appeared in 1684, the year Bada started using the name "Bada Shanren," and the design of this seal may look like, in some way, a combination of the four characters for "ba," "da," "shan," and "ren." Nevertheless, this reading is by no means conclusive,[26] and Bada's seals demand future research.

To conclude, Bada Shanren was one of the most creative and talented artists of the early Qing period. During his lifetime, he diligently studied ancient works, including epigraphs on ancient metal and stone objects, and, in a highly conscious effort at stylistic innovation and self expression, he created a style of great individual distinction. While Bada's calligraphy was closely associated with his life experiences and intellectual pursuits, it is often difficult to understand in what manner his seals establish his identity and personal philosophy, for the exact meanings of many of them remain elusive, even when we can read their characters. These "mysterious" seals, together with Bada's stylistic inclusiveness, have intrigued later generations, have invited repeated investigations of Bada Shanren and his art, and have produced endless, sometimes inexcusably misguided interpretations of his works and life.

1 Lothar Ledderose, "Chinese Calligraphy: Art of the Elite," in *World Art: Theme of Unity in Diversity,* ed. Irving Lavin (University Park: Pennsylvania State University Press, 1989), 2:291–94.

2 This article has benefited from scholarship on Bada's calligraphy by Wang Fangyu, "Bada Shanren de shufa" (The calligraphy of Bada Shanren), in *Bada Shanren lunji* (An anthology of essays on Pa-ta-shan-jen), ed. Wang Fangyu (Taipei: Guoli Bianyiguan Zhonghua congshu Bianshen weiyuanhui, 1984), 2:379–410, and Richard M. Barnhart, "Reading the Paintings and Calligraphy of Bada Shanren," in Wang Fangyu and Richard M. Barnhart, *Master of the Lotus Garden: The Life and Art of Bada Shanren (1626–1705)* (New Haven: Yale University Art Gallery and Yale University Press, 1990), 83–216.

3 The meanings of the paintings and inscribed poems in this album have been thoroughly examined by Richard M. Barnhart (with translations of all the poems) in Wang and Barnhart, *Master of the Lotus Garden,* 97–101. My discussion here is focused on the style of the calligraphy.

4 For Richard M. Barnhart's detailed discussion of these two leaves, see Wang and Barnhart, *Master of the Lotus Garden,* 110–11.

5 Wen C. Fong, "Stages in the Life and Art of Chu Ta (a.d. 1626–1705)," *Archives of Asian Art* 40 (1987): 14.

6 Bai Qianshen (Qianshen Bai), "Qingchu jinshixue de fuxing dui Bada Shanren wannian shufeng de yingxiang" (The influence of the revival of the study of *jinshixue* in the early Qing on late calligraphy of Bada Shanren), *Gugong xueshu jikan* (National Palace Museum Monthly) 12, no. 3 (April 1995): 89–124; see also Qianshen Bai, *Fu Shan's World: The Transformation of Chinese Calligraphy in the Seventeenth Century* (Cambridge, Mass.: Harvard University Asia Center, 2003), chapter 3.

7 This passage is found in Chen Jie's *Shufa ouji* (Random notes on calligraphy), in *Pinglu congke* (Various writings published by Pinglu), ed. Jin Yue (Beijing: Beijingshi zhongguo shudian, 1985), 5b.

8 For a detailed discussion of this album, see Gu Bing, "Spontaneous Interpretation: An Album of Bada Shanren's Seal-Script Calligraphy," *Orientations* 20, no. 5 (May 1989): 65–70.

9 Richard M. Barnhart's discussion of this set of hanging scrolls can be found in Wang and Barnhart, *Master of the Lotus Garden,* 206–7.

10 See Wang Fangyu, *Bada Shanren lunji,* 1:531.

11 This letter, mounted as one leaf of an album, is now in the collection of the Shanghai Library and published in Wang Zhaowen, ed., *Bada Shanren quanji* (Complete works of Bada Shanren) (Nanchang: Jiangxi meishu chubanshe, 2000), 2:260.

12 Matteo Ricci and Nicolas Trigault, *China in the Sixteenth Century: The Journal of Matthew Ricci: 1583–1610,* trans. Louis J. Callagher (New York: Random House, 1953), 24.

13 The use of such stones in seal carving can be traced to much earlier times; some scholars, such as Sha Menghai, place the beginning of literati seal carving as early as the Northern Song, arguing that Mi Fu (1051–1107) may have engaged in it. The Yuan dynasty painter Wang Mian (1287–1359) was one of the earliest of the literati to carve seals in soft stone, according to some textual evidence. See Sha Menghai, *Sha Menghai lunshu conggao* (Collected discussions on calligraphy by Sha Menghai) (Shanghai: Shanghai shuhua chubanshe, 1987), 188–89. Recent archaeological excavations have confirmed that soft stone was being used for seal carving before the sixteenth century. See Sun Weizu, *Sun Weizu lunyin wengao* (Sun Weizu's writings on seals) (Shanghai: Shanghai shudian, 1999), 183–87.

14 James C. Y. Watt, "The Literati Environment," in *The Chinese Scholar's Studio: Artistic Life in the Late Ming Period,* ed. Chu-tsing Li and James C. Y. Watt (New York: The Asia Society Galleries, 1987), 11.

15 The seals Bada used can be found in Wang and Barnhart, *Master of the Lotus Garden,* Appendix A, 245–50. Discussions of Bada's seals can be found in Zhou Shixin, *Bada Shanren ji qi yishu* (Bada Shanren and his art) (Taipei: Huagang shuju, 1970), 167–77; see also Xiao Hongming, *Bada Shanren yinkuan shuo* (Interpretations of Bada Shanren's seals, studio names, and ciphers) (Beijing: Beijing Yanshan chubanshe, 1998).

16 Wang and Barnhart, *Master of the Lotus Garden,* 30.

17 Ibid.

18 For a discussion in English of Bada's original name, see Wang and Barnhart, *Master of the Lotus Garden,* 24–34.

19 Jonathan Spence, *The Search for Modern China* (New York: W. W. Norton & Co., 1990), 49–53.

20 See Wang and Barnhart, *Master of the Lotus Garden,* 14.

21 For a discussion of Bada Shanren's madness and his art, see James Cahill, "The 'Madness' in Bada Shanren's Paintings," *Ajia bunka kenkyu* (Asian culture studies) 17 (March 1989): 119–43. Cahill's article deals chiefly with Bada's paintings. But in order to support his argument, Cahill also uses some elements of Bada's calligraphy as evidence. For instance, Cahill argues that Bada's calligraphy "has its own elements of the cryptic—the use of uncommon seal-script forms or rare, archaic forms of characters; an abstruse way of writing the dates on some of his works." He also implies a connection between the strange aspect of Bada's calligraphy and his "madness" (page 122). Cahill was not aware that writing unusual and archaic forms of characters was a fashionable game among late-Ming and early-Qing calligraphers. Such calligraphers as Huang Daozhou (1585–1646), Wang Duo (1593–1652), and Fu Shan, who had no records of madness, also loved to write strange forms of characters. For a detailed discussion of this game, see Bai Qianshen, "Minmatsu Shinsho no shohō ni okeru itaiji shiyo no fūchō ni tsuite" (A study of the fashion of writing strange characters in late-Ming to early-Qing calligraphy), *Shoron* 32 (2001): 181–87, and no. 33 (2002); Qianshen Bai, *Fu Shan's World,* chapter 1.

22 Wang and Barnhart, *Master of the Lotus Garden,* 13.

23 Wang Fangyu, "Bada Shanren bingdian he yangkuang," (Mental illness and feigning madness in Bada Shanren) *Gugong wenwu yuekan* (National Palace Museum Monthly) 102 (September 1991): 16–23.

24 Jiang Zhaoshen, *Shuangxi duhua suibi* (Notes on viewing paintings in the National Palace Museum) (Taipei: National Palace Museum, 1987), 57–58.

25 Shen Ye, *Yin tan* (Talking about seals), in *Lidai yinxue lunwen xuan* (The study of seals through the ages, selected texts), ed. Han Tianheng (Hangzhou: Xiling yin-she, 1999), 64.

26 Some of Bada's works bear both a seal with this design and another of four characters reading "Bada Shanren." Since it is rare for a Chinese artist to put two name seals with the same legend on the same artwork, it may be that the text of the "slipper" seal is something other than "Bada Shanren."

BAI

Catalogue

STEPHEN D. ALLEE

荷花圖　八開冊
1 Lotus ca. 1665

Album of eight double leaves; ink on paper
AVERAGE 25.4 x 33.66 cm
Bequest from the collection of Wang Fangyu and Sum Wai, donated in their memory by Mr. Shao F. Wang

OUTSIDE LABEL (NOT SHOWN) by Zhang Daqian (1899–1983), running script

Lotus Album by the Buddhist monk Chuanqi [Bada Shanren]. The sobriquets Fajue and Ren'an, which appear in the seals, were alternative names used by Bada Shanren while he was a monk. Yuan [Zhang Daqian][1]

TWO SEALS *Zhang Yuan* (square intaglio), *Daqian* (square relief)

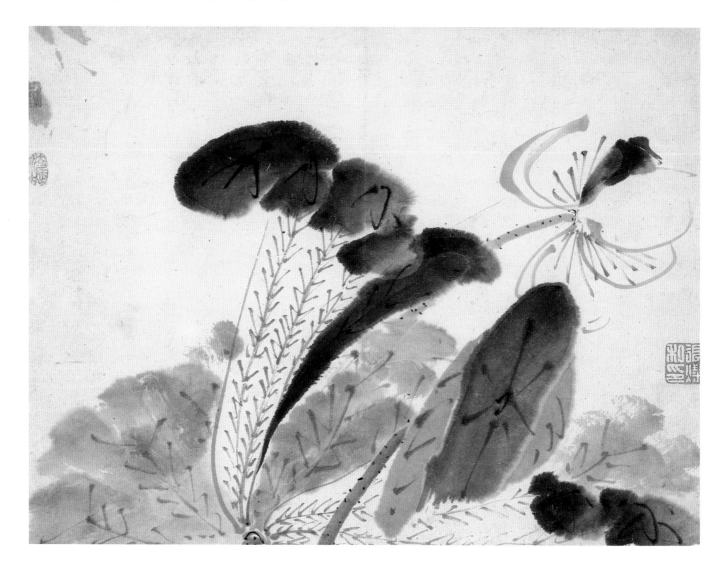

LEAF 1
NO SIGNATURE
ONE SEAL *Fajue* (oval relief)

TWO COLLECTOR SEALS
Zhang Can (19th–20th century?), one seal: *Zhang Can siyin* (square intaglio)

Unidentified collector, one seal: illegible (intaglio half-seal)

LEAF 2
NO SIGNATURE
TWO SEALS *Shi Chuanqi yin*
(square intaglio), *Ren'an*
(square relief)

NO COLLECTOR SEALS

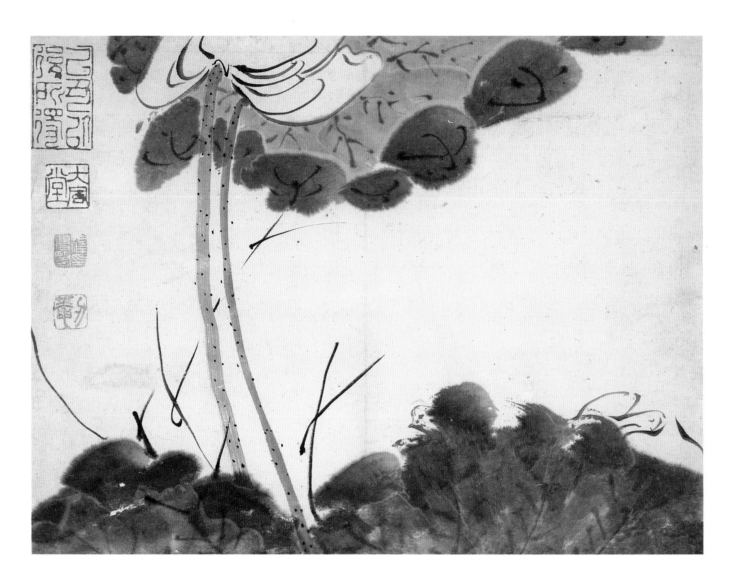

LEAF 3

NO SIGNATURE

TWO SEALS *Shi Chuanqi yin*
(square relief), *Ren'an* (square
relief)

TWO COLLECTOR SEALS
Zhang Daqian (1899–1983),
two seals: *Dafengtang* (square
relief), *Jichou yihou suo de*
(rectangle relief)

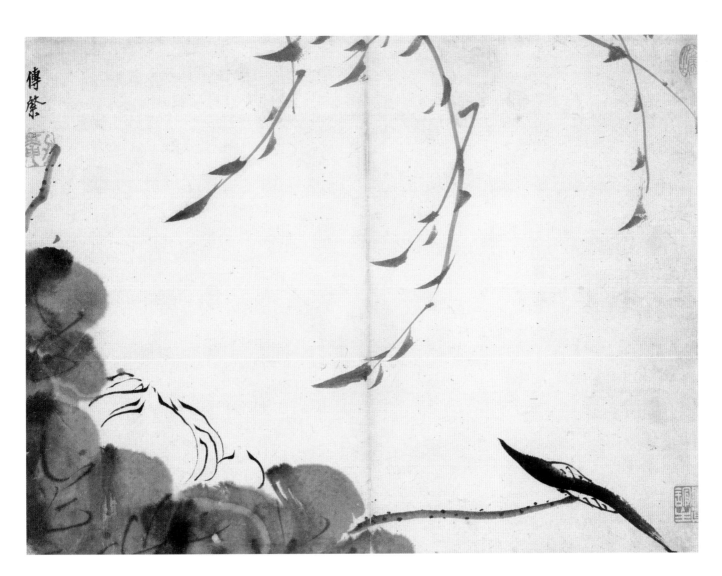

LEAF 4
SIGNATURE Chuanqi
TWO SEALS *Fajue* (oval relief),
Ren'an (square relief)

ONE COLLECTOR SEAL
Unidentified collector, one
seal: *x x guanzhu* (intaglio
half-seal)

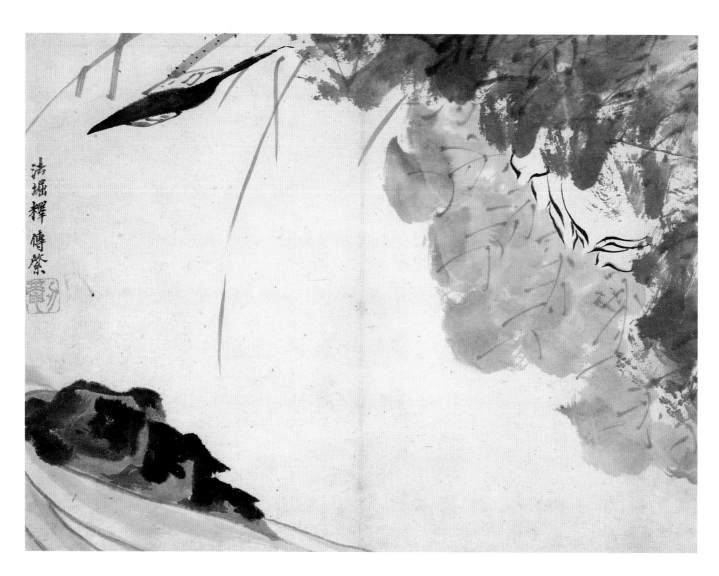

LEAF 5
SIGNATURE Fajue shi Chuanqi
ONE SEAL *Ren'an* (square
relief)

NO COLLECTOR SEALS

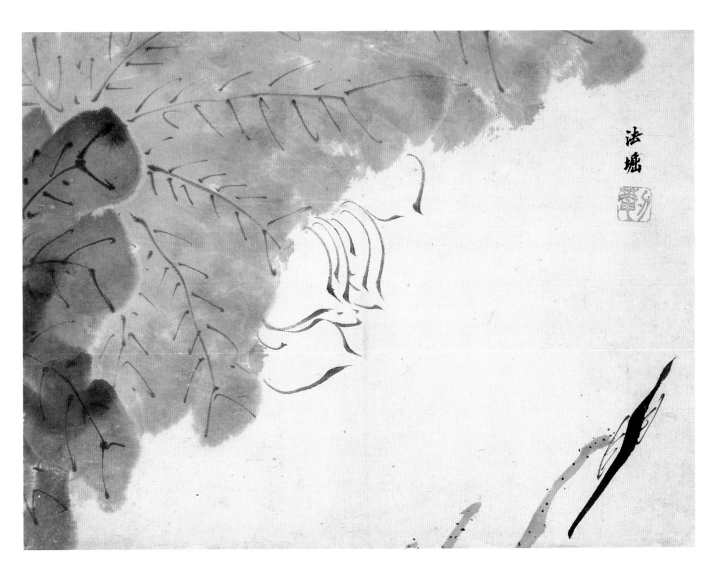

LEAF 6
SIGNATURE Fajue
ONE SEAL *Ren'an* (square
relief)

NO COLLECTOR SEALS

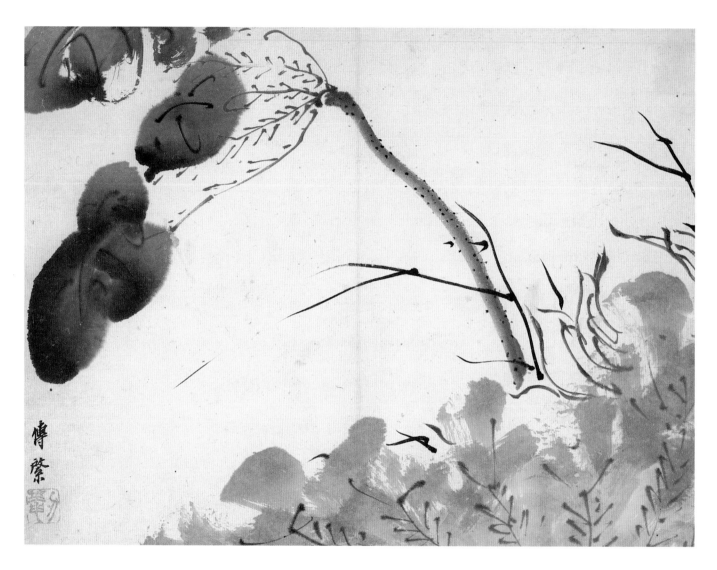

LEAF 7
SIGNATURE Chuanqi
ONE SEAL *Ren'an* (square relief)

NO COLLECTOR SEALS

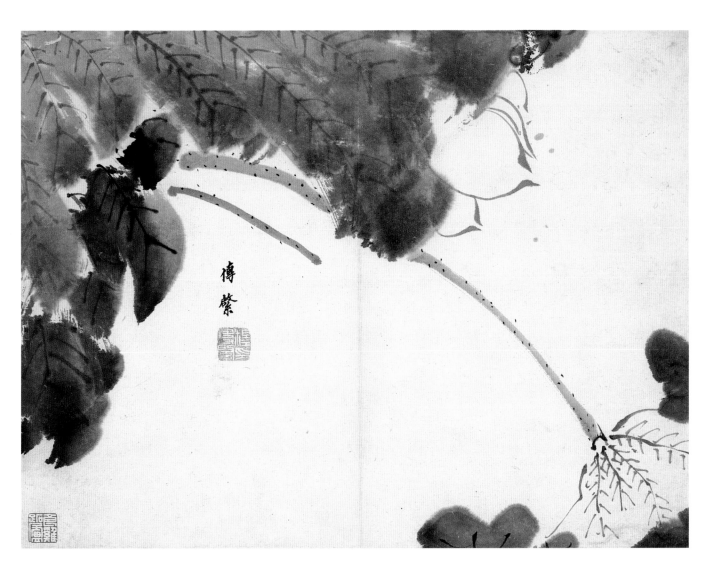

LEAF 8
SIGNATURE Chuanqi
ONE SEAL *Shi Chuanqi yin*
(square intaglio)

ONE COLLECTOR SEAL
Wang Fangyu (1913–1997),
one seal: *Shijizhilu* (square
intaglio)

行楷書節錄《黃庭內景經》 十二開冊

2 Scripture of the Inner Radiances of the Yellow Court
four excerpts in running-standard script, 1684

Album of twelve leaves; ink on paper
AVERAGE 22.0 x 11.66 cm
Purchase — Funds provided by the E. Rhodes and Leona B.
Carpenter Foundation in honor of the 75th Anniversary of
the Freer Gallery of Art

LEAF 1
Stanza 1 (paraphrase)[2]

Before the Lord of the Void, who resides among purple auroras
in the Heaven of Highest Purity, / The Most High Jade Dawn
Ruler of the Great Dao / Dwelt at ease in the Palace of Stamens
and Pearls, composing lines in heptasyllabic meter, / Dispersing
change to the Five Shapes and transforming the ten-thousand
deities. / These comprise the Yellow Court Scripture and are
called the Inner Verses, / Which harmonize the heart and set
the embryo immortals to dancing in the Triple Cinnabar Fields,
/ Causing the Nine Breaths to glisten and gleam and emerge
from the empyrean of the brain / And the pupils of the eyes
under the divine canopies of the brows to emit a purple mist. /
This is called the Jade Text which can be scrutinized with a pure
heart: / By reciting it ten thousand times one will ascend to the
Triple Heaven, / With it one may dispel the thousand calamities
and cure the hundred illnesses, / And undaunted by the fell
depredations of tigers and wolves, / One may also thwart old
age thereby and extend one's years forever.[3]

NO SIGNATURE
THREE SEALS *Baihua* (rectangle intaglio; leaf 1), *Bada Shanren*
(square intaglio; leaf 11), *Xiashanpianxuan* (square intaglio; leaf 11)

LEAF 12
Colophon in running script, by Bada Shanren

Long ago, when someone asked, "Are Daoism and
Confucianism the same or different," [Ruan Zhan, ca. 279 – ca.
308 C.E.] answered, "Are they not the same?" In the sequence of
officials from Chenliu, was it Ruan Qianli [Ruan Zhan] who
amended the deficiencies of Chenliu? I have followed the callig-
raphy of the Two Wangs to present this. Enjoying the rain on the
first day in the seventh lunar-month of the *jiazi* year [August 11,
1684], I inscribed [a colophon] after the "Inner Radiances" for a
second time, Bada Shanren.[4]

TWO SEALS *Lü* (square relief), *Ke de shenxian* (square intaglio)

FOUR COLLECTOR SEALS

Unidentified collectors, two
seals: *Yonghe shizheng* (square
relief; leaf 1), *Haiqiu shending*
(rectangle relief; leaf 1)

Wang Fangyu (1913 – 1997),
one seal: *Fangyu* (rectangle
relief; leaf 1)

Sum Wai (1918 – 1996), one seal:
Shen Hui (square relief; leaf 12)

內景經

LEAF 1

上清紫霞虛皇前　太上大道玉晨君　閑居蕊珠作七
言　散化五形變萬神　是為黃庭曰內篇　琴心三疊舞胎
仙　九氣映明出霄間　神蓋童子生紫煙　是曰玉書可精研
詠之萬遍昇三天　千災以消百病痊　不憚虎狼之凶殘
亦以卻老年永延　上有魂靈下關元　左為少陽右太陰後

LEAF 2

有密戶前生門　出日入月呼吸存　元氣所合列宿分
煙上下三素雲　灌溉五華植靈根　七液洞流衝廬間
迴紫抱黃入丹田　幽室內明照陽門　口為玉池太和官
咽靈液災不干體　生光華氣香蘭　卻滅百邪玉煉顏
審能修之登廣寒　晝夜不寐乃成真　雷鳴電激神
泯泯　黃庭內人服錦衣　紫華飛裙雲氣羅丹青綠

LEAF 3

念三光子轉羅翳　長生久死軼脈部之宮六腑精
十有童子耀威明　雷電八振揚玉旌龍旗橫天擲
火鈴主諸身力撓停兵　外攘明堂青奧柱間胎髮
相扶二仵鮮九氣鈴承華裡佩金帶玉龍虎身
文能存我亦慶雲役六高神豹三元脾長一
又挾太倉中部老其治明堂歌子靈兒名混康

LEAF 4

治人百疾消穀糧　虛無寂寂氣常帶龍虎章長精盦
命賴其王三呼我名神自通三老同坐各有朋或
或胎別執方飛揚　令延生華芒男女迴九有桃康
道父道母對相望　扶養性命守虛無用存思室
虛宮紫室一會師　蔽映揚門章靈根擢固停喜微
金醴玉英遂完堅　去冥飢三老扶上含景和攝欣昌

五嶽之雲氣起青烟　保灌玉廬以自償　玉石完堅

無突狹上觀三元如連珠唇明星丹如九色五靈
照八達手存內皇与我遊身披鳳衣銜虎符

一至不久昇虛無手空之手含漱金禮不方不圓閉

牖塞宓三神還精老方壯魂魄內守不爭競神生
腹中銜玉鐺靈注幽闕那浮羨琳條森尋梧

LEAF 5

薩使三魂自寧帝書卞靈臺棋霧鬱鬱野

三寸異室有上下間異華德高玄龔洞房紫極
靈門戶星精者左扉公子發神語右者

白元俯立靈明堂金匱玉房間上清真人當吾前

黃裳子丹氣炳煩借詞奸在兩眉端內俠日月

列宿陳七曜九元冠生門三調之中精氣深九

LEAF 6

日月吾上道持儀持遠善相保乃見玉清虛無老

老可以迴顏填命口衝靈芒攜五皇腦常曉錄

佩金鐺駕欻接生宴東蒙玄元上乙魂魄鍊乙之

為物斷辛兒須浮至真乃頥睇玉忌死筆諸撒

賜六神會集虛中宴結珠固精養神根玉芝金

簪華完堅閉口屈舌含臨津生我逆鍊獲飛仙

LEAF 7

偉人道士非有神積精累筆以為真黃臺妙青霏

玉閣玉書綠高赤丹文字曰真人中金巾貢甲揚符

閉七門火兵符圖備靈室黃奇昇卑高下陳執劍

百丈舞錦惟十絕盤空隔紛紅火鈴冠需隆虛

煙安在黃闕兩眉間此非枝葉實是根紫清玉皇大

道君太玄太和俠侍端化生素妁蚨紅飛昇十天駕

LEAF 8

真養藥榮內朗沈點鍊五形三筆統細得神
明隱氣道芝空琅英可以元化使高靈上蓋三
下虎章沐浴盛潔棄肥薰入金東向誦玉篇約
得柔編義自辭散變無終以長存五味皆去正筆
守夷以廉問真頌究迫敗己畢體神精羹藥玉
幼苦示靖真人能守兑六丁竹捩項荳大洞推于

LEAF 10

雄存雄項三光外方內圓禊在中通利血脈五藏
豐骨考爾志髓凝霜脾救七霰各不祥日月列宿
設陰陽兩神相會下玉英漊絲無味天人糧于丹
進慣看匹黃乃日環膏及玉霜太上隱珠八素瓊
溉養八液腎愛精伏于太陰見我形揚風三玄出焰
青蛻慚之向玉清靈戚于飈臺見赤生遞城煉

LEAF 9

昔有閭老莊醒教同美會將
無同官序陳海補陳佃所
末備者阮于玉即余次二
玉書似之甲子肯新春雨
吏路內昜　　朱文

LEAF 12

讀四拞形太上先謁太帝後北向秀遞內經玉書
暢授者曰師受者誓雲錦鳳罷金紐纏八代割
髮肌膚金攜于蟄山歃漊丹金書玉景乃可宣
傳得審授告三官勿令七祖受責生太上微言致
禊仙不死之道此其父

LEAF 11

丁香花圖并行草對題　冊頁兩開

3 Lilac Flowers and Calligraphy
in running-cursive script, 1690

Two album leaves; ink and color on paper, and ink on paper
20.1 x 14.6 cm and 20.1 x 14.5 cm
Bequest from the collection of Wang Fangyu and Sum Wai,
donated in their memory by Mr. Shao F. Wang

LEAF 2
Calligraphy in running-cursive script

INSCRIPTION Spring of the *gengwu* year [1690], imitating the painting style of Baoshan [Lu Zhi, 1496–1576] Bada Shanren

ONE SEAL *Shan* (oval intaglio)[5]

TWO COLLECTOR SEALS
Wang Fangyu, one seal: *Wang Fangyu* (linked-square relief)

Sum Wai, one seal: *Shen Hui* (square relief)

LEAF 1
Lilac Flowers[6]

SIGNATURE Painted by
Bada Shanren

ONE SEAL *Huazhu*
(rectangle relief)

TWO COLLECTOR SEALS
Wang Fangyu (1913–1997),
one seal: *Wang Fangyu*
(linked-square relief)

Sum Wai (1918–1996), one
seal: *Shen Hui* (square relief)

ALLEE

43

竹石小鳥圖　軸

4 Bamboo, Rocks, and Small Birds 1692

Hanging scroll; ink on paper
164.0 x 90.6 cm
Bequest from the collection of Wang Fangyu and Sum Wai,
donated in their memory by Mr. Shao F. Wang

INSCRIPTION First month of summer in the *renchen* year
[May 16–June 14, 1692], "involved in affairs" *[sheshi]*.
Bada Shanren[7]
THREE SEALS *Zaifu* (rectangle relief), Slipper seal with border,
Bada Shanren (rectangle intaglio)

Colophon in running script, by Zhang Daqian (1899–1983)

Modern enthusiasts [of painting] prize small hanging scrolls
the most, with around three feet as the norm. This custom has
spread throughout north and south alike, but is particularly
prevalent in the Wuzhong [region of Jiangsu Province]. There,
whenever a dealer of antiquities comes across a large-scale
hanging scroll, he will chop it down in size hoping to better
his price. The damage [such a practice has inflicted] on the
heart's blood of earlier masters is more vicious and cruel than
[the tortures of] an executioner. On acquiring this scroll
recently in Hong Kong, I felt sorry for its broken state and
got the idea of adding a few strokes to fix it up. While I could
not make it shine like the masterpiece it once was, or immedi-
ately restore the painting to its former appearance, I privately
compare [my added brushstrokes] to a blind man's cane: As
consolation, they are better than nothing. Spring day in the
renchen year [1952], [painted] and inscribed by the student
Daqian in the Dafengtang [studio].[8]

THREE SEALS *Zhang Yuan siyin* (square relief), *Daqian fu* (square
relief), *Qian qian qian* (square intaglio)

SEVEN COLLECTOR SEALS
Zhang Daqian (1899–1983),
six seals: *Dongxi nanbei zhi ren*
(rectangle relief), *Bieshi rongyi*
(square relief), *Nanbei dongxi
zhi you xiangsui wu bieli* (square
relief), *Diguo zhi fu* (square
relief), *Qiutu bao gurou qing*
(horizontal rectangle intaglio),
*Dafengtang Jianjiang Kuncan
Xuege Kugua moyuan* (rectangle
relief)

Wang Fangyu (1913–1997),
one seal: *Shijizhilu* (square
intaglio)

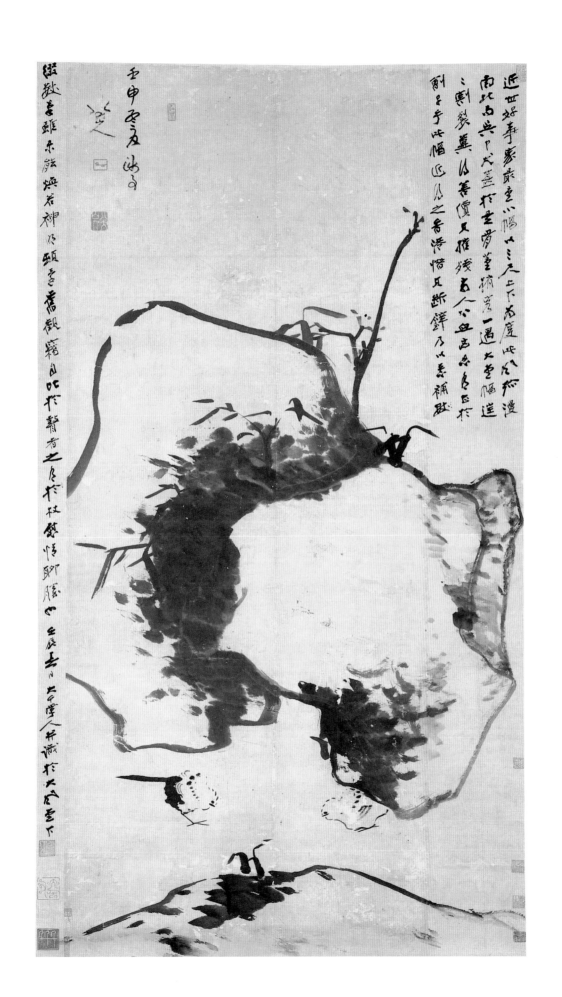

落花、佛手、芙蓉、蓮蓬　　冊頁四開

5 Falling Flower, Buddha's Hand Citron, Hibiscus, and Lotus Pod 1692

Four album leaves; ink on paper
AVERAGE 21.9 x 28.8 cm
Bequest from the collection of Wang Fangyu and Sum Wai, donated in their memory by Mr. Shao F. Wang

LEAF 1
Falling Flower[9]

SIGNATURE "Involved in affairs" *(sheshi).* Bada Shanren
ONE SEAL Slipper seal with border

THREE COLLECTOR SEALS
Zhang Daqian (1899–1983), two seals: *Dafengtang Jianjiang Kuncan Xuege Kugua moyuan* (rectangle relief), *Zhang Yuan* (square intaglio)

Wang Fangyu, one seal: *Shijizhilu* (square intaglio)

LEAF 2
Buddha's Hand Citron

SIGNATURE "Involved in affairs" *(sheshi).* Bada Shanren
TWO SEALS Slipper seal without border, *Sheshi* (rectangle intaglio)

———————————

TWO COLLECTOR SEALS
Zhang Daqian, two seals: *Nanbei dongxi zhi you xiangsui wu bieli* (square relief), *Cangzhi daqian* (square relief)

LEAF 3
Hibiscus

SIGNATURE Bada Shanren
ONE SEAL Slipper seal with
border

TWO COLLECTOR SEALS
Zhang Daqian, two seals:
Bieshi rongyi (square relief),
Cang zhi daqian
(square intaglio)

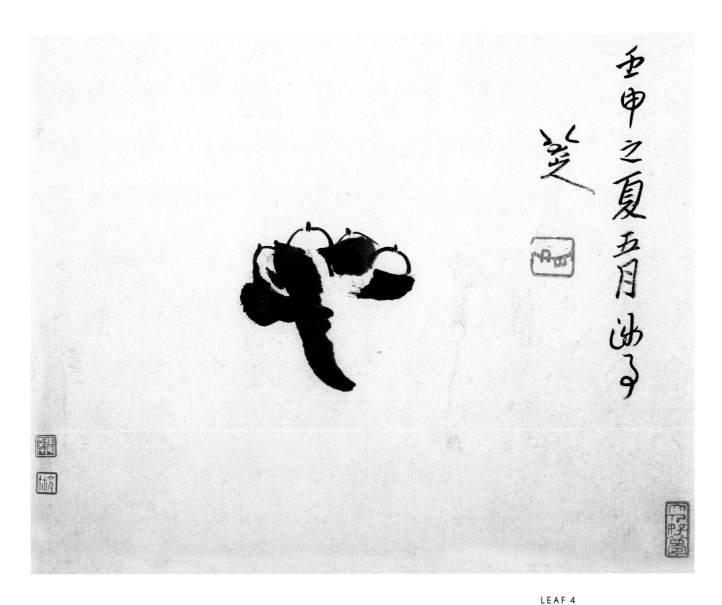

LEAF 4
Lotus Pod

INSCRIPTION Summer, fifth
lunar-month of the *renchen*
year [June 15–July 13, 1692],
"involved in affairs"
[sheshi]. Bada Shanren
ONE SEAL Slipper seal
with border

<hr>

THREE COLLECTOR SEALS
Zhang Daqian, three seals:
Daqian haomeng (rectangle
relief), *Zhang Yuan* (square
intaglio), *Daqian xi*
(rectangle relief)

ALLEE

49

行楷節臨褚遂良書《聖教序》　冊頁

6 Excerpt from the "Preface to the Sacred Teachings"

in running-standard script, ca. 1693

Album leaf; ink on paper
26.5 x 14.3 cm
Purchase—Funds provided by the E. Rhodes and Leona B.
Carpenter Foundation in honor of the 75th Anniversary of
the Freer Gallery of Art

[Xuanzang] received the ultimate instructions from the leading
sages and obtained the true teachings from the most eminent
worthies, investigated arcane principles within the gates of mys-
tery and exhausted the quintessential properties of abstruse
tenets. The doctrines of the One Vehicle and Five Canons raced
like fleet horses through the fields of his mind and the texts of
the Eightfold Storehouse and Three Baskets rolled like billowing
waves from the ocean of his lips. Thus from all the lands through
which he traveled, he gathered together the essential texts of the
Tripitaka [Buddhist Canon], in 657 parts all told. His translations
spread throughout Middle Xia [China], proclaiming abroad his
surpassing karma and drawing the clouds of compassion from the
westernmost extremity to pour down the rain of dharma on
these eastern outskirts. Deficiencies in the sacred teachings are
again made whole and the masses in their sins are restored to a
state of grace, dousing the dry blaze of this burning house that
everyone may be saved from the paths of error, and illuminating
the murky waves on the river of desire that all may safely reach
the Other Shore.

It is known that evil befalls one because of karma and good
rises for one due to causality, while success and failure all come
down to what we depend upon [in life]. For example, if a cassia
tree grows on a high ridge where clouds and mist can water its
blossoms, or a lotus emerges from limpid waves where flying
dust cannot defile its leaves, the lotus is not pure because it is so
by nature, nor is the cassia perfect because of anything inherent,
but rather, because the [cassia] relies on something high, so petty
matters cannot entangle it, while the [lotus] depends on some-
thing clean, so dirty things cannot stain it. Thus, if even an
unknowing plant or tree can better itself through finding a good
[environment], then how much more can we sentient humans
seek for blessings though we have no cause to receive them.[10]

POSTSCRIPT Copied *[lin]* after the writing of Chu Henan
[Chu Suiliang, 596–658]. Bada Shanren
ONE SEAL Slipper seal without border[11]

ONE COLLECTOR SEAL
Sum Wai (1918–1996):
Shen Hui (square relief)

CATALOGUE

50

承至言於先聖受真教於上賢探賾妙門精窮奧業
一乘五津之道馳驟於心田八藏三篋之文波濤於口海爰
自所歷之國總將三藏要文凡六百五十七部譯布中夏
宣揚勝業引慈雲於西極注法雨於東垂聖教缺而復
全蒼生罪而還福濕火宅之乾燄共拔迷途朗愛水之
昏波同臻彼岸是知惡因業墜善以緣昇昇墜之端惟人
所託譬夫桂生高嶺雲露方得泫其花蓮出淥波飛塵
不能污其葉非蓮性自潔而桂質本貞良由所附者高則微物
不能累所憑者淨則濁類不能霑夫以卉木無知猶資善而成
善況乎人倫有識不緣慶而求慶

行褚河南書

仿北苑山水圖　冊頁
7 Landscape after Dong Yuan ca. 1693

Album leaf; ink on paper
26.5 x 14.3 cm
Purchase—Funds provided by the E. Rhodes and Leona B.
Carpenter Foundation in honor of the 75th Anniversary of
the Freer Gallery of Art

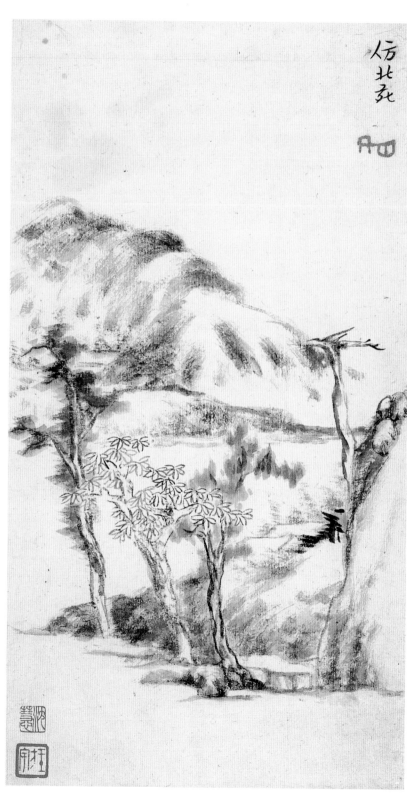

INSCRIPTION After Beiyuan
[Dong Yuan, died 962][12]
NO SIGNATURE
ONE SEAL Slipper seal
without border[13]

TWO COLLECTOR SEALS
Wang Fangyu (1913–1997),
one seal: *Wang Fangyu*
(square relief)

Sum Wai (1918–1996), one
seal: *Shen Hui* (square relief)

《故國興悲》書畫合冊

8 Combined Album of Painting and Calligraphy: "Grieving for a Fallen Nation" ca. 1693–96

Album of fifteen leaves; ink on paper
PAINTING AVERAGE 24.9 x 17.1 cm; calligraphy average:
24.5 x 16.2 cm
Bequest from the collection of Wang Fangyu and Sum Wai,
donated in their memory by Mr. Shao F. Wang

OUTSIDE LABEL (NOT SHOWN) by Naitō Torajirō (1866–1934),
running script
Album of poetry and painting by Bada Shanren. Label slip
inscribed by Naitō Tora[14]
TWO SEALS *Tora* (oval relief), *Konan* (rectangle intaglio)

LEAF 1
FRONTISPIECE by Shanqi,
Prince Su (1866–1922),
standard script

"Grieving for a Fallen
Nation." Inscribed by Ouyuan
at the request of Mister
Wenqing[15]

THREE SEALS *Dingsi* (square
relief), *Su qinwang* (square
relief), *Ouyuan* (square
intaglio)

ALLEE

53

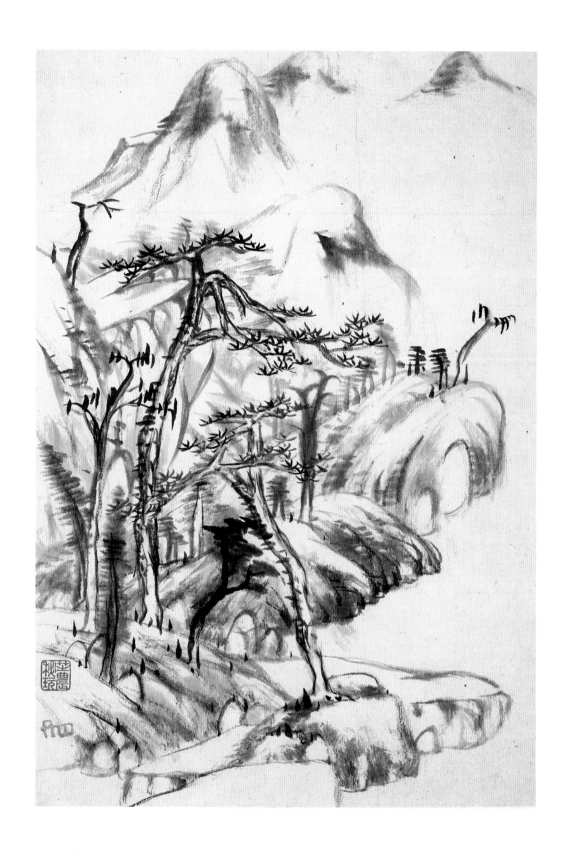

LEAF 2
Landscape[16]

NO SIGNATURE
ONE SEAL Slipper seal
without border

————————

ONE COLLECTOR SEAL
Dai Zhi (act. 1820s–40s),
one seal: *Zhinong miwan*
(square relief)[17]

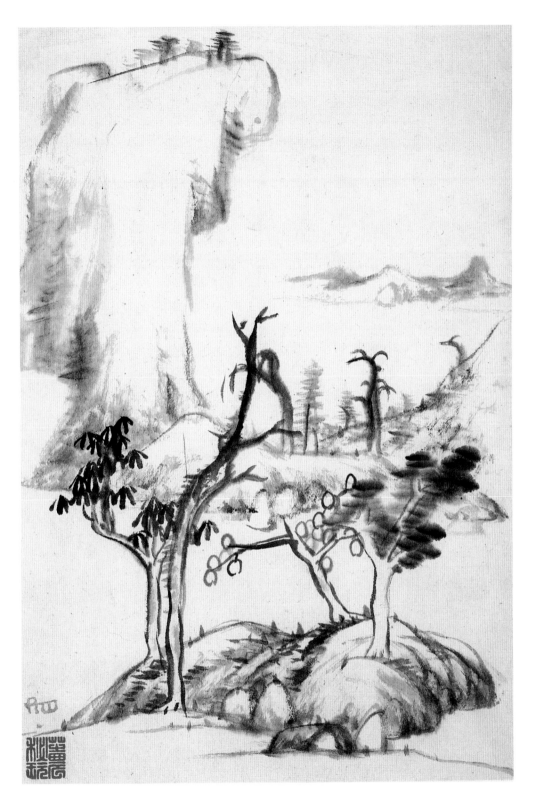

LEAF 3
Landscape

NO SIGNATURE
ONE SEAL Slipper seal
without border

ONE COLLECTOR SEAL
Dai Zhi, one seal: *Zhinong
miwan* (square relief)

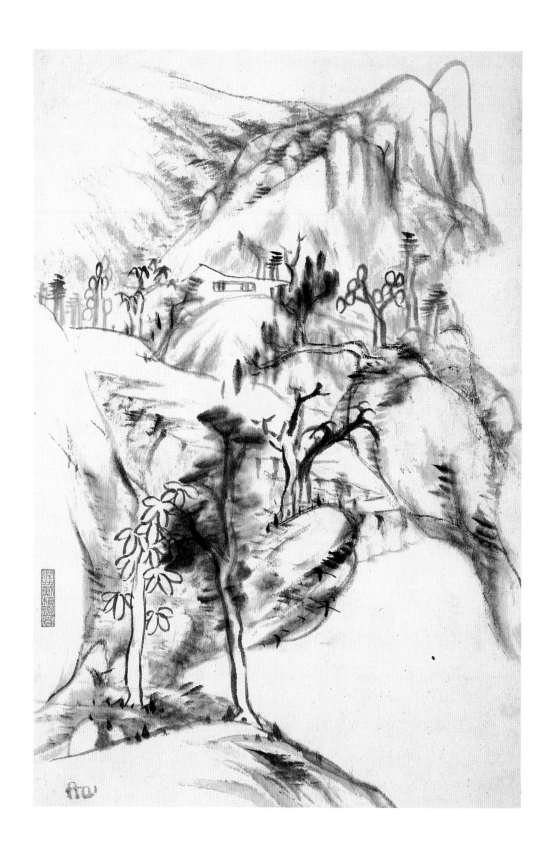

LEAF 4
Landscape

NO SIGNATURE

ONE SEAL Slipper seal
without border

ONE COLLECTOR SEAL
Dai Zhi, one seal: *Runzhou
Dai Zhi jianshang* (rectangle
relief)

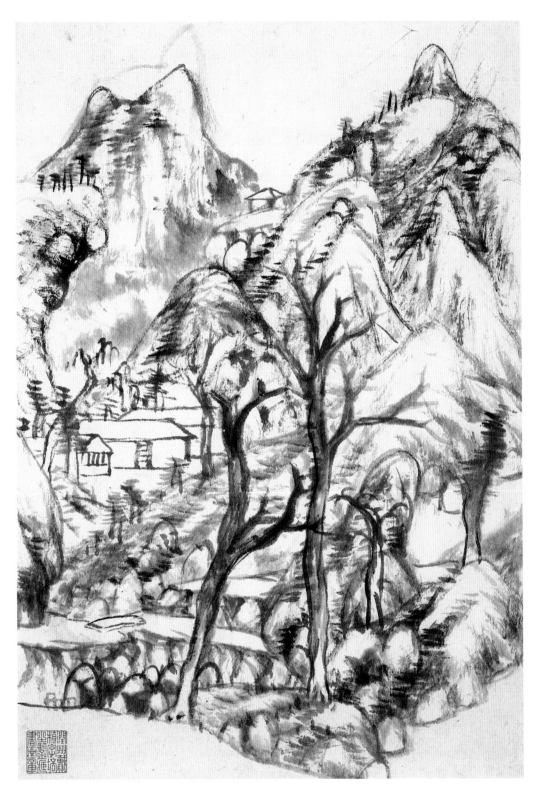

LEAF 5
Landscape

NO SIGNATURE
ONE SEAL Slipper seal
without border

ONE COLLECTOR SEAL
Dai Zhi, one seal: *Runzhou
Dai Zhi zi Peizhi jiancang
shuhua zhang* (square relief)

LEAF 6
Four poems in running-standard script, by Bada Shanren

POEM 1
A chunk of rock is this Youquan,
A pine tree stands above the flood;
When you hear the Mountain Man is coming,
He has just departed with the white clouds.[18]

POEM 2
Famous authors write many documents,
But it is their lofty songs that pull one in.
To return to the top of Slanting Stairs,
At Upright Stairs, moved by past experience.[19]

POEM 3
Once you undo a girdle-gem and go far away,
How do you get the girdle-gem you left behind?
Departing by carriage through the city's eastern gate,
I race my chariot up the great shelving rocks.[20]

POEM 4
A slender form is meet to hide one's shadow,
Among white clouds, writing about to stop.
How is it he spent one night in the garden,
And next morning it was the southeast park?[21]

POSTSCRIPT On the seventh day in the fourth lunar-month of the *bingzi* year [May 7, 1696], I have recorded some poems that I wrote to inscribe on paintings and am sending them to Master Baoyai [Wu Chenyan, 1663–after 1722] for his correction. Bada Shanren[22]

TWO SEALS *Yaozhu* (rectangle relief), Slipper seal without border

TWO COLLECTOR SEALS
Dai Zhi, one seal: *Peizhi qingshang* (square relief)

Zhang Daqian (1899–1983), one seal: *Zhang Daqian changnian daji you rili* (square intaglio)[23]

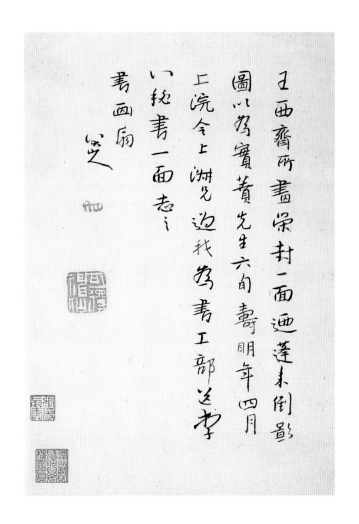

LEAF 7
Copy of a colophon in running-standard script, by Bada Shanren

Wang Xizhai has graced one side of this painted fan with a
picture of *Penglai's Upside-Down Reflection,* which he did for
the sixtieth birthday of Mister Shifen. The next year in the first
decade of the fourth lunar-month, he sent my "elder brother"
Shangshu to me, so that I could inscribe [Du Fu's] "Seeing Off
Secretary Li the Eighth" on the other side, and record it as a fan
of combined calligraphy and painting.[24]

SIGNATURE Bada Shanren
TWO SEALS Slipper seal without border, *Ke de shenxian*
(square intaglio)

TWO COLLECTOR SEALS
Dai Zhi, one seal: *Runzhou
Daishi Beiwanlou jianzhen*
(square relief)

Zhang Daqian, one seal: *Zhang
Yuan changshou* (square relief)

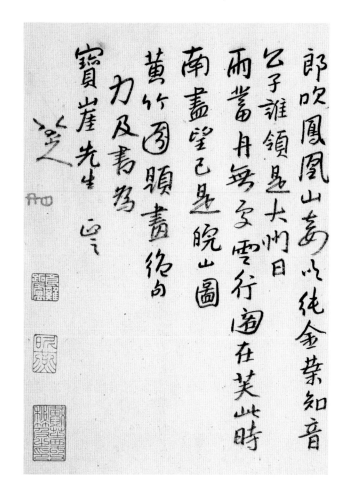

LEAF 10

Two poems in running-standard script, by Bada Shanren

POEM 7

The young man plays "Up on Phoenix Hill,"
The maiden plays "Leaves of Purest Gold."
Whichever lord understands their music,
Commands our great province on this day.[31]

POEM 8

Rain gathers, my boat has nowhere to be,
Clouds move, my chamber is in the lotus.
I have looked all through the south,
And made this picture of the Shining Hills.[32]

POSTSCRIPT I have written out several quatrains that
I composed in the Yellow Bamboo Garden to inscribe
on paintings, so that Master Baoyai may correct them.
Bada Shanren[33]
ONE SEAL Slipper seal without border

THREE COLLECTOR SEALS
Dai Zhi, one seal: *Dai Zhi
Nongfu miji zhi yin* (rectangle
relief)

Zhang Daqian, one seal: *Niyan*
(rectangle relief)

Wang Fangyu (1913–1997),
one seal: *Shijizhilu* (square
intaglio)

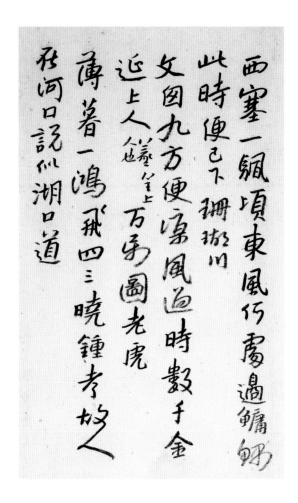

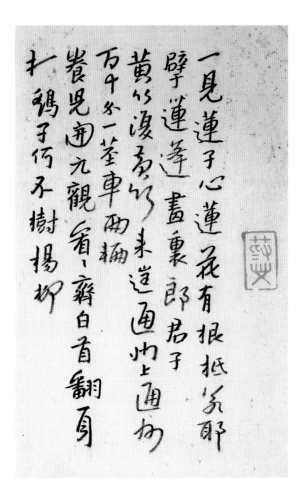

LEAF 9

Three poems in running-standard script, by Bada Shanren

POEM 4

Sailing full tilt off of West Pass Hill,
To which border does the east wind blow?
The time is right for big-headed stripe,
So they have come down the Coral Stream.[28]

POEM 5

My latticed windows favor all directions,
And cooling breezes often come along.
A thousand in gold welcomes the primeval man,
For a million, he'll make the picture of a tiger.[29]

POEM 6

On toward dusk, a single goose flies,
The morning bell tolls three or four.
My old friend down at River Mouth,
Talks with the dialect of Lake Mouth.[30]

LEAF 8

Three poems in running-standard script, by Bada Shanren

POEM 1

Once I looked in the heart of a lotus seed,
And found a lotus flower with its roots;
Breaking open lotus pods on Ruoye Creek,
The fine young gentlemen in this painting.[25]

POEM 2

Yellow bamboo and more yellow bamboo,
Coming and going all across Tongzhou;
In Tongzhou when divided into tenths,
A single stem equals a pair of carts.[26]

POEM 3

They raised sons at the Kaiyuan Temple,
Take a look, now all are white of hair;
Flipping to strike a sparrow-hawk pose,
Why don't they plant some willow trees?[27]

ONE SEAL *Wei'ai* (rectangle relief)

文區九方便凌凄厘道时贵干金

近上人人也幾壹上万乘圖老虎

溥暮一鴻飛四三曉鐘考故之

孤河口說似湖口道

郎吹鳳凰山高以純金葉知音

乞子誰領是大州日

而些舟無字雲行圖在芙此時

南畫望己是皖山圖

一見蓮子心蓮花有根抵沅郎

壁于蓮蓬畫裏郎君子

黃竹復高竹未道遍州上遍州

万千矛一莖車兩輛

養兒通元觀看齊白首翻身

十鴉子何不樹揚柳

西塞一颽頃東風行雲過鱸魚

北寺更已下冊故口

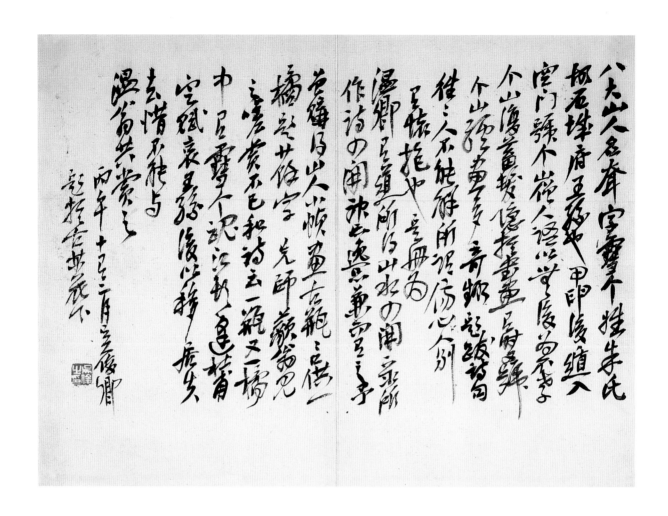

LEAVES 11-12

Colophon in running script, by Wu Changshuo (1844–1927),
Ink on lightly sized paper; single sheet with fold, 30.2 x 41.3 cm

Bada Shanren's given name was Da, and his courtesy name Xuege. He bore the surname Zhu, and was a grandson of the Prince of Shichengfu [Anhui]. After [the fall of the Ming dynasty in] the *jiashen* year [1644], he absconded into an "empty gate" [became a Buddhist monk] and called himself Monk Geshan. As people say it is unfilial to have no progeny, Geshan let his hair grow again [rejoined the laity in order to marry] and found reclusion in calligraphy and painting. Sometimes he still called himself Donkey Geshan. His paintings have many eccentricities and people are often unable to understand the poetic lines he inscribed on them, for as they say, "Heartbreak has its hidden reasons."

This album is owned by my fellow art lover Wenqing. It contains four leaves of landscape painting and four leaves where Bada recorded some of his own poems, and all are equally works

of the divine and untrammeled classes. I once purchased a small hanging scroll by Shanren, which was painted with an antique vase holding a single branch of tangerine and inscribed with [a poem of] some twenty characters. When my former teacher Miaoweng [Yang Xian, 1819–1896] saw it, he could not stop sighing in admiration and composed the following poem to harmonize [with Bada's]: A single vase and a single tangerine, /Xuege's soul lies within them; / Meeting Du Fu in a river village, / In vain he chanted, "Alas, the prince!" I later lost the scroll while moving, so I regret that Old Wen[qing] and I cannot enjoy it together. Twelfth lunar-month of the *bingwu* year [January 14–February 12, 1907], inscribed by Wu Junqing [Wu Changshuo] beneath the flowers of an ancient plum tree.[34]

ONE SEAL *Wu Jun zhi yin* (square intaglio)

LEAVES 13-15

Colophon in running-standard script, by Naitō Torajirō
(1866–1934)
Ink on paper; two sheets, each with fold, 25.5 x 37.2 cm

In his "Biography of Bada Shanren," Shao Qingmen [Shao Chengheng, 1637–1704] describes especially well how Bada feigned madness and "had contempt for the world," saying "the swelling and closing down of his emotions came about for their own inexplicable reasons, as when a giant boulder blocks a spring or wet rags resist the fire, there was nothing he could do about it," and "if Shanren had only met such companions as Fang Feng [1240–1321], Xie Ao [1249–1295], and Wu Siqi [1238–1301], they would have clasped each other around the shoulders and wailed in anguish until their voices were gone." Since Bada's experiences in life and his own personality were both truly like this, isn't that why one cannot figure out the strange and unusual [aspects] of his painting and calligraphy. Now in looking at this album, I am particularly amazed at the "secret and rough" quality of the paintings, which are quite unlike his usual eccentricities. The style of his calligraphy is also ancient and mellow, desolate and untrammeled, like that of masters from the Jin dynasty [265–420 C.E.]. This is certainly because what one sees in this album is a true expression of his innermost feelings, while the strange and unusual works that one usually encounters are simply works he made to show his "contempt for the world." Oh, if one uses this to explain [the works of] Bada Shanren, then indeed there is nothing about Bada Shanren that cannot be explained. Utsudō Hayashi-kun acquired this album and continues to esteem it most highly, and since he would have me inscribe something at the end, I have written this [colophon]. Eighth lunar-month in the *kōgo* year of the Shōwa reign period [September 22–October 21, 1930]. Naitō Tora[35]

ONE SEAL *Hōma-an* (square intaglio)

TWO COLLECTOR SEALS
Hayashi Heizō (20th century), one seal: *Utsudō hōhi* (rectangle relief)

Zhang Daqian, one seal: *Dafengtang* (square relief)

荷花雙鳧圖　軸

9 Lotus and Ducks ca. 1696

Hanging scroll; ink on paper
184.1 x 95.5 cm
Bequest from the collection of Wang Fangyu and Sum Wai,
donated in their memory by Mr. Shao F. Wang

OUTSIDE LABEL (NOT SHOWN) by Zhang Daqian (1899–1983),
running script
"Lotus and Ducks," done by Bada Shanren late in life and
venerated by Dafengtang [Zhang Daqian]. A genuine work
of the divine category, with inscription by Wu Changshuo
[1844–1927]

SIGNATURE ON PAINTING Bada Shanren[36]
THREE SEALS *Zaifu shanfang* (square intaglio), *Bada Shanren*
(rectangle intaglio), *Yaozhu* (rectangle relief)

INSCRIPTION *Poem in running script,* by Wu Changshuo

Birds talk, quack and chatter, the rock's face gaunt,
Virtue and merit emerge from the lotus man's pond,
Hidden are the gulls and herons, sunken are the fish,
Who was that Snowy Donkey, who once painted this?
Donkey was the name of a Buddhist monk,
A monk who appeared in the House of Zhu,
He sat cross-legged among the lotus leaves,
As birds called out, fleeing the shot of a bow.
Painting Zen, in his ideas, he was all a tonsured monk,
Preaching Dharma, he was a leftover prince of the Ming,
If his flower bore no fruit, it was but a matter of karma.
But a matter of karma,
Today we heave a sigh:
Wolves are besting tigers, bear gives birth to fox,
Long in dream, a butterfly comes fluttering along.[37]

POSTSCRIPT Spring of the *bingyin* year [1926], inscribed
by Wu Changshuo in his eighty-third year.
SEAL *Laofou* (square relief)

EIGHT COLLECTOR SEALS
Yan Shengbo (20th century),
two seals: *Yanshi Baomengtang
zhenshang* (square relief),
Shengbo (square relief)

Unidentified collector, one seal:
Shizhong jushi (square relief)

Zhang Daqian (1899–1983),
four seals: *Dafengtang Jianjiang
Kuncan Xuege Kugua moyuan*
(rectangle relief), *Nanbei
dongxi zhi you xiangsui wu bieli*
(square relief), *Dafengtang
zhencang yin* (rectangle relief),
Qiutu bao gurou qing
(horizontal rectangle relief)

Wang Fangyu (1913–1997)
and Sum Wai (1918–1996),
one seal: *Fang Hui gongshang*
(square relief)

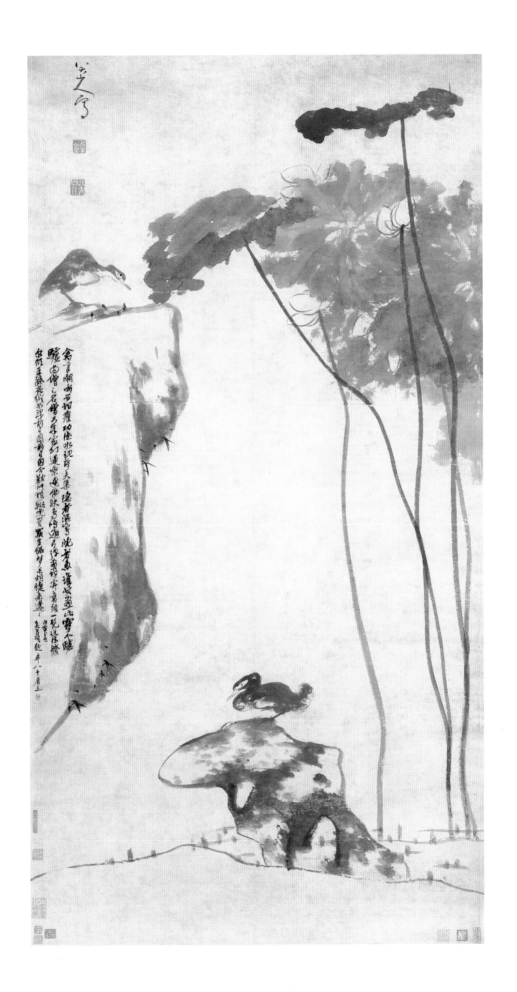

行楷書節錄韓愈《送李愿歸盤谷序》 冊頁

10 Poem by Han Yu
in running-standard script, 1697

Album leaf; ink on paper
33.0 x 26.8 cm
Purchase—Funds provided by the E. Rhodes and Leona B.
Carpenter Foundation in honor of the 75th Anniversary of
the Freer Gallery of Art

From the "Preface to Seeing Off Li Yuan on His Return to
Winding Valley," by Han Yu (768–824)[38]

When Li Yuan of Shannan[39] was about to return to Winding
Valley, Wengong [Han Yu] heard his words and was strongly
moved, so he sent [Li] some wine and made a song for him,
which says:
Within the Winding lies your palace,
Above the Winding is where you till;
In the springs of Winding, one can wash and one can swim,
On the slopes of Winding, who is there to contest your place?
Hidden and deep, broad in its compass,
Twisting and turning, running off and coming back.
Ah, the joys of Winding, joys that never end!
Tigers and leopards keep away, dragons and krakens
 skulk and hide;
Ghosts and spirits keep and guard, and fend off any
 untoward harm.
So drink and eat, long life and good health,
Be lacking in nothing, in whatever you want;
I shall grease my cart, and fodder my horse,
And follow you to Winding, to spend my life in rambling.[40]

POSTSCRIPT Li Yuan was the son of [Li] Liangqi, who was
praised as "a match for ten-thousand foes" and whose given
name was Sheng. He was a prince, hence the line, "Within the
Winding lies your *palace* [translator's italics]." Twenty-fifth day
of the tenth lunar-month in the *qiangxingji* year [December 8,
1697], written by Bada Shanren at his Mountain Lodge amid the
Lotus[41]
TWO SEALS Slipper seal without border, *Ke de shenxian*
(square intaglio)

THREE COLLECTOR SEALS
Zhang Shanzi (1882–1940),
one seal: *Huchi xinshang*
(square intaglio)

Zhang Daqian (1899–1983),
one seal: *Dafengtang* (square
relief)

Sum Wai (1918–1996), one
seal: *Shen Hui* (square relief)

山南李愿隱歸盤谷文々聞其言而壯之與之酒
而為之歌曰盤之中唯子之宮盤之上維子之稼盤
之泉可濯可湘盤之阻誰爭子所窈而深廓其有
容繚而曲如往如復嗟盤之樂子樂且無央虎豹遠
迹子餒蛟遁藏鬼神守護呵禁不祥飲且食子
壽而康無不足子其所望膏吾車兮秣吾馬從子於
盤兮終吾生焉逍遥

李愿良㗊㗊之子也器稱萬人教名晟為王摅曰盤之中維
子之官僵星紀十月廿五日之書于五羊之辰

行楷書曾鞏《山水屏詩》 冊頁

11 Poem by Zeng Gong
in running-standard script, 1697

Double album leaf; ink on paper
26.0 x 51.6 cm
Purchase—Funds provided by the E. Rhodes and Leona B.
Carpenter Foundation in honor of the 75th Anniversary of
the Freer Gallery of Art

TEXT "The Landscape Screen," by Zeng Gong (1019–1083);
not translated[42]

POSTSCRIPT This poem is the "Landscape Screen" by Zeng
[Gong]. Contemplating the place [where he says], "how far
one can go" [line 29] . . . he must have considered this [screen]
to be the furthest one can go in painting. "Little spring" [tenth
lunar-month] in the *dingchou* year [November 14–December 12,
1697]. Written by Bada Shanren[43]

THREE SEALS *Yaozhu* (rectangle relief), Slipper seal without
border, *Ke de shenxian* (square intaglio)

SIX COLLECTOR SEALS
Unidentified collectors, two
seals: *Yunju* (rectangle relief),
Boxing changnian (square
intaglio)

Zhang Shanzi (1882–1940),
two seals: *Huchi xinshang*
(square intaglio), *Huchi
xinshang* (square intaglio)

Zhang Daqian (1899–1983),
one seal: *Daqian haomeng*
(rectangle relief)

Sum Wai (1918–1996), one
seal: *Shen Hui* (square relief)

吳維約夭風老輩人上自秋中此圖畫乃予隨於

曲搜羅得殊匠授佈思先躊經營填刻肉于里手

一副定視逃迤迫通紀敷離迫促山房若無窮負掩

頻重複高秩歲當中築乘勢先獨田環眾峰接

題向若府伏玲瓏晬九州爭險掛星宿深鬆雪霜

積暗覺爛霧閣泉源出青寒鴻潦兩崖束庭

遠始遂徐派列騰細睿輕舟漢其前沿溽無履速

激尋潯遂側起破蓄蘘立到無根諄寧升犯

雲族掉子宅竹之頃野停馬忽臨石長自閑堂居

偶誰藥塵鞅見蕰林物之存古俗梁美幽花蕎

殷嘉木遺牛上奎蘪藉露出褸股鮮明極萬壯

拓似巨一粟雜徑人力為頹頹陰愓續深堂得歆眼

亮挽生逮矚因然助生審宵傾蹟果旭將相有時

丰鴿嘉貞武欲儒林孤未博俗穿思自贖婚嫁果

菊輕聃釣心思逖

此曾　一山水屏之作遠到豪禪之圖正寫

一流必以此為圖畫中之釣也

　　　　　　　丁丑冬

　　　　　　　　　笨人書

毛族遂子空何之頤勝作臣勝不長自際堂

偶誰藥塵鞚見菑林物〻存古俗絮美幽花蕃、

殷嘉木遺牛上崔巔麓磨出楂腹鮮明獨萬怯眠

拍似巨一粟誰徑人力為頹穎陰怪續深堂得敬眠

嵩挽生遠矚因能助雌寧宵頤躋杲旭將相有時

丰繫嵓真我欲儒林孤末博俗宵思自瀆婚嫁累

苟狂肼釣心思逐

吳縑約天風寒舒人上目秋中此圖畫又寸隨形
曲搜羅湅孫匠後倚思先躊躇望頃刻內千里丰
一刷定視迤迤通紀數雜迫倨山屬若無氣負枯
頫重複高積衆當中集小勢先獨面環衆峰頫揭
趨向若井伏衿耞時九州爭險推星宿深翹雪霸
積暗覺灼霧鶴泉源出青冥讌涼涼兩崖束磨
遠始迂徐派列鯐細谷輕舟漾其間沿涯無遠速
致尋

撫董其昌《臨古山水》 六開冊
12 Album after Dong Qichang's "Copies of Ancient Landscape Paintings"
ca. 1697

Album of six leaves; ink on paper
AVERAGE 31.2 x 24.7 cm
Bequest from the collection of Wang Fangyu and Sum Wai,
donated in their memory by Mr. Shao F. Wang

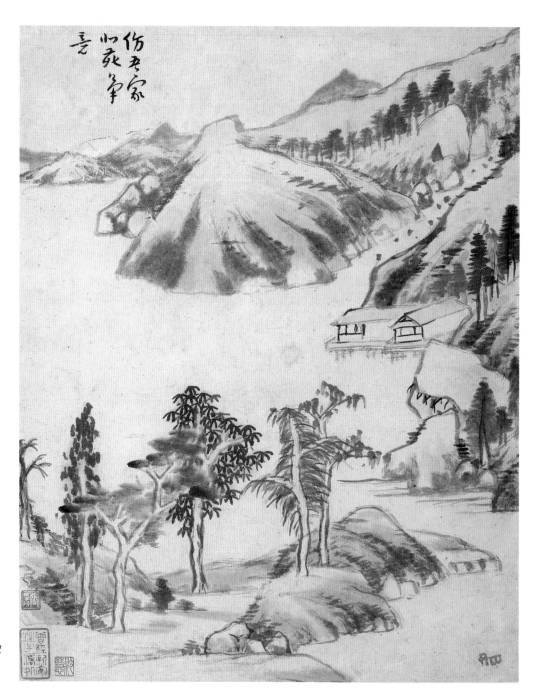

LEAF 1
INSCRIPTION Imitating the
brushwork ideas of my
relative, Beiyuan [Dong Yuan,
died 962][44]
ONE SEAL Slipper seal
without border

———————————

THREE COLLECTOR SEALS
Wang Zitao (20th century),
one seal: *Cengjing Xin'an Wang
Zitao chu* (rectangle relief)

Zhang Daqian (1899–1983),
one seal: *Zhang Yuan* (square
intaglio)

Sum Wai (1918–1996), one
seal: *Shen Hui* (square relief)

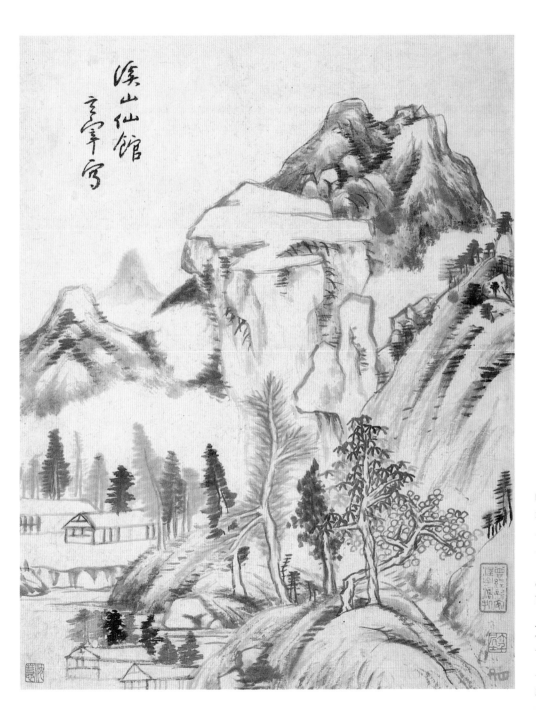

LEAF 2

INSCRIPTION *Lodge of the Immortals among the Hills and Streams,* drawn by Xuanzai [Dong Qichang (1555–1636)] ONE SEAL Slipper seal without border

THREE COLLECTOR SEALS
Wang Zitao, one seal: *Cengjing Xin'an Wang Zitao chu* (rectangle relief)

Zhang Daqian, one seal: *Daqian jushi* (square relief)

Sum Wai, one seal: *Shen Hui* (square relief)

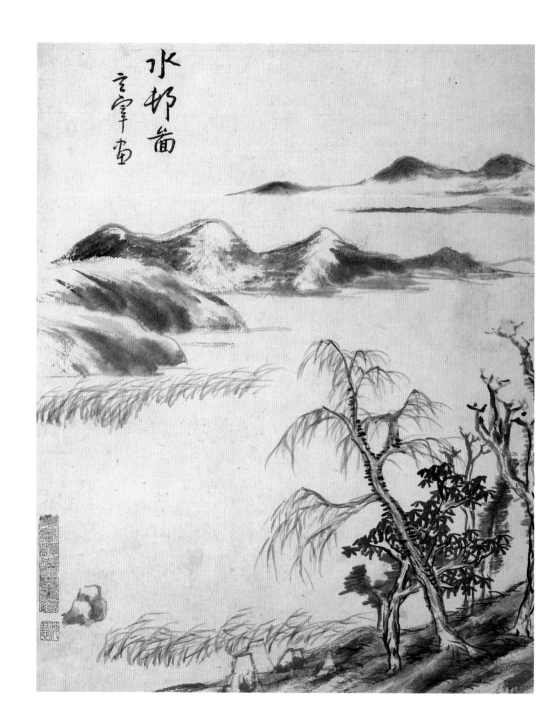

水邨畵
玄宰畫

LEAF 3
INSCRIPTION *River Village,*
painted by Xuanzai [Dong
Qichang]
ONE SEAL Slipper seal
without border

TWO COLLECTOR SEALS
Zhang Daqian, one seal:
*Dafengtang Jianjiang Kuncan
Xuege Kugua moyuan*
(rectangle relief)

Sum Wai, one seal: *Shen Hui*
(square relief)

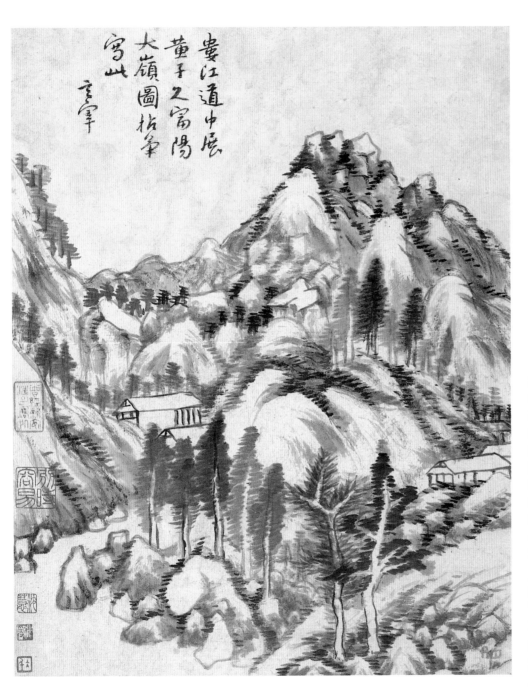

LEAF 4

INSCRIPTION On the road to Loujiang [in Jiangsu Province], I unrolled the painting *The Fuyang Mountain Range* by Huang Zijiu [Huang Gongwang, 1269–1364], and took out my brush to draw this. Xuanzai [Dong Qichang][45]

ONE SEAL Slipper seal without border

FIVE COLLECTOR SEALS

Wang Zitao, one seal: *Cengjing Xin'an Wang Zitao chu* (rectangle relief)

Zhang Daqian, three seals: *Bieshi rongyi* (square relief), *Zhang Yuan* (square relief), *Daqian* (square relief)

Sum Wai, one seal: *Shen Hui* (square relief)

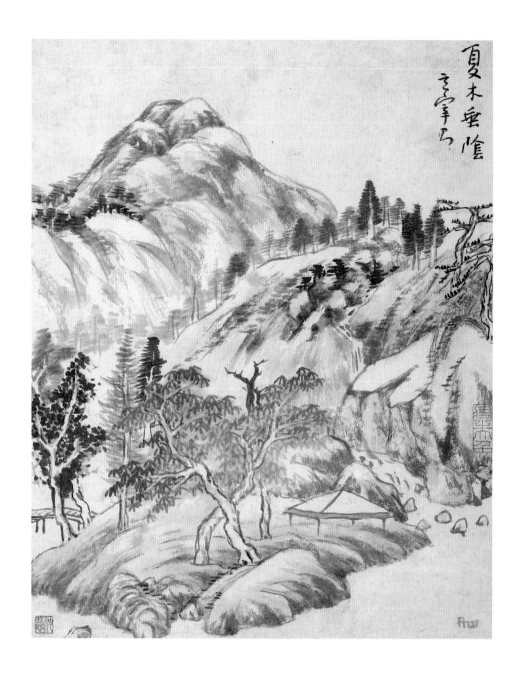

LEAF 5

INSCRIPTION *In the Shade
of Summer Trees,* painted by
Xuanzai [Dong Qichang][46]
ONE SEAL Slipper seal
without border

TWO COLLECTOR SEALS
Zhang Daqian, one seal:
Cang zhi daqian (rectangle
relief)

Sum Wai, one seal: *Shen Hui*
(square relief)

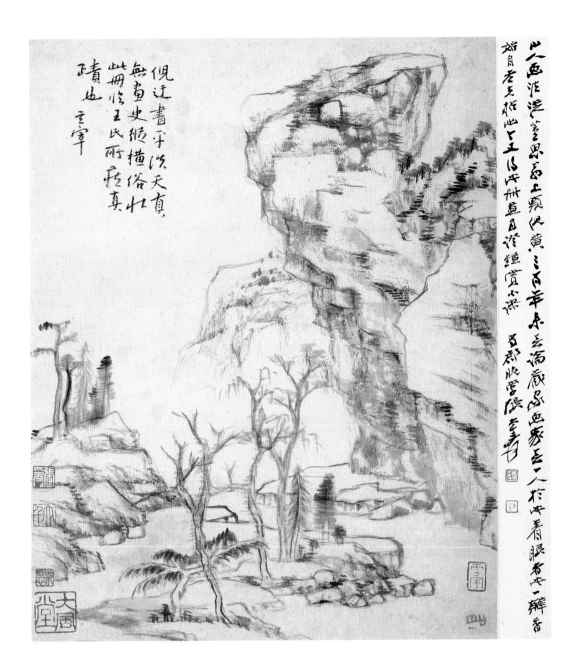

LEAF 6

INSCRIPTION The paintings of Ni Yu [Ni Zan, 1306–1374] are plain and natural, and have none of the helter-skelter vulgarity of common painters. For this album leaf, I copied a genuine work [by Ni] in the collection of Mister Wang. Xuanzai [Dong Qichang][47]

ONE SEAL Slipper seal without border (upside down)

———

FIVE COLLECTOR SEALS

Zhang Daqian, three seals:
Zhang Yuan (square intaglio),
Daqian (square relief),
Dafengtang (square relief)

Wang Fangyu (1913–1997), one seal: *Fangyu* (rectangle relief)

Sum Wai, one seal: *Shen Hui* (square relief)

Colophon in running script, by Zhang Daqian

In his style of painting, Shanren looked back to Ni Zan and Huang Gongwang [by studying] Dong Siweng [Dong Qichang]. Over the last three hundred years, no collector or painter ever viewed [Bada's work] from this angle. I, this old fellow, was the first to figure out his artistic lineage and now that I have acquired this album, it further verifies that my connoisseurship was not mistaken. Elderly pupil from Shujun [Sichuan Province], Zhang Daqian Yuan[48]

TWO SEALS *Zhang Yuan* (square intaglio), *Daqian* (square relief)

行楷書《臨河集序》 冊頁

13 Excerpt from "Preface to the Gathering at the River"

in running-standard script, ca. 1697

Album leaf; ink on paper
26.2 x 19.0 cm
Purchase—Funds provided by the E. Rhodes and Leona B.
Carpenter Foundation in honor of the 75th Anniversary of
the Freer Gallery of Art

Excerpt from "Preface to the Gathering at the River," by Wang
Xizhi (ca. 303–ca. 361 C.E.)[49]

During late spring in the ninth year of the Yonghe reign period
[353 C.E.], we assembled at the Orchid Pavilion in Shanyin
prefecture, Kuaiji county, to observe the purification rites.
Sundry worthies all arrived and both young and old gathered
together, for in this spot there are lofty ranges and exalted
mountains, thick groves and tall bamboo, and a clear current
gushing and swirling, shining about us left and right, that has
been led to form a winding stream for floating wine cups. And
we seated ourselves in order each to his place. On this day, the
sky was bright and the weather clear, and how pleasant the gen-
tle breeze! We delighted our eyes and gave rein to our passions,
so truly enjoyable it was. Though we hadn't the opulence of
silken strings and bamboo flutes, for every cup there was a song,
and that was quite sufficient for the pleasing expression of our
private feelings. Therefore, I have listed in order the persons then
in attendance and recorded their compositions.

"Preface to the Gathering at the River." Bada Shanren[50]
TWO SEALS Slipper seal without border, *Ke de shenxian*
(square intaglio)

TWO COLLECTOR SEALS
Zhang Daqian (1899–1983),
one seal: *Jiyuan* (square
intaglio)

Sum Wai (1918–1996), one
seal: *Shen Hui* (square relief)

永和九年暮春會于會稽山陰之蘭亭脩

禊事也群賢畢至少長咸集此地逦峻領崇

山茂林脩竹更清流激湍暎帶左右引以為

流觴曲水列坐其次是日也天朗氣清惠風竹

暢娛目騁懷洵可樂也雖無絲竹管絃之盛

一觴一詠亦足以暢敘幽情已故列序時人錄其

所述

行楷書張九齡《題畫山水障詩》 冊頁

14 Poem by Zhang Jiuling

in running-standard script, ca. 1697

Album leaf; ink on paper
26.1 x 19.2 cm
Purchase—Funds provided by the E. Rhodes and Leona B.
Carpenter Foundation in honor of the 75th Anniversary of
the Freer Gallery of Art

"Inscribed on a Landscape Folding Screen," by Zhang Jiuling
(678–740)[51]

Though the burdens of my heart will never end,
I am still attracted to transcendental things;
So when I have the chance to please my senses,
I take advantage of the beauty in a painting.
I have always embraced the idea of wilderness,
But am pressured by my fate within the world;
While mundane affairs, indeed, are ever thus,
I shall hold fast to that idea and never budge.

This artist has captured my innermost desires,
Wielding his marvelous brush before the cliff;
Every change conforms to what is really there,
Every height and depth is identical to nature.
When it is displayed within the northern hall,
One seems to stand beside the southern hills;
Though one stay put and never leave his door,
In spirit he has traveled to someplace far away.

The day lily can be planted against sorrow,
And coupled bliss will assuage one's anger;
If little things can have such great effects,
How much more then, this secluded fish trap!
Words and images melt away of themselves,
I have simply used them to express my idea;
I've gotten such enjoyment from this object,
That it will linger on forever in my mind.[52]

POSTSCRIPT Du [Fu], of the public works department, "piled
dirt to make a mountain." In this [poem], then, "all the other
mountains resound." Bada Shanren[53]
ONE SEAL *Ke de shenxian* (square intaglio)

TWO COLLECTOR SEALS
Zhang Daqian (1899–1983),
one seal: *Daqian zhi bao*
(square relief)

Sum Wai (1918–1996), one
seal: *Shen Hui* (square relief)

心累形不盡狗爲物外孝偶因耳目好復假

丹青妍蚩掌拖野間意而迫區中緣塵事固已

矢志意終不遷良工適我頤妙筆揮巖而寄

化無窮合擎有高深作自然寫陳此堂上

仿像南山邊靜無戶達出行己並地偏萱州

夏可樹合惟愁匃翳所因本激物此迢遞

幽簽玄象會自底意名稱相宣對玩有佳趣

使我心耿孫眾峰響

杜工部墨士爲此列

笑

行楷書孫逖《奉和李右相中書壁畫山水詩》　冊頁

15 Poem by Sun Ti

in running-standard script, ca. 1697

Album leaf; ink on paper
26.2 x 19.1 cm
Purchase—Funds provided by the E. Rhodes and Leona B.
Carpenter Foundation in honor of the 75th Anniversary of
the Freer Gallery of Art

"Respectfully harmonizing with the *Poem on the Landscape
Mural in the Secretariat* by Minister of the Right Li," by Sun
Ti (ca. 699–ca. 761) [54]

On your many free days from the halls of court,
Landscape found a match in your true feelings;
Wishing to express all those heights and depths,
You turned to elegant painting to accomplish it.
Nine Rivers approach the doors and windows,
Three Gorges entwine the eaves and pillars,
Flowers and willows bloom throughout the year,
While mist and clouds appear upon your whim.
Ten-thousand miles seem just next door,
One does not feel the four seasons passing;
The air is redolent with Xun Yu's fragrance,
And the light is clear as Yue Guang's mirror.
Poetry describes going forth and staying put,
Paintings express both the empty and the full;
Preserving the experiences of a thousand years,
How can you speak of but eight years of glory! [55]

SIGNATURE Bada Shanren
ONE SEAL *Ke de shenxian* (square intaglio)

TWO COLLECTOR SEALS
Zhang Daqian (1899–1983),
one seal: *Cang zhi Daqian*
(square intaglio)

Sum Wai (1918–1996), one
seal: *Shen Hui* (square relief)

廟堂多暇目山水契真情欲寫氣

深逐還因藻繪成九江臨石牖三峽

繞簷楹花柳窮年裝烟雨逐意

生秩令萬里止不覺四時行爭榮

蘭膏散光舍樂鏡清詠歌齋書空

圖書亏論心裁榮 笑 表中盈自保千年迈

行楷書杜甫《戲題王宰畫山水圖歌詩》　冊頁

16 Poem by Du Fu

in running-standard script, ca. 1697

Album leaf; ink on paper
26.1 x 19.2 cm
Purchase—Funds provided by the E. Rhodes and Leona B.
Carpenter Foundation in honor of the 75th Anniversary of
the Freer Gallery of Art

"Song Playfully Inscribed on a Landscape Painting by
Wang Zai," by Du Fu (712–770)[56]

Ten days to paint a river,
 five days to paint a rock,
An expert does not suffer feeling pressed or hurried,
Wang Zai must approve before he leaves a mark behind.
How mighty, this landscape from the Kunlun to Fanghu,
That hangs upon the whitened wall of your lofty hall.
From Baling along Dongting Lake to east of far Japan,
The river passes Red Bluff to join the Silver Stream:
In the middle, dragons fly among the clouds and mist,
Fishermen and boatmen pull in to riverbank and shore,
Mountain trees are flattened by huge billows of wind.
No one from the past equals him in painting distance,
Just a foot must correspond to, say, ten-thousand *li,*
If I could get a pair of sharpened Bingzhou scissors,
I'd slice off a half of Wusong Creek to take along.[57]

SIGNATURE Bada Shanren
ONE SEAL *Ke de shenxian* (square intaglio)

TWO COLLECTOR SEALS
Zhang Daqian (1899–1983),
one seal: *Daqian jushi* (square
relief)

Sum Wai (1918–1996), one
seal: *Shen Hui* (square relief)

十日畫一水五日畫一石能事不受相

促迫王宰始肯留真蹟壯哉崑崙方

壺圖掛君高堂之素壁巳陵洞庭日

本東赤岸水與銀河通中有雲氣隨

飛龍舟人漁子入浦溆山木盡亞洪濤風

尤工遠勢古莫比咫尺應須論萬里駕浔

焉如快剪刀翦刀剪取吳松半江水

八還書

17 Rubbing of the "Holy Mother Manuscript" with Transcription and Colophon in running-standard script, 1698

Handscroll, ink on paper
RUBBING 29.4 x 250.8 cm

TRANSCRIPTION AND COLOPHONS 29.4 x 96.0 cm
Bequest from the collection of Wang Fangyu and Sum Wai, donated in their memory by Mr. Shao F. Wang

OUTSIDE LABEL (NOT SHOWN) Unidentified calligrapher, running-standard script
Song dynasty rubbing of the "Holy Mother Manuscript" by Huaisu (725–ca. 799), with transcription and colophon by Bada Shanren of the Ming dynasty[58]

INSIDE LABEL by Xiaobao (unidentified), clerical script
Song-dynasty rubbing of the "Holy Mother Manuscript" by Huaisu, with personal transcription by Bada Shanren of the Ming dynasty; a genuine work of the divine class. Label slip inscribed by Xiaobao
ONE SEAL *x-sun* (rectangle relief)

Transcription of the "Holy Mother Manuscript," by Bada Shanren[59]

The Holy Mother in her heart approved the ultimate instructions of the sages. . . . Thus when she received the Daoist teachings of Highest Purity, she forthwith ascended to a place among the ranks of the holy, her supernatural influence extended afar to all those who exalted the immortals, and her divine responsiveness moved swiftly to all those who excelled in extraordinary merit. Whereupon, the perfected one, Lord Liu, bearing a scepter and riding a *qilin* [unicorn], descended into her courtyard. Lord Liu is named Gang, and is one of the noble perfected. And since her Way *[dao]* corresponded to what is written in the precious records and her talents accorded with those of the highest immortals, he provided her with magical formulas and fed her on perfected elixirs, so that her divine appearance was instantly transformed, her flesh and bones grew slender and lovely, and setting herself apart from the common masses, she distanced herself from carnal affections. At first, her husband Mister Du was greatly enraged and reprimanded her for neglecting her wifely duties, but the Holy Mother went on as she was and paid him no heed, until in time he brought suit against her, which led to her confinement. While detained in prison, all of a sudden she was arrayed in rainbows, and an immortal's carriage descended from the air, inquiring for her as it approached the door. Looking back, she called to her two daughters and together they ascended, climbing into the void. When the rays of sunrise began to glow, they shot straight upward into the sky, banners and streamers bright and gleaming, shining and radiant beyond compare, and with strange music and exotic fragrances, they disappeared into the sky and were gone. Emperor Kang [reigned 342–44 C.E.] of the Jin considered this a sign of dynastic renewal and had the story inscribed on a tablet where she had lived, establishing a temple there to celebrate these auspicious events. And he named her the Holy Mother of Dongling: for her home had been in Guangling and she became an immor-

tal in a place east of this, thus he called her "Dongling" [literally: east of Guangling]; and whereas she ascended together with her two daughters, thus he called her "Holy Mother." And when the vast hall had been raised aloft and her true likeness beautifully decorated, everyone from near and far came thronging to her temple, emptying the very market places of Jianghuai. During times of drought or pestilence, there were none who did not pray to her and petition for relief, for the [Holy Mother] bestowed radiant answers by which the people were restored to great good health. And if there was an evil robber who had not been brought to account, then she would send a wondrous bird to hover over the place he lived and drop a supernatural writ, whereby his guilt was proven. Thus, no one in the towns and villages dared to commit such evil acts.

From the Jin dynasty until the Sui, for some three hundred years, both town and country made fine offerings to her, flocking to her temple by cart and foot. When Emperor Yang of the Sui dynasty [reigned 604–617] moved east to Jiangdu [modern Yangzhou], the dynastic cycle was ending and there was great superstition, Daoist adherents were strictly forbidden and the Mysterious Prime [missing characters]. Now the Nine Sage Emperors [of the Tang dynasty] have magnificently carried on her tradition, devoutly proclaiming the ultimate Dao and establishing storehouses in the temples of truth. Thus, how much more can her numinous traces be detected and her transformative influence be found among men, for although rank growth may cover the barren suburbs, the libations and prayers of the people still gather like clouds. Old men grieve that the rafters and eaves are not yet fixed, so whoever shall restore this temple, him shall they call great in virtue. Thus, the Way of my uncle Guo, Duke of Taiyuan, Military and Surveillance Commissioner of Huainan, Minister of Rites, and Commissioner Supervising

the Army, crowns the four corners of the world and his merit is revered throughout the southern lands. Until the rivers Huai and Yi run dry, [the renown of] his great deed shall never perish and will be preserved forever in hymns of praise. In the ninth year of the Zhenyuan reign period, the *guiyou* year of the cycle, during the *ji* month [July 13–August 10, 793]. Written by the Buddhist monk Cangzhen[60]

NO SIGNATURE
ONE SEAL Slipper seal without border

Colophon in running-standard script, by Bada Shanren,

The *Autobiography, Thousand Character Essay,* and other works written by Lütian'an [Huaisu, ca. 725–ca. 799] while drunk were solely rooted in the abstract cursive script of Zhang Youdao [Zhang Zhi, active ca. 150–192 C.E.]. Only the *Holy Mother Manuscript* was written while he was sober and captures the standardized forms of Zhang Youdao's style made by Suo You'an [Suo Jing, 239–303 C.E.]. While one may imagine he is looking at calligraphy by two Han masters, they were both born and raised in the territory of Jiuquan [Gansu Province], which became a dependent state only after they left. The writing of Lütian'an, how can one not treasure it! "Little spring" [tenth lunar-month] in the *wuyin* year [November 3 to December 1, 1698], inscribed by Bada Shanren at his Mountain Lodge amid the Lotus[61]

TWO SEALS *Gui'ai* (rectangle relief), *Ke de shenxian* (square intaglio)

Colophon in running script, by Yang Chunhua (unidentified)[62]

In the past I have seen many rubbings of the "Holy Mother Manuscript," but none quite so beautiful and outstanding as this one. Obtaining Bada Shanren's transcription of the text is like seeing the true appearance of Mount Lu. One should not view it lightly. Inscribed by Yang Chunhua

ONE SEAL *Yang Chunhua yin* (square intaglio)

TWENTY-FIVE COLLECTOR SEALS[63]
Bada Shanren (1626–1705), three seals on rubbing: *Gui'ai* (rectangle relief), Slipper seal without border, *Ke de shenxian* (square intaglio)

Zhu Yizun (1629–1709) or descendant, one seal on rubbing: *Xiushui Zhishi Qiancaitang tushu* (square relief)

Shen Tong (1688–1752), one seal on rubbing: *Guotang shending* (gourd-shape relief)

Li Puquan (19th–20th century?), three seals: *Puquan zhenmi* (rectangle intaglio; on rubbing), *Baimen Lishi zhencang* (square relief; on rubbing), *Puquan zhenmi* (rectangle intaglio; on transcription)

Lin Xiongguang (1898–1971), five seals: *Linshi Baosongshi suocang* (square relief; on front mounting), *Baosongshi* (square relief; on rubbing), *Lang'an jiancang* (square intaglio; on rubbing), *Lang'an suode* (rec-tangle relief; after colophons), *Lin Xiongguang yin* (square intaglio; on back mounting)

Unidentified collectors, three seals: *Miaojixiang'an* (rectangle relief; on front mounting), *Yunhuaxianguan shending* (square relief; on rubbing), *Baozhi guoyan* (square intaglio; on back mounting)

Cheng Qi (20th century), four seals: *Cheng Bofen zhencang yin* (rectangle relief; on rubbing), *Shuangsonglou* (rectangle relief; on rubbing), *Ke'an zhenmi* (rectangle relief; on transcrip-tion), *Cheng Bofen tushu ji* (rec-tangle intaglio; after colophons)

Wang Fangyu (1913–1997), one seal: *Fangyu* (rectangle relief; after colophons)

Sum Wai (1918–1996), four seals: *Shen Hui* (square relief; on rubbing), *Shen Hui* (square relief; on rubbing), *Shen Hui* (square relief; on transcrip-tion), *Shen Hui* (square relief; after colophons)

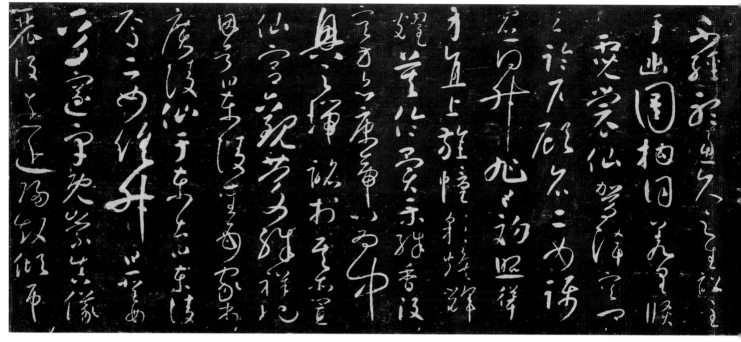

SECTION 2

SECTION 4

SECTION 1

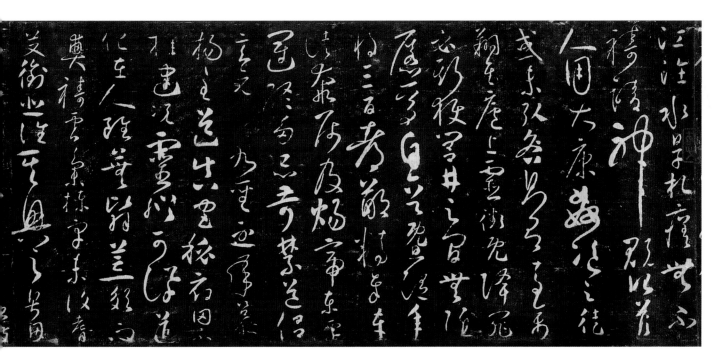

SECTION 3

綠天庵自序千文草帖
強書一本于張有道
之玉唯聖妙帖猶之得
索易安與坤看已之
褪因觀見漢二家書法
峥生長沔泉州郡一考
而為屬圓綠天庵書
郎行而孫重之
戊寅如春以芝稅于
在笑山房

聖老帖余昔年所觀者多多未芳山
之秀孤傑出奇得小大山人雜久又
見慶山出面目向易視之
楊春華穎

SECTION 6

聖母帖釋文

聖母心愈至言無繇永辭以遂奉上清之教旋
登列聖之位仙階竈者靈感速遂豐功邁于神
庭速迴有真人劉珝擁節佇立合上仙授
告名繇貴真此以聖母母道名之寶籙于連功劉
之秘訴師以真筴遵神儀藥寶戒鈞禮姍脫
篆籙流鄽遠塵憂杜氏初列貴我鈞禮聖母
備然不經聽憲之了生謚已于幽圖拘同愛里陵
寞空仙駕降空宇之臨戶頌名二妹躋虛同升屺
仙于東去心東陵駕二女瑤昇躋聖母家遠宇晚
香没空方息家市以爲中興之瑞銘于其兩寶仙
宝真儀麗設遠之歸赴頌物涇淮水旱扎慶世
六禱請神眠睇畣人用去原救益之後或未致
畣則有斋翁翔其廬上靈衛暇降踪邪雅閣
精奉車誰奔沙及煬帝東運運洿多忌前禁
井之旨無諸愆駕自晉隋年將三方都鄽
道侶玄元九聖丕承春揚玉道真官秘府印
掁建況靈踪乃道化在人雖無的首郭印
真禱丈集楝宇來渡者受謗慇誰其興之傳
因碩德行垂殊文淮南序度觀察使禮部尚書
監軍文太原郭公道冠方隅勛崇南積淮河晚
畣試作而不朽乎頌聲

行楷書孫逖《奉和李右相中書壁畫山水詩》 軸

18 Poem by Sun Ti

in running-standard script, ca. 1698

Hanging scroll; ink on paper
204.8 x 72.2 cm
Bequest from the collection of Wang Fangyu and Sum Wai,
donated in their memory by Mr. Shao F. Wang

"Respectfully harmonizing with the *Poem on the Landscape
Mural in the Secretariat* by Minister of the Right Li," by Sun Ti
(ca. 699 – ca. 761)[64]

On your many free days from the halls of court,
Landscape found a match in your true feelings;
Wishing to express all those heights and depths,
You turned to elegant painting to accomplish it.
Nine Rivers approach the doors and windows,
Three Gorges entwine the eaves and pillars,
Flowers and willows bloom throughout the year,
While mist and clouds appear upon your whim.
Ten-thousand miles seem just next door,
One does not feel the four seasons passing;
The air is redolent with Xun Yu's fragrance,
And the light is clear as Yue Guang's mirror.
Poetry describes going forth and staying put,
Paintings express both the empty and the full;
Preserving the experiences of a thousand springs,
How can you speak of but eight years of glory!

SIGNATURE Bada Shanren
THREE SEALS *Yaozhu* (rectangle relief), *Ke de shenxian*
(square intaglio), *Bada Shanren* (square intaglio)

ONE COLLECTOR SEAL
Wang Fangyu (1913–1997)
and Sum Wai (1918–1996),
one seal: *Fang Hui gongdu*
(rectangle relief)

廟堂多暇日山水契真情欲寫高深趣還因
藻繪成九江臨戶牖三峽繞簾櫳花柳窮
榮悴煙雲逐意生能令萬里近不覺四時行筆涘
香馥芟合樂鏡清詠歌齋出霞圖書袋沖盈句
保于春遇几論以成榮　芝

艾虎圖　軸

19 Crouching Cat 1699

Hanging scroll; ink on paper
164.0 x 90.6 cm
Bequest from the collection of Wang Fangyu and Sum Wai,
donated in their memory by Mr. Shao F. Wang

INSCRIPTION Painted on the
duanyang day in the *jimao* year
[June 2, 1699]. Bada Shanren[65]
THREE SEALS *Bada Shanren*
(square intaglio), *Heyuan*
(square relief), *Yaozhu* (square
intaglio)

ELEVEN COLLECTOR SEALS
Wu Hufan (1894–1968)[66] and
Pan Jingshu, five seals: *Hufan
Jingshu zhencang huazhan*
(rectangle intaglio), *Wu Hufan
zhencang yin* (rectangle relief),
*Wu Hufan Pan Jingshu zhencang
yin* (square relief), *Chouyi
shuhua* (square relief), *Meijing
shuwu miji* (rectangle relief)

Zhang Daqian (1899–1983),
five seals: *Nanbei dongxi zhi you
xiangsui wu bieli* (square relief),
*Dafengtang Jianjiang Kuncan
Xuege Kugua moyuan* (rectangle
relief), *Dafengtang zhencang yin*
(rectangle relief), *Zhang Yuan
siyin* (square intaglio), *Qianqiu
yuan* (square relief)

Wang Fangyu (1913–1997)
and Shen Hui (1918–1996),
one seal: *Fang Hui gongshang*
(square relief)

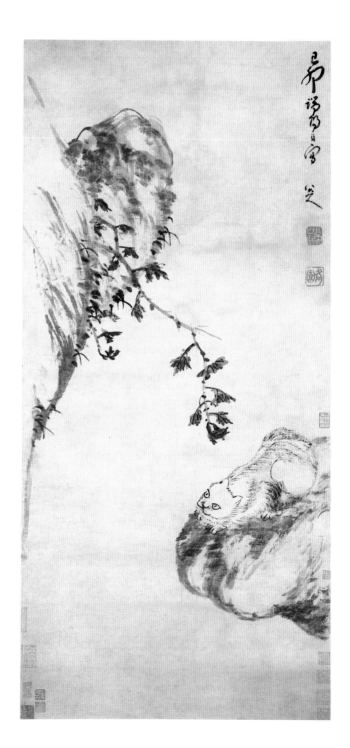

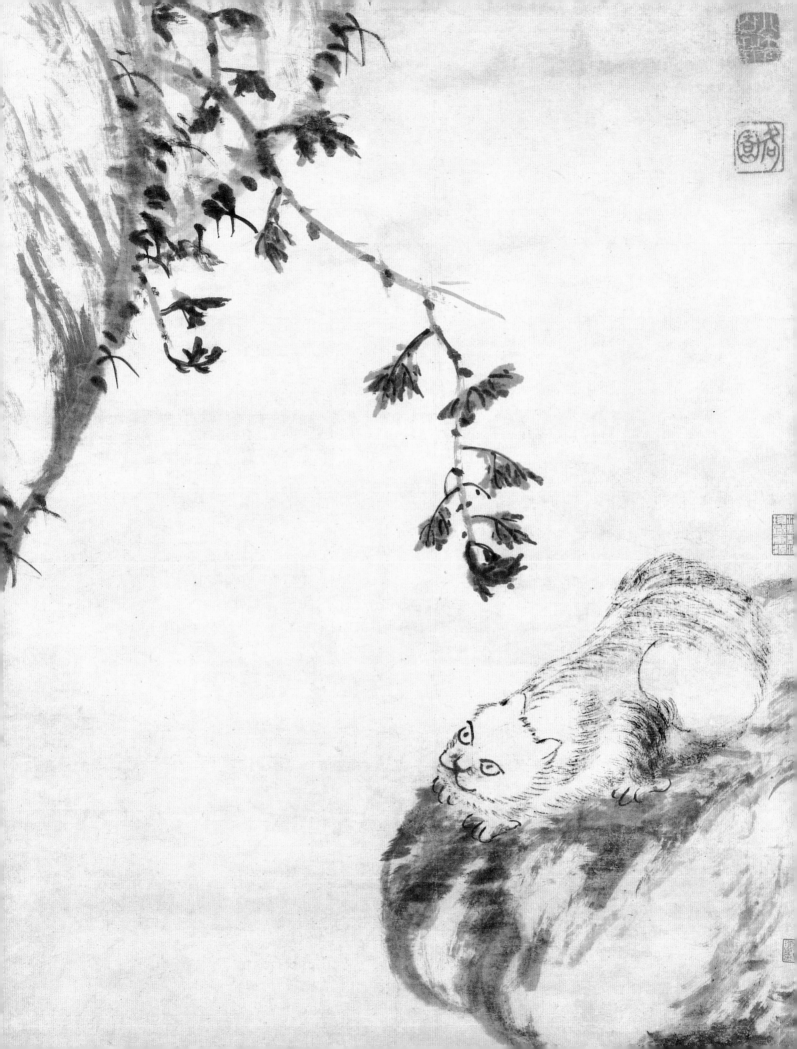

行楷書《興福寺半截碑》　廿開冊

20 Copy of the "Half-Stele of Xingfu Temple"

in running-standard script, 1699

Album of twenty leaves; ink on paper
AVERAGE 25.25 x 8.63 cm
Bequest from the collection of Wang Fangyu and Sum Wai,
donated in their memory by Mr. Shao F. Wang

OUTSIDE LABEL (NOT SHOWN) by Zhang Daqian (1899–1983), running script
The *Half-Stele of Xingfu Temple* by Bada Shanren, a genuine work venerated in the collection of Dafengtang [Zhang Daqian].
Remounted in the intercalary fifth lunar-month of the *renchen* year [June 22–July 21, 1952]. Inscribed by Daqian jushi
TWO SEALS *Zhang Yuan* (square relief), *Daqian jushi* (square intaglio)

LEAVES 19-20
Postscript, by Bada Shanren

This is the record on stone of "the stele that stood at the Xingfu
Temple . . . with running script culled by the resident monk
Daya from calligraphy [written] by General of the Army of the
Right, Wang Xizhi [ca. 303–ca. 361 C.E.], of the Jin dynasty, and
carved thereon." *Jimao* year [1699], copied *[lin]* by Bada
Shanren[67]

TWO SEALS *Yaozhu* (leaf 1: rectangle relief), Slipper seal without
border (leaf 20)

LEAF 20
Colophon in standard script, by Tang Yunsong (*jinshi* 1840)

Bada Shanren was the grandson of Prince Yi of the Ming
dynasty [1368–1644]. After the change in dynasty [1644], he
settled as a refugee along the Xujiang [river in eastern Jiangxi
Province] and became famous for his painting. He was also
thoroughly fluent in the calligraphy of the Two Wangs, and was
particularly successful in this work copying the *Half-Stele of
Xingfu Temple*, which can be treasured and enjoyed for its tran-
scendent qualities of naturalness and freedom. Mid-autumn
month of the *dingwei* year [September 9–October 8, 1847],
inscribed by Tang Yunsong[68]

TWO SEALS *Tang Yunsong yin* (square intaglio), *Heshu*
(square relief)

FIVE COLLECTOR SEALS
Zhang Daqian (1899–1983),
three seals: *Cang zhi Daqian*
(square intaglio), *Dafengtang
Jianjiang Kuncan Xuege Kugua
moyuan* (rectangle relief),
Dafengtang (square relief)

Wang Fangyu (1913–1997),
one seal: *Fang Yu* (linked-
square relief)

Sum Wai (1918–1996), one
seal: *Shen Hui* (square relief)

肇自石樓東鎮守封司
地之班金冊西符礦命將
軍之秩雖混昂中尉摠

南宮之禁其或瞻劉如
鐵搦緊明霜酚龍豹之韜
壽神武之策名溫寰海

功埤勲植其誰由於裁惟大
將軍吴之諱文字士大夫
行内給事父之所皇朝金紫

LEAF 3

芜祿大夫行内劳侍七貂之洪
是使金鋪擒慶玉臺承官
長戟磊於日宫高門弦于寺

LEAF 4

伯之雅局乾於掞年量穆奇
覩英斷裁於稚齒源之乎
鵬之為鳥不就言勵已荷之不

LEAF 5

私補過愕、於宫闈邦斠兢、
於風夜芳捄之以祆操之文林郎
適興径班也々謹室居體諱

LEAF 6

羌潛乃間之賞非乎而有冬十二月

又制轉之右監門衛大將軍建

宸神龍三年又制舉之鎮軍

LEAF 7

大將軍　行右監門衛杜固照銛

交衛霍擁衛田寶橫需步於

朱斬跪龍領　於青宮之之祿

LEAF 8

敢對敭天子之休命也唐元年

又制進封二拜三階應歷以命騰

還持大義而不可奪保元勳而

LEAF 9

苦無有則皇上銳腹以之寧也之

平均土政蕃踐五朝樹遠務涵

循躬成脩乃奏之嚴膚貞⊕

LEAF 10

常樂詔許之寫尚書謝病坐
無給觀四府之畲雜秋蓬
飄飛收百年之卷侶賈長沙

LEAF 11

之憤結唐鵬呼維公開國承祀
正家崇秩葉嗣傳於紫綬鼎
胄民於黃雲元戎亞之行乎大

LEAF 12

鑿其量府也黃金白玉于滿詔
之北堂其實頳也凱風軹物傑
臣飛將其在公乎夫人恒國李氏

LEAF 13

圓姿替月潤靄呈花已七年十一
月十二兊已而彌亮開元九年十月
廿三目循蔗於扃金維鳴而春

LEAF 14

駕扵壽議大夫行內常侍上柱
國奚行明姿鑒俗謹身行道元
方長子為行內僕局承上捐

不曉玉犬伙而秋以暮瘂將軍扵地
下意氣附于平生容帳殊扵空室
則之夫人之頤命頋不合扵殯檳

門而出飛屆五神出自天秀蓋非凡人
復禮由己依扵立身與于圖横海之平動
靽有桂詩徵孟子相與學王替南山之壽
寺立其齊西山之照不意念仍銘金穎州

上柱國昇行及獻塵澤開心大棄出
佾納之三寂迴遲局承騎都尉寂昂等
亞相功扵天恕衞肖西雍頃合延夜篜
飛五色詞膽七炭玉子砬助聖主承知夢

右軍將軍王羲之行書勒上石者也

笑之作

八大山人明益王孫鼎革後流寓盱江以畫名家書法六出入二王此臨
興福寺半截碑尤其得意之作瀟洒出塵可寶可玩丁未中秋湯雲松識

故事遵楊堅音查、藤榔青栢林旋勒一表頌孝子雖孫又林郎直將作監徐愚忠壽刻字善捏像一鋪居士張高文達此碑載于興福寺僧參住佛英雅集晉

山水圖　軸

21 Landscape ca. 1699

Hanging scroll; ink and color on paper
149.1 x 64.1 cm
Bequest from the collection of Wang Fangyu and Sum Wai,
donated in their memory by Mr. Shao F. Wang

SIGNATURE Painted by
Bada Shanren
THREE SEALS *Ke de shenxian*
(square intaglio), *Bada Shanren*
(square intaglio), *Yaozhu*
(square intaglio)

———————————

THREE COLLECTOR SEALS
Unidentified collector, two
seals: *Mijinzhai yinzhang*
(rectangle relief), *x-lou yanfu*
(square intaglio)

Wang Fangyu (1913–1997)
and Shen Hui (1918–1996),
one seal: *Fang Hui gongshang*
(square relief)

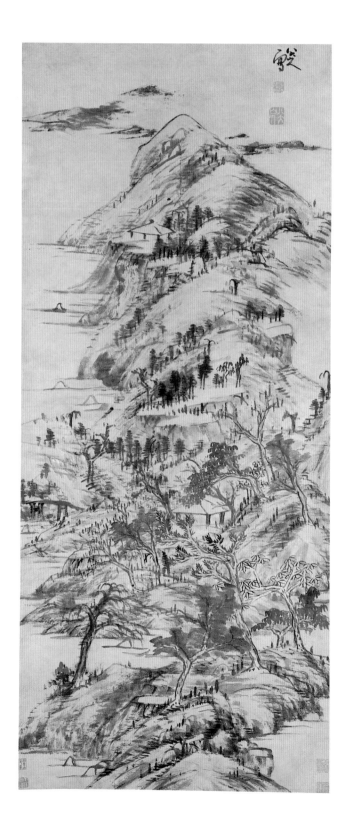

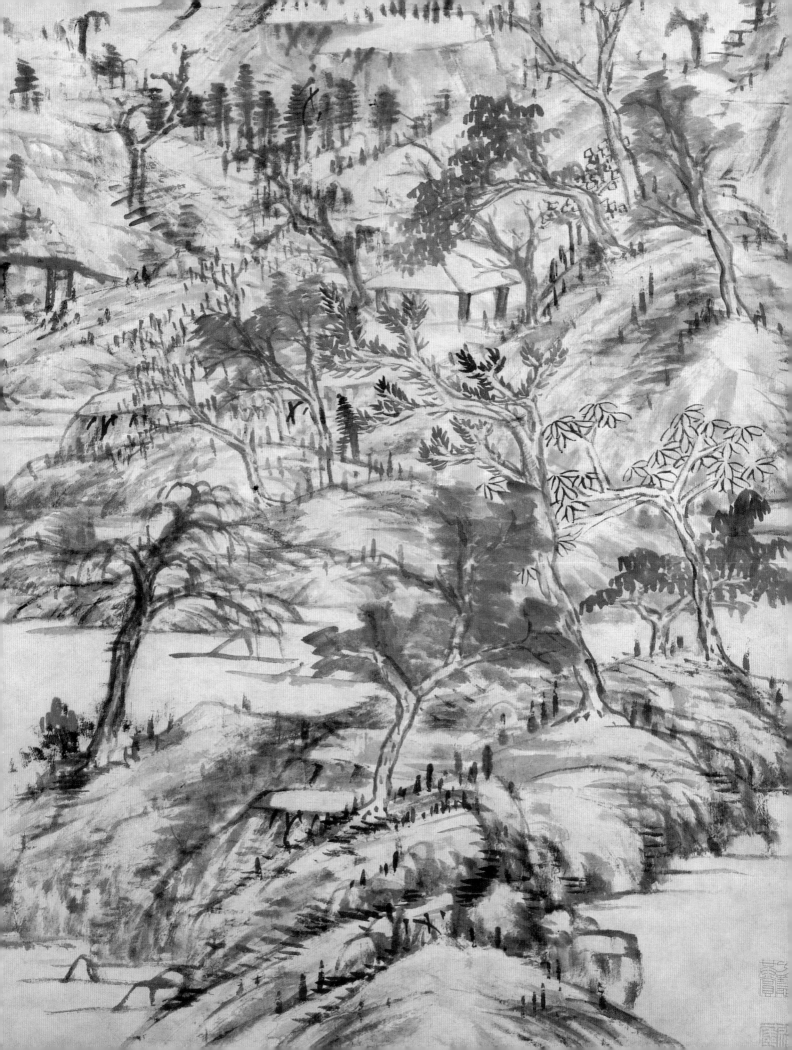

草書耿湋《題清源寺詩》　軸

22 Poem by Geng Wei
in cursive script, ca. 1699

Hanging scroll; ink on paper
154.8 x 75.3 cm
Bequest from the collection of Wang Fangyu and Sum Wai,
donated in their memory by Mr. Shao F. Wang

"Inscribed at Clear Springs Temple," by Geng Wei
(active mid- to late 8th century)[69]

Blending Ruism, Moism, and the Holy Religion,
By the cloudy spring, he built his former hut;
But Meng Wall Cove is desolate now and still,
And Wheel Rim Creek just winds naturally away.
The inner teachings dissolved his many cares,
The western garden transformed his old abode;
In the deep chamber, spring bamboo grows old,
In the thin rain, the night bell seldom tolls.
His dusty tracks remain in the golden earth,
His writings are kept beside the Stone Canal;
Still I do not know which of his companions,
Has inherited the books of this Cai Yong.[70]

SIGNATURE Bada Shanren
THREE SEALS *Yaozhu* (rectangle relief), *Ke de shenxian*
(square intaglio), *Bada Shanren* (square intaglio)

FIVE COLLECTOR SEALS
Zhang Daqian (1899–1983),
four seals: *Bieshi rongyi* (square
intaglio), *Qiutu bao gurou qing*
(rectangle intaglio), *Dafengtang
Jianjiang Kuncan Xuege Kugua
moyuan* (rectangle relief), *Bufu
guren gao houren* (horizontal
rectangle relief)

Wang Fangyu (1913–1997)
and Sum Wai (1918–1996),
one seal: *Fang Hui gongshang*
(square relief)

芍藥圖 軸

23 Peonies ca. 1699-1700

Hanging scroll; ink on paper
87.2 x 44.1 cm
Bequest from the collection of Wang Fangyu and Sum Wai,
donated in their memory by Mr. Shao F. Wang

INSCRIPTION *Poem in running-cursive script,* by Bada Shanren

I perused the classics, unnumbered glosses from the Han,
Lord Shao could not do any better than our feast today.
I dispatch this lovely flower within its pearl of jade,
Tell people just to wait until the later days of spring.[71]

POSTSCRIPT On the Birthday of Flowers [twelfth day of
the second lunar-month], upon reading the "Poem on the
Crab apple" by Mister Kezhai, I wrote this to solicit his
correction. Bada Shanren[72]
TWO SEALS *Bada Shanren* (square intaglio), *Heyuan*
(square relief)

SIX COLLECTOR SEALS
Zhang Daqian (1899–1983),
four seals: *Dafengtang Jianjiang
Kuncan Xuege Kugua moyuan*
(rectangle relief), *Qiutu bao
gurou qing* (horizontal-
rectangle intaglio), *Bieshi rongyi*
(square relief), *Diguo zhi fu*
(square relief)

Zhang Shanzi (1882–1940),
one seal: *Shanzi xinshang*
(rectangle relief)

Wang Fangyu (1913–1997),
one seal: *Shijizhilu* (square
intaglio)

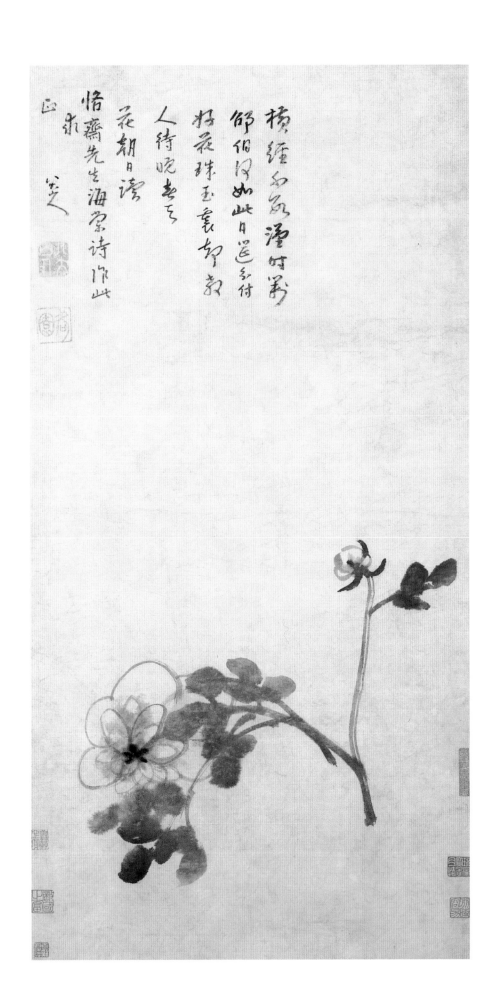

横經而爲潘時第
鄒伯月如此月逕念付
好花珠玉裏智裹
人待晚春心
花朝日譜
悟齋先生海棠詩作此
正水
笑

24 Five Pines Mountain ca. 1699

Hanging scroll; ink and color on paper
111.0 x 43.3 cm
Bequest from the collection of Wang Fangyu and Sum Wai,
donated in their memory by Mr. Shao F. Wang

OUTSIDE LABEL (NOT SHOWN) by Zhang Daqian (1899–1983),
running script
Five Pines Mountain, by Bada Shanren. Light color on paper, a master-
piece from his late period. Venerated by Dafengtang [Zhang Daqian][73]
TWO SEALS *Zhang Yuan* (square intaglio), *Daqian jushi* (square relief)

SIGNATURE ON PAINTING Painted by Bada Shanren
THREE SEALS *Lü* (rectangle relief; upside down), Slipper seal without
border, *Zhenshang* (square relief)

Colophon in standard script, by Ye Dehui (1864–1927)[74]

Long ago, when Zhang Pushan [Zhang Geng, 1685–1760]
composed the *Huazhenglu* [Records on painters of the Qing
dynasty] and placed Bada Shanren as the first entry, this anachro-
nism was meant to say that Bada was the best.[75] Zhang also
quoted the words of provincial graduate Qiu Yueju [active
1717–1734], who said, "As an artist, Shanren was most certainly
a master in the simple and abbreviated style of brushwork. Not
knowing that his refined, meticulous works were even more
marvelous and exceptional, people of the time did not often
collect them."[76] This painting is altogether a masterpiece of
Bada's refined, meticulous style. The texturing of the mountain-
sides and the tree branches were both done using "backward
strokes," which was probably because Bada had seen his whole
world turned upside down before his very eyes, and his grief and
bitterness were therefore ingrained in his calligraphy and paint-
ing.[77] But this is not something that ordinary histories of paint-
ing discuss. This scroll was avidly admired in the past by my
kind "elder brother," Surveillance Commissioner Jieqing, who
gallantly snatched it up for me when he saw it in the market-
place of Changsha.[78] Now, all of a sudden, more than twenty
years have passed, and who would have imagined that [in the
meantime] our own generation would personally witness the
[same kind of] painful national calamity that affected Shanren.
The surveillance commissioner retired to the seashore, closed his
door and studied painting, becoming, as the *Dongtian qinglu* says,
the foremost man of his generation.[79] Thus, I looked through my
luggage and found this painting to present to him, so that Bada
Shanren may be with a friend who truly appreciates him. May
the surveillance commissioner treasure it forever. Beginning of
summer in the *dingsi* year [May–June 1917], inscribed by your
old family friend, your foolish "younger brother" Ye Dehui,
while lodging in the Qingjiafang [quarter] of Suzhou

ONE SEAL *Ye Dehui* (square relief)

ELEVEN COLLECTOR SEALS

Li Puquan (19th–20th cen-
tury), two seals: *Puquan zhenmi*
(rectangle intaglio), *Baimen
Lishi zhencang* (square relief)[80]

Wang Wenxin (19th–20th
century), three seals: *Wang
Wenxin cang* (square relief),
Wenxin shending (square re-
lief), *Mengquan shuwu shuhua
shending yin* (square intaglio)[81]

Unidentified collectors
(19th–20th century), two
seals: *Sanyangzhai cang jinshi*

shuhua (rectangle relief),
Ding Bochuan jianshang zhang
(rectangle relief)

Zhang Daqian (1899–1983),
three seals: *Dafengtang Jianjiang
Kuncan Xuege Kugua moyuan*
(rectangle relief), *Zhang
Daqian changnian daji you rili*
(square intaglio), *Bieshi rongyi*
(square relief)

Wang Fangyu (1913–1997),
one seal: *Shijizhilu* (square
intaglio)

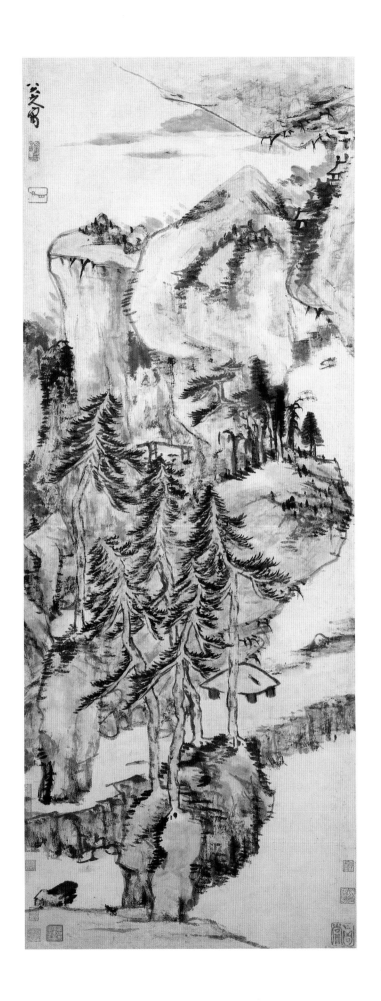

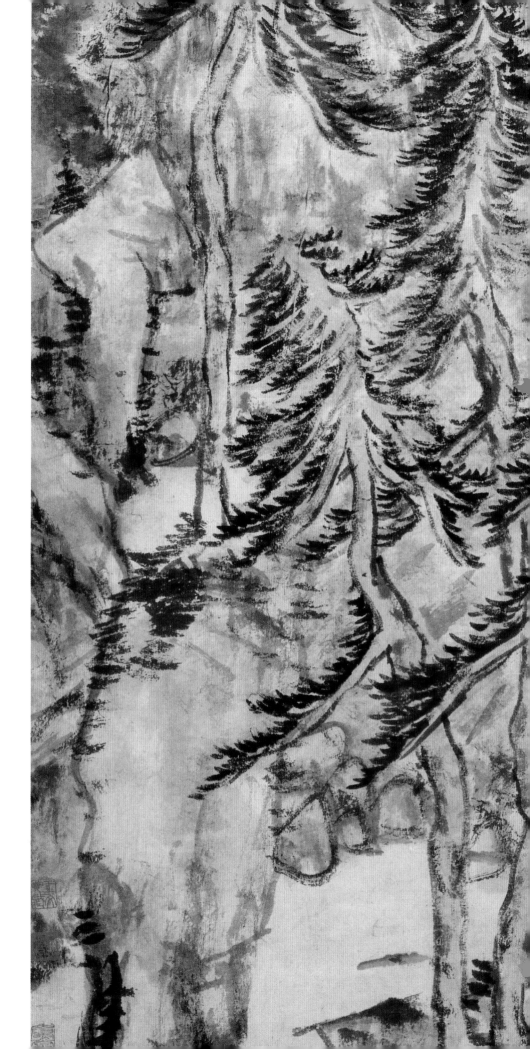

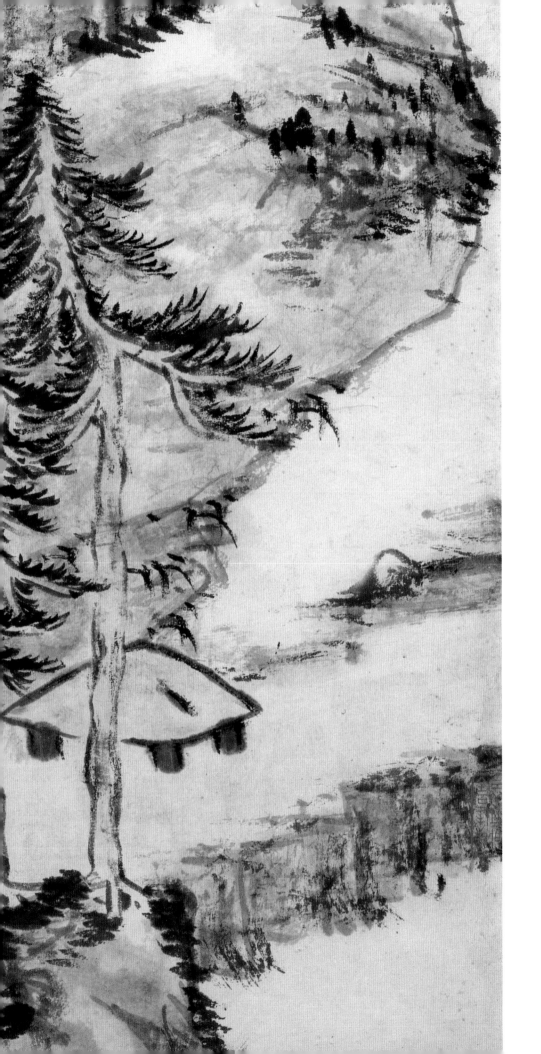

行草書白居易《北窗三友詩》 冊頁三開

25 Poem by Bai Juyi
in running-cursive script, 1700

Three album leaves; ink on paper
AVERAGE 31.4 x 23.5 cm
Purchase—Funds provided by the E. Rhodes and Leona B.
Carpenter Foundation
in honor of the 75th Anniversary of the Freer Gallery of Art

"Three Friends of the Northern Window," by Bai Juyi (772–846)[82]

Today, below the northern window,
I ask myself what I shall do?
Happily, I have three friends,
And these three friends, now, who are they?
When I stop the lute, I drink some wine,
When I stop the wine, I croon a poem;
These three friends lead each other ever on,
Round and round we go, for time without end.
Every strum contents my inmost heart,
Every chant brings joy to my four limbs,
And if I fear a gap appear between them,
I just use a little wine to patch it up.

Is a clod like me alone in liking this?
Many of the ancients did just the same!
There was Yuanming, who loved wine,
There was Qiqi, who loved the lute,
And there was Bolun, who loved poems,
These three men were all my teachers.
While one lacked even the meanest provision,

And the other was clad in rope-belted robes,
Singing to the strings, chanting in their cups,
Each of them knew well the road to happiness.

These three teachers departed long ago,
Their lofty manners cannot be followed;
But my three friends keep me company,
And not a day goes by we do not consort.
Left, I grasp the beaker of whitest jade,
Right, I stroke the stops of yellow gold,
And merry with wine, I do not fold the paper,
My brush just runs, jotting crazy words.
So who will take these words of mine,
And give my thanks to family and friends:
You may not believe that I am right,
But how can you believe that I am wrong![83]

POSTSCRIPT This poem by Bai Xiangshan [Bai Juyi] is marvelous in every [respect], but has never been painted.[84] *Gengchen* year, third lunar-month, twentieth day [May 8, 1700], recorded by Bada Shanren

THREE SEALS *Yaozhu* (rectangle relief), *Bada Shanren* (square intaglio), *Heyuan* (square relief)

ELEVEN COLLECTOR SEALS
Zhang Wei (19th–20th century?), two seals: *Gushi Zhangshi Jinghanxie yin* (rectangle intaglio), *Xiaobin miwan* (square relief)

Unidentified collector, three seals: *Chun* (rectangle relief), *Chun* (rectangle relief), *Chun* (rectangle relief)[85]

Zhang Daqian (1899–1983),

five seals: *Daqian jushi* (square relief), *Daqian xi* (square intaglio), *Dafengtang Jianjiang Kuncan Xuege Kugua moyuan* (rectangle relief), *Zhang Yuan* (square intaglio), *Sanqian daqian* (square relief)

Wang Fangyu (1913–1997), one seal: *Shijizhilu* (square intaglio)

七日北囱下自向夕雨為所坐得三友

三友之為佳惡正弦飲沔、罷敘

吟詩三友逼初引循環無已時一

諍怔出一詠暢四肢狂乜中有了

沿弦進之筌狗聲壮好支身矣

竹嗜病有困私情來有因鄙嗜病有

伯倫之人哉為之師 哉之儔石儕

武字無書而去法於頂韻詠安

去無所拘 三師去之去高風亭上

三友趣 甚孤一無了初隱 左鄰曰

玉后在拂去去廟與別而豈汪

走筆擦柱詞 涯於趙長詞家我柳

26 Cedar Tree, Day Lily, and Wagtails 1700

Hanging scroll; ink on paper
172.1 x 92.4 cm
Bequest from the collection of Wang Fangyu and Sum Wai,
donated in their memory by Mr. Shao F. Wang

OUTSIDE LABEL (NOT SHOWN) by Zhang Daqian (1899–1983),
running script
Venerated by Dafengtang [Zhang Daqian]: *Cedar Tree, Day Lily, and
Wagtails,* a genuine work painted by Bada Shanren during the *gengchen*
year [1700], in his seventy-fifth year [86]

SIGNATURE ON PAINTING *Gengchen* year [1700]. Bada Shanren
THREE SEALS *Bada Shanren* (square intaglio), *Heyuan* (square
relief), *Yaozhu* (rectangle relief)

EIGHT COLLECTOR SEALS
Zhang Daqian (1899–1983),
seven seals: *Dafengtang Jianjiang
Kuncan Xuege Kugua moyuan*
(rectangle relief), *Bufu guren
gao houren* (horizontal rectan-
gle relief), *Nanbei dongxi zhi
you xiangsui wu bieli* (square
relief), *Jichou yihou suo de*
(rectangle relief), *Qiutu bao
gurou qing* (horizontal rectangle
intaglio), *Diguo zhi fu* (square
relief), *Bieshi rongyi* (square
relief)

Wang Fangyu (1913–1997)
and Sum Wai (1918–1996),
one seal: *Fang Hui gongshang*
(square relief)

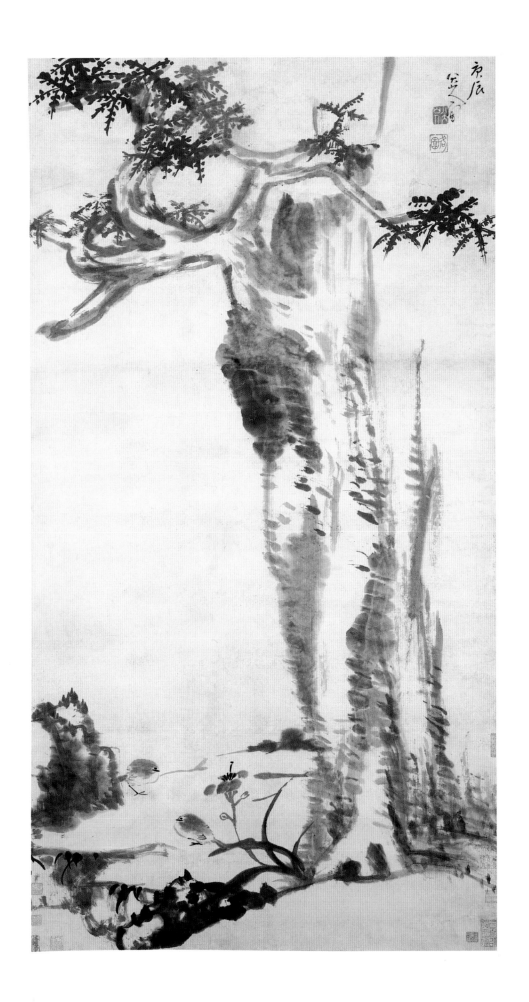

雙雁圖　軸
27 Two Geese ca. 1700

Hanging scroll; ink on paper
83.5 x 90.2 cm
Bequest from the collection of Wang Fangyu and Sum Wai,
donated in their memory by Mr. Shao F. Wang

OUTSIDE LABEL (NOT SHOWN) by Zhang Daqian (1899–1983),
running script
Geese and Reeds, a late painting by Bada Shanren, venerated
by Dafengtang [Zhang Daqian]. A genuine work of the divine
category; acquired in Hong Kong after 1949[87]

SIGNATURE ON PAINTING Drawn by Bada Shanren
THREE SEALS *Bada Shanren* (square intaglio), *Heyuan* (square
relief), *Yaozhu* (square intaglio)

EIGHT COLLECTOR SEALS
Zhang Daqian (1899–1983),
six seals: *Jichou yihou suo de*
(rectangle relief), *Qiutu bao
gurou qing* (horizontal rectangle
intaglio), *Nanbei dongxi zhi you
xiangsui wu bieli* (square relief),
Dafengtang (square relief),
Bieshi rongyi (square relief),
*Dafengtang Jianjiang Kuncan
Xuege Kugua moyuan* (rectangle
relief)

Unidentified collector, one
seal: *x x Zhangshi shoucang
shuhua yin* (square intaglio)

Wang Fangyu (1913–1997)
and Sum Wai (1918–1996),
one seal: *Fang Hui gongshang*
(square relief)

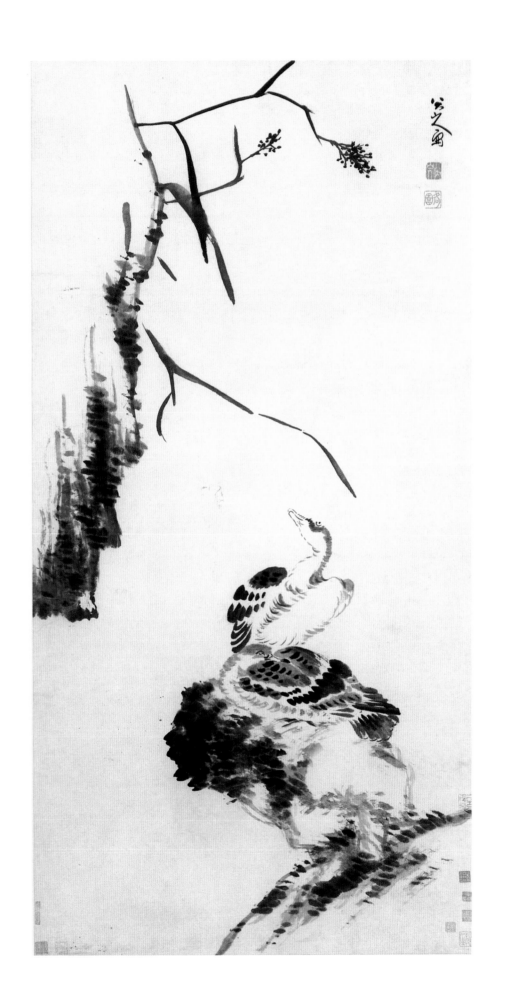

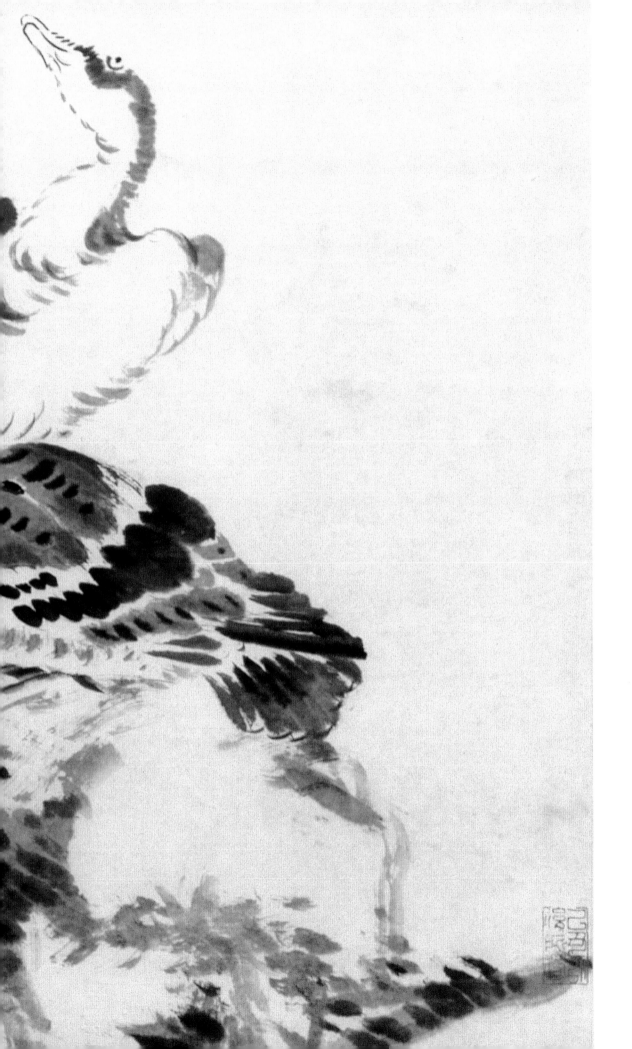

行草書唐詩　四條屏

28 Four Tang Poems

in running-cursive script, 1702-1703

Four hanging scrolls; ink on paper
AVERAGE 176.8 x 44.0 cm
Bequest from the collection of Wang Fangyu and Sum Wai,
donated in their memory by Mr. Shao F. Wang

SCROLL 1[88]

"Seeing Off a Buddhist Monk," by Liu Changqing
(ca. 710–after 787)[89]

The lonely cloud and the wilderness goose,
How should they abide in the world of man?
Do not buy land on Fertile Isles Mountain,
People of the time already know the place.[90]

SIGNATURE Bada Shanren

THREE SEALS *Zhenshang* (square relief), *Bada Shanren*
(square intaglio), *Heyuan* (square relief)

SCROLL 2

"Climbing Hooded Crane Tower," by Wang Zhihuan
(688–742)[91]

Daylight disappears along the hills,
The Yellow River flows into the sea.
If I wish to see a thousand *li* away,
I climb another story in this tower.

SIGNATURE Bada Shanren

THREE SEALS *Zhenshang* (square relief), *Bada Shanren*
(square intaglio), *Heyuan* (square relief)

THREE COLLECTOR SEALS
Zhang Daqian (1899–1983),
two seals: *Dafengtang* (square
relief), *Daqian haomeng*
(rectangle relief)

Wang Fangyu (1913–1997),
one seal: *Shijizhilu* (square
intaglio)

TWO COLLECTOR SEALS
Zhang Shanzi (1882–1940),
one seal: *Shanzi xinshang*
(square relief)

Zhang Daqian, one seal:
Daqian zhi bao (square relief)

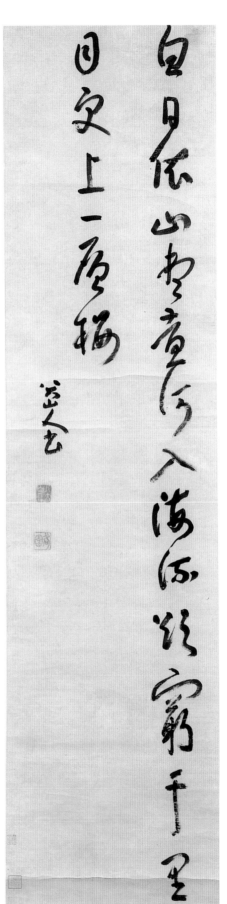

SCROLL 1

SCROLL 2

SCROLL 3

"On Passing the Exams," by Meng Jiao (751–814)[92]

The wretchedness of former days isn't worth a sigh,
For dawn is broad and vast and my thoughts are without
bounds.
The springtime wind is to my mind, my horse's hoofs run swift,
All in a day, I shall see every flower in Chang'an.

SIGNATURE Bada Shanren
THREE SEALS *Zhenshang* (square relief), *Bada Shanren* (square
intaglio), *Heyuan* (square relief)

SCROLL 4

"Congratulating Pei Tingyu on Passing the Exams in Shu,"
by Li Bo (active 870s–880s)[93]

At Tongliang, a thousand leagues, the clouds of dawn disperse,
For the list of the immortals has come from the Purple Palace.
In heaven above you already spread your newly feathered wings,
And shall not return to the dust and grime of the world before.[94]

SIGNATURE Bada Shanren
THREE SEALS *Zhenshang* (square relief), *Bada Shanren* (square
intaglio), *Heyuan* (square relief)

TWO COLLECTOR SEALS
Zhang Shanzi, one seal:
Shanzi shending (square relief)

Zhang Daqian, one seal:
Dafengtang changwu (rectangle
relief)

TWO COLLECTOR SEALS
Zhang Daqian, two seals:
Daqian youmu (oval relief),
Bufu guren gao houren
(horizontal-rectangle relief)

玉簪花圖並草書節錄姜夔《續書譜》　冊頁兩開軸

29 Jade Hairpin Blossoms and Excerpt from the "Sequel to the Treatise on Calligraphy"

in cursive script, ca. 1702

Two album leaves mounted as hanging scroll; ink on paper
PAINTING 29.9 x 34.3 cm; CALLIGRAPHY 30.0 x 34.3 cm
Bequest from the collection of Wang Fangyu and Sum Wai,
donated in their memory by Mr. Shao F. Wang

OUTSIDE LABEL (NOT SHOWN) by Zhang Daqian (1899–1983)
Jade Hairpin, by Bada Shanren. Presented by Dafengtang
[Zhang Daqian]
TWO SEALS *Zhang Yuan* (square intaglio), *Daqian jushi*
(square relief)

BOTTOM LEAF
Jade Hairpin Blossoms[95]

INSCRIPTION On a day in "little spring" [tenth lunar-month].
Heyuan[96]
ONE SEAL *Heyuan* (square relief)

TOP LEAF
Excerpt from the *Sequel to the Treatise on Calligraphy,* by Jiang Kui
(ca. 1155–ca. 1235)[97]

"Emperor Taizong of the Tang dynasty said, 'He lay Wang Meng
upon the paper and sat Xu Yan under his brush,' so as to ridicule
Xiao Ziyun," and such people. Written by Bada Shanren[98]

ONE SEAL *Heyuan* (square relief)

SEVEN COLLECTOR SEALS
Cao Buxun (unidentified),
one seal: *Yangyi Cao Buxun
jianding yin* (rectangle intaglio)

Zhang Daqian (1899–1983),
four seals: *Bieshi rongyi* (square
relief), *Daqian youmu* (oval
relief), *Nanbei dongxi zhi you
xiangsui wu bieli* (square
relief), *Dafengtang Jianjiang
Kuncan Xuege Kugua moyuan*
(rectangle relief)

Wang Fangyu (1913–1997),
one seal: *Fangyu* (rectangle
relief)

Sum Wai (1918–1996), one
seal: *Shen Hui* (square relief)

THREE COLLECTOR SEALS
Zhang Daqian, two seals:
*Dafengtang Jianjiang Kuncan
Xuege Kugua moyuan*
(rectangle relief), *Qiutu bao
gurou qing* (horizontal-rectangle
intaglio)

Sum Wai, one seal: *Shen Hui*
(square relief)

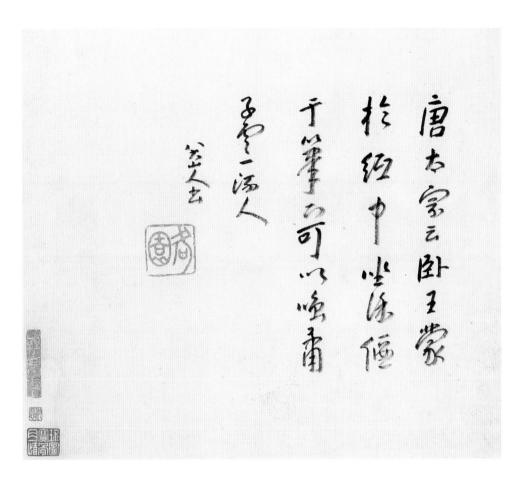

唐古家云卧王蒙
於绢中坐法僵
于筆可以喚雨
孟雪一滴人
笠人玄

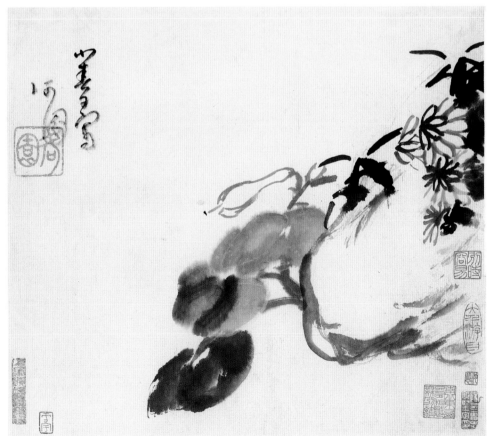

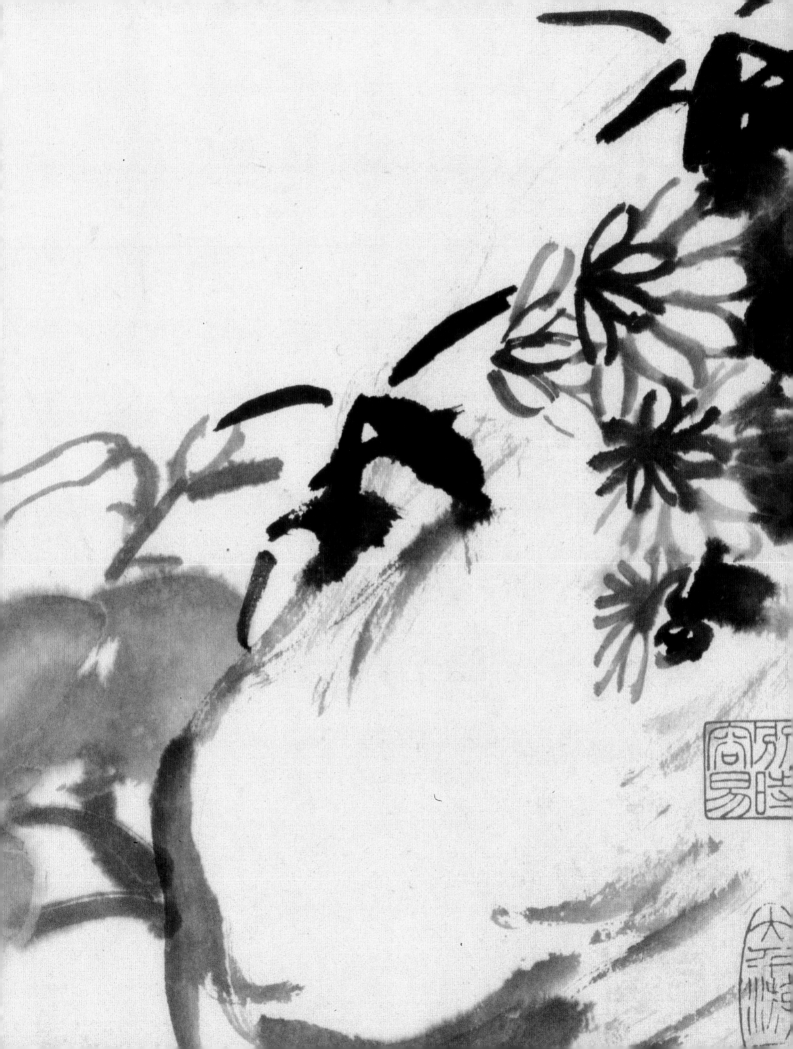

行書五言句 對聯

30 Couplet

in running script, ca. 1702

Pair of hanging scrolls; ink on paper
EACH 141 x 30.4 cm
Purchase—Funds provided by the E. Rhodes and Leona B.
Carpenter Foundation in honor of the 75th Anniversary of
the Freer Gallery of Art

Books and pictures are themselves an Immortals' Chamber,
I view the Southern Capital as the Dipper and Mount Tai.[99]

SIGNATURE Bada Shanren
THREE SEALS *Yaozhu* (square intaglio), *Bada Shanren*
(square intaglio), *Heyuan* (square relief)

SIX COLLECTOR SEALS
Unidentified collectors, five
seals: *Jingcaoshuwu* (oval relief;
right scroll); *Ci Quan tangcang*
(square intaglio; right scroll),
Yingquan zhencang (square
relief; left scroll); *Guoshi
zhencang* (rectangle relief;
right scroll), *Haoliang Guoshi
Baiyun-shanguan jiancang*
(square relief; left scroll)

Wang Fangyu (1913–1997),
one seal: *Shijizhilu* (square
intaglio; left scroll)

行楷臨王寵書閣防《夕次鹿門山作詩》 冊頁
31 Poem by Yan Fang
in running-standard script, ca. 1702

Album leaf; ink on paper
30.0 x 34.3 cm
Purchase—Funds provided by the E. Rhodes and Leona B.
Carpenter Foundationin honor of the 75th Anniversary of
the Freer Gallery of Art

"Composed on Stopping for the Evening at Deer Gate
Mountain," by Yan Fang (early to mid-8th century)[100]

The place Pang Gong went to seek reclusion,
Is hard to find as footprints on the waves.
My drifting boat arrives before nightfall,
I grip my walking-stick and take a stroll,
Between double cliffs, the Deer Gate opens,
A hundred winding valleys heaped with gems.
Water spouts and spurts above the torrent,
Mountains pound and boom within the surge,
More lofty they stand than the Jiao Plateau,
The Lüliang Gorge was never quite so rough.
I've been traveling since the middle of spring,
Now summer birds chatter tenderly and low,
On sweet grasses, the color has grown late,
Still the wayfarer's heart does not return.
Wandering abroad, I do not flee the world,
But seek the Dao to save my youthful face;
How can one follow cleverness and cunning,
Grab and contend for an awl's-tip of space?[101]

POSTSCRIPT Copying *[lin]* the calligraphy of Yayi Shanren
[Wang Chong, 1494–1533]. Bada Shanren[102]
THREE SEALS *Shide* (rectangle relief), *Bada Shanren*
(square intaglio), *Heyuan* (square relief)

THREE COLLECTOR SEALS
Zhang Daqian (1899–1983),
one seal: *Dafengtang* (square
relief)

Zhu Shengzhai (ca. 1902–
1970), one seal: *Zhu Shengzhai
shuhua ji* (rectangle relief)

Wang Fangyu (1913–1997),
one seal: *Shijizhilu* (square
intaglio)

龐公嘉遁所浪迹難追攀浮舟
暝怡至柂枝卿自前渡奪開鹿門百
谷集珠灣噴薄滿上水春容橐橐
山樵原乏險峻梁輕未感難我行自
仲春夏鳥語稻寧畫料色之晚窮心
苔來還遠游州石地访迄夏童韻
安能徇揆巧争奪錐刀間
昭邪豆山人書　笠人

32 Copy of Two Letters by Huang Daozhou

in running-cursive script, ca. 1702-1705

Two double album leaves; ink on paper
25.1 x 32.2 cm; 25.1 x 32.5 cm
Purchase—Funds provided by the E. Rhodes and Leona B. Carpenter Foundation
in honor of the 75th Anniversary of the Freer Gallery of Art

LEAF 1

Excerpt from a letter by Huang Daozhou (1585–1646)[103]

My small-cursive script being sparse and spare, I follow conven-
tion and make outline copies, so my writing is unable to achieve
the standard. If the scribes in the marketplace were to see it, they
would simply make fun of me. Having received your order to
write something for you [in this style], when I have one or two
days' free time, I shall come to get my "flock of geese." [Last sen-
tence unintelligible due to losses in original paper and text.]
Daozhou bows his head to you.[104]

POSTSCRIPT Copying [lin] the calligraphy of Master Shizhai
[Huang Daozhou]. Bada Shanren
ONE SEAL *Shide* (rectangle relief)

LEAF 2

Excerpt from a letter by Huang Daozhou

I am returning the *Wenxian tongkao* [General history of institu-
tions and critical examination of documents and studies], but the
Illustrated Scripture seems fine. Since my bookshelf cannot bear
such large volumes, I am sending them to you, so you can have a
look to see if you want them. I have also written two poems,
which I am sending along. Daozhou bows his head to you.[105]

POSTSCRIPT Calligraphy of Master Shizhai [Huang Daozhou].
Bada Shanren
ONE SEAL *Shide* (rectangle relief)

TWO COLLECTOR SEALS
Wang Fangyu (1913–1997),
one seal: *Fangyu* (linked-square
relief)

Sum Wai (1918–1996), one
seal: *Shen Hui* (square relief)

THREE COLLECTOR SEALS
Zhang Daqian (1899–1983),
one seal: *Dafengtang zhenwan*
(horizontal rectangle relief)

Wang Fangyu, one seal: *Wang
Fangyu* (square relief)

Sum Wai, one seal: *Shen Hui*
(square relief)

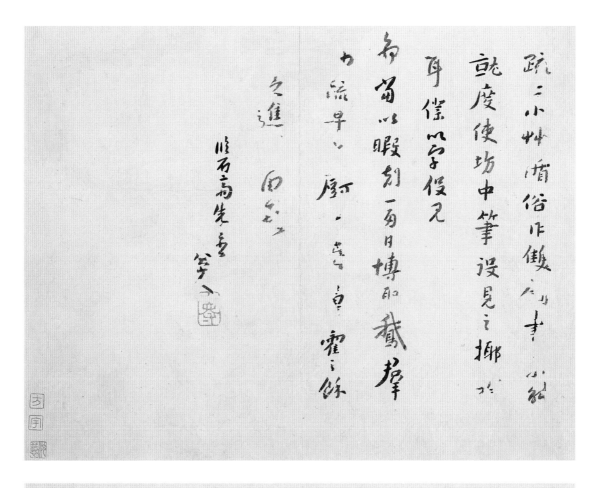

疏二小妹循俗作數人書小紙
虽度使坊中筆設見之揶揄
耳偿以字俊之
多留以暇刻一兩日博雅藏擘
力疏草之廚一饱自足霍之餘
久進　白云
　順石翁先生　笠人〔印〕

文齋週政遠去小經圖以自己
架上無幾裁此为編具以分
先生如蒙寄則孔說三字詩三房寫
上了南春
　石嘉先生書　笠人〔印〕

傲倪瓚山水圖　冊頁

33 Landscape after Ni Zan ca. 1703-1705

Double album leaf; ink on paper
25.1 x 32.3 cm
Bequest from the collection of Wang Fangyu and Sum Wai,
donated in their memory by Mr. Shao F. Wang

INSCRIPTION Ni Yu [Ni Zan, 1306–1374] painted like a celestial
steed bounding the void or white clouds emerging from a ridge,
showing not a speck of mundane vulgarity. I drew this [painting]
in my spare time.[106]

NO SIGNATURE
ONE SEAL *Shide* (rectangle relief)

TWO COLLECTOR SEALS
Wang Fangyu (1913–1997),
one seal: *Wang Fangyu*
(linked-square relief)

Sum Wai (1918–1996), one
seal: *Shen Hui* (square relief)

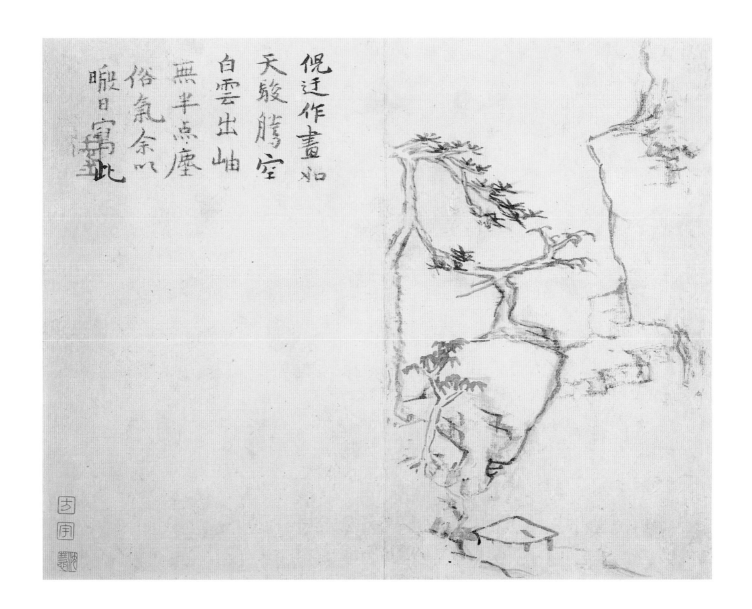

倪迂作畫如
天駿騰空
白雲出岫
無半點塵
俗氣余以
暇日寫此

NOTES TO CATALOGUE

ABBREVIATION

WSKQS for *Wenyuange Siku quanshu dianziban* 文淵閣四庫全書電子版 (The Electronic Version of *Siku quanshu* [Wenyuange edition], professional version 1.0). 163 discs. Hong Kong: Digital Heritage Publishing, Chinese University Press, 1999.

ENTRY 1. *Lotus*

1 Dated by Wang Fangyu to ca. 1665, this album is among the handful of surviving works done by Bada Shanren while he was still a Buddhist monk. For a discussion of this album, see Wang Fangyu and Richard M. Barnhart, *Master of the Lotus Garden: The Life and Art of Bada Shanren (1626–1705)* (New Haven: Yale University Art Gallery and Yale University Press, 1990), 83–84 (cat. no. 1, fig. 45).

On the names that Bada used as a monk, see Rao Zongyi, "Chanseng Chuanqi qianhou qi minghao zhi jieshuo" (Interpretations of various pseudonyms of the Chan monk Chuanqi), in *Duoyun* (Art Clouds Quarterly) 15 (October 1987): 150–53, reprinted in Wang Zhaowen, ed., *Bada Shanren quanji* (Complete works of Bada Shanren), 5 vols. (Nanchang: Jiangxi meishu chubanshe, 2000), 5:1041–45.

ENTRY 2. *Scripture of the Inner Radiances of the Yellow Court*

2 Dating to the mid-fourth century of the common era, the *Huangtingjing* (Scripture of the Yellow Court) is one of the most influential and popular texts belonging to the Shangqing (Highest Purity) School of medieval Daoism. The text exists in two poetic versions: a single 99-line version, known as the outer scripture, and a more complex 435-line version divided into thirty-six stanzas of uneven length, known as the inner scripture, which is the text that Bada Shanren recorded in this album. The contemporary calligrapher Wang Xizhi (ca. 303–ca. 361 C.E.), who was himself a practicing Daoist, is said to have transcribed both versions of the text in standard script, examples of which still exist in the form of rubbings. Each version has a long and independent history in the calligraphic tradition, and it was probably this history that prompted Bada to create his own transcription, and not the philosophical or religious content of the text. For an overview of the early calligraphic tradition surrounding the *Scripture,* see Lothar Ledderose, *Mi Fu and the Classical Tradition of Chinese Calligraphy* (Princeton: Princeton University Press, 1979), 70–71.

For a brief discussion of this album, see Wang Fangyu, *Bada Shanren fashu ji* (Bada Shanren's calligraphy in the collection of Wang Fangyu), in *Mingjia hanmo: Zhongguo mingjia fashu quanji* (Han Mo, Calligraphy of Famous Masters), ed. Hui Lai Ping (Xu Liping), 2 vols. (Hong Kong: Han Mo Xuan Publishing, 1998), 1:6–17 (leaves published out of order). Apart from the inner version of the *Scripture* seen in this album, Bada Shanren also transcribed the outer version on at least one occasion; see Wang Fangyu, *Bada Shanren fashu ji,* 1:18–33 (album of thirteen leaves, dated to ca. 1684).

3 Bada Shanren wrote the text of the *Scripture* as a continuous whole and did not indicate any breaks between stanzas. To the casual viewer, this may obscure the fact that the current album is incomplete and contains a little less than two-fifths of the total text; the whereabouts of the missing leaves is unknown. The current album contains four discrete sections of the text: Leaves 1–2 run from the beginning of stanza 1 to the beginning of stanza 4; leaves 3–6 run from the end of stanza 13 to the beginning of stanza 18; leaves 7–8, though currently mounted in reverse order, run from the end of stanza 26 to the beginning of stanza 29; and leaves 9–11 run from the middle of stanza 35 to the end of stanza 36.

Bada Shanren's transcription differs in many significant instances from both the standard published text and the rubbing cited below. His immediate source therefore remains unidentified. For an annotated text of the inner version of the *Scripture,* see Zhang Junfang (active 1008–1029), comp., *Yunji qiqian* (Seven lots from the book bag of the clouds), 11:11a–12:31b, in *WSKQS,* disc 116. For a rubbing of the complete text, see Bi Yuan (1730–1797), comp., *Jingxuntang fashu* (Exemplary calligraphy in the Jingxuntang), 12 vols. (China: privately published, 1789), vol. 1.

Two recent works provide a general introduction to the *Huangtingjing* in English: Isabelle Robinet, "The Book of the Yellow Court," in *Taoist Meditation: The Mao-shan Tradition of Great Purity,* trans. Julian F. Pas and Norman J. Girardot (Albany: State University of New York Press, 1993), 55–96; and Paul W. Kroll, "Body Gods and Inner Vision: The Scripture of the Yellow Court," in *Religions of China in Practice,* ed. Donald S. Lopez Jr. (Princeton: Princeton University Press, 1996), 149–55 (with translations of the first four stanzas of the inner version).

4 Dated August 11, 1684, this colophon bears the artist's earliest recorded signature in which he uses the sobriquet Bada Shanren, the name by which he is best known to history. While Bada asserts in the colophon that he emulated the calligraphy of the "Two Wangs," which is to say Wang Xizhi (ca. 303–ca. 361 C.E.) and his son Wang Xianzhi (344–388 C.E.), he actually chose to employ his own style of running-standard script, rather than the pure standard script that appears in rubbings of the text attributed to the elder Wang.

Bada Shanren also quotes a conversation preserved in the biography of Ruan Zhan (ca. 279–ca. 308 C.E.), courtesy-name Qianli, who was from the commandery of Chenliu (Henan Province). The conversation occurred when Ruan was a young man and had gone for an interview with the powerful minister Wang Rong (234–305 C.E.), who was so impressed with the subtle ambiguity of his response to the question recorded here that he appointed Ruan to his staff. See Fang Xuanling (578–648) et al., comps., *Jin shu* (History of the Jin dynasty, 265–420 C.E.) (Beijing: Zhonghua shuju, 1974), 49:1363.

Bada Shanren's comment following this quotation does not have any obvious point of reference. A possible answer may lie in Bada's final statement that this was the second time he had written a colophon for the album. This suggests that the current text may be a sort of postscript to the previous colophon, which is now lost along with the missing two-fifths of the scripture text. In any case, given Ruan Zhan's life dates,

there is no known historical connection either between Ruan Zhan and the *Scripture of the Yellow Court,* or Ruan Zhan and the Two Wangs.

ENTRY 3. *Lilac Flowers* and *Calligraphy*

5 This striking seal is engraved with an archaic form of the character for "mountain." For a second work bearing an impression of this seal, see Wang Zhaowen, ed., *Bada Shanren quanji,* 2:714 (cat. no. 14, leaf 6; album dated 1689).

6 Aside from some of his late landscape paintings, this small album leaf is one of few extant works where Bada Shanren uses color. On the accompanying leaf of calligraphy, Bada states that he was following the style of Lu Zhi (1496–1576), whose sobriquet *(hao)* was Baoshan. Lu Zhi is primarily known as a landscape painter but was also renowned for his sensitive flower studies, which generally bear little resemblance in style or execution to the current leaf. As is often the case with Bada Shanren, the precise basis for his assertion of stylistic affinity with a particular artist remains elusive.

This painting once belonged to a larger album, only one other leaf from which is known to exist (showing a quince). For discussions of the current leaf and accompanying leaf of calligraphy, see Wang and Barnhart, *Master of the Lotus Garden,* 110–11 (cat. no. 11, fig. 55); and Wang Fangyu, *Bada Shanren fashu ji,* 1:36–37. For the quince painting, which is in the collection of the Princeton Art Museum, see discussion in Wang and Barnhart, *Master of the Lotus Garden,* 111–12 (cat. no. 12, fig. 56). For another Bada Shanren painting of lilac flowers (done in pure ink), see Wang Zhaowen, ed., *Bada Shanren quanji,* 1:67 (cat. no. 15, leaf 8; album dated 1684). More recently, the two leaves seen here previously belonged to a mixed album of ten leaves assembled from disparate sources, six of painting and four of calligraphy. five leaves, two of painting and three of calligraphy, are included elsewhere in this volume (cat. entries 6, 7, 32, and 33). Two other leaves (respectively showing a cat and a chicken) are published in Wang and Barnhart, *Master of the Lotus Garden,* 108–9 (cat. no. 10, fig. 54).

ENTRY 4. *Bamboo, Rocks, and Small Birds*

7 For a discussion of this painting, see Wang and Barnhart, *Master of the Lotus Garden,* 129–31 (cat. no. 23, fig. 68). It is difficult to nail down Bada Shanren's precise usage of the word *sheshi,* which appears both as part of his signature and as a seal on numerous works produced between 1690 and 1694 (see also cat. entry 5). Over the past fifteen years, the term has received a number of different translations into English. For example, see Wen C. Fong, "Stages in the Life and Art of Chu Ta (a.d. 1626–1705)," *Archives of Asian Art* 40 (1987): 15–16; Wang and Barnhart, *Master of the Lotus Garden,* 112 and 149; and Hui-shu Lee, "Bada Shanren's Bird-and-Fish Painting and the Art of Transformation," *Archives of Asian Art* 44 (1991): 8–9. For the purposes of this book, the authors have chosen to follow the translation established in *Master of the Lotus Garden:* "involved in affairs."

8 As stated in his colophon, the modern painter and collector Zhang Daqian believed the current work to have been much larger originally than when he acquired it. He therefore added wide strips of paper to both the right and left of the painting, and "restored" a corner of the rock and foreground on the right side with a few strokes. Zhang then inscribed his colophon down both sections of new paper, framing the original painting with his text. Since Zhang himself produced quite a number of copies and original works in the style of Bada Shanren, the current scroll showing the brushwork of both men side by side is an invaluable resource for understanding the difference between their respective techniques.

ENTRY 5. *Falling Flower, Buddha's Hand Citron, Hibiscus,* and *Lotus Pod*

9 For discussions of this leaf, see Shen C. Y. Fu, *Traces of the Brush: Studies in Chinese Calligraphy* (New Haven: Yale University Art Gallery, 1977), 188 (cat. no. 71), 198, and 280; and Wang Fangyu, *Bada Shanren fashu ji,* 1:39.

The four leaves presented here originally come from an album of sixteen leaves. Eight leaves, including these four now in the Freer collection, are published in Zhang Daqian, *Dafengtang mingji* (Famous works in the Dafengtang collection of Zhang Daqian) (Kyoto: Benridō, 1955–56), vol. 3, plates 13–16. Eight other leaves, now in the Princeton University Art Museum, are published along with a discussion of the complete album in Wang and Barnhart, *Master of the Lotus Garden,* 131–35 (cat. nos. 24–26; figs. 69–71). The sixteen leaves are also published in two sections in Wang Zhaowen, ed., *Bada Shanren quanji,* 4:744–47 (cat. no. 35.1–8) and 4:766–69 (cat. no. 45.1–8).

ENTRY 6. *Excerpt from the "Preface to the Sacred Teachings"*

10 This text is an excerpt from the second half of the "Sanzang shengjiao xu" (Preface to the sacred teachings [translated] by Tripitaka), composed in 648 for the Buddhist monk and translator Xuanzang (602–664), also known as Sanzang (Tripitaka), by Emperor Taizong of the Tang dynasty (reigned 626–49). Xuanzang had recently brought a large group of Buddhist texts from India to China and had embarked on a massive translation project under the patronage of Emperor Taizong. After his succession to the throne in the following year, Emperor Gaozong (reigned 649–83) continued to support Xuanzang. In 652, the monk requested that a pagoda be built to house the texts and images he had brought back, and the emperor complied by ordering construction of the Wild Goose Pagoda (Yanta) at the Temple of Compassionate Grace (Ciensi), located in the imperial capital. On the south side of the pagoda, a stone monument was erected in 654 bearing Emperor Taizong's preface written in standard script by the eminent court calligrapher and imperial advisor Chu Suiliang (596–658). Through dissemination of rubbings made from this stone, which still stands at the pagoda, Chu's transcription of Emperor Taizong's preface became part of the mainstream calligraphic tradition and was frequently emulated over

the centuries as an orthodox model of standard script. Although Bada asserts that he was copying *(lin)* the style of Chu Suiliang in writing this album leaf, his use of running-standard script, instead of the traditional form of standard script established by Chu, adds a measure of idiosyncrasy to his rendition of the text.

Bada's usage of the word "copying" *(lin)* is problematic and clearly means something other than the usual definition. For other examples and further discussion, see catalogue entries 20, 31, and 32; and notes 67, 97, 102, and 103. For a rubbing of the stele bearing Chu Suiliang's transcription of Emperor Taizong's preface, see *Yanta "Shengjiao xu" bei* (Stele of the "Preface to the Sacred Teachings" at the Wild Goose Pagoda), in *Shoseki meihin sōkan* (Compendium of famous works of calligraphy), vol. 10 (Tokyo: Nigensha, 1969–81). For the standard printed text of Emperor Taizong's preface, see Huili (615–?) and Yancong (active mid- to late 7th century), *Datang da Ci'ensi Sanzang fashi zhuan* (Biography of Tripitaka, the Teacher of the Law, of the Great Temple of Compassionate Grace of the Great Tang Dynasty), in *Taishō shinshū Daizō-kyō* (The Taishō edition of the Buddhist Canon) (Tokyo: Taishō shinshū Daizō-kyō kanko kei, 1962), 50:256.

For discussions of this leaf, see Shen C. Y. Fu, *Traces of the Brush*, 160 (cat. no. 70), 188, and 280; Wang and Barnhart, *Master of the Lotus Garden*, 144–46 (cat. no. 32, fig. 80, leaf b); and Wang Fangyu, *Bada Shanren fashu ji,* 1:40. Bada Shanren evidently felt some attraction for the text of this preface since he wrote it out on at least two other occasions: an album leaf, dated 1692, from a ten-leaf album, containing a different excerpt starting from the beginning of the preface, published in *Kokka* 724 (July 1952): 230; and a pair of album leaves, dated 1693, from an album of sixteen leaves in the Shanghai Museum, containing an excerpt that starts at the same place, but is twenty-two characters longer than the Freer text, in *Zhongguo gudai shuhua jiandingzu* (Group for the authentication of ancient works of Chinese painting and calligraphy), comp., *Zhongguo gudai shuhua tumu* (Illustrated catalogue of selected works of ancient Chinese painting and calligraphy), vol. 4 (Beijing: Wenwu chubanshe, 1990), 338 (Hu 1:2724, leaves 10–11); also published in Conglin, *Bada Shanren hanmo ji* (Collection of ink works by Bada Shanren) (Beijing: Zhishi chubanshe, 1990), 50–51. For a brief discussion of these various album leaves, see Wang Fangyu, "Bada Shanren de shufa" (The calligraphy of Bada Shanren), in *Bada Shanren lunji* (An Anthology of Essays on Pa-ta-shan-jen), ed. Wang Fangyu, 2 vols. (Taipei: Guoli Bianyiguan Zhonghua congshu bianshen weiyuanhui, 1984), 1:394.

This calligraphy leaf most recently belonged to a mixed album of ten leaves assembled from disparate sources, six of painting and four of calligraphy. Six leaves, three of painting and three of calligraphy, are included elsewhere in this volume (cat. entries 3, 7, 32, and 33). One leaf is unpublished and two other leaves (respectively showing a cat and a chicken) are published in Wang and Barnhart, *Master of the Lotus Garden,* 108–9 (cat. no. 10, fig. 54).

11 According to Wang Fangyu, this slipper seal is different from Bada Shanren's usual slipper seal and only appears on works dating from 1692

to 1693, a fact that aids in the dating of this leaf. The same seal also appears on the accompanying landscape painting (see cat. entry 7), confirming that these two thematically unrelated works were probably created around the same time and for the same album. See Wang Fangyu, *Bada Shanren fashu ji,* 1:40.

ENTRY 7. *Landscape after Dong Yuan*

12 Beiyuan (North Park) is an abbreviation of an official title once held by the mid-tenth-century landscape painter Dong Yuan (died 962). Dong served as Administrator of the North (or Rear) Park under the rulers of the Southern Tang kingdom (937–975), which had its capital on the Yangzi River at the modern city of Nanjing, Jiangsu Province. He is considered the founder of the Southern School of landscape painting, which Bada Shanren generally followed. For other works by Bada in the style of Dong Yuan, see catalogue entries 8 (leaves 2–5) and 12 (leaf 1) in this volume; Wang and Barnhart, *Master of the Lotus Garden,* 164–66 (cat. no. 43, fig. 96; hanging scroll, ca. 1696); and Wang Zhaowen, ed., *Bada Shanren quanji,* 2:457 (cat. no. 118; hanging scroll, undated), 3:560 (cat. no. 173; hanging scroll, undated), and 4:836 (cat. no. 84; leaf 7, undated).

This leaf most recently comes from a mixed album of ten leaves assembled from disparate sources, six of painting and four of calligraphy. Six leaves, two of painting and four of calligraphy, are included elsewhere in this volume (cat. entries 3, 6, 32, and 33). One leaf is unpublished and two other leaves (respectively showing a cat and a chicken) are published in Wang and Barnhart, *Master of the Lotus Garden,* 108–9 (cat. no. 10, fig. 54).

13 See note 11.

ENTRY 8. *Combined Album of Painting and Calligraphy: "Grieving for a Fallen Nation"*

14 Naitō Torajirō (1866–1934), also known as Naitō Konan and Naitō Tora, was an important Japanese scholar of Chinese history and a connoisseur of Chinese painting and rare books. Naitō probably inscribed this outside label around the same time that he wrote his colophon for the album in 1930 (see leaves 13–15). On the life and career of Naitō Torajirō, see *Kokushi daijiten* (Encyclopedia of Japanese history) (Tokyo: Yoshikawa kobunsha, 1978–89), 10:516–17; and *Kodansha Encyclopedia of Japan* (Tokyo and New York: Kodansha Ltd., 1983), 5:311. See also note 35 below.

15 Shanqi, Prince Su (1866–1922), who sometimes used the sobriquet Ouyuan, was a high-ranking member of the Qing imperial house and last holder of the hereditary title Prince Su, which he received in 1898. Shanqi rose through a series of high government positions during the last decade of the Qing dynasty (1644–1911), and after the founding of the Republic of China in February 1912, retired to Tianjin (Hebei Province) and then to Lüshun (Liaoning Province). See Chen Yutang,

ed., *Zhongguo jinxiandai renwu minghao dacidian* (Dictionary of given names and sobriquets for figures from recent and contemporary China) (Hangzhou: Zhejiang guji chubanshe, 1993), 899 (which also gives an alternative death year of 1927); and Arthur W. Hummel, ed., *Eminent Chinese of the Ch'ing Period,* 2 vols. (Washington, D.C.: United States Government Printing Office, 1943), 1:281 (which gives Shanqi's life dates as: 1863–1921).

Shanqi evidently wrote the frontispiece to this album at the request of a Mister Wenqing (unidentified), who is also mentioned as the album's owner by Wu Changshuo (1844–1927) in his 1907 colophon (see leaves 11–12). Shanqi affixed three seals on the frontispiece, one of which is carved with the cyclical date *dingsi* (1917), presumably the year he wrote the frontispiece for Wenqing. As a fellow imperial survivor of a fallen dynasty, Shanqi must have identified closely with the fate of Bada Shanren, and seeing this album brought the sorrows of his own times to mind. The phrase he chose for the frontispiece, "grieving for a fallen nation," equally applied to the lives of both men and was intended to set the correct political and psychological tone for viewing works by Bada.

16 For a discussion of the four paintings in this album, see page 7 and Wang and Barnhart, *Master of the Lotus Garden,* 162–64 (cat. no. 42, fig. 95).

17 Little has been published about the important nineteenth-century collector Dai Zhi. He was from Zhenjiang (Jiangsu Province), and was active as a collector during the Daoguang reign period (1821–50). Seven of Dai's seals appear in this album: one on each painting by Bada Shanren (four seals), and one with each calligraphy leaf or set of calligraphy leaves by Bada (three seals).

18 As many commentators have noted, Bada Shanren's poetry is often quite difficult to understand. A highly educated man, he was apparently fond of word play and seems to have had an active sense of humor. Ambiguity is a constant tool and, while Bada's language is generally simple on the surface, he frequently employed colloquialisms, puns, odd syntax, rare locutions, private references, and a complex array of topical allusions and associations that sometimes render the meaning of a poem almost unintelligible. The four poems on this leaf are a good example of the problem. For previous translations, see Wang and Barnhart, *Master of the Lotus Garden,* 226–27 (cat. no. 42). For transcriptions and other brief comments, see also Wang Fangyu, *Bada shanren fashu ji,* 1:47.

Poem 1, lines 1–2: At the end of line 1, Bada used the unusual ancient place name, Youquan (from, or by, fist), which corresponds to three locations in modern Zhejiang Province: the prefecture of Jiaxing; a mountain near Yuhang (west of Hangzhou); and a village at the foot of the same mountain where a kind of writing paper was made. While some, or all, of these associations may play a role in this line, the strange literal meaning of the place name was probably the primary attraction for Bada. He also used the place name Youquan in a different poem, where it apparently refers to writing paper; see Wang Zhaowen, ed., *Bada Shanren quanji,* 2:347 (cat. no. 88, leaf 2; album dated 1694) and 2:395 (cat. no. 94, leaf 2; album undated).

In line 2, the word *hong* (flood; broad, vast) may stand for Hongzhou, an alternative historical name for Nanchang, the city where Bada Shanren lived after leaving the Buddhist clergy.

19 Poem 2, lines 3–4: Xiejie (literally: slanting stairs) is an old name for Shixing Prefecture in northern Guangzhou Province. The prefecture bore this name from the third to the early sixth century C.E., when it was briefly changed to Zhengjie (literally: upright, or main, stairs), and finally Shixing. In the case of this poem, Bada Shanren appears to be less concerned with an actual place, than with playing on the various meanings of the word *xie* (slanting, leaning, tilted, oblique, sideways), which has a somewhat negative connotation, and the word *zheng* (upright, true, proper, correct; principal, chief), which has strongly positive connotations. Each of these is joined as an adjective to the base word *jie,* which can mean not only a physical staircase, but also the steps or official ranks of government.

Line 4 ends with the term *ganyu* (stirred, or moved, by experience), which is the title of a famous series of eighteen poems by the poet Chen Zi'ang (661–702), who served at the court of the usurper Empress Wu Zetian (reigned 690–705). Full of Daoist references, the poems in this series were also interpreted to have hidden political connotations critical of the goings-on at court. How this reference might relate to either the place names discussed above or Bada's life and times remains unclear.

20 Poem 3, lines 1–4: This poem may allude to the poet and prince Cao Zhi (192–232 C.E.), who composed a famous work called the "Luoshen fu" (Rhapsody, or Prose-poem, on the Goddess of the Luo River), in which he describes leaving the capital at Luoyang (Henan Province) for his fiefdom located far east of the city in Shandong Province. On the way, he encountered the Goddess of the Luo River, who invited him to join her in her watery domain. Forced by circumstance to continue on his way, Cao cast his girdle-jade (a jade ornament suspended on a cord from the belt or girdle) into the river as a pledge of his loyal affection. See David R. Knechtges, trans., *Wen Xuan: or Selections of Refined Literature,* comp. Xiao Tong (501–531), vol. 3 (Princeton: Princeton University Press, 1996), 355–65, esp. 361 (line 80).

21 Poem 4, lines 1–2: These two lines are built around references to the famous author, alchemist, and Daoist master Tao Hongjing (456–536 C.E.). As quoted by Bada, some biographies of Tao mention that he had a "slender form" *(xixing)* and that he "hid his shadow" *(biying)* while serving as a young man at court, which is to say that he did not participate in the social or political life of the capital. Tao did, however, establish close relations during these years with a number of prominent courtiers and imperial family members, such as Xiao Yan (463–549), future founder of the Liang dynasty (502–557). On retiring from government in 492 C.E., Tao moved to the sacred Daoist mountain Maoshan (Mount Mao), located south of the imperial capital Jiankang (modern Nanjing, Jiangsu Province), where he spent the next forty-four years pursuing the life of a recluse. For a relevant biography of Tao Hongjing, see Yao Cha

(533–606) and Yao Silian (died 637), comps., *Liang shu* (History of the Liang dynasty, 502–557) (Beijing: Zhonghua shuju, 1973), 51:742–43.

After his ascension to the throne, Xiao Yan, better known as Emperor Wu of the Liang dynasty (reigned 502–49), continued to seek advice from Tao Hongjing and often invited him to return to court. On one such occasion, he asked Tao what it was he found so appealing in the mountains, and Tao composed the following famous quatrain in reply: "What is there in the mountains? / On the peaks, there are white clouds. / One can only enjoy them for oneself, / I cannot take them to send to You." (N.B., Many sources name the emperor in question as Emperor Gao of the Qi dynasty, Xiao Daocheng [reigned 479–82 C.E.], under whom Tao Hongjing first took government service.) "White clouds" are a frequent trope in Chinese literature, symbolizing the realms of paradise that lie beyond the mortal world, as well as the spiritual transcendence and life of freedom enjoyed by the recluse. Bada may have had Tao's poem in mind when he wrote line 2. For Tao Hongjing's poem, see Li Fang (925–996) et al., comps., *Taiping guangji* (Miscellaneous records of the Taiping reign period, 976–83), 202:9b–10a, in *WSKQS*, disc 114.

Lines 3–4: The meaning behind these two lines remains opaque. There is no apparent connection to Tao Hongjing, and no other relevant allusion has been located.

22 On May 7, 1696, Bada Shanren wrote the leaf bearing these four quatrains for his friend Baoyai. He probably composed the poems at an earlier time as inscriptions for paintings, however it is uncertain if the four landscape paintings that accompany this leaf complement the texts in any way. The current album also contains three undated leaves of calligraphy with eight additional quatrains that Bada sent to Baoyai for his perusal (leaves 8–10).

Joseph Chang was the first to correctly identify the recipient of the paintings and calligraphy in this album as Wu Chenyan, courtesy name Baoyai, a scholar, poet, and painter from Qiantang (modern Hangzhou, Zhejiang Province); see Zhang Zining (Joseph Chang), "Chen Yan xing 'Chen' ma?" (Was Chen Yan surnamed Chen?), *Gugong wenwu yuekan* (National Palace Museum Monthly) 134 (May 1994): 94–103. A considerable amount of additional biographical information concerning Wu Chenyan has come to light during research for this volume, including material that now establishes his life dates as: 1663–after 1722.

Bada Shanren created at least two other known works for his friend Baoyai in 1694 and 1696. He wrote a sixteen-line poem for him on June 28, 1694; see Wang Zidou, comp., *Bada Shanren shichao* (Poetry of Bada Shanren) (Shanghai: Shanghai renmin meishu chubanshe, 1981), 25–26. He also painted a landscape hanging scroll for Baoyai, which he inscribed with a quatrain on February 9, 1696, three months prior to writing the current album leaf; see Wang Zhaowen, ed., *Bada Shanren quanji*, 2:410 (cat. no. 101). From all this, one may surmise that Bada Shanren and Wu Chenyan maintained a measure of regular social contact from at least 1693/1694 to mid-1696, when Wu was in his early thirties and Bada in his late sixties.

23 Zhang Daqian applied his seals to each of Bada's three calligraphy works (leaves 6, 7, 10) and at the end of the album (leaf 15), but not the frontispiece (leaf 1), four paintings (leaves 2–5) or colophon by Wu Changshuo (leaves 11–12). Zhang apparently acquired this album from Cheng Qi, who first published it: see Cheng Qi, *Bada Shanren shuhua ji* (Collection of calligraphy and painting by Bada Shanren), works in the Jinsong caotang collection of Cheng Qi (Kyoto: Tōhō bunka kankōkai, 1956), plates 5–7 (five calligraphy leaves) and 16–19 (four landscape leaves).

24 On this leaf, Bada Shanren copied the text of an earlier prose inscription that he had written for a fan painting. Judging from its inclusion in this album, the leaf was presumably intended for the enjoyment of his friend Wu Chenyan (see note 22). None of the contemporaries named here by Bada have been identified: Wang Xizhai, Mister Shifen, and "elder brother" Shangshu. Bada states that he wrote this leaf in the first ten-day period of the fourth lunar-month, but does not specify the year; however, it may have been around the same time that he wrote the preceding calligraphy leaf, which was dated on the seventh day in the fourth lunar-month of the *bingzi* year (May 7, 1696). For a previous translation of the text, see Wang and Barnhart, *Master of the Lotus Garden*, 227.

In the original Chinese, Bada refers to the famous Tang dynasty poet Du Fu (712–770) by an abbreviation of an official title he once held in the *gongbu* (Ministry of Works). Du Fu's eight-line poem, "Seeing off Secretary Li the Eighth," has no apparent connection either to a birthday celebration or to Penglai, a mythical island in the eastern sea inhabited by immortals and the subject of the fan painting Bada inscribed. For Du Fu's poem, see Hong Ye (William Hung), comp., *Dushi yinde* (Concordance to the poems of Tu Fu), 3 vols., in Harvard-Yenching Institute Sinological Index Series, supplement 14 (Beijing: Yenching University, 1940), 2:435–36 (poem no. 2).

25 Poem 1, lines 3–4: Ruoye Creek, near modern Shaoxing (Zhejiang Province), was famous as a place where the ancient beauty Xi Shi (early 5th century B.C.E.) once picked lotus blossoms.

Bada Shanren wrote this poem on at least two earlier works: a lotus painting in the album "Fish, Lotus, Globefish, and Bamboo" (dated 1689), in the L. and C. Rosshandler Collection; and a handscroll, "Lotus and Birds" (dated 1690), in the collection of the Cincinnati Art Museum. See Wang and Barnhart, *Master of the Lotus Garden*, 103 (cat. 7, fig. 51, leaf b) and 115–18 (cat. 15, fig. 59).

26 Poem 2, lines 1–2: The term "yellow bamboo" *(huangzhu)* may allude to a story concerning King Mu of Zhou (Zhou Muwang; reigned 1001–947 B.C.E.). On one of the king's many travels, he discovered that the local people were suffering and dying from an intense cold spell. To demonstrate his compassion for them, King Mu composed three poems using yellow bamboo as a metaphor, and personally went to spend the night in a nearby grove to share their misery. How, or if, this story relates to Bada Shanren's poem is unclear, as is the reference to Tongzhou (modern Nantong, Jiangsu Province), which is the name of both a

town and county located north of the Yangzi River near its mouth. There is no known connection between Tongzhou and King Mu; however, Bada Shanren also used the term *huangzhu* in one of his studio names (see note 33).

Lines 3–4: The last character in line 3 (taken here as *fen,* divided) has not been reliably deciphered, and the meaning of these two lines is uncertain.

27 Poem 3, lines 1–2: There were at least two temples in Bada Shanren's native Jiangxi Province named Kaiyuan Temple (or monastery): one in Xinjian (modern Nanchang), near Bada's home; and one farther away, in Chongren. It is not clear if Bada had either place in mind.

Lines 3–4: The phrase *yaozi fanshen* (sparrow-hawk flipping over) refers to a particular maneuver or pose employed by acrobats performing on a vertical pole during temple festivals; see Tian Rucheng (early to mid-16th century), *Xihu youlanzhi yu* (Sightseeing at West Lake, continued), 20:7b, in *WSKQS,* disc 62. According to ancient law and custom, the graves of commoners were planted with willow trees; see Ban Gu (32–92 C.E.), *Baihu tongyi* (Comprehensive discussions in the White Tiger Hall), 2:74b, in *WSKQS,* disc 92.

28 Poem 4, lines 1–2: West Pass Hill (Xisaishan), located near modern Wuxing, Zhejiang Province, was where the Tang poet and recluse Zhang Zhihe (ca. 742–ca. 782) composed five well-known poems titled *Yufu ge* (Fishermen songs).

Lines 3–4: "Big-headed stripe" is the translator's coinage for a kind of fish known as *yongyong,* described in standard sources as a striped fish with a large bovinelike head. The only river in China officially bearing the name Coral Stream (Shanhuchuan) is located near Ningxian, in eastern Gansu Province; however, it seems unlikely that Bada Shanren had this specific place in mind, and he simply may have been playing with the name.

29 Poem 5: Lines 1–3 are built around references to the famous poet and recluse Tao Qian (365–427 C.E.), who once wrote a letter to his sons in which the following passage appears: "Often in the fifth and sixth months I lay beneath the northern window, and when a cool breeze suddenly came, I would think myself a man of the remote times of Emperor Fuxi," translation adapted from A. R. Davis, *Tao Yuan-ming, a.d. 365–427: His Works and Their Meaning,* 2 vols. (Cambridge: Cambridge University Press, 1983), 1:229. Following line 3 of the poem, Bada Shanren added his own brief note in small characters explicitly identifying the primordial ruler Fuxi as the subject, and leading back to Tao Qian's passage above. It is unclear how line 4 fits with the rest of the poem.

30 Poem 6, lines 3–4: Hekou (River Mouth) is the name of a town in northern Yanshan county, Jiangxi Province, where two smaller streams flow into the Xinjiang River. Hukou (Lake Mouth) is the name of a county located on the Yangzi River in northern Jiangxi Province.

31 Poem 7, lines 1–2: "Up on Phoenix Hill" and "Leaves of Purest Gold" are apparently the titles of unknown songs or tunes, and may refer to the story of the musician Xiao Shi (mid-7th century B.C.E.) and Longyu, the daughter of Duke Mu of Qin (reigned 659–21 B.C.E.). Xiao Shi excelled at playing the flute (or panpipes) and Longyu fell in love with and married him. He taught her how to make the sound of a phoenix call on the pipes, and when she had practiced for several years, phoenixes began to come to her windowsill. Accordingly, the duke built the Phoenix Terrace for the couple, where they lived. One morning, husband and wife flew away on a phoenix into the realm of the immortals and were never seen again.

32 Poem 8, line 2: This line perhaps refers to one of Bada Shanren's studio names, the Mountain Lodge amid the Lotus, which he used both as a seal and as part of his signature.

Line 4: Wanshan (Shining Hills), is located north of the Yangzi River near the town of Qianshan, in Anhui Province. The first part of the place name (Wan), is sometimes used alone as a general reference to Anhui, so the compound here might simply mean: "the hills of Anhui."

Bada Shanren also wrote this poem as an independent hanging scroll on at least one occasion; see Wang Zhaowen, ed., *Bada Shanren quanji,* 3:628 (cat. no. 196).

33 Wang Fangyu has dated the leaves on which these poems appear to ca. 1693, three years prior to Bada Shanren's creation of the other six leaves in the album. Bada wrote out the eight quatrains on these leaves for his friend Baoyai (Wu Chenyan, see note 22 above), but did not compose the poems for him, as they clearly predate the creation of the album and were written to accompany paintings that are not included. For previous translations of the poems, see Wang and Barnhart, *Master of the Lotus Garden,* 139–40 (cat. 30, fig. 75), with translations of poems 2 and 8; page 115, with translation of poem 1; and page 224, with translations of poems 3 to 7. For transcriptions and further comments, see Wang Fangyu, *Bada shanren fashu ji,* 1:41. Texts of the eight poems are also published in Wang Zidou, comp., *Bada Shanren shichao,* 39–40.

The place name Huangzhuyuan (Yellow Bamboo Garden) appears in seals used by Bada Shanren from 1686 to 1690 and ca. 1692 to 1698, and first appears as part of his signature in 1689. It is unclear if Bada used the phrase simply as an alternate name, or if it also referred to an actual physical location, such as a studio or residence. For discussion and examples of "Huangzhuyuan" in seals and signatures, see Wang and Barnhart, *Master of the Lotus Garden,* 104, 140, 248 (no. 63), 249 (no. 79), and 103 (fig. 51, leaf c). On the significance of "yellow bamboo," see note 26.

34 The calligrapher and painter Wu Changshuo (1844–1927), whose given name was Junqing, was considerably influenced by Bada Shanren, and his inscriptions appear on a number of Bada's surviving works. For other inscriptions by Wu Changshuo on Bada Shanren's paintings, see catalogue entry 9 in this volume; and Wang Zhaowen, ed, *Bada Shanren quanji,* 2:404 (cat. no. 95; hanging scroll, inscription dated 1924), and

3:482 (cat. no. 131; hanging scroll, inscription dated 1895). On Bada Shanren and Wu Changshuo, see Wang Fangyu, "Bada Shanren dui Wu Changshuo de yingxiang" (Bada Shanren's influence on Wu Changshuo), in *Bada Shanren lunji*, ed. Wang Fangyu, 1:423–30.

The erroneous assertions that Bada Shanren's "given name was Da and his courtesy name Xuege" and that he was a "grandson of the Prince of Shichengfu" are based on statements in Zhang Geng's (1685–1760) biography of Bada Shanren. For the full Chinese text of this biography, see Zhang Geng, *Guochao huazhenglu* (Records on painters of the Qing dynasty, preface 1739), in *Zhongguo shuhua quanshu* (Complete writings on Chinese calligraphy and painting), comp. Lu Fusheng et al., 14 vols. (Shanghai: Shanghai shuhua chubanshe, 1992–99), 10:425; or Wang Fangyu, ed., *Bada Shanren lunji*, 1:533. For a brief discussion of the commonly reiterated errors in that text, see Wang and Barnhart, *Master of the Lotus Garden,* 24. On Zhang Geng, see also catalogue entry 24 (Ye Dehui colophon).

The origin of the phrase, "Heartbreak has its hidden reasons," is not recorded.

The identity of Wenqing, former owner of this album and Wu Changshuo's fellow "art lover" *(youdao),* is not known. However, since Wenqing is also named as the recipient of Shanqi's 1917 frontispiece (see leaf 1 and note 15 above), it is clear that he owned the album for at least the ten years between 1907, when Wu Changshuo wrote this colophon, and 1917.

The individual named by Wu Changshuo as his teacher Yang Xian (1819–1896) sobriquet Miaoweng, largely pursued a life devoted to poetry and other scholarly pastimes. As a calligrapher, Yang exerted a considerable influence on a number of younger contemporaries, in particular Wu Changshuo, with whom he maintained a close relationship. The small Bada hanging scroll that inspired Yang Xian has not been located; however, Wu Changshuo composed his own variant on the same quatrain of poetry, which he inscribed on a different Bada hanging scroll in the spring of 1924; see Wang Zhaowen, ed., *Bada Shanren quanji,* 2:404 (cat. no. 95). For another inscription by Yang Xian on a painting by Bada Shanren, see Wang and Barnhart, *Master of the Lotus Garden,* 152 (cat. no. 36, fig. 87; album leaf, ca. 1694).

Du Fu (712–770) composed the famous poem, "Ai wangsun" (Alas, a prince!), in the autumn of 756 during the dark days of the An Lushan rebellion, which marked the end of a golden age of the Tang dynasty (618–907). In the ruined capital of Chang'an (modern Xi'an, Shaanxi Province), Du Fu came across a miserable imperial prince huddled by the wayside, scratched and bruised from brambles and dressed in rags. Though recognizing that "just now royalty is humbled and monstrosity rampant," he reminded the young man that where there is life, there is hope. Translation quoted from William Hung (Hong Ye), *Tu Fu: China's Greatest Poet,* 2 vols. (Cambridge: Harvard University Press, 1952), 1:101–02. For the Chinese text, see Hong Ye (William Hung), comp., *Dushi yinde,* 2:43–44 (no. 21).

35 The highly regarded Japanese calligrapher and sinologist Naitō Torajirō (1866–1934) wrote this colophon in 1930 at the request of the Kyoto collector Hayashi Heizō (20th century; studio name, Utsudō), who then owned the album. Hayashi affixed his own collector seal on the last leaf of the album following Naitō's colophon and, judging from the seal of the Kōsaidō mounting studio (in Kyoto) affixed inside the front cover, he may also have been responsible for the current mounting of the album. On the life and career of Naitō Torajirō, see note 14. On his calligraphy, see the series of articles and plates in: *Shoron* 13–17 (Autumn 1978–Autumn 1980), inclusive.

In his colophon, Naitō Torajirō quoted two passages from the closing section of the biographical notice on Bada Shanren written by the poet and essayist Shao Changheng (1637–1704), whose sobriquet was Qingmen. Shao visited Nanchang in 1688 to 1689, where he arranged to meet Bada Shanren through a mutual acquaintance, and subsequently wrote a highly personal biographical notice describing the event, which he included in his *Qingmen lügao* (Notes on my travels). For the complete Chinese text of Shao's biographical notice, see Wang Fangyu, ed., *Bada Shanren lunji*, 1:527–28. For previous translations of the section of text quoted by Naitō Torajirō, see Wen C. Fong, "Stages in the Life and Art of Chu Ta," 12; and Wang and Barnhart, *Master of the Lotus Garden,* 19. For more on Shao's visit to Bada and other partial translations of the biography he wrote, see Wang and Barnhart, *Master of the Lotus Garden,* 18, 24, 35, 41, and 60–61.

The three individuals mentioned in the quotation from Shao Changheng's essay—Fang Feng (1240–1321), Xie Ao (1249–1295), and Wu Siqi (1238–1301)—were a trio of poets and scholars who refused to serve the alien Yuan dynasty (1279–1368) after the fall of the Song in 1279 and took to wandering the countryside of eastern Zhejiang Province together. Particularly grieved by the capture and execution of the great Song patriot and military commander Wen Tianxiang (1236–1283), the three companions climbed the Western Terrace of Yanling (Yanling Xitai, in Zhejiang Province) in 1287 and performed a ceremony calling his soul to return and "wailing in anguish" *(tongku).* On Fang Feng, Wu Siqi, and Xie Ao, see Chang Bide et al., comps., *Songren chuanqi ziliao suoyin* (Index to biographical materials on Song dynasty figures), 6 vols. (Taipei: Dingwen shuju, 1973), 1:61–62, 2:1158–59, and 5:4111.

ENTRY 9. *Lotus and Ducks*

36 For a discussion of this painting, see Wang and Barnhart, *Master of the Lotus Garden,* 170–71 (cat. no. 47, fig. 100). For examples of nine compositionally related paintings dating from ca. 1690–92 to 1705, see the following works discussed and/or illustrated in the same volume: "Lotus and Duck" (ca. 1690–92), 124–25 (cat. no. 20, fig. 63); "Lotus and Birds" (ca. 1692–94), 137–38 (cat. no. 28, fig, 73); "Lotus, Birds, and Rocks" (1694), 146–48 (cat. no. 33, fig. 81); "Lotus and Peony" (1694), 265 (Appendix C, no. 80); "Lotus and Rock" (1694), 266 (Appendix C, no. 81); "Lotus and Rock" (ca. 1694–95), 156–57 (cat. no. 38, fig. 90); "Lotus and Ducks" (1696), 267 (Appendix C, no. 91); "Lotus and Duck" (1696), 268 (Appendix C, no. 100); and "Lotus" (1705), 215–17 (cat. no. 72, fig. 130).

Gao Yong (1850–1921), a previous owner, first published this paint-

ing prior to the time Wu Changshuo added his inscription in the spring of 1926; see photograph in Wang Fangyu, ed., *Bada Shanren lunji,* 2:192, plate 38.2, taken from an unspecified volume of Gao Yong, *Taishan Canshilou canghua* (Paintings in the collection of the Broken Stone Tower of Taishan) (Shanghai: Xiling yinshe, 1926–29). The current painting with Wu Changshuo's inscription was first published in Zhang Daqian, *Dafengtang mingji,* vol. 3, plate 4.

37 Lines 4–6: The name translated here as "Snowy Donkey" is actually made up of two names Bada Shanren used while still a Buddhist monk: Xuege (Snowy One) and Lü (Donkey), the latter being a derogatory slang term for a monk. Bada Shanren was a member of the Ming dynasty imperial clan, surnamed Zhu.

Lines 14–15: Line 14 contains typical images of the world upside down, full of prodigies and ill-omened occurrences. Line 15 alludes to the Daoist philosopher Zhuang Zhou (Zhuangzi, ca. 369–ca. 286 B.C.E.), who once dreamt he was a butterfly, but on waking could not determine if he had been Zhuangzi dreaming of a butterfly, or was now the butterfly dreaming he was Zhuangzi. See Guo Qingfen (1844–1896), comp., *Zhuangzi jishi* (Collected commentaries on the *Zhuangzi*), 4 vols. (Beijing: Zhonghua shuju, 1961; reprint 1978), 1:112; and Burton Watson, trans., *The Complete Works of Chuang Tzu* (New York: Columbia University Press, 1968), 49.

This fifteen-line poem by Wu Changshuo was previously translated in Wang and Barnhart, *Master of the Lotus Garden,* 171. For more information on Wu Changshuo and his other inscriptions on paintings by Bada Shanren, see note 34.

ENTRY 10. *Poem by Han Yu*

38 In 801, the Tang poet and prose stylist Han Yu (768–824) composed the "Preface to Seeing Off Li Yuan on His Return to Winding Valley." Judging from the longer prose section of the preface, Li Yuan, the individual for whom Han Yu wrote the work, was a well-regarded scholar of strong Confucian values, who retired that same year from public life in the capital to a Buddhist temple in Winding Valley (Pangu), which is located in the southern foothills of the Taihang Mountains about ten to twelve kilometers north of the town of Jiyuan, Henan Province. The preface concludes with, or introduces, a poem written in a unique combination of ancient metrical forms, which is the text that Bada Shanren recorded here.

39 In his one-line introduction to Han Yu's poem, Bada Shanren refers to Li Yuan as coming from Shannan (south of the mountains), which in the Tang dynasty was part of the name for two provinces, east and west respectively. Since Li Yuan had no known connection with either province of Shannan, Bada probably employed the term simply as an informal reference to Winding Valley, which is located *south* of the Taihang Mountains. Note that Bada used "Shannan" in three of the four other known versions he created of this text (see note 40), while in the fourth version (album leaf in the Asian Art Museum, San

Francisco), he reversed the constituents to read "Nanshan" (South Mountain), a common place name that does not pertain to Li Yuan in any ascertainable way.

40 In addition to the current album leaf, Bada Shanren wrote out the text of Han Yu's poem on at least four other occasions, all probably during the period 1696 to 1698: Leaf d, in a mixed album of sixteen leaves of painting and calligraphy dated spring 1698, in the Asian Art Museum, San Francisco; an undated album leaf, in the Tang Yun Art Museum, Hangzhou; an undated hanging scroll, in the Tokyo National Museum; and a second undated hanging scroll, in the Shanghai Museum of Art. Bada used exactly the same poem text for all five versions, which consistently differs from standard printed recensions of Han Yu's famous preface in several particulars. See, for example: Wei Zhongju (late 12th–early 13th century), comp., *Wubaijia zhu Changli wenji* (Five hundred commentators on the works of Han Yu, preface 1200), 19:22a–25a, esp. 19:24a–b, in *WSKQS,* disc 118; and Gao Buying, comp. and annotator, *Tang Song wen juyao* (Essential prose of the Tang and Song dynasties), 3 vols. (Hong Kong: Zhonghua shuju, 1985), 1:232–39, esp. 237–38. For two recent translations of Han Yu's complete preface, see Yu-shih Chen, *Images and Ideas in Classical Chinese Prose* (Stanford: Stanford University Press, 1988), 24–25; and Stephen Owen, ed. and trans., *An Anthology of Chinese Literature: Beginnings to 1911* (New York: W. W. Norton & Co., 1996), 607–9.

The current leaf originally belonged to a nine-leaf calligraphy album, seven other leaves from which are in the Freer collection: see catalogue entries 11 (two leaves), 13, 14, 15, 16, and 31. For a list of the contents of the original album, see Wang and Barnhart, *Master of the Lotus Garden,* 269 (Appendix C, no. 106).

41 In his postscript, Bada Shanren confuses Han Yu's hermit friend with another individual bearing the same name. This second Li Yuan (died 825) was the son of the Tang general Li Sheng (727–793), whose courtesy name *(zi)* was Liangqi. Li Sheng joined the army as a young man and in 746 to 747 accompanied Wang Zhongsi (705–749) on a campaign in eastern Central Asia. During the Chinese attack on an unnamed city: "a brave [enemy] general mounted the wall and resisted vigorously, wounding quite a number of Chinese soldiers. Wang Zhongsi sent out a call to his troops that anyone who could shoot him [with an arrow] should do so. Li Sheng then drew his bow and slew the man with a single shot, whereupon the whole army sent up a great shout. Greatly appreciative, Zhongsi patted Li Sheng on the back and said: *'This [man] is a match for ten thousand foes'* [translator's italics]." See Liu Xu et al., comps., *Jiu Tang shu* (Old history of the Tang dynasty, 618–907) (Beijing: Zhonghua shuju, 1975), 133:3661.

Due largely to his military prowess, Li Sheng eventually rose to high office and was rewarded with the hereditary title, Prince of Xiping (in Gansu Province), an appanage of 1,500 households located near the ancestral home of the Li family. Li Yuan was heir to this title and also rose to high military and civil office. Bada evidently felt that Li Yuan's inherited princely rank explained Han Yu's use of the word *gong*

(palace) in the opening line of his poem; however, this is too narrow an interpretation of the word, which may also be applied to a Buddhist temple, for example. There is no indication that Li Yuan, the prince, ever retired to the life of a recluse or had any connection with Winding Valley in Henan Province. For his official biographies, see Liu Xu et al., comps., *Jiu Tang shu,* 133:3676–77; and Ouyang Xiu et al., comps., *Xin Tang shu* (New history of the Tang dynasty, 618–907) (Beijing: Zhonghua shuju, 1975), 154:4874–75.

Bada Shanren used an unusual formula to record the year of this work (1697); for explication, see Wang Fangyu, *Bada Shanren fashu ji,* 1:65. For another occurrence of the same formula, see Wang Zhaowen, ed., *Bada Shanren quanji,* 2:455 (album leaf; sprig of chrysanthemum).

ENTRY 11. *Poem by Zeng Gong*

42 Zeng Gong (1019–1083), also known as Zigu, was a scholar-official from Nanfeng in Jiangxi Province. He was highly regarded as a prose writer, but his poetry is generally less well known. As with many of the texts Bada Shanren copied, his primary point of interest in the current poem was apparently the topic of landscape painting. Variants often appear in Zeng Gong's preserved writings; however, Bada Shanren's version of his poem contains significant discrepancies beyond those found in standard printed sources. The first three lines in particular differ radically from the standard text and, more importantly, while Zeng Gong's original poem consists of sixty lines, Bada Shanren's version contains only fifty-four lines, completely omitting lines 47–50, as well as ten characters from lines 58–60, thus compressing the final three lines into one. These and other discrepancies in Bada's version of the text considerably alter the meaning and flow of Zeng Gong's poem. Two characters are also missing due to damage, but can be supplied from published versions of the text. For two published versions of the text, see: Zeng Gong, *Yuanfeng leigao* (Collected works of Zeng Gong), comp. Chen Shidao (1053–1102), 4:4b–5b, in *WSKQS,* disc 121; and Chen Bangyan (1603–1647), comp., *Lidai tihuashi lei* (Poems on paintings through the ages, by category), 22:11a–12a, in *WSKQS,* disc 157.

The following is a brief outline of the poem's contents: Fine silk from Wu was cut to fit the frame of a folding screen and the best craftsmen were sought to paint a vast landscape across it. Looking at the picture slowly and taking in all the details, the poet describes a boundless expanse of mountains. A great massif occupies the center surrounded by a host of lesser peaks. Mighty and perilous, it bestrides the land and reaches the stars. From high mountain springs, water gathers into torrents and rushes down between the cliffs, gradually slowing as it gets farther and farther away. Looking into the distance, "there is no end or limit to how far one can go" (line 29). The traveler halts his horse to look around, then stays to enjoy the pristine wilderness, marveling at the fauna and flora and the beauty of the natural scene. Everything in the painting is so fresh and bright, perfect in every detail, that a supernatural being must have had a hand in completing it. Looking at the screen painting as he goes to bed brings the poet pleasant dreams. He realizes that he has no talent for the times and wishes to escape the pitfalls of the

world. Since his obligations are light, he will follow his heart and find some remote spot where he can survive by farming and fishing.

These two leaves originally belonged to a nine-leaf calligraphy album (dated December 1697), six other leaves from which are in the Freer collection: see catalogue entries 10, 13, 14, 15, 16, and 31. For a list of the contents of the original album, see Wang and Barnhart, *Master of the Lotus Garden,* 269 (Appendix C, no. 106).

43 Damage to the calligraphy in three locations makes it difficult to understand the full thrust of this comment. The two characters following the surname Zeng probably contained either Zeng Gong's courtesy name (Zigu), or the name of his home district (Nanfeng). The phrase "how far one can go" evidently refers to line 29 of the poem, translated above.

ENTRY 12. *Album after Dong Qichang's "Copies of Ancient Landscape Paintings"*

44 The six paintings in this album are careful copies (even down to the inscriptions and signatures) of works by the important Ming artist Dong Qichang (1555–1636), who in turn was either copying or working in the style of earlier artists belonging to the Southern School of landscape painting. Due to their common surname, Dong Qichang claimed a family relationship with Dong Yuan (died 962), whom he considered to be the founder of the Southern School. On the important landscape painter Dong Yuan and other works by Bada Shanren in his style, see catalogue entry 7, note 12; and catalogue entry 8, leaves 2–5.

Dong Qichang exerted a profound influence on Bada Shanren both as a stylist and theorist. See discussions of this album and Dong's influence in Wang and Barnhart, *Master of the Lotus Garden,* 178–81 (cat. no. 53, fig. 106); Zhang Zining (Joseph Chang), "Bada Shanren shanshuihua de yanjiu" (Researches on the landscape painting of Bada Shanren), *Gugong wenwu yuekan* (National Palace Museum Monthly) 97 (April 1991): 88–115, esp. 103–111; and Zhang Zining (Joseph Chang), "Bada Shanren zhi shanshuihua chutan" (Preliminary discussion of Bada Shanren's landscape painting), *Duoyun* (Art Clouds Quarterly) 15 (October 1987): 143–49, esp. 148–49. This album was first published in slightly different order in Zhang Daqian, *Dafengtang mingji,* vol. 3, plates 14–19.

45 Huang Gongwang (1269–1354) was one of the most important Yuan dynasty followers of the landscape painter Dong Yuan. Huang exerted a major influence on Dong Qichang, and through him, Bada Shanren. Huang's painting titled *The Fuyang Mountain Range* is otherwise unknown. For another work by Bada Shanren in the style of Huang Gongwang, see Wang Zhaowen, ed., *Bada shanren quanji,* 2:458–59 (cat. no. 119).

46 *In the Shade of Summer Trees* is the title of a famous hanging-scroll painting by Dong Qichang, who in turn attributed the original composition to Dong Yuan. Dong Qichang's extant painting by this title bears little resemblance to the current album leaf in composition; see

Gugong shuhua tumu (Photo-catalogue of Chinese painting and calligraphy in the National Palace Museum, Taipei) (Taipei: Gugong bowuyuan, 1991), 8:232.

47 Ni Zan (or Ni Yu, 1306–1374), noted for his spare brushwork and stark landscape compositions, was an important Yuan dynasty follower of Dong Yuan and a strong influence on both Dong Qichang and Bada Shanren. For another work by Bada in Ni's style, see catalogue entry 33 in this volume. The identity of Master Wang, who owned the Ni Zan painting copied by Dong Qichang, is unknown.

48 As noted above, Ni Zan and Huang Gongwang were two of the most important landscape painters of the fourteenth century. In this colophon, Zhang Daqian (1899–1983), a previous owner of the album, congratulates himself for realizing the importance of Dong Qichang's reinterpretation of their styles in establishing the primary model for the landscape painting of Bada Shanren.

ENTRY 13. *Excerpt from "Preface to the Gathering at the River"*
49 On the third day in the third lunar-month of 353 C.E., which corresponded to April 22, the famous calligrapher Wang Xizhi (ca. 303–ca. 361 C.E.), along with forty friends and family members of various ranks and ages, traveled some ten kilometers from the town of Kuaiji (modern Shaoxing, Zhejiang Province) to the picturesque Orchid Pavilion (Lanting), a private retreat that Wang had built in a nearby mountain valley. Here they celebrated an ancient springtime purification ceremony that had transformed over the centuries into a secular holiday, when people would gather near a body of water to enjoy the scenery, eat and drink together, and compose poetry. At the Orchid Pavilion, a channel had been dug and water from the local river diverted to form a small meandering stream, along which the participants sat in order of seniority. Cups were floated down the water course, and each member of the group had to compose a poem when a cup arrived at his location, or pay the penalty of drinking three dippers of wine. At the end of the day, thirty-seven poems were collected and Wang Xizhi composed a preface to record the circumstances of the occasion. Two versions of his preface exist: a ubiquitous 324-character version known as the *Lanting xu* (Preface to the Gathering at the Orchid Pavilion), which is recorded in the *Jin shu* (History of the Jin dynasty) and plays an important role in the calligraphic tradition; and a more obscure 154-character version known as the *Linheji xu* (Preface to the Gathering at the River), which is the text Bada Shanren excerpted here (see following note). For the text of the *Lanting xu*, see Fang Xuanling et al., comps., *Jin shu*, 80:2099. For two recent English translations, see: Richard E. Strassburg, *Inscribed Landscapes: Travel Writing from Imperial China* (Berkeley: University of California Press, 1994), 65–66; and Stephen Owen, ed. and trans., *An Anthology of Chinese Literature*, 283–84. For an English summary of the early calligraphic tradition surrounding this text, see Lothar Ledderose, *Mi Fu and the Classical Tradition of Chinese Calligraphy*, 19–24.

50 The *Linheji xu* (Preface to the Gathering at the River) is preserved in an annotation by Liu Jun (462–521 C.E.) to a passage concerning Wang Xizhi in the *Shishuo xinyu* (New account of tales of the world), a collection of anecdotes compiled under the aegis of Liu Yiqing, the Prince of Linchuan (403–444 C.E.). Bada's exclusive preference for this text was a radical departure from the prevailing orthodoxy in scholarship and the arts. Unlike any calligrapher before or since, Bada Shanren chose to ignore the *Jin shu* version of the preface that appeared in countless available rubbings, and instead used the *Shishuo xinyu* text as the sole basis for all his calligraphic interpretations of the Wang Xizhi preface. Between 1693 and 1700, Bada produced at least twelve dated and undated versions of the *Shishuo xinyu* text using various formats — hanging scroll, single album leaf, multiple album leaves, and folding fan — making the "Preface to the Gathering at the River" both the most commonly quoted text in Bada's entire extant corpus and the single text with which he conducted the most widely varied calligraphic experiments. Rather than imitating the calligraphy of Wang Xizhi, however, Bada Shanren felt free to use his own reconstruction of fourth-century, running-standard script to write the text of this leaf. Moreover, in transcribing the text, Bada Shanren consistently employed several variant readings that do not appear in the standard printed edition of the *Shishuo xinyu*. Among the twelve known examples of the preface written by Bada, none quotes the entire passage of Liu Jun's note to the *Shishuo xinyu*. While four versions produced between 1693 and spring 1697 quote excerpts of different lengths from the text, the Freer leaf, which can be dated to November 1697, appears to be the earliest example of a fixed 106-character excerpt that Bada Shanren used in all eight later renditions. For the full text of the *Lingheji xu* and a recent English translation, see Liu Yiqing, comp., *Shishuo xinyu*, 16:165, in *Zhuzi jicheng* (Compendium of works by famous masters) (Beijing: Zhonghua shuju, 1954; 1986 edition), vol. 8; and Richard B. Mather, trans., *Shih-shuo Hsin-yu: A New Account of Tales of the World*, comp. Liu I-ch'ing (Minneapolis: University of Minnesota Press, 1976), 321–22 (anecdote 16/3). For further discussion of Bada's different renditions of the text, see Wang Fangyu, "Bada Shanren de shufa" (The calligraphy of Bada Shanren), in *Bada Shanren lunji*, ed. Wang Fangyu, 1:388–91; Wang Fangyu, "Bada Shanren de shufa," in Wang Fangyu, *Bada Shanren fashu ji*, 2:64–68; and Bai Qianshen, "Cong Bada Shanren lin 'Lanting xu' lun Mingmo Qingchu shufa zhong de linshu guannian" (Bada Shanren's copies of the *Lanting xu* and the late-Ming to early-Qing concept of free copying), in *Lanting lunji* (Collection of essays on the Orchid Pavilion), ed. Hua Rende and Bai Qianshen (Suzhou: Suzhou daxue chubanshe, 2000), 462–72.

This work originally belonged to a nine-leaf calligraphy album (two leaves dated December 1697), seven other leaves of which are in the Freer collection: see entries 10, 11 (two leaves), 14, 15, 16, and 31. For the contents of the original album, see Wang and Barnhart, *Master of the Lotus Garden*, 269 (Appendix C, no. 106).

51 This twenty-four line poem, titled "Inscribed on a Landscape Folding Screen," was composed by Zhang Jiuling (678–740), an important Tang dynasty scholar-official and poet. Bada Shanren's text of the poem differs from all printed versions that appear in standard anthologies. For example, it contains a two-character interpolation in line 11 that is clearly out of place and changes the line from five to seven characters, and several one-character variants that alter the meaning of the lines in which they occur; four of these variants do not appear in any standard source. For a standard text of the poem and a modern commentary, see: Peng Dingqiu (1645–1719) et al., comps., *Quan Tang shi* (Complete Tang poems, 1705) (Beijing: Zhonghua shuju, 1960; 1985 edition), 417:577–78; and Kong Shoushan, ed., *Tangchao tihuashi zhu* (Annotated Tang dynasty poems on paintings) (Chengdu edition: Sichuan meishu chubanshe, 1988), 52–54.

The current leaf originally belonged to a nine-leaf calligraphy album (two leaves dated December 1697), seven other leaves from which are in the Freer collection: see catalogue entries 10, 11 (two leaves), 13, 15, 16, and 31. For the contents of the original album, see Wang and Barnhart, *Master of the Lotus Garden,* 269 (Appendix C, no. 106).

52 Lines 17–18: These lines are directly adapted from a passage in the "Yangsheng lun" (Treatise on nurturing life), by the third-century writer and philosopher Xi Kang (223–262 C.E.), who cultivated these plants in his garden. The passage reads: "Coupled bliss soothes away anger, day lilies make one forget sorrow." See Xiao Tong (501–531), comp., *Liuchen zhu Wen xuan* (Literary selections, with commentaries by six Tang scholars) (Taipei: Guangwen shuju, 1964; 1972 edition), 53:976.

The day lily *(Hemerocallis fulva)* is a common Chinese garden plant. From early times, it was popularly known by the name "forgetting sorrow." For an image of day lilies by Bada Shanren and more information about the traditional symbolism of the plant, see catalogue entry 26 and note 86.

The plant, translated literally here as "coupled bliss," is a kind of mimosa *(Albizzia julibrissen).* In Chinese tradition, it is considered an auspicious tree that possesses the power to alleviate anger and bring contentment to the heart.

Lines 19–22: The first two lines allude to a famous passage attributed to the early Daoist philosopher Zhuang Zhou (ca. 369–ca. 286 B.C.E.), better known as Zhuangzi (Master Zhuang). The passage may be translated as follows: "The fish trap exists because of the fish; once you've gotten the fish, you can forget the trap. The rabbit snare exists because of the rabbit; once you've gotten the rabbit, you can forget the snare. Words exist because of ideas; once you've gotten the idea, you can forget the words." Translation adapted from Burton Watson, trans., *The Complete Works of Chuang Tzu,* 302. For the original Chinese text, see Guo Qingfen, comp., *Zhuangzi jishi,* 4:944.

In the context of this poem, Zhang Jiuling uses Zhuangzi's "fish trap" as a reference to the landscape painting he is viewing; i.e., the painting is simply a means to achieve the idea of wilderness. Zhang then extends the quotation of Zhuangzi to lines 21–22, which continue to play on the relationship between "words" and "ideas." Once one has gotten the idea of wilderness, the words and images that express it can be forgotten.

53 The phrase "piled dirt to make a mountain" appears in the title of a poem by Du Fu (712–770), who once held an official position in the Ministry of Works *(gongbu).* See Peng Dingqiu et al., comps., *Quan Tang shi,* 224:2391–92.

The phrase "all the mountains resound" appears in the biography of the famous early landscape painter Zong Bing (375–443 C.E.). The relevant passage reads: "[Zong Bing] said with a sigh: 'I am old and ailing; I fear that I can no longer wander among famous mountains. Now I can only purify my heart by contemplating the Dao, and do my roaming from my bed.' All that he had visited he depicted in his chamber. He told someone: 'I strum my *qin* [zither, lute] with such force because I want *all the mountains to resound* [annotator's italics],'" translation adapted from Alexander C. Soper, *Textual Evidence for the Secular Arts of China in the Period from Liu Song through Sui,* Artibus Asiae Supplement 24 (Ascona, Switzerland: Artibus Asiae Publishers, 1967), 16. For the original Chinese text, see: Shen Yue (441–513 C.E.), comp., *Song shu* (History of the Liu-Song dynasty, 420–479 C.E.), 4 vols. (Beijing: Zhonghua shuju, 1974), 93:2278–79; or Li Yanshou (active 618–676) et al., comps., *Nan shi* (History of the Southern Dynasties), 3 vols. (Beijing: Zhonghua shuju, 1975), 75:1861.

ENTRY 15. *Poem by Sun Ti*

54 This sixteen-line poem, titled "Respectfully harmonizing with the *Poem on the Landscape Mural in the Secretariat* by Minister of the Right Li," was composed sometime during the years 742 to 744 by the Tang dynasty scholar-official and poet Sun Ti (ca. 699–ca.761). Sun served in the imperial secretariat from 736 to 744, primarily under Li Linfu (died 752), who is best known for his fifteen-year tenure, from 737 to 752, as the extraordinarily powerful chief minister of Emperor Xuanzong (reigned 712–56). An imperial relative, Li was appointed to the prime ministerial position, Director of the Secretariat *(zhongshu ling),* on January 2, 737; the title of this position was changed to Minister of the Right *(youxiang)* on March 31, 742; and he continued to hold the title until his death on December 22, 752. Li Linfu's family included a number of famous artists, such as his uncle the painter Li Sixun (651–716), and he himself also achieved a measure of renown for his landscape painting. Judging from Sun Ti's text, Li Linfu, whose own now lost poem evidently served as a model for Sun, was the artist of the mural commemorated in this text. Bada Shanren's transcription of Sun Ti's poem differs from standard published versions of the text in several instances. For the standard text and a modern commentary, see Peng Dingqiu et al., comps., *Quan Tang shi,* 118:1195–96; and Kong Shoushan, ed., *Tangchao tihuashi zhu,* 55–57. For a brief notice on Lin Linfu as a painter, see William R. B. Acker, *Some T'ang and Pre-T'ang Texts on Chinese Painting,* 3 vols. (Leiden: E. J. Brill, 1954), 2:243–44.

This poem on a landscape painted by a member of the imperial clan may have held some special appeal for Bada Shanren, since he is known

to have transcribed it on at least three other occasions: a large hanging scroll (ca. 1698), which is also in the collection of the Freer Gallery of Art (see cat. entry 18); an album leaf (dated 1698) written in the same style of running-standard script seen here, now in the Asian Art Museum, San Francisco (see Wang and Barnhart, *Master of the Lotus Garden,* 182); and a horizontal hanging scroll written in running script (undated, but ca. 1697–98), in the Anhui Provincial Museum (see Wang Zhaowen, ed., *Bada Shanren quanji,* 2:462–63 [cat. no. 121]).

The current leaf originally belonged to a nine-leaf calligraphy album, seven other leaves from which are in the Freer collection; see catalogue entries 10, 11 (two leaves), 13, 14, 16, and 31. For a full list of that album's contents, see Wang and Barnhart, *Master of the Lotus Garden,* 269 (Appendix C, no. 106).

55 Lines 1–2: Translated here as "the halls of court," the first two characters of the poem, *miaotang,* are an abbreviation for two palace buildings dedicated to the veneration of the imperial ancestors. While in this instance the term may be a subtle reference to Li Linfu's status as a member of the Tang imperial clan, in practical usage the term simply serves as a general designation for the court. In line 2, the term *shanshui* (hills and streams, or landscape) refers not only to actual terrain, but also to paintings of landscape.

Lines 5–6: The place name Nine Rivers (Jiujiang) refers to a stretch of the Yangzi River near the modern town of the same name in Jiangxi Province, while the Three Gorges (Sanxia) are located higher along the Yangzi River as it passes from Sichuan into Hubei Province. Here, the use of these terms signifies the grand sweep of the mural painting.

Lines 11–12: Just like Li Linfu, the two men named in these lines were former directors of the imperial secretariat *(zhongshu ling),* and by naming them in his description of Li's painting, Sun Ti indirectly attributes their qualities to him. Xun Yu (163–212 C.E.) was said to be so fragrant that when he visited a home or sat on a pillow, the scent could be detected for three days afterward. Yue Guang (252–354 C.E.) was known both for his tolerant disposition and brilliance as a conversationalist. A contemporary once remarked: "This man is a *water mirror* to other men. Seeing him is like rolling away the clouds and mist and gazing at the blue sky [annotator's italics]," translation quoted from Richard B. Mather, trans., *Shih-shuo Hsin-yu,* 219, anecdote 8/23. For the Chinese text, see Liu Yiqing, *Shishuo xinyu,* 8A:113.

Line 13 alludes to a passage attributed to Confucius (551–479 B.C.E.) in the ancient Chinese divinatory text, the *Yijing* (Book of changes), which states: "In the Dao of the noble man / There's a time for *going forth* / And a time for *staying still,* / A time to remain silent / And a time to speak out [annotator's italics]." Translation quoted from Richard John Lynn, *The Book of Changes: A New Translation of the I Ching as Interpreted by Wang Bi* (New York: Columbia University Press, 1994), 58 and 217. For the Chinese text, see Hong Ye (William Hung) et al., eds., *Zhou Yi yinde* (A concordance to the Yi Ching), Harvard-Yenching Sinological Institute Index Series, supplement 10 (Beiping [Beijing]: Yanjing University Library, 1935), 41 (sect. 6, end).

Line 14 alludes to a passage in the seminal Daoist text, the *Daodejing*

(Book of the Way and its power), attributed to the ancient sage Laozi (Master Lao, ca. 6th century B.C.E.), which states: "What is most perfect seems to have something missing; yet its use is unimpaired. What is most *full* seems *empty,* yet its use will never fade [annotator's italics]." Translation by Arthur Waley, *The Way and Its Power: A Study of the Tao Tê Ching and Its Place in Chinese Thought* (London: George Allen & Unwin, 1934; 1965 edition.), 198. For the Chinese text, see Wang Bi (226–249 C.E.), *Laozi Daodejing zhu* (Commentary to *The Way and its power,* by Laozi), 2:28 (stanza 45), in *Zhuzi jicheng* (Compendium of works by famous masters) (Beijing: Zhonghua shuju, 1954; 1986 reprint), vol. 3.

Line 13 therefore means that poetry (and perhaps Li Linfu's poem in specific) describes the human condition, whether one participates in society or stays in private life, while line 14 means that paintings (and perhaps Li Linfu's painting in particular) depict the ebb and flow of nature. In other words, Li's poem and painting encompass both the human and natural worlds.

Lines 15–16: In this version, line 15 ends with the character *nian* (years), whereas the hanging-scroll version of this line ends with *chun* (springs); see catalogue entry 18. According to a note appended to some published versions of the poem, line 16 is a direct reaction by Sun Ti to a self-deprecating remark that appeared in Li Linfu's original poem. The line may also refer to the fact that in 744, Li was serving in his eighth year as chief minister.

ENTRY 16. *Poem by Du Fu*

56 This fifteen-line poem, titled "Song Playfully Inscribed on a Landscape Painting by Wang Zai," was composed in 760 by the Tang dynasty poet Du Fu (712–770), who was then residing in Chengdu, capital of Sichuan Province. There, he evidently had the opportunity to view an imposing work by the contemporary Sichuanese landscape painter Wang Zai (active mid- to late 8th century), and composed this poem. For a brief notice on Wang Zai, see William R. B. Acker, *Some T'ang and Pre-T'ang Texts on Chinese Painting,* 2:277–78.

This poem by Du Fu appears in numerous standard collections and anthologies, all of which agree with Bada Shanren's rendering of the text. For example, see Peng Dingqiu et al., comps., *Quan Tang shi,* 219:2305; and Kong Shoushan, ed., *Tangchao tihuashi zhu,* 124–26. For two previous English translations of the poem, see William Hung (Hong Ye), *Tu Fu: China's Greatest Poet,* 1:169–70 (poem 176); and A. R. Davis, *Tu Fu* (New York: Twayne Publishers, 1971), 138–39.

The current leaf originally belonged to a nine-leaf calligraphy album, seven other leaves from which are in the Freer collection: see catalogue entries 10, 11 (two leaves), 13, 14, 15, and 31. For a full list of that album's contents, see Wang and Barnhart, *Master of the Lotus Garden,* 269 (Appendix C, no. 106).

57 Line 5: The Kunlun mountain range, located in modern Xinjiang Province south of the Takla Makan desert, was traditionally believed to be the home of the mythological Xiwangmu (Queen Mother of the West) and her garden containing the peaches of immortality. In the

opposite direction, Fanghu was one of three mythological islands situated in the ocean east of China, where large numbers of immortal beings were said to dwell. The references to Kunlun and Fanghu may indicate that Wang Zai's painting actually included depictions of these two mythological paradises, or may simply be a case of poetic hyperbole, indicating that the painting depicted a broad swath of terrain from west to east.

Lines 7–8: Baling is an ancient name for the town of Yueyang, located on the northeastern shore of Dongting Lake in Hunan Province, near its outflow into the Yangzi River. Red Bluff (Chi'an) may refer to a now eroded hill that once stood on the north shore of the Yangzi River in Jiangsu Province, south of the modern city of Yangzhou. These place names again indicate the broad scope of the painting. The Silver Stream (Yinhe) is one of several common names given to the Milky Way, which is thought of in Chinese tradition as a celestial river.

Lines 14–15: Bingzhou is an ancient name for the city of Taiyuan, in Shanxi Province, which was evidently famous for its manufacture of sharp blades. Wusong Creek is the name of a river in Jiangsu Province that flows east from Taihu (Lake Tai), through the municipality of Shanghai, and empties into the Yangzi River near its mouth.

ENTRY 17. *Rubbing of the "Holy Mother Manuscript"*

58 The text of the "Holy Mother Manuscript" was composed in 793 by an unknown author to record the renovation of a Daoist temple dedicated to the Holy Mother of Dongling (Dongling Shengmu) near the modern city of Yangzhou (Jiangsu Province). Although unsigned, both the text and calligraphy were traditionally attributed to the famous Tang dynasty calligrapher and Buddhist monk Huaisu (ca. 725–ca. 799), who was renowned for his wild-cursive script, as seen in the rubbing. This association with Huaisu led to the preservation of the calligraphy in 1088 during the Northern Song dynasty when the text was carved onto a slab of stone, which still survives in the Beilin (Forest of Steles) in the city of Xi'an, Shaanxi Province. The original manuscript of the text was lost, but rubbings of the stone were produced soon after carving and have been made ever since. For a list of traditional commentaries on the subject, see Yang Dianxun, *Shike tiba suoyin* (Index of comments and colophons on stone inscriptions) (Shanghai: Shangwu yinshuguan, 1957), 693. On the calligraphy of Huaisu and a brief discussion of the attribution of this work to him, see Adele Schlombs, *Huai-su and the Beginnings of Wild-cursive Script in Chinese Calligraphy*, Münchener Ostasiatische Studien, Band 75 (Stuttgart: Franz Steiner Verlag, 1998), 149–50.

Judging from the placement of his three seals, the current rubbing evidently belonged to Bada Shanren and was the immediate source for his transcription of the text that follows on a separate sheet of paper. While it is not known if Bada himself considered the rubbing to date from the Song dynasty, the writers of the two labels affixed to the scroll believed it to be an early example from the period. Further study is required to accurately date the rubbing.

59 Bada Shanren's transcription of the text contains a number of omissions and anomalies. For example, in columns 4 and 11 of his transcription, Bada writes the character *hua* (to transform), while all other transcriptions read the original character as *ye* (copula) (Note: Bada correctly transcribes the character *hua* in column 19); and in columns 11 and 12 of his transcription, Bada twice writes the character *jiu* (old) instead of the correct character *yue* (to say, be called), thereby rendering the affected passage unintelligible. Over the course of the text, he also omits three individual characters and fails in two locations to indicate lacunae in the actual stone. While other transcribers of the text may vary at times, they are generally unanimous in their analysis of such characters and details. For those passages of Bada Shanren's transcription that are garbled, the translation follows the consensus of opinion recorded in the following six transcriptions:

1. Dong Qichang (1555–1636), *Xingshu shi "Shengmu tie" yice* (Album: Transcription of the "Holy Mother Manuscript," in running script), in *Shiqu baoji xubian* (Catalogue of the Qing imperial collection of painting and calligraphy, second series [1793]), comp. and ed. Wang Jie (1725–1805) et al., 7 vols. (Taipei: Gugong bowuyuan, 1971), 6:3309–10.
2. Zhang Tingji (1768–1848), *Qingyige tiba* (Inscriptions and colophons by Zhang Tingji) (China: privately published [Ding family], 1891), 144a–b (text) and 143a–144a (comments).
3. Lu Yaoyu (1771–1836), *Jinshi xubian* (Further studies in epigraphy) (China: Shuangbaiyantang, 1874), 9:18a–b (transcription directly from the stone) and 9:19a–b (comments).
4. Lu Zengxiang (1816–1882), *Baqiongshi jinshi buzheng* (Studies in epigraphy) (Beijing: Wenwu chubanshe, 1985), 741 (text) and 741–42 (comments).
5. Sugimura Kunihiko, *Kaiso Seibo chō* (The "Holy Mother Manuscript" by Huaisu), in *Shoseki meihin sōkan* (Compendium of famous works of calligraphy), vol. 191 (Tokyo: Nigensha, 1974), 24–45 (rubbing), 64–65 (discussion), and 67–68 (transcription).
6. Nakata Yūjirō, *Ri Yō, Chō Kyoku, Kaiso, Yō Gyōshiki* (Li Yong, Zhang Xu, Huaisu, and Yang Ningshi), in *Shodō geijutsu* (The art of calligraphy), ed. Nakata Yūjirō, vol. 5 (Tokyo: Chūō koronsha, 1976), 207–08 (transcription and discussion) and plates 134–39 (rubbing).

60 The first two-thirds of the "Holy Mother Manuscript" agree with and amplify the earliest biography of the Holy Mother, which was written by the medieval Daoist author Ge Hong (284–364 C.E., or 254–334 C.E.); see Ge Hong, *Shenxian zhuan* (Biographies of the immortals), 6:10b–11a, in *WSKQS*, disc 116. The last third provides information that is not contained in other sources. It mainly concerns the popularity of the Holy Mother's temple and briefly traces imperial support for the temple from its founding in the early 340s C.E. during the reign of Emperor Kang, to Emperor Yang of the Sui dynasty in the early seventh century, and finally to the 790s in the Tang dynasty.

In the rubbing text, two characters are evidently missing at the end of the passage concerning Emperor Yang of the Sui dynasty, perhaps owing to damage in the original manuscript prior to its carving onto stone. This lacuna in the text makes interpretation of the passage somewhat problematic. In the following passage, the term "nine sages" probably refers to the nine Tang emperors who had occupied the throne from the founding of the dynasty until the current emperor: i.e., from Emperor Gaozu (reigned 618–26) to Emperor Dezong (reigned 779–805), omitting the usurpation of Empress Wu Zetian (reigned 690–705).

After noting Tang imperial support for Daoism in general and the current need to renovate the Holy Mother's temple, the unknown author of the "Manuscript" states that his paternal uncle had taken up the task of repairing the temple, an act of patronage for which he will long be remembered. In his transcription of the text, Bada Shanren identifies this generous benefactor as someone bearing the name "Guo, Duke of Taiyuan"; however, most other transcribers interpret the relevant character *Guo* (surname) as *jun* (commandery) and simply read the phrase as "the duke of Taiyuan commandery" (located in northern Shanxi Province). In either case, the evidence is insufficient to further identify this individual, whose last named title ("Commissioner Supervising the Army of . . .") is also lacking two characters in the rubbing, probably for the same reasons suggested above.

Finally, while the original rubbing bears no artist's signature, Bada Shanren added to his transcription the purported signature of Cangzhen, an alternative name for Huaisu, thus clearly indicating that he accepted the traditional attribution of the calligraphy to the monk.

61 The *Autobiography* and *Thousand Character Essay* are two of Huaisu's best-known surviving works written in wild-cursive script. As here, Huaisu is sometimes referred to by the name of a temple where he stayed in his early years, the Lütian'an (Temple of the Emerald Sky), near modern Lingling, Hunan Province.

Zhang Zhi (active ca. 150–192 C.E.), also known as Youdao, is celebrated as one of the most important early masters of cursive script. He was the first to apply a consistent logic to cursive writing, and is considered the originator of the modern form. Zhang's family was from the frontier region of Jiuquan (near Dunhuang, in Gansu Province), but his father had been allowed to change his registration to a city in China proper.

Suo Jing (239–303 C.E.), known as You'an, was famous for his cursive script. His family was also from Jiuquan and he was a grandson of Zhang Zhi's older sister. In cursive script, Suo Jing applied himself to modifying and standardizing the forms previously devised by Zhang. The statement that Jiuquan became a dependent territory only after these men had left is historically inaccurate. Equally unclear is the association Bada Shanren draws between Zhang Zhi and Suo Jing on one hand, and Huaisu on the other, unless it is simply to note that Huaisu's cursive script historically derives from theirs.

62 Several early Qing sources record a seventeenth-century Ming loyalist by the name of Yang Chunhua, but judging from the details of his

biography, the colophon-writer of the same name must have been a different person and remains unidentified. For a biography of the Ming loyalist, see Sun Huanjing (late 19th–early 20th century), *Ming yimin lu* (Records of Ming loyalists) (Hangzhou: Zhejiang guji chubanshe, 1985), 163–64.

63 The collectors who owned twenty-two of these twenty-five seals have been identified. Five seals, belonging to one unidentified and three identified owners, appear only on the rubbing and not the transcription and colophon. Three of these belonged to Bada Shanren himself, who was apparently the earliest owner of the rubbing to apply his seals. One seal may have belonged to Bada's contemporary, the poet and epigrapher Zhu Yizun (1629–1709), but could also have been applied by one of Zhu's descendants, while the fifth seal may have belonged to the younger scholar Shen Tong (1688–1752), whose sobriquet was Guotang; however, this identification remains uncertain since no comparable seals belonging to Shen have been located.

Three other seals on the scroll belonged to the as yet unidentified collector Li Puquan (19th–20th century?), who applied two seals on the rubbing and one on Bada Shanren's transcription, the earliest collector seal to appear there. He was evidently a collector of Bada's works, for three of his seals also appear on the hanging-scroll landscape, "Five Pines Mountain" (see cat. entry 24 and note 80).

The remaining fourteen seals on the handscroll all belonged to twentieth-century collectors: five belonged to Lin Xiongguang (1898–1971), who may have taken the scroll to Japan, and four to the collector Cheng Qi, who also resided for much of his life in Japan and first published the scroll; see Cheng Qi, *Bada Shanren shuhua ji*, plate 1 (rubbing), plates 1.1–2 (Bada's transcription), and plate 1.3 (Bada's colophon). Wang Fangyu acquired the scroll from Cheng Qi, and most recently published it along with comments in Wang Fangyu, *Bada Shanren fashu ji*, 2:4–13, esp. page 6. See also Wang's earlier discussion in "Bada Shanren de shufa," in *Bada Shanren lunji*, ed. Wang Fangyu, 1:397–98.

ENTRY 18. *Poem by Sun Ti*

64 For discussion of this poem, see catalogue entry 15 and relevant notes. See also Wang and Barnhart, *Master of the Lotus Garden*, 183–84 (cat. no. 55, fig. 108).

ENTRY 19. *Crouching Cat*

65 Bada Shanren made several paintings of cats. For a study that includes this scroll, see Wang Fangyu, "Bada Shanren's *Cat on a Rock: A Case Study*," *Orientations* 29 (April 1998): 40–46.

66 Wu Hufan (1894–1968) was an important painter, connoisseur, and collector of Chinese painting during the mid-twentieth century. As here, works that were once part of his collection frequently bear seals with both his own name and that of his wife, Pan Jingshu.

ENTRY 20. *Copy of the "Half-Stele of Xingfu Temple"*

67 During the Wanli reign period (1573–1619) of the Ming dynasty, a dredging project in the moat outside the southern wall of Chang'an (modern Xi'an, Shaanxi Province) exposed a broken grave stele from the Tang dynasty, which contains the text that Bada Shanren transcribed in this album. The forms of the individual characters on the stone were ostensibly copied from authentic examples of running script by the famous calligrapher Wang Xizhi (ca. 303–ca. 361 C.E.). In his postscript, Bada quotes the first two half-columns of the stele text, which record that the stone originally stood on the grounds of the Xingfu Temple (located a short distance south of the city), and that an otherwise unidentified Buddhist monk named Daya was responsible for selecting, copying, and rearranging Wang's original characters into a new text.

After its excavation, the broken stone was placed in the Forest of Steles (Beilin) in Xi'an, where it remains to this day. Analysis reveals that the stele originally contained thirty-five vertical lines of text with some fifty characters in each; however, only the bottom portion of the stone survived at the time of its discovery and each column of text was cut roughly in half, leaving three columns of text entirely blank and the remainder containing just twenty-three to twenty-five characters each. While these losses render a coherent reading, or translation, of the text impossible, numerous scholars and epigraphers have recognized the stele as one of the finest surviving examples of Wang Xizhi's calligraphy in running script as it was understood and practiced during the Tang.

The stele was evidently carved as a tomb memorial for an individual whose surname does not appear in the surviving text, but who in 707 attained two relatively important military ranks in the imperial palace. The last clear date on the stele is November 17, 721, which may have been around the time that the man died and the stone was carved. A misreading of the emphatic particle *yi* in the fifth column of the stele led some early commentators, such as Zhao Han (active 1590s–after 1618) and Guo Zongchang (late 16th–early 17th century), to believe that the subject of this grave memorial was surnamed Wu, an error that continued to influence many discussions of the stele throughout the Qing dynasty and that was followed by Bada Shanren in his transcription of the text. However, another Ming dynasty scholar and epigrapher, An Shifeng (1558–after 1630), correctly read the character in question and noted that the man's surname does not in fact appear, a conclusion confirmed by all modern scholars of early Chinese writing. See Wang Chang (1725–1806), *Jinshi cuibian* (Compiled comments on metal and stone inscriptions) (China: Qingxuntang, 1805), 73:20a–21a.

While Bada Shanren's interest in this text was based on its calligraphic pedigree leading back to Wang Xizhi, he actually executed this album in his own style of running-standard script, rather than as a close imitation of Wang's calligraphy. Bada's usage of the word "copy" is problematic and clearly means something other than the usual definition. For other examples, see catalogue entries 6, 31, and 32; and notes 10, 97, 102, and 103.

Bada Shanren wrote the *Half-Stele* as a continuous whole and did not indicate breaks between the original columns of text or other lacunae. His transcription differs in many instances from both the actual stele text and other available transcriptions, occasionally adding characters that do not appear on the original stone, omitting some characters, and mis-transcribing others. Despite these shortcomings, Bada's personal rendition of the text is apparently among the earliest calligraphic transcriptions of the stele known to survive. The following four published transcriptions, three of which are accompanied by rubbings of the original stone, were consulted in preparing the Chinese text of this album: Wang Chang, *Jinshi cuibian,* 73:18a–20a (apparently the earliest published transcription of the stele); Matsui Joryū, "Kōfukuji danpi" (The half-stele of Xingfu Temple), in *Shohin* 83 (October 1957): 67–70 (discussion and transcription), and plates 1–28 (rubbing in album format); Fushimi Chūkei, "Ō Gishi Kōfukuji danpi" (Wang Xizhi's "Half-Stele of Xingfu Temple"), in *Shoseki meihin sōkan* (Compendium of famous works of calligraphy), vol. 73 (Tokyo: Nigensha, 1969), full rubbing of existing stele together with rubbing in album format, plus discussion and transcription; and Liu Tao, ed., *Zhongguo shufa quanji 19. Sanguo, Liang Jin, Nanbeichao: Wang Xizhi Wang Xianzhi, juan er* (Complete Chinese calligraphy, volume 19. Three Kingdoms, Two Jin Dynasties, and Northern and Southern Dynasties: Wang Xizhi and Wang Xianzhi, part 2) (Beijing: Rongbaozhai, 1991), 216–35, plates 129:1–20 (rubbing in album format), and 409–11 (comments and transcription).

The Bada Shanren album has been published twice in full, however the leaves are out of order in both cases. See Wang Fangyu, *Bada Shanren fashu ji,* 2:17–27 (with discussion); and Wang Zhaowen, ed., *Bada Shanren quanji,* 4:826–33 (cat. no. 83).

68 Little is known about the colophon writer Tang Yunsong, other than the fact that he hailed from the city of Nanfeng, in Jiangxi Province, and received his *jinshi* (advanced scholar) degree in 1840. Tang mistakenly claims that Bada Shanren was the grandson of Prince Yi, in this case probably Zhu Youben (active 1615–after 1646), who was the sixth and last individual to hold this princely title, which he inherited from his father in 1615. The Yi princedom was located in the city of Jianchangfu (modern Nancheng), on the Xujiang River in eastern Jiangxi Province. In fact, there is no indication that Bada ever settled in either in the town of Jianchang or the Xujiang area in general, and recent scholarship has established an entirely different line of descent for Bada Shanren—from the Yiyang branch of the Ning princedom in Nanchang, Jiangxi Province. For a review of modern scholarship on the subject of Bada's name and lineage, see Wang and Barnhart, *Master of the Lotus Garden,* 24–30 and 37.

The term, "Two Wangs," refers to the father and son calligraphers, Wang Xizhi (ca. 303–ca. 361 C.E.) and Wang Xianzhi (344–388 C.E.).

ENTRY 22. *Poem by Geng Wei*

69 This twelve-line poem, titled "Inscribed at Clear Springs Temple," was composed by the Tang dynasty poet Geng Wei (active mid- to late 8th century), who is best known as one of the Ten Talents of the Dali Period (766–79). Geng wrote this poem during a visit to the Clear

Springs Temple (Qingyuan si), located on the Lantian estate of the recently deceased statesman and nature poet Wang Wei (ca. 701–761), who is the actual subject of the poem. Situated along the Wangchuan (Wheel Rim Creek) in the foothills of the Qinling range south of the Tang imperial capital of Chang'an (modern Xi'an, Shaanxi Province), Wang Wei's country estate subsequently became one of the most celebrated spots in Chinese cultural history. He built a villa there for the comfort of his elderly mother and, being a devout Buddhist, when she passed away he established the Clear Springs Temple in her memory. On his own demise, the poet himself was interred on the temple grounds next to her. Wang wrote many famous poems about his estate and is also credited with a painting of the local landscape that inspired generations of later painters. Bada Shanren's transcription of Geng Wei's poem differs in several places from the texts found in standard anthologies. For example, see: Li Fang (925–996) et al., comps., *Wenyuan yinghua* (Bright blossoms in the garden of literature, 987), 6 vols. (Beijing: Zhonghua shuju, 1966; 1990 edition), 2:1572–73 [307:3b-4a], and Peng Dingqiu et al., comps., *Quan Tang shi,* 269:2995–96.

Bada wrote Geng Wei's poem on at least one other occasion: Leaf b, running-standard script (dated 1698), in a sixteen-leaf album in the Asian Art Museum, San Francisco. For a discussion of this album, see Wang and Barnhart, *Master of the Lotus Garden,* 181–83 (cat. no. 54; fig. 107) and 229–30.

70 Line 1: "Ruism" refers to the philosophy of Confucius, who stressed the values of humaneness, social order, and duty. "Moism" refers to the philosophy of Mozi (Master Mo, or Mo Di, ca. 480–ca. 420 B.C.E.), who preached an ascetic doctrine of universal love and social welfare, with an emphasis on agriculture and strict avoidance of excess. Wang Wei was famous for balancing these philosophies with his personal devotion to Buddhism, the "Holy Religion."

Line 3: Meng Wall Cove was one of the famous sites on Wang Wei's estate.

Line 5: The term "inner teachings" refers here to Buddhism.

Lines 9–10: "Golden earth" refers to the site of a Buddhist temple or monastery. The line simply means that Wang Wei's mortal remains are buried at the Clear Springs Temple. The Stone Canal is a reference to one of the official libraries located on the grounds of the imperial palace. Many of Wang Wei's poems and other writings were lost during the troubles of the late 750s. Thus, when his younger brother Wang Jin (died 781) later served as a minister to Emperor Daizong (reigned 763–80), he was instructed to collect his brother's surviving works. Although many were scattered and lost, Wang Jin managed to gather more than four hundred poems to present to the emperor. See Liu Xu et al., comps., *Jiu Tang shu,* 190C:5053.

Line 12: When the scholar and high official Cai Yong (133–192 C.E.) was serving at court late in his life, the promising teenage poet Wang Can (177–217 C.E.) came for a visit. Cai Yong was so impressed by the youth that he instructed his household to transfer all his books and documents to Wang. See Chen Shou (233–297 C.E.), comp., *Sanguo zhi*

(Record of the Three Kingdoms period, 221–280 C.E.) (Beijing: Zhonghua shuju, 1959; 1973 edition), 21:597.

ENTRY 23. *Peonies*

71 The theme of this poem and accompanying painting is the *shaoyao* peony *(Paeonia lactiflora),* an extremely popular garden plant in China. Bada Shanren evidently created this work on the annual celebration of the Birthday of Flowers, a festival that occurs on the twelfth day of the second lunar-month, in response to a poem by a friend.

Lines 1–2: In line 1, the "classics" refer to a particular group of ancient texts that collectively comprise the headwaters of mainstream Chinese culture and constitute its earliest literature, history, and philosophy. Originally composed during the Zhou dynasty (1050–221 B.C.E.), many of these early texts only received their current form during the subsequent Han dynasty (206 B.C.E.–220 C.E.), when they were formally elevated to canonical status and scholars began to compile critical glosses and commentaries. The name of Shaobo (Lord Shao, 11th–10th century B.C.E.), a worthy minister of the early Zhou, appears in several of the ancient classics; in particular, in the three stanzas of the poem "Gantang" (Sweet pear), in the *Shijing* (Classic of Poetry, *Mao* 16), where he is said to have "taken shelter," "rested," and "reposed" beneath this tree, also known as *tangli (Pyrus betulifolia).* While there is no apparent association between Lord Shao and feasting, the *gantang* blooms during the second lunar-month, which corresponds to the time of year when Bada created this poem and painting; i.e., the Birthday of Flowers, when friends would traditionally get together and write poems about the season.

The *haitang* (crabapple; *Chaenomeles lagenaria,* or *Malus micromalus),* which was evidently the topic of a poem by Bada Shanren's unidentified friend, Mister Kezhai, is one of the most spectacular flowers to bloom during the second lunar-month. It also shares the second character of its name with *gantang,* which may have provided a connective association with Lord Shao. In any case, in these two lines, Bada is simply saying: I have looked diligently through the records of antiquity and can find no record of a feast as fine and sumptuous as the one we are enjoying today on the Birthday of Flowers, when the pear and crabapple are in bloom.

Lines 3–4: The *shaoyao* peony begins to bud in the second lunar-month, but only blossoms fully during the fourth lunar-month. In these lines, Bada symbolically sends the budding peony (i.e., this painting) to remind Mister Kezhai and others that in just a few weeks it will blossom even more splendidly than even the crabapple, sweet pear, and other second-month flowers (If you think the flowers we are enjoying today are glorious, just wait a few weeks until the peonies are in bloom!). Natural messengers bearing this sort of "news" are a common trope in Chinese poetry.

Shen Tonglü commented on this poem in his article, "Shishi Bada Shanren tihuashi" (Explanations of Bada Shanren's poems on paintings), in *Bada Shanren yanjiu* (Studies on Bada Shanren), ed. Bada Shanren jinianguan (Nanchang: Jiangxi renmin chubanshe, 1986), 136–37. The

poem is also annotated in Zhu Anqun and Xu Ben, *Bada Shanren shi yu hua* (Poems and paintings of Bada Shanren) (Wuchang: Huazhong ligong daxue chubanshe, 1993), 51–2. These commentators directly tie the *shaoyao* peony to the city of Yangzhou, with which it is traditionally associated, and advance a complex argument to arrive at a somewhat different interpretation of the allusions in the poem. Wang Fangyu agreed with their general argument and added further comments; see Wang Fangyu, *Bada Shanren fashu ji,* 2:34. For a previous translation of the poem, see Wang and Barnhart, *Master of the Lotus Garden,* 36–37. The poem is also recorded in Wang Zidou, *Bada Shanren shichao,* 41.

72 Bada Shanren painted this scroll in an unspecified year on the annual celebration of the Birthday of Flowers (see above). If Wang Fangyu is correct in dating this work, then the day in question was either March 13, 1699, or April 1, 1700.

This painting was once owned by Zhang Daqian (1899–1983), who along with his brother Shanzi (1882–1940), added five seals to the scroll. Zhang published a photograph of the work in his *Dafengtang mingji,* vol. 3, plate 7, and a transcription of Bada's poem and seals in his *Dafengtang shuhua lu* (Record of calligraphy and painting in the Dafengtang collection) (China: privately published, 1943), 46b.

ENTRY 24. *Five Pines Mountain*

73 The outside label written by Zhang Daqian, also known by his studio name Dafengtang (Hall of Great Wind), provides the only recorded title for this landscape painting. Bada Shanren seldom gave formal titles to his paintings and rarely depicted specific geographical locations, so in all likelihood this is simply a descriptive title invented by Zhang. The composition of this ink-and-color painting, with its odd perspective created by the overhanging cliff at top right, is closely related to a second landscape by Bada titled "Pavilion in the Autumn Woods," in the Shanghai Museum of Art. See Wang Zhaowen, ed., *Bada Shanren quanji,* 3:518 (cat. no. 142; hanging scroll, 1699).

74 Attached to the mounting at the lower left of the painting, this colophon was written in May/June 1917 by Ye Dehui (1864–1927), a scholar, calligrapher, bibliophile, and conservative politician from Changsha, Hunan Province. Judging from Ye's comments, the painting was acquired in Changsha and had been in his possession since the early to mid-1890s. Ye Dehui also included a general description and discussion of this painting in notes to his *Guanhua baiyong* (One hundred poems on paintings I have seen) (China: Yeshi Guangutang, 1917), 4:2b.

75 Zhang Geng (1685–1760), also known as Pushan, was a painter, connoisseur, and author of several books on contemporary painters and painting, among them the *Guochao huazhenglu* (Records on painters of the Qing dynasty), in which he discusses some 465 seventeenth- and early-eighteenth-century artists. As noted by Ye Dehui, Zhang arranged the artists in this book more or less by date of birth, with the exception of Bada Shanren, who anachronistically appears as the first entry. See

Zhang Geng, *Guochao huazhenglu* (Records on painters of the Qing dynasty, preface 1739), in *Zhongguo shuhua quanshu* (Complete writings on Chinese calligraphy and painting), comp. Lu Fusheng et al., 10:425.

76 Qiu Yueju (active 1717–34) came from a scholar-official family of Xinjian (modern Nanchang), Jiangxi Province. He passed the provincial examinations in 1717 and later served as a county magistrate in Guangdong Province. Qiu's specific connection with Bada Shanren is not certain, but probably reaches back to the previous generation, when other members of his clan, such as Qiu Lian (1644–1729), counted themselves among Bada's closest friends.

77 Ye's usage of the term *fanbi,* translated here as "backward strokes," is unclear. While it would seem to mean brushstrokes that are executed in opposite the usual fashion (from bottom to top, for example), careful scrutiny of the painting reveals that this is not the case. Ye Dehui's main point, which he reiterates in his *Guanhua baiyong* (see note 74), seems to be a presumed correlation between the manner of Bada Shanren's brushwork and the emotional distress of his social and political circumstance as a surviving member of the imperial clan of the defunct Ming dynasty.

78 Jieqing remains unidentified.

79 Ye Dehui is apparently referring to the well-known Southern Song dynasty work, the *Dongtian qinglu ji* (Pure records from the cavern heaven), by Zhao Xigu (ca. 1170–after 1242), which contains a collection of random entries on various types of collectible art objects, such as zithers, inkstones, and ancient bronzes, as well as rubbings, paintings, and calligraphy. What he is actually saying, however, and how this reference relates to Jieqing is unclear.

80 Li Puquan remains unidentified; however, his collector seals also appear on both the rubbing and Bada Shanren's transcription of the "Holy Mother Manuscript" (see cat. entry 17 and note 63).

81 The collector seals of Wang Wenxin (19th–20th century) appear on a number of other works by Bada Shanren: for example, see Wang Zhaowen, ed., *Bada Shanren quanji,* 1:162–69 (cat. no. 23; calligraphy handscroll, 1688); 2:412–13 (cat. no. 102; painting handscroll, 1696); 3:596–605 (cat. no. 182; painting album, 1702); and 3:696–702 (cat. no. 9; calligraphy album, undated, but ca. 1684).

ENTRY 25. *Poem by Bai Juyi*

82 This thirty-four-line poem, titled "Three Friends of the Northern Window," was written in 834 by the famous Tang dynasty poet Bai Juyi (772–846). Bada Shanren's transcription of the poem disagrees with standard printed versions of the text in several instances, four of which significantly alter the meaning of the lines in which they occur. In particular, Bada reversed the words for "wine" and "poetry" in lines 15 and 17, creating an infelicitous reading of the text. See: Peng Dingqiu et al.,

comps., *Quan Tang shi*, 452:5115; and Bai Juyi, *Bai Juyi ji jianjiao* (Collected works of Bai Juyi, with notes and variants), ed. Zhu Jincheng (Shanghai: Shanghai guji chubanshe, 1988), 29:2030–31. For a discussion of these three leaves, see Wang Fangyu, *Bada Shanren fashu ji,* 2:39.

Bada Shanren transcribed this poem on at least one other occasion, some three and a half years after he wrote the Freer album leaves; see Gao Yong (1850–1921), *Taishan Canshilou canghua,* 32:3 (hanging scroll in running-standard script, dated November–December, 1703). In this later version, the only known work of his calligraphy dated to the year 1703, Bada also wrote lines 15 and 17 with the same reversal of characters that appears in the Freer leaves (see below), suggesting that he was working from memory and may simply have mis-remembered the poem in this way.

83 Line 15: Tao Qian (365–427 C.E.), courtesy name Yuanming, was one of the most popular and influential poets in the history of China. He chose to live in poverty rather than serve in the corrupt government of his time. While Tao was famous for his fondness for wine, all standard versions of Bai Juyi's poem have the word "poems" here instead of "wine." Although both readings make sense in regard to Tao, it is clear that Bada Shanren has reversed the word "wine" with the word "poems" in line 17 (see below).

Line 16: Rong Qiqi (6th century B.C.E.) was a poor recluse who lived near Mount Tai, in Shandong Province. Confucius once met him dressed in a deerskin and with only a rope for a belt, happily singing and playing his *qin* (translated here as "lute"). When Confucius asked why he was so happy, Rong replied that he had three reasons: he was happy to have been born human, happy to be male, and happy to have reached the age of ninety: "For all men poverty is the norm and death is the end. Abiding by the norm, awaiting my end, what is there to be concerned about?" Confucius then commented, "He is a man who knows how to console himself." Quotations from A. C. Graham, trans., *The Book of Lieh-tzu* (London: John Murray, 1960; 1973 edition), 24; for the Chinese text, see Yang Bojun, comp., *Liezi jishi* (Collected explanations of the *Liezi*) (Beijing: Zhonghua shuju, 1979), 22.

Line 17: Liu Ling (died after 265 C.E.), courtesy name Bolun, was a famous drinker, and belonged to a mid-third-century group of eccentric poets and musicians, who were celebrated in history as the Seven Sages of the Bamboo Grove. Although Liu once composed a "Eulogy on the Virtue of Wine" *(Jiude song),* he produced no other written works. In this line, all other consulted versions of Bai Juyi's poem read the word "wine" instead of "poems." Since Liu Ling was famous for having no interest in verse and *not* writing poetry, it is clear that Bada Shanren reversed the word "poems" with the word "wine" in line 15 (see above).

Line 19: This line might well apply to all three men in lines 15–17, but here it specifically refers back to Tao Qian (Yuanming), in line 15.

Line 20: This line refers back to Rong Qiqi in line 16.

Lines 29–30: It became fashionable during the Tang dynasty to fold stationery into columns before starting to write, thus enabling the writer to keep his text vertically straight and evenly spaced. In these lines, Bai Juyi is simply saying that he is too inebriated to go through the formality of preparing the paper properly, and just lets his brush spontaneously write any crazy thing that occurs to him.

84 This sentence is difficult to understand as written and may suffer from a missing character.

85 For other works by Bada Shanren with the same unidentified *chun* (rectangle relief) seal in the lower right corner, see Zhang Daqian, *Dafengtang mingji,* vol. 3, plates 24–28 (album of ten leaves, eight leaves with *chun* seal, one of which bears a date corresponding to May 5, 1700, around the same time Bada created the current set of leaves). Four leaves from this album now belonging to the Museum für Ostasiatische Kunst in Köln are discussed in Wang and Barnhart, *Master of the Lotus Garden,* 192–94 (cat. no. 61, fig. 114).

ENTRY 26. *Cedar Tree, Day Lily, and Wagtails*
86 The descriptive title for this painting was provided in an outside label by the collector Zhang Daqian, who acquired the scroll sometime after 1949, according to one of his seals. While it is unknown if Bada Shanren would have called this work by the same title, the painting does appear to be a kind of visual rebus. In traditional Chinese culture, the *chun* (cedar; *Cedrela sinensis, Juss.)* is primarily revered for its great longevity. The tree also stands as a metaphor for one's father, especially when used in conjunction with the day lily *(xuan),* as here. The *xuan* (day lily; *Hemerocallis fulva)* is a common Chinese garden plant. From early times, it was popularly known by the name "forgetting sorrow" (see also cat. entry 14, line 17 of poem and note 52), but when used in conjunction with the word for cedar *(chun),* the day lily commonly stands for one's mother. In literature and painting, the *jiling* (wagtail; *Motacilla chinensis)* is often used as a metaphor for brothers, both older and younger. To the extent that these meanings are applicable here, the painting forms a portrait of a happy family. For additional discussion of this painting, see Wang and Barnhart, *Master of the Lotus Garden,* 194–96 (cat. no. 62, fig. 117).

ENTRY 27. *Two Geese*
87 Geese were an important subject in the painting of Bada Shanren during his later years, and have always ranked as one of his most popular themes among collectors. For a brief discussion of the theme, see Wang and Barnhart, *Master of the Lotus Garden,* 196. Other versions of this basic composition exist; for example, see Wang Zhaowen, ed., *Bada Shanren quanji,* 3:549 (cat. no. 162).

The current work is closely related to a group of other paintings of geese, such as: Wang Zhaowen, ed., *Bada Shanren quanji,* 3:544 (cat. no. 157; two geese, undated); 3:553 (cat. no. 166; four geese, undated); 3:583 (cat. no. 180; two geese, undated); 3:609 (cat. no. 184; two geese, dated 1702); 3:625 (cat. no. 193; four geese, undated); 3:640 (cat. no. 205; six geese, undated); and 4:807 (cat. no. 7; four geese, dated 1698). See also

Wang and Barnhart, *Master of the Lotus Garden,* 278, Appendix C, no. 174 (six geese, dated 1705); and 279, Appendix C, no. 177 (four geese, dated 1705).

ENTRY 28. *Four Tang Poems*

88 These four calligraphy scrolls are basically uniform in their physical dimensions, style of running-cursive script, signatures, and seals, and were presumably created around the same time. In composition, scrolls 1 and 2 present texts of five-character verse written in two columns of fourteen and six characters each, while scrolls 3 and 4 contain texts of seven-character verse distributed over three columns: thirteen, twelve, and three characters; and twelve, thirteen, and three characters, respectively. All four of the scrolls contain Tang dynasty poems that are essentially generic in nature and were originally composed for specific social occasions, such as parting, sightseeing, and offering congratulations. Scroll 1 contains a teasing poem of farewell, with an underlying theme of escape from the mundane world; scroll 2 contains an equally light-hearted poem on the well-worked metaphorical theme of climbing high to see far; and scrolls 3 and 4 celebrate successfully passing the national examinations. Three of the quatrains (scrolls 1, 2, and 3) are among the best-known and most frequently anthologized poems in Chinese literature.

Bada Shanren produced a number of other individual hanging scrolls that bear quatrains of either five- or seven-character verse and closely resemble the current set of works in composition, style of script, signature, and seals. One work in particular, in the Palace Museum in Beijing, is virtually a companion to scrolls 3 and 4 of the current set. Marginally larger in its recorded dimensions (177.5 x 45.5 cm), the scroll contains a farewell quatrain in seven-character verse by the Tang dynasty poet Zhang Yue (667–731). The scroll is written in the same style of running-cursive script and uses the same basic distribution of characters over three columns (13, 12, 3), has the same style of signature, and bears the same three seals (plus one additional seal); see Wang Zhaowen, ed., *Bada Shanren quanji,* 3:619 (cat. no. 187). Two smaller hanging scrolls of roughly the same size (147 x 40.7 cm and 148 x 39 cm) also bear quatrains in seven-character verse by the Tang poets Li She (early to mid-9th century) and Du Mu (803–852); see Wang Zhaowen, ed., *Bada Shanren quanji,* 3:622 (cat. no. 190) and 4:807 (cat. no. 72). Other related hanging scrolls contain quatrains in seven-character verse by Bada Shanren himself; see Wang Zhaowen, ed., *Bada Shanren quanji,* 3:543 (cat. no. 156, undated; first line taken from the Tang poet Qian Qi [ca. 722–ca. 780]); 3:618 (cat. no. 186, dated 1702); 3:638 (cat. no. 203); and 4:781 (cat. no. 57). For a smaller work of five-character verse by Bada Shanren that is written in the same style of script, uses the same distribution of characters over two columns (14, 6), and bears the same signature and seals as scrolls 1 and 2 in the current set, see Wang Zhaowen, ed., *Bada Shanren quanji,* 3:628 (cat. no. 196); and for a related quatrain in four-character verse with the same signature and seals, see 3:627 (cat. no. 195).

The current arrangement of the four scrolls follows the order pub-lished in Zhang Daqian, *Dafengtang shuhua lu,* 43a–44b. For a different arrangement, see Wang and Barnhart, *Master of the Lotus Garden,* 206–8 (cat. no. 68, fig. 126), where the four scrolls are presented in reverse order as a suite of texts following a particular thematic sequence; see also Wang Fangyu, *Bada Shanren fashu ji,* 1:44–45.

89 Liu Changqing (ca. 710–after 787) was one of the most important and popular poets in the Tang capital during the mid- to late eighth century. Bada Shanren's version of this well-known quatrain completely agrees with standard published versions. For example, see Peng Dingqiu et al., comps., *Quan Tang shi,* 147:1481.

90 Wozhoushan (Fertile Isles Mountain) is located east of Xinchang, Zhejiang Province. The mountain was closely associated with the famous fourth-century monk Zhidun (314–366 C.E.), who founded a temple there. Zhidun once approached another monk about acquiring a mountain ridge to build a hermitage, and received the teasing reply that the recluses of antiquity were not known for acquiring land before retreating from the world. In this poem, Liu Changqing simply advises his Buddhist friend to avoid such well-known haunts as Wozhoushan if he truly wishes to escape the trammels and encumbrances of the world. For an English translation of the anecdote about hermits purchasing land, see Richard B. Mather, trans., *Shih-shuo Hsin-yü,* 412–13 (anec-dote 25/28).

91 Wang Zhihuan (688–742) was a highly regarded poet during his lifetime; however, only six of his poems have survived, all well-known quatrains. According to its title, this poem was composed on climbing the Guanquelou (Hooded Crane Tower), a three-story tower on the southwest city wall of Puzhou (modern Yongji, Shanxi Province). The site was located below high mountains on a bluff extending into the east side of the Yellow River as it flows south. The tower was a popular viewing place during the Tang dynasty and a number of other contem-porary poets also composed poems on climbing it. On Wang Zhihuan and his poetry, see Stephen Owen, *The Great Age of Chinese Poetry: The High T'ang* (New Haven: Yale University Press, 1981), 91–92 and 247–48 (with translation and brief explication of this poem).

This quatrain was often anthologized and appears in at least twenty-seven major Tang to Qing dynasty compilations. In about a third of these works, including an early poetry anthology compiled during the Tang (744), the poem is attributed to an individual named Zhu Bin, a virtually unknown contemporary of Wang Zhihuan. Bada does not name the poet of this quatrain, so it is uncertain whether he believed the author of the poem to be Wang or Zhu. In any case, his transcrip-tion entirely agrees with standard printed versions of the text. For attri-butions to Wang Zhihuan, see: Li Fang et al., comps., *Wenyuan yinghua,* 2:1604 [312:7a]; and Peng Dingqiu et al., comps., *Quan Tang shi,* 253:2849. For attributions to Zhu Bin, see: Rui Tingzhang (8th cen-tury), comp., *Guoxiu ji* (A poetry anthology, 744), 3:9b, in *WSKQS,* disc 146, or *Tangren xuan Tang shi, shizhong* (Tang poems selected by Tang compilers, ten examples), 2 vols. (Shanghai: Shanghai guji chubanshe,

92 Meng Jiao (751–814) is generally known as a rather bleak poet, who was often given to strange and jarring imagery. In 792 and again in 793, he sat for and failed the *jinshi* (advanced scholar) examinations for entry to the ranks of government, but succeeded in passing on his third attempt in 796, which was the occasion for his composing this straight-forward, ebullient quatrain. The poem remains one of the best-known graduation pieces in the Chinese language.

This quatrain appears in numerous traditional anthologies and compilations. Certain characters in each line have known variants, four of which are employed by Bada Shanren. Although every variant that appears in Bada's version of the text also occurs in at least one of the standard sources, his specific version of the text as a whole is apparently unique. See Meng Jiao (751–814), *Meng Dongye shiji* (Collected poetry of Meng Jiao), comp. Song Minqiu (1019–1079), 3:13a, in *WSKQS,* disc 118; and Peng Dingqiu et al., comps., *Quan Tang shi,* 374:4205.

93 The text selected by Bada Shanren for this scroll comprises the first four lines of an eight-line poem in regulated verse *(lüshi)* by the little-known, late-Tang poet Li Bo (active 870s–880s). Li wrote the poem both as congratulations and a light jest to his friend Pei Tingyu (active 880s–890s), who passed the national examinations for the *jinshi* (advanced scholar) degree sometime during 881 to 885, when the capital was occupied by rebel forces, and the imperial court was in exile in Sichuan Province.

This poem appears in at least five traditional anthologies. Bada Shanren employed two variant characters in line 2, one of which may be original to him, but neither of which substantially changes the meaning of the line. All standard sources print the entire eight-line poem, and not just the first four lines, as quoted by Bada Shanren. See: Wang Dingbao (870–after 954), comp., *Tang zhiyan* (Collected sayings from the Tang dynasty), 3:8b, in *WSKQS,* disc 113; Ji Yougong (*jinshi* 1121), comp., *Tangshi jishi* (Tang poems and related anecdotes), 61:4b–5a, in *WSKQS,* disc 162; and Peng Dingqiu et al., comps., *Quan Tang shi,* 667:7636–37.

94 In line 1, Tongliang (Bronze Bridge) is the name of a location in Sichuan Province and stands here for the province as a whole. The "Purple Palace" in line 2 is the Chinese name for a constellation that surrounds the pole star and is the residence of the celestial emperor. Accordingly, the term is often used as an alternative name for its terrestrial counterpart, the residence of the Chinese emperor on earth. While the celestial emperor was served by immortals, the Chinese emperor was served by officials selected from the ranks of successful degree candidates. The "list of immortals" in line 2 therefore signifies the roster of successful candidates in the national examinations, many of whom will receive positions at court or other government appointments. In sum, the four lines congratulate Pei Tingyu on his successful completion of the exams, which will surely lead to a glorious career.

ENTRY 29. *Jade Hairpin Blossoms* and *Excerpt from the "Sequel to the Treatise on Calligraphy"*

95 This hanging scroll is composed of two album leaves mounted one above the other: a painting of jade hairpin blossoms on the bottom and a leaf of calligraphy on top. The subject of jade hairpin flowers and the text of the calligraphy leaf have no ascertainable thematic relationship. While it is not known if the two album leaves were originally paired together or were joined at a later time, this incongruity between text and image is not unusual in Bada's works. The only clear relationship between the two leaves is the complementary style of brushwork, in which both the painting and the calligraphy were executed.

In Western botanical nomenclature, the jade hairpin flower *(yuzan-hua)* is identified as either *Hosta sieboldiana,* or *Hosta plantaginea, Aschers.* Prior to opening, its tubular white flowers resemble the jade ornaments worn as hairpins in the coiffures of palace ladies, from which the Chinese name derives. Blossoming in the eighth lunar-month, which generally corresponds to the period from early September to early October, it was primarily cultivated as an ornamental garden plant for its broad attractive leaves and sweet-smelling flowers. In keeping with the autumn season, Bada Shanren's painting also shows a bunch of chrysanthemums in the upper right corner.

The jade hairpin seldom served as the primary focus of paintings, though Bada Shanren chose to explore the subject on more than one occasion. For five other paintings of the jade hairpin flower in his surviving corpus, see Wang Zhaowen, ed., *Bada shanren quanji,* 1:24 (cat. no. 2; leaf 7, undated); 3:500 (cat. no. 139; hanging scroll, 1699); 3:682 (cat. no. 6; leaf 5, undated, with a poem on the subject); 3:722 (cat. no. 18; hanging scroll, undated); and 4:767 (cat. no. 45; leaf 4, undated).

96 In his discussion of these two album leaves, Wang Fangyu noted that the signature "Heyuan" appears only on works from the last three years of Bada Shanren's life, 1702 to 1705. He also conjectured that the two leaves mounted on this hanging scroll once belonged to a larger album of mixed painting and calligraphy, but was unable to identify any other surviving leaves. See Wang Fangyu, *Bada Shanren fashu ji,* 2:50−51; and Wang Fangyu, "Bada Shanren shi shijie" (Explaining the poetry of Bada Shanren), in *Bada Shanren lunji,* ed. Wang Fangyu, 1:353−54, note 5.

97 The source of Bada Shanren's quotation on this leaf is the opening passage to the chapter "Copying" *(lin)* in the *Xu shupu* (Sequel to the treatise on calligraphy) by the Southern Song dynasty calligrapher and poet Jiang Kui (ca. 1155–ca. 1235). Jiang's chapter begins with the following statement: "It is very easy to trace *(mu)* calligraphy. *Emperor Taizong of the Tang dynasty said, 'He lay Wang Meng upon the paper and sat Xu Yan under his brush,' so as to ridicule Xiao Ziyun* [translator's italics]. But when one is just beginning to study calligraphy, one cannot do otherwise than to trace, both to exercise one's hand and to facilitate ultimate mastery." In other words, Jiang Kui qualified the Tang emperor's disdainful criticism of Xiao Ziyun (see below) by stating that tracing and copying the works of earlier masters were necessary steps in learning the art of calligraphy. See Jiang Kui, *Xu shupu* (sequel to the treatise on

calligraphy), in *Yishu congbian* (Compendium of writings about art), ed. Yang Jialuo, vol. 2 (Taipei: Shijie shuju, 1966), 5; and for a previous English translation, see Chang Ch'ung-ho and Hans H. Frankel, trans., *Two Chinese Treatises on Calligraphy* (New Haven: Yale University Press, 1995), 25. For more on Bada's own approach to copying, see catalogue entries 6, 20, 31, and 32; and notes 10, 67, 102, and 103.

98 As stated above, most of the sentence inscribed on this calligraphy leaf is quoted directly from Jiang Kui's *Sequel to the Treatise on Calligraphy*. Within that passage, Jiang in turn quoted a decree *(zhi)* traditionally attributed to Emperor Taizong of the Tang dynasty (reigned 626–49), which is appended to the biography in the *Jin shu* (History of the Jin dynasty) of the emperor's favorite calligrapher, Wang Xizhi (ca. 303–ca. 361 C.E.). Taizong's decree extols the calligraphy of Wang Xizhi and disparages the stylistic lineage represented by Xiao Ziyun (486–548), an otherwise acclaimed calligrapher who served at the Liang dynasty court and often filled imperial commissions. The emperor's full statement condemning Xiao Ziyun reads: "Ziyun emerged more recently as a calligrapher and his fame dominated the area south of the Yangzi River, but in reality he was barely able to write calligraphy at all and did not have the air of a real man. Column after column of his writings looks like wriggling earthworms in the spring, and character after character looks like coiling snakes in autumn. *He lay Wang Meng upon the paper and sat Xu Yan under his brush* [translator's italics], but though he wielded a brush made from the fur of a thousand rabbits, he did not possess the 'sinew' *(jin)* of even a single hair, and though he gathered the fiber from myriad fields of grain, he could not achieve even a moiety of 'bone' *(gu)*. To proclaim his virtuosity when such was the case, isn't his fame widely overblown?" Judging from the full passage, Emperor Taizong's decree primarily addresses the qualities of brushwork referred to in Chinese as sinew *(jin)* and bone *(gu)*, neither of which were present, in his estimation, in Xiao's calligraphy. Despite the emperor's specific application, however, later writers such as Jiang Kui borrowed the phrase in question simply to describe the act of copying. See Fang Xuanling et al., comps., *Jin shu*, 80:2107–8, esp. 2108.

In framing his criticism of Xiao Ziyun, Emperor Taizong referred to two other individuals: Wang Meng (309–347 C.E.) and Xu Yan Wang (10th or 7th century B.C.E.). Wang Meng achieved notable success as a calligrapher, especially for his clerical and draft-cursive scripts, but it is said that while he succeeded in capturing the external forms of the characters, the sinew *(jin)*, and bone *(gu)*, of his calligraphy were imperfectly expressed. The first part of the emperor's statement ("he lay Wang Meng upon the paper") therefore disparages Xiao Ziyun as a mere copyist.

The name Xu Yan refers to King Yan of the ancient state of Xu (Xu Yan Wang), who may or may not have been a real historical figure. In the context of Taizong's decree, the only relevant, albeit indirect, connection between Xu Yan and the art of writing is apparently an early explanation of his given name, "Yan" (to bend, bow, or recline), which states that Xu Yan was born with sinews *(jin)*, but without bones *(gu)*, nouns that were later used metaphorically to describe certain inherent

qualities of both calligraphic brushwork, as mentioned above, and perhaps writing brushes as well. If this analysis is correct, then the allusion to Xu Yan in the second part of the emperor's statement ("and sat Xu Yan under his brush") refers to weak and deficient qualities in Xiao Ziyun's brushwork.

Taken together, the full clause ("he lay Wang Meng upon the paper and sat Xu Yan under his brush") thus applies to a tracing or copy of a previous master's calligraphy that, while accurate in its external features, lacks the coherent internal structures of the original work. In other words, Emperor Taizong was criticizing Xiao Ziyun as a mere copyist whose work suffered from sloppy execution. Jiang Kui, on the other hand, while he did not contest the emperor's evaluation of Xiao Ziyun, simply commented that copying the former masters, even poorly, is a necessary part of the learning process.

Following the quotation from Jiang Kui's treatise, Bada Shanren added three final characters to the text as a kind of closing remark. The three-character phrase translated as "and such people" is Bada's only original contribution to the text, and its precise relationship to the rest of the sentence is typically ambiguous.

Wang Fangyu located a second pair of album leaves (mounted as a handscroll) with a painting of a plum tree on one leaf, and an accompanying leaf of calligraphy that bears an identical text, signature, and seal as the present leaf. He judged this second calligraphy leaf to be a forgery, with all elements copied directly from the present work; see Wang Fangyu, *Bada Shanren fashu ji*, 2:74–75.

ENTRY 30. *Couplet*

99 For a discussion of the calligraphy in the present couplet, see Wang Fangyu, *Bada Shanren fashu ji*, 2:43. Bada Shanren rarely created couplets, or at least few have survived. One extant couplet, belonging to the Shanghai Museum of Art, is an important comparative example of Bada's work in the style of running script seen here. While the Shanghai work is smaller than the Freer example, it too employs five-character lines and three of the same characters as the Freer couplet; see Guo Zixu et al., eds., *Zhongguo shufa quanji 64. Qingdai: Zhu Da, Shitao, Gong Xian, Gong Qinggao* (Complete Chinese calligraphy 64. Qing dynasty: Zhu Da, Shitao, Gong Xian, Gong Qinggao) (Beijing: Rongbaozhai chubanshe, 1998), 142 (plate 31) and 300–301 (comments). Two other published examples of couplets by Bada Shanren are written in cursive script; see Wang Zhaowen, ed., *Bada shanren quanji*, 2:252 (cat. no. 70; five-character verse) and 461 (cat. no. 120; seven-character verse).

The exact meaning of the two lines is elusive, and the current translation represents merely one possibility:

Line 1: During the Eastern Han dynasty (25–220 C.E.), the "Immortals' Chamber" was an alternative name for the imperial library, where scholars and writers were frequently assigned during their service at court. The building derived this name from the many texts on esoteric Daoism that were housed there along with works on history and other matters. The building was officially known as the Dongguan (Eastern Tower). Bada may have been drawing on this

reference to add prestige to his description of a library, *tushu* (literally: charts, or pictures, and books).

Line 2: The first two characters, *shandou,* are an abbreviation for: Taishan (Mount Tai, in Shandong Province), easternmost of the five sacred mountains; and the constellation Beidou (Northern Dipper). Since at least the ninth century, the combined term (Mount Tai and Northern Dipper) has been used to indicate an individual, to whom people look up as a paragon.

The term "Southern Capital" may refer to the city of Nanchang (Jiangxi Province), where Bada resided in his later years. In 959 Nanchang was designated a second imperial capital under the Southern Tang kingdom (937–75) and was given the official name, Southern Capital. See Zhu Yulong, comp., *Wudai shiguo fangzhen nianbiao* (Chronology of regional administrative districts during the Five Dynasties and Ten Kingdoms period) (Beijing: Zhonghua shuju, 1997), 448 and 452, note 7.

ENTRY 31. *Poem by Yan Fang*

100 The Tang dynasty poet, Yan Fang (early to mid-8th century), wrote this eighteen-line poem on a visit to Deer Gate Mountain, in Hubei Province, where an ancient recluse once lived (see note 101, lines 1–2 and 5–6). Relatively little is known about the life and career of Yan Fang; however, all five of his extant works are descriptive landscape poems focusing on recluses. Bada Shanren's rendition of Yan Fang's poem differs in several significant details from the versions found in standard anthologies: see Yin Fan (active mid-8th century), comp., *Heyue yingling ji* (Collection of poems by eminent spirits of the rivers and mountains, 753), in *Tangren xuan Tang shi, shizhong* (Tang poems selected by Tang compilers, ten examples), 1:114; Ji Yougong, comp., *Tangshi jishi,* 26:6a–b, in *WSKQS,* disc 162; and Peng Dingqiu et al., comps., *Quan Tang shi,* 253:2851.

101 Lines 1–2: Pang Gong, also known as Pang Degong (late 2d–early 3d century C.E.), was a poor recluse, who lived during the troubled years at the end of the Eastern Han dynasty (25–220 C.E.). Despite recommendation, he refused all official rank and salary and sustained a happy but hardscrabble existence as a farmer. To escape the dangers of the times, Pang disappeared with his family into Lumenshan (Deer Gate Mountain; see below) and was never seen again. For Pang Gong's biography, see Fan Ye, comp., *Hou Han shu* (History of the Eastern Han dynasty, 25–220 C.E.) (Beijing: Zhonghua shuju, 1965), 83:2776–77; and Alan J. Berkowitz, *Patterns of Disengagement: the Practice and Portrayal of Reclusion in Early Medieval China* (Stanford: Stanford University Press, 2000), 124–25.

Lines 5–6: Deer Gate Mountain (Lumenshan) is located about twenty kilometers southeast of modern Xiangfan, Hubei Province. According to tradition, Pang Degong lived on the eastern slopes near Deer Gate Temple, which was built during the Eastern Han dynasty in the reign of Emperor Guangwu (reigned 25–57 C.E.), and where there is still a shrine in his honor today. Two large stone statues of deer

flanked the entrance to the temple enclosure, from which the mountain subsequently took its name.

"Valleys heaped with gems" is a standard trope in Chinese eremetic literature used to describe the remote habitations of recluses and immortals. Not only is the terrain fantastic and wild, but those who dwell in such places are so indifferent to wealth and social station that piles of valuable gems are left ungathered on the ground.

Line 8: The proper reading of the third character of this line is uncertain; the translation "surge" derives from the character that appears in this position in most standard editions: *piao* (to float, drift, be tossed about).

Lines 9–10: Jiaoyuan (Jiao Plateau) is the name of a mountain located in the ancient state of Ju (near modern Juxian), in southeastern Shandong Province. Local people were afraid to approach the brink of the mountain because of its unusually precipitous drop, until one day a man walked over and calmly stood with his heels out over the edge. Commentators noted that his equanimity in the face of danger emanated from the principles of humaneness and righteousness that he held in his breast. See Fan Ye, comp., *Hou Han shu,* 59:1917, note 5.

Lülianghuo (Lü Bridge Gorge) is located in the ancient state of Lü, near modern Tongshanxian, in northwestern Jiangsu Province. The gorge contains a natural stone arch, hence its name. A large waterfall drops hundreds of feet into the gorge, reemerging as a tumultuous foaming stream. Here, the sage Confucius once encountered a man swimming calmly through the wild and perilous waters, and asked how he managed to achieve this feat. A native of the region, the man replied that he simply trusted to destiny and followed the Way *(dao)* of the water. See Yang Bojun, comp., *Liezi jishi,* 62–64; and A. C. Graham, trans., *The Book of Lieh-tzu,* 44.

Line 12: The descriptive binome *mianman* (translated here as "tender and low") alludes to a poem (*Mao* #230) in the ancient Chinese anthology, the *Shijing* (Classic of poetry), which expresses the weariness of a traveler. Dictionaries define the binome as describing either the appearance, or singing, of small birds.

102 Bada Shanren states explicitly that he wrote this leaf to "copy" *(lin)* the style of the Ming dynasty calligrapher Wang Chong (1494–1533), also known as Yayi Shanren; however, the running-standard script Bada employed here has no stylistic precedent among Wang's known works. Bada's usage of the word "copying" is problematic and clearly means something other than the usual definition. For other examples, see catalogue entries 6, 20, and 32; and notes 10, 67, 97, and 103. For further discussion of Bada's use of the word "copying," see Wang Fangyu, "Bada Shanren de shufa," in *Bada Shanren lunji,* ed. Wang Fangyu, 1:385–98; Wang Fangyu, "Bada Shanren de shufa," in Wang Fangyu, *Bada Shanren fashu ji,* 2:69–70; and Bai Qianshen, "Cong Bada Shanren lin 'Lanting xu' lun Mingmo Qingchu shufa zhong de linshu guannian," 462–72.

During the mid-twentieth century, the collector Zhang Daqian owned the original eight-leaf album from which this calligraphy leaf was taken. At the time, the undated album contained four leaves of painting paired with four unrelated leaves of calligraphy. Three of the

texts, including the poem here by Yan Fang, are Tang dynasty poems concerning visits to a place called Lumenshan (Deer Gate Mountain, see above). In the original album, the current leaf was paired with a painting of magnolia blossoms. See Zhang Daqian, *Dafengtang mingji*, vol. 3, plates 37–40, esp. plate 37.

Wang Fangyu dated Zhang Daqian's album on the basis of style to ca. 1702. According to Wang, the Yan Fang leaf was removed from the album by Zhang, who sold it to his friend Zhu Shengzhai (ca. 1902–1970), who later sold it to Zhang Lianqing (20th century), who in turn sold it to Wang Fangyu and Sum Wai. See Wang Fangyu, "Bada Shanren de shufa," in *Bada Shanren lunji*, ed. Wang Fangyu, 1:395; and Wang Fangyu, *Bada Shanren fashu ji*, 2:41.

At some point after leaving Zhang Daqian's collection, the current leaf was included in a nine-leaf calligraphy album, seven other leaves from which are in the Freer collection: see catalogue entries 10, 11 (two leaves), 13, 14, 15, and 16. For a complete list of that album's contents, see Wang and Barnhart, *Master of the Lotus Garden*, 269 (Appendix C, no. 106).

ENTRY 32. *Copy of Two Letters by Huang Daozhou*

103 For a brief discussion of Bada Shanren's calligraphy in these leaves, see Wang Fangyu, *Bada Shanren fashu ji*, 2:59. Both leaves contain copied excerpts from private letters sent to unknown recipients by Huang Daozhou (1585–1646), also known as Shizhai. An important personage at the end of the Ming dynasty, Huang achieved fame for his poetry, painting, and especially calligraphy, in which he established his own individual style. A pillar of moral rectitude, he was also a staunch Ming loyalist, who helped to lead resistance against the Manchu conquerors until he was killed during internecine struggles among various Ming pretenders. For a Chinese scholar of Bada Shanren's age and personal circumstance, Huang Daozhou was a figure of heroic dimensions, which undoubtedly lent a certain allure to the study of his calligraphy. In the case of these leaves, however, although he was ostensibly copying *(lin)* Huang directly, Bada Shanren chose to employ his own style of running-cursive script, which possesses none of the particular qualities that characterize Huang Daozhou's distinctive style. Bada's usage of the word "copying" is problematic and clearly means something other than the usual definition. For other examples, see catalogue entries 6, 20, and 31; and notes 10, 67, 97, and 102. For examples of original letters written by Huang Daozhou, see Zheng Wei et al., eds., *Huang Daozhou moji daguan* (Overview of Huang Daozhou's calligraphy) (Shanghai: Shanghai renmin meishu chubanshe, 1992), 104–6, 123–46, and 166–68.

These two leaves most recently belonged to a mixed album of ten leaves assembled from disparate sources, six of painting and four of calligraphy. Five leaves, three of painting and two of calligraphy, are included elsewhere in this volume (cat. entries 3, 6, 7, and 33); one leaf is unpublished; and the two other leaves (respectively showing a cat and a chicken) are published in Wang and Barnhart, *Master of the Lotus Garden*, 108–9 (cat. no. 10, fig. 54).

104 In several critical places, damage to the paper has led to losses in the texts of Huang Daozhou's two letters, and without further information regarding his relationship with the intended recipient(s) of these missives, as well as the immediate context of some remarks made within them, any translation can only be speculative.

The expression "flock of geese" alludes to a story concerning the great early calligrapher, Wang Xizhi (ca. 303–361 C.E.). One day Wang, who was very fond of geese, heard that a Daoist master living in nearby Shanyin (modern Shaoxing, Zhejiang Province) had raised a particularly fine flock. He went to see the geese and was very impressed, and wanted to strike a deal with the owner. The Daoist master refused to sell, but offered to give Wang the entire flock in exchange for him writing out the text of the *Daodejing* (Classic of the Way and its power), the seminal text of philosophical Daoism. Wang happily complied, then caged up the birds, and returned home extremely pleased. In time, the expression "flock of geese" came to indicate payment for a work of calligraphy. For the story of Wang Xizhi and the flock of geese, see Fang Xuanling et al., comps., *Jin shu*, 80:2100.

105 The *Wenxian tongkao* (General history of institutions and critical examination of documents and studies) is a large, multivolume encyclopedic history of Chinese government institutions from earliest times to 1204, compiled by the Yuan dynasty scholar Ma Duanlin (1254–1323).

The full title of the book translated here as "Illustrated Scripture" is unknown due to losses in the original paper and text.

ENTRY 33. *Landscape after Ni Zan*

106 The stark ink-landscapes of the Yuan dynasty painter Ni Zan (1306–1374) held a strong appeal for many seventeenth-century artists of the late-Ming and early-Qing dynasties, especially Dong Qichang (1555–1636) and his followers such as Bada Shanren. While both the dry, crumbly ink and small, open pavilion at the lower left of this work are strongly reminiscent of Ni Zan, the painting also clearly illustrates the loose structural relationships and unconventional use of space that typify works from Bada Shanren's later years. For brief comments on Bada's attraction to Ni Zan and a discussion of the present work, see Wang and Barnhart, *Master of the Lotus Garden*, 80–81; and Wang Fangyu, *Bada Shanren fashu ji*, 2:54–55. For another work by Bada in the style of Ni Zan, see catalogue entry 12, leaf 6.

This double leaf most recently came from a mixed album of ten leaves assembled from disparate sources, six of painting and four of calligraphy. Six leaves, two of painting and four of calligraphy, are included elsewhere in this volume (cat. entries 3, 6, 7, and 32); one leaf is unpublished; and two other leaves (respectively showing a cat and a chicken) are published in Wang and Barnhart, *Master of the Lotus Garden*, 108–9 (cat. no. 10, fig. 54).

上清紫霞虛皇前　太上大道玉晨君閑居蕊珠作

七言散化五形變萬神是為黃庭曰內篇琴心三疊舞

胎仙九氣映明出霄間神蓋童子生紫煙是曰玉書可精研

詠之萬過昇三天千災以消百病痊不憚虎狼之凶殘

CHINESE DOCUMENTATION



ENTRY 1. (F1998.53.1–.8)

荷花圖　　八開冊

外簽：釋傳綮畫荷冊。号法堀又号刃菴，即山人爲僧時之名號也。
爰。
鈐印兩方：『張爰』(白文方印)、『大千』(朱文方印)

第一開
無款識
鈐印一方：『法堀』(朱文橢圓印)

鑑藏印兩方
張燦一方：『張燦私印』(白文方印)
待考一方 (白文半印)

第二開
無款識
鈐印兩方：『釋傳綮印』(白文方印)、『刃菴』(朱文方印)

第三開
無款識
鈐印兩方：『釋傳綮印』(朱文方印)、『刃菴』(朱文方印)

鑑藏印兩方
張大千：『大風堂』(朱文方印)、『己丑以後所得』(朱文長方印)

第四開
名款：傳綮
鈐印兩方：『法堀』(朱文橢圓印)、『刃菴』(朱文方印)

鑑藏印一方
待考一方：『館主』(白文半印)

第五開
名款：法堀釋傳綮
鈐印一方：『刃菴』(朱文方印)

第六開
名款：法堀
鈐印一方：『刃菴』(朱文方印)

第七開
名款：傳綮
鈐印一方：『刃菴』(朱文方印)

第八開
名款：傳綮
鈐印一方：『釋傳綮印』(白文方印)

鑑藏印一方
王方宇：『食雞跎盧』(白文方印)

ENTRY 2. (F1998.29.1–.12)

行楷書節錄《黃庭內景經》　　十二開冊

外簽：八大山人小楷《內景經》眞跡逸品。
內簽：神仙法論。

第一開
　　　　　　《內景經》
[第一章全]：　上清紫霞虛皇前，太上大道玉晨君，閒居蘂珠作七言，
散化五形變萬神，是爲黃庭曰內篇，琴心三疊舞胎仙，
九氣映明出霄間，神盖童子生紫烟，是曰玉書可精研，
詠之萬徧昇三天。千灾以消百病痓，不憚虎狼之凶殘，
亦以却老年永延。

[第二章始]：　上有魂靈下關元，左爲少陽右太陰，後

第二開
[第二章末]：　有密戶前生門，出日入月呼吸存，元氣所合列宿分，
紫烟上下三素雲，灌漑五花植靈根，七液洞流衝廬間，
迴紫抱黃入丹田，幽室內明照陽門。

[第三章全]：　口爲玉池太和官，漱咽靈液灾不干，體生光華氣香蘭，
却滅百邪玉鍊顏，審能脩之登廣寒，晝夜不寐乃成眞，
雷鳴電激神泯泯。

[第四章始]：　黃庭內人服錦衣，紫華飛裙雲氣羅，丹青綠…(下佚)

第三開
[第十三章末]：　…念三老子輕翔，長生高仙遠死殃。

[第十四章全]：　膽部之宮六腑精，中有童子曜威明，雷電八振揚玉旌，
龍旗橫天擲火鈴，主諸氣力攝虎兵，外應眼童鼻柱間，
腦髮相扶亦俱鮮，九色錦衣綠華裙，佩金帶玉龍虎文，
能存威明乘慶雲，役使萬神朝三元。

[第十五章始]：　脾長一尺掩太倉，中部老君治明堂，厥子靈元名混康，

第四開
[第十五章]：　治人百病消穀糧，黃衣紫帶龍虎章，長精益命賴君王，
三呼我名神自通，三老同坐各有朋，或精或胎別執方，
桃孩合延生華芒，男女回九有桃康，道父道母對相望，
師父師母丹玄鄉，可用存思登虛空，殊塗一會歸要終，
閉塞三關握固停，含漱金醴吐玉英，遂至不飢三虫亡，
心意常和致欣昌，

第五開
[第十五章末]：　五嶽之雲氣彭亨，保灌玉廬以自償，五形完堅無灾殃。

[第十六章始]：　上覩三元如連珠，落落明星照九隅，五靈夜燭煥八區，
子存內皇與我遊，身披鳳衣銜虎符，一至不久昇虛無，
方寸之中念深藏，不方不圓閉牖窗，三神還精老方壯，



魂魄內守不爭競，神生腹中唧玉鐺，靈注幽闕那得喪，琳條萬尋可

第六開
[第十六章末]：　蔭仗，三魂自寧帝書令。

[第十七章全]：　靈臺鬱靄望黃野，三寸異室有上下，間關營衛高玄受，洞房紫極靈門戶，是昔太上告我者，左神公子發神語，右有白元併立處，明堂金匱玉房間，上清眞人當吾前，黃裳子丹氣頻煩，借問何在兩眉端，內俠日月列宿陳，七曜九元冠生門。

[第十八章始]：　三關之中精氣深，九…（下佚）

第七開
[第二十六章末]：　……日月吾上道，鬱儀結璘善相保，乃見玉清虛無老，可以迴顏填血腦，口銜靈芒攜五皇，腰帶虎籙佩金鐺，駕欻接生宴東蒙。

[第二十七章全]：　玄元上乙魂魄鍊，乙之爲物頗卒見，須得至眞乃顧盼，至忌死氣諸穢賤，六神合集虛中宴，結珠固精養神根，玉芝金籥常完堅，閉口屈舌食胎津，使我遂鍊獲飛仙。

第八開
[第二十八章全]：　僊人道士非有神，積精累氣以爲眞，黃童妙音難可聞，玉書絳簡赤丹文，字曰眞人巾金巾，負甲持符開七門，火兵符圖備靈關，前昂後卑高下陳，執劍百丈舞錦幡，十絕盤空扇紛紜，火鈴冠霄墜落烟，安在黃闕兩眉間，此非枝葉實是根。

[第二十九章始]：　紫清上皇大道君，太玄太和俠侍端，化生萬物使我仙，飛昇十天駕…（下佚）

第九開
[第三十五章始]：　…雌存雄項三光，外方內圓神在中，通利血脉五藏豐，骨青筋赤髓如霜，脾救七竅去不祥，日月列宿張陰陽，兩神相會下玉英，澹然無味天人糧，予丹進饌看正黃，乃曰琅膏及玉霜，太上隱環八素瓊，溉益八液腎受精，伏于太陰見我形，揚風三玄出始青，恍惚之間至清靈，戲于飈臺見赤生，逸域熙

第十開
[第三十五章末]：　眞養華榮，內盼沉默鍊五形，三氣徘徊得神明，隱龍遁芝雲琅英，可以充飢使萬靈，上蓋玄玄下虎章。

[第三十六章始]：　沐浴盛潔棄肥熏，入室東向誦玉篇，約得萬徧義自鮮，散髮無欲以長存，五味皆去正氣還，夷心寂悶莫煩冤，過數已畢體神精，黃華玉女告子情，眞人既至使六丁，即授隱芝大洞經，十

第十一開
[第三十六章末]：　讀四拜朝太上，先謁太帝後北向，黃庭內經玉書暢，授者曰師受者盟，雲錦鳳羅金紐纏，以代割髮肌膚全，攜手登山歃液丹，金書玉景乃可宣，傳得審授告三官，勿令七祖受冥患，太上微言致神仙，不死之道此其文。

無款識
鈐印三方：『白畫』（白文長方印：第一開）、『八大山人』（白文長方印：第十一開）、『鰕魿篇軒』（白文長方印：第十一開）

第十二開　　八大山人行書跋文
昔有問，『老莊、聖教同異？』；答，『將無同』。官序陳留，補陳留所未備者，阮千里耶？余次二王書似之。甲子七月朔喜雨再跋《內景》，八大山人。
鈐印兩方：『驢』（朱文方印）、『可得神仙』（白文方印）

鑑藏印四方
王方宇一方：『方宇』（朱文長方印）
沈慧一方：『沈慧』（朱文方印）
待考兩方：『用龢諟正』（朱文方印）、『海秋審定』（朱文長方印）

ENTRY 3. (F1998.58.1-.2)
丁香花圖并行草對題　　冊頁兩開

第一開　　《丁香花圖》
款識：八大山人畫。
鈐印一方：『畫渚』（朱文長方印）

鑑藏印兩方
王方宇一方：『方』『宇』（朱文連珠方印）
沈慧一方：『沈慧』（朱文方印）

第二開　　《行草對題》
款識：庚午春，倣包山畫法。八大山人。
鈐印一方：『山』（白文橢圓印）

鑑藏印兩方
王方宇一方：『方』『宇』（朱文連珠方印）
沈慧一方：『沈慧』（朱文方印）

ENTRY 4. (F1998.48)
竹石小鳥圖　　軸

款識：壬申孟夏，涉事。八大山人。
鈐印三方：『在芙』（朱文長方印）、屨形有框扁方印、『八大山人』（白文長方印）

鑑藏印七方
張大千六方：『東西南北之人』（朱文長方印）、『別時容易』（朱文方印）、『南北東西只有相隨無別離』（朱文方印）、『敵國之富』（朱文方印）、『球圖寶骨肉情』（白文扁方印）、『大風堂漸江髡殘雪個苦瓜墨緣』（朱文長方印）

王方宇一方：『食雞跖廬』(白文方印)

張大千行書跋文

(右)：近世好事家最重小幅，以三尺上下為度。此風彌漫南北，而吳中尤甚。於是骨董掮客一遇大堂幅，往往割裂，冀得善價。其摧殘前人心血，凶忍有甚於劊子手。此幅近得之香港，惜其斷璧，乃以意補[數]

(左)：綴數筆。雖未能煥若神明，頓還舊觀，竊自比於瞽者之有[於]杖，慰情聊勝也。壬辰春日，大千學人并識於大風堂下。 (注：[數]、[於]兩字點去)

鈐印三方：『張爰私印』(朱文方印)、『大千父』(朱文方印)、『千千千』(白文方印)

ENTRY 5. (F1998.56.1-.4)

落花、佛手、芙蓉、蓮蓬　　冊頁四開

第一開　《落花》
款識：涉事，八大山人。
鈐印一方：屐形有框扁方印

鑑藏印三方
張大千兩方：『大風堂漸江髡殘雪個苦瓜墨緣』(朱文長方印)、『張爰』(白文方印)
王方宇一方：『食雞跖廬』(白文方印)

第二開　《佛手》
款識：涉事，八大山人。
鈐印兩方：屐形無框扁方印、『涉事』(白文長方印)

鑑藏印兩方
張大千：『南北東西只有相隨無別離』(朱文方印)、『大千藏之』(朱文方印)

第三開　《芙蓉》
款識：八大山人。
鈐印一方：屐形有框扁方印

鑑藏印兩方
張大千：『別時容易』(朱文方印)、『藏之大千』(白文方印)

第四開　《蓮蓬》
款識：壬申之夏五月，涉事。八大山人。
鈐印一方：屐形有框扁方印

鑑藏印三方
張大千：『大千好夢』(朱文長方印)、『張爰』(白文方印)、『大千璽』(朱文方印)

ENTRY 6. (F1998.28)

行楷節臨褚遂良書《聖教序》　　冊頁

承至言於先聖，受眞教於上賢，探賾妙門，精窮奧業，一乘五律之道，馳驟于心田，八藏三篋之文，波濤於口海。爰自所歷之國，總將三藏要文，凡六百五十七部。譯布中夏，宣揚勝業，引慈雲於西極，注法雨於東垂：聖教缺而復全，蒼生罪而還福，濕火宅之乾燄，共拔迷途，朗愛水之昏波，同臻彼岸。是知惡因業墜，善以緣昇，昇墜之端，惟人所託。譬夫桂生高嶺，雲霧方得泫其花，蓮出淥波，飛塵不能汙其葉，非蓮性自潔而桂質本貞，良由所附者高，則微物不能累，所憑者淨，則濁類不能霑。夫以卉木無知，猶資善而成善，況乎人倫有識，不緣慶而求慶。

款識：臨褚河南書，八大山人。
鈐印一方：屐形無框扁方印

鑑藏印一方
沈慧：『沈慧』(朱文方印)

ENTRY 7. (F1998.27)

仿北苑山水圖　　冊頁

款識：仿北苑。
鈐印一方：屐形無框扁方印

鑑藏印兩方
王方宇一方：『王方宇』(朱文方印)
沈慧一方：『沈慧』(朱文方印)

ENTRY 8. (F1998.54.1-.15)

《故國興悲》書畫合冊

外盒內側日本裝池堂印一方：『平安近者光彩堂裝池記』(朱文長方印)
外簽：八大山人詩畫冊。內藤虎署檢。
鈐印兩方：『虎』(朱文橢圓印)、『湖南』(白文長方印)

第一開　《引首》
《故國興悲》。溫卿先生屬，偶園題。
鈐印三方：『丁巳』(朱文長方印)、『肅親王』(朱文方印)、『偶園』(白文方印)

第二開　《山水》
無款識
鈐印一方：屐形無框扁方印

鑑藏印一方
戴植：『芝農秘玩』(朱文方印)

第三開　《山水》
無款識
鈐印一方：屐形無框扁方印

鑑藏印一方
戴植：『芝農秘玩』（朱文方印）

第四開　《山水》
無款識
鈐印一方：屐形無框扁方印

鑑藏印一方
戴植：『潤州戴植鑑賞』（朱文長方印）

第五開　《山水》
無款識
鈐印一方：屐形無框扁方印

鑑藏印一方
戴植：『潤州戴植字培之鑒藏書畫章』（朱文方印）

第六開　行楷書《題畫絕句》四首
塊石此由拳，株松任洪上，聞得山人來，正與白雲往。
名家數文獻，高歌引人處，爲復斜階頭，正階昔感遇。
解珮一以遠，留珮曷可得，別駕城東門，驅車上盤石。
細形適閉影，白雲書欲斷上聲，何哉一宿園，比曉西南苑。

款識：丙子四月七日，題畫之作，錄寄寶崖先生正之。八大山人。
鈐印兩方：『遙屬』（朱文長方印）、屐形無框扁方印

鑑藏印兩方
戴植一方：『培之清賞』（朱文方印）
張大千一方：『張大千長年大吉又日利』（白文方印）

第七開　行楷書《尺牘》
王西齋所畫榮封一面，酒《蓬萊倒影圖》，以爲寶賷先生六旬壽。明
年四月上浣，令上淑兄過我，爲書工部《送李八秘書》一面。志之書
畫扇。八大山人。
鈐印兩方：屐形無框扁方印、『可得神仙』（白文方印）

鑑藏印兩方
戴植一方：『潤州戴氏倍萬樓鑑眞』（朱文方印）
張大千一方：『張爰長壽』（朱文方印）

第八開　行楷書《題畫絕句》三首
一見蓮子心，蓮花有根柢，若耶擘蓮蓬，畫裏郎君子。
黃竹復黃竹，來往通州上，通州百十分，一莖車兩輛。
養兒開元觀，看看齊白首，翻身打鷂子，何不樹楊柳？
鈐印一方：『蔦艾』（朱文長方印）

第九開　行楷書《題畫絕句》三首
西塞一飄頃，東風何處邊，鱅鯢此時便，已下珊瑚川。
文窗九方便，涼風過時數，千金延上人羲皇上人也，百萬圖老虎。
薄暮一鴻飛，四三曉鍾考，故人在河口，說似湖口道。

第十開　行楷書《題畫絕句》二首
郎吹鳳凰山，妾吹純金葉，知音公子誰，領是大州日。
雨蓄舟無處，雲行閣在芙，此時南盡望，已是皖山圖。

款識：黃竹園題畫絕句，力及書爲寶崖先生正之。八大山人。
鈐印一方：屐形無框扁方印

鑑藏印三方
戴植一方：『戴芝農父秘笈之印』（朱文長方印）
張大千一方：『昵燕』（朱文長方印）
王方宇一方：『食雞跖廬』（白文方印）

第十一至第十二開　　吳昌碩行書跋文
八大山人，名耷，字雪个，姓朱氏，故石城府王孫也。甲申後，遁
入空門，號个山僧。人語以無後爲不孝，个山復蓄髮，隱於書畫。
有時又號个山驢。畫多奇趣，題跋詩句，往往人不能解，所謂『傷心
人別有懷抱』也。是冊爲溫卿有道所得，山水四開，錄所作詩四開，
神品逸品兼而有之。予曾購得山人小幀，畫古瓶，瓶口供一橘，題廿
餘字。先師薇翁見之，嗟賞不已，和詩云：『一瓶又一橘，中有雪个
魂，江村逢杜甫，空賦哀王孫』。後以移居失去，惜不能與溫翁共賞
之。
丙午十有二月，吳俊卿題於古梅花下。
鈐印一方：『吳俊之印』（白文方印）

第十三至第十五開　　內藤虎次郎行楷書跋文
邵青門作《八大山人傳》，尤善盡其佯狂玩世之狀，謂其『胸次汩
浡鬱結，別有不能自解之故，如巨石窒泉，如濕絮之遏火，無可如何
…假令山人遇方鳳、謝翱、吳思齊輩，又當相扶攜慟哭至失聲』。山
人之遭逢與其爲人誠如此，則其發於書畫者之怪奇非常，無可端倪，
豈非其耶？及乎觀此冊而獨異其畫一味幽澀，不似平生之詭僻，
其書法古淡蕭逸亦如晉人，蓋此冊所見，實其性情之眞，而世間所
常有怪奇非常者，則其玩世之作已。嗚乎，以此解山人而山人無不可
解矣。蔚堂林君得此冊，珍襲殊甚，使余題其後，因書。昭和庚午八
月，內藤虎。
鈐印一方：『寶馬盦』（白文方印）

鑑藏印兩方
林平造一方：『蔚堂寶秘』（朱文長方印）
張大千一方：『大風堂』（朱文方印）

ENTRY 9. (F1998.45)

荷花雙梟圖　軸

外簽：大風堂供養八大山人晚歲畫《荷花雙梟》眞跡神品。吳昌老詩
跋。

款識：八大山人寫。
鈐印三方：『在芙山房』（白文方印）、『八大山人』（白文長方印）、『遙
　　屬』（朱文長方印）

鑑藏印八方
張大千四方：『大風堂漸江髡殘雪個苦瓜墨緣』（朱文長方印）、『南北東
　　西只有相隨無別離』（朱文長方印）、『大風堂珍藏印』（朱文長方印）、
　　『球圖寶骨肉情』（朱文扁方印）
燕笙波兩方：『燕氏寶蒙堂眞賞』（朱文方印）、『笙波』（朱文方印）

王方宇和沈慧一方：『方慧共賞』（朱文方印）

待考一方：『石鐘居士』（朱文方印）

吳昌碩行書《題畫詩》一首

禽言嘲哳石相癭，功德水現荷夫渠；
隱者漚鷺沉者魚，誰其畫此雪个鱸。
鱸爲僧之名，僧乃朱家幻；
蓮葉遲佛跃，鳥鳴避弓彈。
畫禪寄意頭一髡，說法贗爾明王孫，花縱不果前有因。
前有因，今嘆吁，狼跳虎負羆生猵，夢長胡蜨來蘧蘧。

款識：丙寅春，吳昌碩題，年八十有三。

鈐印一方：『老缶』（朱文方印）

ENTRY 10. (F1998.32)

行楷書節錄韓愈《送李愿歸盤谷序》　冊頁

山南李愿既歸盤谷，文公聞其言而壯之，與之酒而爲之歌。歌曰：
盤之中，唯子之宮。盤之上，維子之稼。
盤之泉，可濯可湘。盤之阻，誰爭子所。
窈而深，廓其有容。繚而曲，如往如復。
嗟盤之樂兮，樂且無央。
虎豹遠迹兮，蛟螭遁藏。
鬼神守護兮，呵禁不祥。
飲且食兮壽而康，無不足兮其所望。
膏吾車兮秣吾馬，從子於盤兮終吾生以徜徉。

款識：李愿，良器之子也。器稱『萬人敵』，名晟，爲王，故曰：『盤之中，維子之宮』。彊星紀十月廿五日，八大山人書于在芙山房。

鈐印兩方：屐形無框扁方印、『可得神仙』（白文方印）

鑑藏印三方

張善孖一方：『虎癡心賞』（白文方印）

張大千一方：『大風堂』（朱文方印）

沈慧一方：『沈慧』（朱文方印）

ENTRY 11. (F1998.36)

行楷書曾鞏《山水屏詩》　冊頁

吳繒約天風，卷舒人上目，秋中此圖畫，尺寸隨折曲。
搜羅得珍匠，徙倚思先躅，經營頃刻內，千里才一副。
定視迤漸通，紀數難促促，山處若無窮，負抱頗重複。
高稜最當中，桀木勢尤獨，回環衆峰接，趨向若奔伏。
矜雄跨九州，爭險挂星宿，深疑雪霜積，暗覺烟霧觸。
泉源出青冥，漲潦兩崖束，歷遠始迂徐，派列輸細谷。
輕舟漾其間，沿溯無緩速，微尋得［修］逕，側起破蒼麓。
遠到無限極，窮升犯雲族，遊行定何之，顧盼停馬足。
盤石長自閑，堂房偶誰築，塵鞅見荒林，物［色］存古俗。
粲粲弄幽花，蒼蒼殷嘉木，遺牛上崖巔，驚麕出槎腹。
鮮明極萬狀，指似亡一粟，雖從人力爲，頗類陰怪續。

深堂得歌眠，高枕生遠矚，因能助佳夢，肯顧躋杲旭。
將相有時才，谿畒眞我欲，儒林恥未博，俗穽思自贖。
婚嫁累苟輕，耕釣心思逐。

款識：此曾□□《山水屏》之作，『遠到』處禪□以□圖□闇一流，必以此爲圖畫中之遠到也。丁丑小春，八大山人書。

鈐印三方：『遙屬』（朱文長方印）、屐形無框扁方印、『可得神仙』（白文方印）

鑑藏印六方

張善孖兩方：『虎癡心賞』（白文方印）、『虎癡心賞』（白文方印）

張大千一方：『大千好夢』（朱文長方印）

沈慧一方：『沈慧』（朱文方印）

待考兩方：『雲居』（朱文長方印）、『伯行長年』（白文方印）

ENTRY 12. (F1998.55.1-.6)

撫董其昌《臨古山水》　六開冊

第一開

［仿董其昌題識］：仿吾家北苑筆意。

鈐印一方：屐形無框扁方印

鑑藏印三方

汪子濤一方：『曾經新安汪子濤處』（朱文長方印）

張大千一方：『張爰』（白文方印）

沈慧一方：『沈慧』（朱文方印）

第二開

［仿董其昌題識］：《溪山仙館》，玄宰寫。

鈐印一方：屐形無框扁方印

鑑藏印三方

汪子濤一方：『曾經新安汪子濤處』（朱文長方印）

張大千一方：『大千居士』（朱文方印）

沈慧一方：『沈慧』（朱文方印）

第三開

［仿董其昌題識］：《水村圖》，玄宰畫。

鈐印一方：屐形無框扁方印

鑑藏印兩方

張大千一方：『大風堂漸江髡殘雪個苦瓜墨緣』（朱文長方印）

沈慧一方：『沈慧』（朱文方印）

第四開

［仿董其昌題識］：婁江道中展黃子久《富陽大嶺圖》，拈筆寫此，玄宰。

鈐印一方：屐形無框扁方印

鑑藏印五方

汪子濤一方：『曾經新安汪子濤處』（朱文長方印）

張大千三方：『別時容易』（朱文方印）、『張爰』（白文方印）、『大千』（朱文方印）

沈慧一方：『沈慧』（朱文方印）

第五開
[仿董其昌題識]：《夏木垂陰》，玄宰畫。
鈐印一方：屐形無框扁方印

鑑藏印兩方
張大千一方：『藏之大千』（朱文長方印）
沈慧一方：『沈慧』（朱文方印）

第六開
[仿董其昌題識]：倪迂畫平淡天眞，無畫史縱橫俗狀。此冊臨王氏所藏眞蹟也。玄宰。
鈐印一方：屐形無框扁方印（倒轉）

鑑藏印五方
張大千三方：『張爰』（白文方印）、『大千』（朱文方印）、『大風堂』（朱文方印）
王方宇一方：『方宇』（朱文長方印）
沈慧一方：『沈慧』（朱文方印）

張大千行書題跋
山人畫法從董思翁上窺倪、黃。三百年來，無論藏家畫家，無一人於此着眼者。此一瓣香始自老夫拈出。今又得此冊，益自證鑑賞不謬。蜀郡晚學張大千爰。
鈐印兩方：『張爰』（白文方印）、『大千』（朱文方印）

ENTRY 13. (F1998.31)
行楷書《臨河集序》　冊頁

永和九年暮春，會于會稽山陰之蘭亭，脩禊事也。群賢畢至，少長咸集。此地酒峻領崇山，茂林脩竹，更清流激湍，映帶左右，引以爲流觴曲水，列坐其次。是日也，天朗氣清，惠風何暢，娛目騁懷，洵可樂也。雖無絲竹管絃之盛，一觴一詠，亦足以暢敍幽情已。故列序時人，錄其所述。

款識：《臨河集序》。八大山人。
鈐印兩方：屐形無框扁方印、『可得神仙』（白文方印）

鑑藏印兩方
張大千一方：『季爰』（白文方印）
沈慧一方：『沈慧』（朱文方印）

ENTRY 14. (F1998.35)
行楷書張九齡《題畫山水障詩》　冊頁

心累果不盡，猶爲物外牽，偶因耳目好，復假丹青妍。
嘗抱野間意，而迫區中緣，塵事固已矣，秉意終不遷。
良工適我願，妙筆揮巖前，變化[無窮]合群有，高深侔自然。
置陳北堂上，仿像南山邊，靜無戶庭出，行已茲地偏。
萱蓂憂可樹，合懽忿亦蠲，所因本微物，況迺憑幽筌。
言象會自泯，意色聊相宣，對玩有佳趣，使我心眇緜。

（注：『無窮』兩字爲八大山人自加者）

ENTRY 15. (F1998.33)
行楷書孫逖《奉和李右相中書壁畫山水詩》　冊頁

廟堂多暇日，山水契眞情，欲寫高深趣，還因藻繪成。
九江臨戶牖，三峽繞簷楹，花柳窮年發，烟雲逐意生。
能令萬里近，不覺四時行，氣概苟香馥，光含樂鏡清。
詠歌齊出處，圖畫表沖盈，自保千年遇，何論八載榮。

款識：八大山人
鈐印一方：『可得神仙』（白文方印）

鑑藏印兩方
張大千一方：『藏之大千』（白文方印）
沈慧一方：『沈慧』（朱文方印）

ENTRY 16. (F1998.34)
行楷書杜甫《戲題王宰畫山水圖歌詩》　冊頁

十日畫一水，五日畫一石：
能事不受相促迫，王宰始肯留眞跡，壯哉崑崙方壺圖，
挂君高堂之素壁。巴陵洞庭日本東，赤岸水與銀河通，
中有雲氣隨飛龍，舟人漁子入浦溆，山木盡亞洪濤風。
尤工遠勢古莫比，只尺應須論萬里，焉得并州快剪刀，
剪取吳松半江水。

款識：八大山人書。
鈐印一方：『可得神仙』（白文方印）

鑑藏印兩方
張大千一方：『大千居士』（朱文方印）
沈慧一方：『沈慧』（朱文方印）

ENTRY 17. (F1998.41)
(傳)懷素草書《聖母帖》并八大山人行楷釋文題跋　卷

外簽：宋拓懷素《聖母帖》，明八大山人書釋文并跋。
內簽：宋搨懷素《聖母帖》，明八大山人自書釋文眞蹟。神品。小寶題簽。
鈐印一方：『□孫』（朱文長方印）

《聖母帖》釋文

聖母心瘉至言，無能冰釋，遂奉上清之教，旋登列聖之位，仙階崇者靈感遠，豐功邁者神應速。廼有眞人劉君，擁節乘麟，降于庭內：劉君名綱，貴眞化。以聖母道應寶籙，才合上仙，授之秘符，[爵]餌以眞藥。遂神儀爽變，膚骼纖妍，脫異俗流，鄙遠塵愛。杜氏初烈，責我婦禮，聖母脩然，不經聽慮。久之生訟，至于幽圉，拘同羑里，倏[忽]霓裳。仙駕降空，問之臨戶，顧名二女，驪虛同升。旭日初照，聳身直上，旌幢彩煥，輝耀莫倫，異樂殊香，沒空方息。康帝以爲中興之瑞，銘于其所置仙宮觀，慶殊祥化。因弘舊東陵聖母：家于廣陵，仙于東土，心東陵焉；二女瑤升，舊聖母家。遂宇既崇，眞儀麗設，遠近歸赴，傾市江淮。水旱札瘥，無不禱請，神貺昭答，人用大康。姦盜之徒，或來取咎，則有奇禽，翔其廬上，靈衛既降，罪[必]斯獲，閭井之間，無作[諸]慝焉。自晉曁隋，年將三百，都鄙精奉，車徒奔涉。及煬帝東遷，運終多忌，苟禁道侶玄元。九聖丕承，慕揚至道，眞宮秘府，网不推建。況靈蹤可訊，道化在人，雖蕪翳荒郊，而奠禱雲集。棟宇未復，耆艾銜悲，誰其興之，粵因碩德。從叔父、淮南節度觀察使、禮部尙書、監軍使、太原郭公，道冠方隅，勳崇南服，淮沂既蒸，試作而不朽，[存]乎頌声。貞元九年歲之癸酉己月。沙門藏眞書。

(注：[爵]、[諸]兩字點去；[忽]、[必]、[存]三字爲八大山人漏寫)

無款識

鈐印一方：屐形無框扁方印

八大山人行楷書跋文

綠天庵《自序》、《千文》等帖醉書，一本于張有道之玄。唯《聖母帖》醒書，得索幼安與張有道之整。因想見漢二家書法，皆生長酒泉州郡，一去而爲屬國。綠天庵書，那得不珍重之。戊寅小春，八大山人題于在芙山房。

鈐印兩方：『蒿艾』(朱文長方印)、『可得神仙』(白文方印)

楊春華行書跋文

《聖母帖》，余昔年所觀者多矣，未若此之秀麗傑出者。得八大山人釋文，又見廬山眞面目，勿易視之。楊春華題。

鈐印一方：『楊春華印』(白文方印)

鑑藏印二十五方

八大山人三方(揚本上)：『蒿艾』(朱文長方印)、屐形無框扁方印、『可得神仙』(白文方印)

朱彝尊一方(揚本上)：『秀水朱氏潛采堂圖書』(朱文印)

沈彤一方(揚本上)：『果堂審定』(朱文葫蘆印)

李溥泉三方：『溥泉珍秘』(白文長方印：揚本上)、『白門李氏珍藏』(朱文方印：揚本上)、『溥泉珍秘』(白文長方印：釋文上)

林熊光五方：『林氏寶宋室所藏』(朱文方印：前隔水)、『寶宋室』(朱文方印：揚本上)、『朗庵鑑藏』(白文方印：揚本上)、『朗盦所得』(朱文長方印：釋文上)、『林熊光印』(白文方印：後隔水)

待考三方：『妙吉祥盦』(朱文方印：前隔水)、『雲華僊館審定』(朱文方印：揚本上)、『寶之過眼』(白文方印：後隔水)

程琦四方：『程伯奮珍藏印』(朱文方印：揚本上)、『雙宋樓』(朱文方印：揚本上)、『可菴珍祕』(朱文方印：釋文上)、『程伯奮圖書記』(白文長方印：釋文上)

王方宇一方：『方宇』(朱文長方印：釋文上)

沈慧四方：『沈慧』(朱文方印：揚本上)、『沈慧』(朱文方印：揚本上)、『沈慧』(朱文方印：釋文上)、『沈慧』(朱文方印：釋文上)

ENTRY 18. (F1998.43)

行楷書孫逖《奉和李右相中書壁畫山水詩》 軸

廟堂多暇日，山水契眞情，欲寫高深趣，還因藻繪成。
九江臨戶牖，三峽繞簷楹，花柳窮年發，烟雲逐意生。
能令萬里近，不覺四時行，氣流荀香馥，光含樂鏡清。
詠歌齊出處，圖畫表沖盈，自保千春遇，何論八載榮。

款識：八大山人

鈐印三方：『遙屬』(朱文長方印)、『可得神仙』(白文方印)、『八大山人』(白文長方印)

鑑藏印一方

王方宇和沈慧一方：『方慧共讀』(朱文長方印)

ENTRY 19. (F1998.49)

艾虎圖 軸

外簽：八大山人《艾虎圖》。無上妙品。大風堂供養。

款識：己卯端陽日寫，八大山人。

鈐印三方：『八大山人』(白文長方印)、『何園』(朱文方印)、『遙屬』(白文方印)

鑑藏印十一方

吳湖帆和潘靜淑五方：『湖颿靜淑珍藏畫戲』(白文長方印)、『吳湖颿珍藏印』(朱文方印)、『吳湖颿潘靜淑珍藏印』(朱文方印)、『醜簃書畫』(朱文方印)、『梅景書屋祕笈』(朱文長方印)

張大千五方：『南北東西只有相隨無別離』(朱文長方印)、『大風堂漸江髡殘雪個苦瓜墨緣』(朱文長方印)、『大風堂珍藏印』(朱文長方印)、『張爰私印』(白文方印)、『千秋願』(朱文方印)

王方宇和沈慧一方：『方慧共賞』(朱文方印)

ENTRY 20. (F1998.40.1-.20)

行楷書《興福寺半截碑》 廿開冊

外簽：八大山人《臨半截碑》眞跡。大風堂供養。壬辰閏五月重裝，大千居士題。

鈐印兩方：『張爰』(朱文方印)、『大千居士』(白文方印)

第一開

[碑第三半行]：…肇自石樓東鎭，守封司地之班，金冊西符，啓命將軍之秩。雖…

[碑第四半行]：…從師中尉，摠

第二開

　　南宮之禁，其或瞻剛如鐵，操緊明霜，酌龍豹之韜…

［碑第五半行］：…奉神武之榮，名溢寰海，

第三開

　　功坤動植，其誰由然哉。惟大將軍吳公，諱文，字才…

［碑第六半行］：…大夫、行內給事，父節皇朝金紫

第四開

　　光祿大夫、行內常侍、七貂…

［碑第七半行］：…之德，是使金鋪接慶，玉璽承官，長戟棨於司宮，高門聯于寺

第五開

　　伯，公…

［碑第八半行］：…雅局就於孩年，量轉奇規，英斷裁於稚齒，源之乎，鵬之爲鳥，不飛…

［碑第九半行］：…茲勵已，荷公不

第六開

　　私，補過愕愕於宮闈，匪懈兢兢於夙夜…

［碑第十半行］：…勞，撫公以袂，授公文林郎，適舉從班也。公謹密居體，謙

第七開

　　光潛旨，問…

［碑第十一行空］

［碑第十二半行］：…之賞，非公而何？多十二月，又制轉公右監門衛大將軍，建…

［碑第十三半行］：…宸，神龍三年，又制舉公鎮軍

第八開

　　大將軍、行右監門衛…

［碑第十四半行］：…杜，固以鋒交衛、霍，權衝田、竇，橫虎步於朱軒，跪龍顏於青…

［碑第十五半行］：…宮，公之祿

第九開

　　敢對揚天子之休命也。唐元年又制進封…

［碑第十六半行］：…二冊，三階應曆，八命騰遷，持大義而不可奪，保元勳而

第十開

　　若無有，則…

［碑第十七行空］

［碑第十八半行］：…皇上欽腹心之寄也。公平均七政，恭踐五朝，樹德務滋，循躬…

［碑第十九半行］：…成脩，乃奏乞骸骨，身歸

第十一開

　　常樂，詔許公焉。尙書謝病，非無給…

［碑第二十半行］：…彩，窺四序之留難，秋蓬颯飛，收百年之卷促，賈長沙

第十二開

　　之憤，結庚鵬…

［碑第二十一半行］：…呼，維公開國承祉，正家崇袟，葉嗣傳於紫紱，鼎冑曳於黃雲，元戎…

［碑第二十二半行］：…兼之行乎大

第十三開

　　壑，其量府也。黃金白玉兮，滿君之北堂，其賓賢也。虹…

［碑第二十三半行］：…風軌物，傑臣飛將，其在公乎。夫人恆國李氏，

第十四開

　　圓姿替月，潤靨呈花…

［碑第二十四半行］：…至七年十一月十二日，先公而殯，公以開元九年十月廿三日，循…

［碑第二十五半行］：…落松扃，金雞鳴而春

第十五開

　　不曉，玉犬吠而秋以暮，瘞將軍於地下，意氣…

［碑第二十六半行］：…附於平生，窅帳殊於窀穸，則公夫人之顧命，願不合於雙棺

第十六開

　　焉。於…

［碑第二十七半行］：…奉議大夫、行內常侍、上柱國處行，明姿鑒俗，謹身從道，元方長子，高…

［碑第二十八半行］：…行內僕局丞、（上柱國）

第十七開

　　上柱國昇行，及厭塵滓，開心大乘，出俗網之三災，迴…

［碑第二十九半行］：…庭局丞、騎都尉處昂等，並痛切終天，悲銜皆血，雖復合庭花，蓴聯…

［碑第三十半行］：…五色，詞騰七步，王公在眄，聖主承知，夢

第十八開

　　八門而出飛，屈五…

［碑第三十一行空］

［碑第三十二半行］：…神，出自天秀，蓋非常人，復禮由己，依仁立身，舉圖橫海，公心動鱗…

［碑第三十三半行］：…有珪，詩徵孟子，相舉王稽，南山之壽，嵂立其齊，西山之照，不意令…

［碑第三十四半行］：…伯銘金，潁川

第十九開

故事，遵揚德音，杳杳藤梛，青青柏林，旌勳表
頌，孝子…

[碑第三十五半行]：…維珍，文林郎、直將作監徐思忠等刻字，善提像
一鋪，居士張愛造。

款識：此碑載在興福寺，倍常住僧大雅集晉

第二十開

右軍將軍王羲之行書，勒上石者也。己卯，八大山
人臨。

鈐印兩方：『遙屬』(朱文長方印：第一開)、屐形無框扁方印 (第二十開)

鑑藏印五方

張大千三方：『藏之大千』(白文方印)、『大風堂漸江髠殘雪個苦瓜墨
緣』(朱文長方印)、『大風堂』(朱文方印)

王方宇一方：『方』『宇』(朱文連珠方印)

沈慧一方：『沈慧』(朱文方印)

湯雲松楷書跋文

八大山人，明益王孫。鼎革後流寓盱江，以畫名家。書法亦出入二
王，此臨《興福寺半截碑》尤其得意之作，瀟灑出塵，可寶可玩。丁
未中秋，湯雲松識。

鈐印兩方：『湯雲松印』(白文方印)、『鶴樹』(朱文方印)

ENTRY 21. (F1998.57)

山水圖　軸

款識：八大山人寫。

鈐印三方：『可得神仙』(白文方印)、『八大山人』(白文長方印)、『遙屬』
(白文方印)

鑑藏印三方

王方宇和沈慧一方：『方慧共賞』(朱文方印)

待考兩方：『祕晉齋印章』(朱文長方印)、『□樓眼福』(白文方印)

ENTRY 22. (F1998.42)

草書耿湋《題清源寺詩》　軸

儒墨兼宗道，　雲泉結舊廬，孟城今寂寞，　輞水自紆徐。
內學銷多累，　西園易故居，深房春竹老，　細雨夜鐘踈。
塵迹留金地，　遺文在石渠，不知登座客，　誰得蔡邕書。

款識：八大山人。

鈐印三方：『遙屬』(朱文長方印)、『可得神仙』(白文方印)、『八大山
人』(白文長方印)

鑑藏印五方

張大千四方：『別時容易』(朱文方印)、『球圖寶骨肉情』(朱文長方印)、

『大風堂漸江髠殘雪個苦瓜墨緣』(朱文長方印)、『不負古人告後人』
(朱文扁方印)

王方宇和沈慧一方：『方慧共賞』(朱文方印)

ENTRY 23. (F1998.51)

芍藥圖　軸

外籤：八大山人《芍藥》無上神品。大風堂供養。

鈐印兩方：『張爰』(白文方印)、『大千璽』(朱文方印)

行草書《七言絕句》一首
橫經不數漢時箋，邵伯何如此日筵，
分付好花珠玉裹，却教人待晚春天。

款識：花朝日讀恪齋先生《海棠詩》，作此求正。八大山人。

鈐印兩方：『八大山人』(白文長方印)、『何園』(朱文方印)

鑑藏印六方

張善孖一方：『善孖心賞』(朱文長方印)

張大千四方：『大風堂漸江髠殘雪個苦瓜墨緣』(朱文長方印)、『球圖寶
骨肉情』(白文扁方印)、『別時容易』(朱文方印)、『敵國之富』(朱
文方印)

王方宇一方：『食雞跖廬』(白文方印)

ENTRY 24. (F1998.50)

五松山圖　軸

外籤：八大山人《五松山圖》。紙本澹設色，晚年精作。大風堂供養。

鈐印兩方：『張爰』(白文方印)、『大千居士』(朱文方印)

款識：八大山人寫。

鈐印三方：『驢』(朱文長方印，倒轉)、屐形有框扁方印、『眞賞』(朱文
方印)

鑑藏印十一方

李溥泉兩方：『溥泉珍祕』(白文長方印)、『白門李氏珍藏』(朱文方印)

王文心三方：『王文心藏』(朱文方印)、『文心審定』(朱文方印)、『蒙泉
書屋書畫審定印』(白文方印)

張大千三方：『大風堂漸江髠殘雪個苦瓜墨緣』(朱文長方印)、『張大千
長年大吉又日利』(白文方印)、『別時容易』(朱文方印)

王方宇一方：『食雞跖廬』(白文方印)

待考兩方：『三羊齋藏金石書畫』(朱文長方印)、『丁伯川鑑賞章』(朱文
長方印)

葉德輝楷書題跋

昔張浦山撰《畫徵》，以為八大山人冠首，其傾倒以云至矣。又引裘
日菊孝廉之言曰：『山人畫筆固以簡略勝，不知其精密者又妙絕，時
人弟不多得耳』。此幅全以精密擅長，其山皴、樹枝均用反筆，蓋其
目中所覩，皆天翻地覆之事，故其悲憤一寓于楮素之間，此豈可以

尋常畫史論哉。此幅為吾友介卿觀察仁兄素所激賞，當時見之長沙市中，為吾豪奪。今忽忽廿餘年矣，山人滄桑之痛，不意吾輩又親見之。觀察遁迹海濱，閉門讀畫，《洞天清祿》為同輩中第一人。因檢行笥出以贈之，俾山人得一知己。觀察其永寶之。丁巳夏初，通家愚弟葉德輝識，時寓蘇城清嘉坊。

鈐印一方：『葉德輝』（朱文方印）

ENTRY 25. (F1998.30.1-.3)

行草書白居易《北窗三友詩》　冊頁三開

今日北窗下，自問何所為，欣然得三友，三友者為誰？琴罷輒飲酒，酒罷輒吟詩，三友遞相引，循環無已時；一彈愜中心，一詠暢四肢，猶恐中有間，以酒彌縫之。豈獨吾拙好，古人多若斯。嗜酒有淵明，嗜琴有啓期，嗜詩有伯倫，三人皆吾師；或乏儋石儲，或穿帶索衣，絃歌復觴詠，樂道知所歸。三師去已遠，高風不可追，三友遊甚熟，無日不相隨；左攔白玉巵，右拂黃金徽，興酣不疊紙，走筆操狂詞。誰能持此詞，為我謝親知，縱未以為是，豈以我為非？

款識：白香山此詩妙在一不及畫。庚辰三月廿日，八大山人記。
鈐印三方：『遙屬』（朱文長方印）、『八大山人』（白文長方印）、『何園』（朱文方印）

鑑藏印十一方
張瑋兩方：『固始張氏鏡菡榭印』（白文長方印）、『傚彬秘玩』（朱文方印）
張大千五方：『大千居士』（朱文方印）、『大千璽』（白文方印）、『大風堂漸江髡殘雪個苦瓜墨緣』（朱文長方印）、『張爰』（白文方印）、『三千大千』（朱文方印）
王方宇一印：『食雞跖廬』（白文方印）
待考三方：『春』（朱文長方印）、『春』（朱文長方印）、『春』（朱文方印）

ENTRY 26. (F1998.46)

椿萱鶺鴒圖　軸

外籤：大風堂供養，八大山人庚辰畫《椿萱鶺鴒圖》眞迹，時年七十五歲。

款識：庚辰，八大山人寫。
鈐印三方：『八大山人』（白文長方印）、『何園』（朱文方印）、『遙屬』（朱文長方印）

鑑藏印八方
張大千七方：『大風堂漸江髡殘雪個苦瓜墨緣』（朱文長方印）、『不負古人告後人』（朱文扁方印）、『南北東西只有相隨無別離』（朱文方印）、『己丑以後所得』（朱文長方印）、『球圖寶骨肉情』（白文扁方印）、『敵國之富』（朱文方印）、『別時容易』（朱文方印）
王方宇和沈慧一方：『方慧共賞』（朱文方印）

ENTRY 27. (F1998.47)

雙雁圖　軸

外籤：大風堂供養，八大山人晚歲畫《蘆雁》眞迹神品。己丑以後香港所得。

款識：八大山人寫。
鈐印三方：『八大山人』（白文長方印）、『何園』（朱文方印）、『遙屬』（白文方印）

鑑藏印八方
張大千六方：『己丑以後所得』（朱文長方印）、『球圖寶骨肉情』（白文扁方印）、『南北東西只有相隨無別離』（朱文方印）、『大風堂』（朱文方印）、『別時容易』（朱文方印）、『大風堂漸江髡殘雪個苦瓜墨緣』（朱文長方印）
王方宇和沈慧一方：『方慧共賞』（朱文方印）
待考一方：『□□張氏收藏書畫印』（白文方印）

ENTRY 28. (F1998.44.1-.4)

行草書唐詩　四條屏

軸一：行草書劉長卿《送方外上人》五言絕句
孤雲將野鶴，豈向人間住，莫買沃州山，時人已知處。

款識：八大山人。
鈐印三方：『眞賞』（朱文方印）、『八大山人』（白文長方印）、『何園』（朱文方印）

鑑藏印三方
張大千兩方：『大風堂』（朱文方印）、『大千好夢』（朱文長方印）
王方宇一方：『食雞跖廬』（白文長方印）

軸二：行草書王之渙《登鸛雀樓》五言絕句
白日依山盡，黃河入海流，欲窮千里目，更上一層樓。

款識：八大山人書。
鈐印三方：『眞賞』（朱文方印）、『八大山人』（白文長方印）、『何園』（朱文方印）

鑑藏印兩方
張善孖一方：『善孖心賞』（朱文方印）
張大千一方：『大千之寶』（朱文方印）

軸三：行草書孟郊《登科後》七言絕句
昔日齷齪不足嗟，今朝曠蕩思無涯，春風得意馬蹄疾，一日看遍長安花。

款識：八大山人。
鈐印三方：『眞賞』（朱文方印）、『八大山人』（白文長方印）、『何園』（朱文方印）

鑑藏印兩方
張善孖一方：『善孖審定』（朱文方印）
張大千一方：『大風堂長物』（朱文長方印）

軸四：行草書李搏《賀裴廷裕蜀中登第詩》七言律詩前半首
銅梁千里曙雲開，仙籙偏從紫府來，天上已張新羽翼，世間無復舊塵埃。

款識：八大山人。
鈐印三方：『眞賞』（朱文方印）、『八大山人』（白文長方印）、『何園』（朱文方印）

鑑藏印兩方
張大千兩方：『大千遊目』（朱文橢圓印）、『不負古人告後人』（朱文扁方印）

ENTRY 29. (F1998.52.1-.2)

玉簪花圖並草書節錄姜夔《續書譜》　冊頁兩開軸

外籤：八大山人《玉簪》。大風堂供。
鈐印兩方：『張爰』（白文方印）、『大千居士』（朱文方印）

《玉簪花圖》一開
款識：小春日寫。何園。
鈐印一方：『何園』（朱文方印）

鑑藏印七方
曹步郇一方：『陽邑曹步郇鑒定印』（白文長方印）
張大千四方：『別時容易』（朱文方印）、『大千游目』（朱文橢圓印）、『南北東西只有相隨無別離』（朱文方印）、『大風堂漸江髡殘雪個苦瓜墨緣』（朱文長方印）
王方宇一方：『方宇』（朱文方印）
沈慧一方：『沈慧』（朱文方印）

草書節錄姜夔《續書譜》一開
『唐太宗云："臥王蒙於紙中，坐徐偃於筆下"，可以嗤蕭子雲』一流人。八大山人書。
鈐印一方：『何園』（朱文方印）

鑑藏印三方
張大千兩方：『大風堂漸江髡殘雪個苦瓜墨緣』（朱文長方印）、『球圖寶骨肉情』（白文扁方印）
沈慧一方：『沈慧』（朱文方印）

ENTRY 30. (F1998.39.1-.2)

行書五言句　對聯

圖書自偃室，山斗望南都。

款識：八大山人。
鈐印三方：『遙屬』（白文方印）、『八大山人』（白文長方印）、『何園』（朱文方印）

鑑藏印六方
王方宇一方：『食雞跖廬』（白文方印：下聯）
待考五方：『勁草書屋』（朱文橢圓印：上聯）、『賜荃堂藏』（白文方印：上聯）、『郭氏珍藏』（朱文長方印：上聯）、『應荃珍藏』（朱文方印：下聯）、『濠梁郭氏白雲山館鑑藏』（朱文方印：下聯）

ENTRY 31. (F1998.37)

行楷臨王寵書閣防《夕次鹿門山作詩》　冊頁

龐公嘉遁所，浪迹難追攀。浮舟暝始至，抱杖聊自閒；雙崖開鹿門，百谷集珠灣。噴薄湍上水，春容栗裏山；焦原足險峻，梁墜未成難。我行自仲春，夏鳥語緜蠻；蕙艸色已晚，客心曾未還。遠游非避地，訪道愛童顏；安能徇機巧，爭奪錐刀間？

款識：臨雅宜山人書，八大山人。
鈐印三方：『十得』（朱文長方印）、『八大山人』（白文長方印）、『何園』（朱文方印）

鑑藏印三方
張大千一方：『大風堂』（朱文方印）
朱省齋一方：『朱省齋書畫記』（朱文長方印）
王方宇一方：『食雞跖廬』（白文方印）

ENTRY 32. (F1998.38.1-.2)

行草書臨黃道周尺牘　冊頁兩開

第一開
疏疏小艸，循俗作雙□，書[不]能就度。使坊中筆役見之，揶[揄]耳。僕以字役見命，當以暇刻一兩日，博取鵝羣[也]。疏早□廚□□□霍之餘之進。[道]周頓首。

款識：臨石齋先生書，八大山人。
鈐印一方：『十得』（朱文長方印）

鑑藏印兩方
王方宇一方：『方』『宇』（朱文連珠方印）
沈慧一方：『沈慧』（朱文方印）

第二開
《文獻通考》還去，□□經圖似可已。架上無可載此大編，且寄先生處，要則取覽之也。寫詩二紙寄上。道周頓首。

款識：石齋先生書，八大山人臨。
鈐印一方：『十得』(朱文長方印)

鑑藏印三方
張大千一方：『大風堂珍玩』(朱文扁方印)
王方宇一方：『王方宇』(朱文方印)
沈慧一方：『沈慧』(朱文方印)

倣倪瓚山水圖　冊頁

倪迁作畫，如天駿騰空，白雲出岫，無半点塵俗氣。余以暇日寫此。

無款識
鈐印一方：『十得』(朱文長方印)

鑑藏印兩方
王方宇一方：『方』『字』(朱文連珠方印)
沈慧一方：『沈慧』(朱文方印)

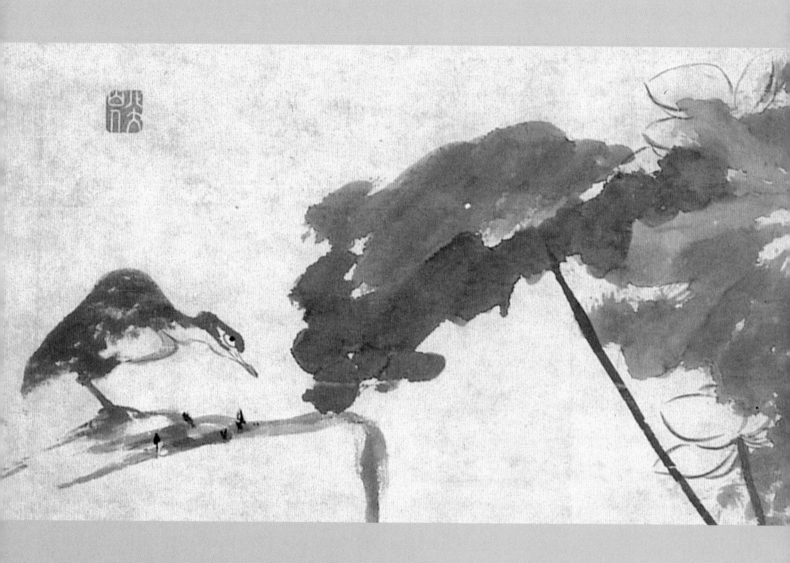

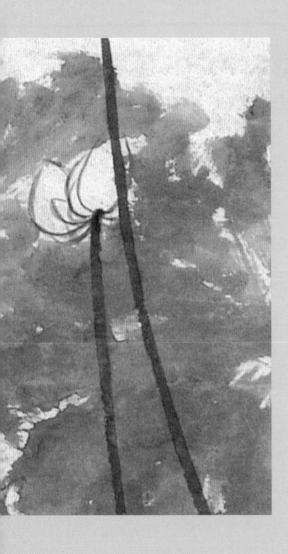

Appendices

SIGNATURES

1 法堀
 釋傳繁

Fajue shi Chuanqi
F1998.53.5
ca. 1665

2 八
 大
 山
 人

Bada Shanren
F1998.29.12
1684

3 八
 大
 山
 人

Bada Shanren
F1998.58.2
1690

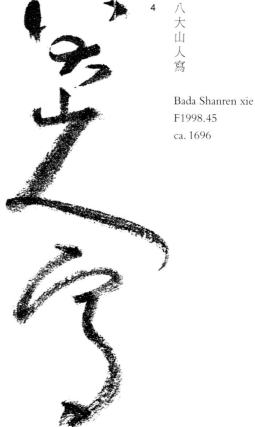

4 八大山人寫

Bada Shanren xie
F1998.45
ca. 1696

5 八
 大
 山
 人
 書

Bada Shanren shu
F1998.32
1697

6 八
 大
 山
 人
 書

Bada Shanren shu
F1998.34
ca. 1697

7　八大山人題

Bada Shanren ti
F1998.41
1698

8　八大山人臨

Bada Shanren lin
F1998.40.20
1699

9　八大山人寫

Bada Shanren xie
F1998.50
ca. 1699

10　八大山人記

Bada Shanren ji
F1998.30.3
1700

11　何園

Heyuan
F1998.52
ca. 1702

12　八大山人

Bada Shanren
F1998.37
ca. 1702

SEALS

 1 法
堀

Fajue
F1998.53.1
ca. 1665

 2 傳釋
繁印

Shi Chuanqi yin
F1998.53.8
ca. 1665

 3 菴刃

Ren'an
F1998.53.6
ca. 1665

 4 白
畫

Baihua
F1998.29.1
1684

 5 山八
人大

Bada Shanren
F1998.29.11
1684

 6 篇鰕
軒鉏

Xiashanpianxuan
F1998.29.11
1684

 7 驢

Lü
F1998.29.12
1684

 8 神可
仙得

Ke de shenxian
F1998.29.12
1684

 9 畫
渚

Huazhu
F1998.58.1
1690

 10 山

Shan
F1998.58.2
1690

 11 在
芙

Zaifu
F1998.48
1692

 12 Not deciphered
F1998.48
1692

 13 Not deciphered
F1998.56.3
1692

 14 Not deciphered
F1998.56.2
1692

15 涉
事

Sheshi
F1998.56.2
1692

16 Not deciphered
F1998.54.3
ca. 1693–96

17 遙
屬

Yaozhu
F1998.54.6
1696

18 神可
仙得

Ke de shenxian
F1998.54.7
ca. 1693–96

19 蔫
艾

Gui'ai
F1998.41
1698

20 山在
房芙

Zaifu shanfang
F1998.45
ca. 1696

21 山八
人大

Bada Shanren
F1998.45
ca. 1696

22 Not deciphered
F1998.41
ca. 1698

23 山八
人大

Bada Shanren
F1998.37
ca. 1702

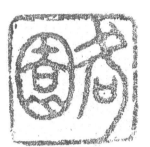

24 園何

Heyuan
F1998.37
ca. 1702

25 屬遙

Yaozhu
F1998.57
ca. 1699

26 驢

Lü
F1998.50
ca. 1699

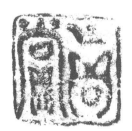

27 賞眞

Zhenshang
F1998.50
ca. 1699

28 十
得

Shide
F1998.37
ca. 1702

CHRONOLOGY OF CHINESE DYNASTIES

Shang dynasty, ca. 1600–1050 B.C.E.

Zhou dynasty, ca. 1050–221 B.C.E.

Qin dynasty, 221–206 B.C.E.

Han dynasty, 206 B.C.E.–220 C.E.

 Western Han dynasty, 206 B.C.E.–8 C.E.

 Eastern Han dynasty, 25–220 C.E.

Period of Division, 220–589 C.E.

 Three Kingdoms period, 220–265 C.E.

 Western Jin dynasty, 265–317 C.E.

 Southern Dynasties, 317–589
 Eastern Jin dynasty, 317–420 C.E.
 Liu-Song dynasty, 420–479 C.E.
 Southern Qi dynasty, 479–502
 Liang dynasty, 502–557
 Chen dynasty, 557–589

 Northern Dynasties, 386–581

Sui dynasty, 581–618

Tang dynasty, 618–907

Five Dynasties period, 907–960

 Southern Tang kingdom, 937–975

Song dynasty, 960–1279

 Northern Song dynasty, 960–1127

 Southern Song dynasty, 1127–1279

Yuan dynasty, 1279–1368

Ming dynasty, 1368–1644

Qing dynasty, 1644–1911

Republic period, 1912–present

 Republic of China, 1912–present

 People's Republic of China, 1949–present

GLOSSARY

PEOPLE

An Shifeng 安世鳳 (1558–after 1630)

Bada Shanren 八大山人 (1626–1705)

Bai Juyi 白居易 (772–846)

Baoyai 寶崖, see Wu Chenyan

C. C. Wang, see Wang Jiqian

Cai Yong 蔡邕 (133–192 C.E.)

Cangzhen 藏眞, see Huaisu

Cao Zhi 曹植 (192–232 C.E.)

Chen Ding 陳鼎 (17th century)

Chen Shun 陳淳 (1483–1544)

Chen Taixue 陳太學 (active ca. 16th century)

Chen Zi'ang 陳子昂 (661–702)

Chu Suiliang 褚遂良 (596–658)

Chuanqi 傳綮 (monk name of Bada Shanren)

Confucius, Kongzi 孔子 (or Kong Qiu 孔丘, 551–479 B.C.E.)

Dai Zhi 戴植 (active 1820s–40s)

Daya 大雅 (active early 8th century)

Dong Qichang 董其昌 (1555–1636)

Dongling Shengmu 東陵聖母 (early to mid-4th century C.E.)

Dong Yuan 董源 (died 962)

Du Fu 杜甫 (712–770)

Du Mu 杜牧 (803–852)

Emperor Daizong of the Tang dynasty 唐代宗 (reigned 763–80)

Emperor Dezong of the Tang dynasty 唐德宗 (reigned 779–805)

Emperor Gao of the Qi dynasty, Xiao Daocheng 齊高帝蕭道成 (reigned 479–82 C.E.)

Emperor Gaozong of the Tang dynasty 唐高宗 (reigned 649–83)

Emperor Gaozu of the Tang dynasty 唐高祖 (reigned 618–26)

Emperor Guangwu of the Eastern Han dynasty 東漢廣武帝 (reigned 25–57 C.E.)

Emperor Kang of the Jin dynasty 晉康帝 (reigned 342–44 C.E.)

Emperor Taizong of the Tang dynasty 唐太宗 (reigned 626–49)

Emperor Wu of the Liang dynasty, Xiao Yan 梁武帝蕭衍 (463–549, reigned 502–49)

Emperor Xianzong of the Ming dynasty, Zhu Jianshen 明憲宗朱見深 (reigned 1464–87)

Emperor Xuanzong of the Tang dynasty 唐玄宗 (reigned 712–56)

Emperor Yang of the Sui dynasty 隋煬帝 (reigned 604–17)

Fajue 法堀 (monk name of Bada Shanren)

Fang Feng 方鳳 (1240–1321)

Fu Shan 傅山 (1606–1684/85)

Fuxi 伏羲 (mythological ruler; traditionally reigned 2852–2738 B.C.E.)

Gao Yong 高邕 (1850–1921)

Geng Wei 耿湋 (active mid- to late 8th century)

Geshan 个山 (alternative name for Bada Shanren)

Guo 郭 (surname)

Guo Zongchang 郭宗昌 (late 16th–early 17th century)

Han Yu 韓愈 (768–824)

Hayashi Heizō 林平造 (20th century)

He Zhen 何震 (1535–1604)

Hu Yitang 胡亦堂 (died 1684)

Huaisu 懷素 (ca. 725–ca. 799)

Huang Anping 黃安平 (active late 17th century)

Huang Daozhou 黃道周 (1585–1646)

Huang Gongwang 黃公望 (1269–1354)

Huang Tingjian 黃庭堅 (1045–1105)

Jiang Kui 姜夔 (ca. 1155–ca. 1235)

King Yan of Xu, see Xu Yan (Wang)

Laozi 老子 (Master Lao, ca. 6th century B.C.E.)

Li Bo 李搏 (active 870s–80s)

Li Linfu 李林甫 (died 752)

Li Puquan 李蒲泉 (19th–20th century?)

Li She 李涉 (early to mid-9th century)

Li Sheng 李晟 (727–793)

Li Sixun 李思訓 (651–716)

Li Yuan 李愿 (active late 8th–early 9th century)

Li Yuan 李愿 (died 825)

Liang Fen 梁份 (1641–1729)

Lin Xiongguang 林熊光 (1898–1971)

Liu Changqing 劉長卿 (ca. 710–after 787)

Liu Jun 劉峻 (462–521 C.E.)

Liu Ling 劉伶 (died after 265 C.E.)

Liu Yiqing, Prince of Linchuan 臨川王劉義慶 (403–444 C.E.)

Long Kebao 龍科寶 (17th century)

Longyu 弄玉, daughter of Qin Mugong 秦穆公 (Duke Mu of Qin, reigned 659–21 B.C.E.)

Lu Zhi 陸治 (1496–1576)

Lü 驢 (donkey; nickname of Bada Shanren)

Ma Duanlin 馬端臨 (1254–1323)

Mei Geng 梅庚 (1640–1722)

Meng Jiao 孟郊 (751–814)

Mi Fu 米芾 (1051–1107)

Mozi 墨子 (Master Mo, ca. 480–ca. 420 B.C.E.)

Naitō Torajirō 內藤虎次郎 (1866–1934)

Ni Zan 倪瓚 (1306–1374)

Ouyang Xun 歐陽詢 (557–641)

Pang Degong 龐德公 (late 2d–early 3d century)

Pei Tingyu 裴廷裕 (active 880s–90s)

Qian Qi 錢起 (ca. 722–ca. 780)

Qiu Lian 裘璉 (1644–1729)

Qiu Yueju 裘曰菊 (active 1717–1734)

Rao Yupu 饒宇朴 (17th century)

Ren'an 忍菴 (monk name of Bada Shanren)

Rong Qiqi 榮啓期 (6th century B.C.E.)

Ruan Zhan 阮瞻 (ca. 279–ca. 308 C.E.)

Sanzang (Tripitaka), see Xuanzang

Shanqi, Prince Su 肅親王善耆 (1866–1922; 1863–1921; or 1866–1927)

Shao Changheng 邵長蘅 (1637–1704)

Shaobo 邵伯 or 召伯 (Lord Shao, 11th–10th century B.C.E.)

Shen Tong 沈彤 (1688–1752)

Shen Ye 沈野 (active second-half of the 16th century)

Shen Zhou 沈周 (1427–1509)

Shitao 石濤 (1642–1707)

Sum Wai (Shen Hui) 沈慧 (1918–1996)

Sun Ti 孫逖 (ca. 699–ca. 761)

Suo Jing 索靖 (239–303 C.E.)

Tang Yunsong 湯雲松 (jinshi 1840)

Tao Hongjing 陶弘景 (456–536 C.E.)

Tao Qian 陶潛 (365–427 C.E.)

Wang Can 王粲 (177–217 C.E.)

Wang Chong 王寵 (1494–1533)

Wang Fangyu 王方宇 (1913–1997)

Wang Jin 王縉 (died 781)

Wang Jiqian 王己千 (C. C. Wang, 1907–)

Wang Meng 王濛 (309–347 C.E.)

Wang Meng 王蒙 (1308–1385)

Wang Mian 王冕 (1287–1359)

Wang Wei 王維 (ca. 701–761)

Wang Wenxin 王文心 (19th–20th century)

Wang Xizhi 王羲之 (ca. 303–ca. 361 C.E.)

Wang Xianzhi 王獻之 (344–388 C.E.)

Wang Yuan 王源 (1648–1701)

Wang Zai 王宰 (active mid- to late 8th century)

Wang Zhihuan 王之渙 (688–742)

Wang Zhongsi 王忠嗣 (705–749)

Wen Peng 文彭 (1498–1573)

Wen Tianxiang 文天祥 (1236–1283)

Wen Zhengming 文徵明 (1470–1559)

Wu 吳 (surname)

Wu Changshuo 吳昌碩 (1844–1927)

Wu Chenyan 吳陳琰 (1663–after 1722)

Wu Hufan 吳湖帆 (1894–1968)

Wu Siqi 吳思齊 (1238–1301)

Wu Zetian 武則天 (empress, reigned 690–705)

Wu Zhen 吳鎮 (1280–1354)

Xi Kang 稽康 (223–262 C.E.)

Xi Shi 西施 (early 5th century B.C.E.)

Xiao Daocheng, see Emperor Gao of the Qi dynasty

Xiao Shi 蕭史 (mid-7th century B.C.E.)

Xiao Yan, see Emperor Wu of the Liang dynasty

Xiao Ziyun 蕭子雲 (486–548)

Xie Ao 謝翱 (1249–1295)

Xiwangmu 西王母 (Queen Mother of the West; mythological)

Xu Wei 徐渭 (1521–1593)

Xu Yan 徐偃, or Xu Yan Wang 王, King Yan of Xu (10th or 7th century B.C.E.)

Xuanzang 玄奘 (602–664)

Xuege 雪个 (sobriquet of Bada Shanren)

Xun Yu 荀彧 (163–212 C.E.)

Yan Fang 閻防 (early to mid-8th century)

Yang Chunhua 楊春華 (unidentified)

Yang Xian 楊峴 (1819–1896)

Ye Dehui 葉德輝 (1864–1927)

Yingxue Hongmin 穎學弘敏 (1607–1672)

Yue Guang 樂廣 (252–354 C.E.)

Zeng Gong 曾鞏 (1019–1083)

Zhang Daqian 張大千 (1899–1983)

Zhang Geng 張庚 (1685–1760)

Zhang Jiuling 張九齡 (678–740)

Zhang Lianqing 張蓮清 (20th century)

Zhang Shanzi 張善孖 (1882–1940)

Zhang Yue 張說 (667–731)

Zhang Zhi 張芝 (active ca. 150–192 C.E.)

Zhang Zhihe 張志和 (ca. 742–ca. 782)

Zhao Han 趙涵 (active 1590s–after 1618)

Zhao Mengfu 趙孟頫 (1254–1322)

Zhao Xigu 趙希鵠 (ca. 1170–after 1242)

Zhidun 支遁 (314–366 C.E.)

Zhou Muwang 周穆王 (King Mu of Zhou, reigned 1001–947 B.C.E.)

Zhou Zhimian 周之冕 (late 16th–early 17th century)

Zhu 朱 (imperial surname, Ming dynasty)

Zhu Bin 朱斌 (8th century)

Zhu Da 朱耷 (common name for Bada Shanren)

Zhu Duozheng 朱多炡 (1541–1589)

Zhu Moujin 朱謀鸛 (died 1644)

Zhu Quan 朱權 (1378–1448)

Zhu Shengzhai 朱省齋 (ca. 1902–1970)

Zhu Tonglin 朱統鏻 (possible birth-name for Bada Shanren)

Zhu Yizun 朱彝尊 (1629–1709)

Zhu Youben, Prince Yi 益王朱由本 (active 1615–after 1646)

Zhuang Zhou 莊周, see Zhuangzi

Zhuangzi 莊子 (Master Zhuang, ca. 369–ca. 286 B.C.E.)

Zong Bing 宗炳 (375–443 C.E.)

PLACES

Beilin 碑林 (Forest of Steles, in Xi'an 西安, Shaanxi Province)

Chang'an 長安 (modern Xi'an 西安, Shaanxi Province)

Changsha 長沙 (Hunan Province)

Chengdu 成都 (Sichuan Province)

Chenliu 陳留 (Henan Province)

Chongren 崇仁 (Jiangxi Province)

Cien Temple 慈恩寺 (Temple of Compassionate Grace)

Dafengtang 大風堂 (Hall of Great Wind—studio name of Zhang Daqian)

Dongguan 東觀 (Eastern Tower)

Fengxin 奉新 (Jiangxi Province)

Guanquelou 鶴雀(or 鸛)樓 (Hooded Crane Tower, Shanxi Province)

Hongyai 洪崖 (mountain in Xinjian 新建 county, Jiangxi Province)

Hongzhou 洪州 (modern Nanchang 南昌, Jiangxi Province)

Huangzhuyuan 黃竹園 (Yellow Bamboo Garden; Bada Shanren)

Jianchangfu 建昌府 (modern Nancheng 南城, Jiangxi Province)

Jiankang 建康 (modern Nanjing 南京, Jiangsu Province)

Jiaoyuan 焦原 (mountain near Juxian 莒縣, Shandong Province)

Jiaxing 嘉興 (Zhejiang Province)

Jiegang 介岡 (near Jinxian 進賢, Jiangxi Province)

Jiuquan 酒泉 (near Dunhuang 敦煌, Gansu Province)

Jiyuan 濟源 (Henan Province)

Juxian 莒縣 (Shandong Province)

Kuaiji 會稽 (modern Shaoxing 紹興, Zhejiang Province)

Lantian 藍田 (Shaanxi Province)

Lanting 蘭亭 (Orchid Pavilion)

Linchuan 臨川 (Jiangxi Province)

Lingling 零陵 (Hunan Province)

Lumenshan 鹿門山 (Deer Gate Mountain)

Luoyang 洛陽 (Henan Province)

Lülianghuo 呂梁壑 (Lü Bridge Gorge, near Tongshanxian 桐山縣, Jiangsu Province)

Lüshun 旅順 (Liaoning Province)

Lütian'an 綠天庵 (Temple of the Emerald Sky)

Maoshan 茅山 (Jiangsu Province)

Nanchang 南昌 (Jiangxi Province)

Nanfeng 南豐 (Jiangxi Province)

Nanjing 南京 (Jiangsu Province)

Ningxian 寧縣 (Gansu Province)

Pangu 盤谷 (Winding Valley, Henan Province)

Puzhou 蒲州 (modern Yongji 永濟, Shanxi Province)

Qianshan 潛山 (Anhui Province)

Qiantang 錢塘 (modern Hangzhou 杭州, Zhejiang Province)

Qingyuan si 清源寺 (Clear Springs Temple)

Qinling 秦嶺 (mountain range in Shaanxi Province)

Shanhuchuan 珊瑚川 (near Ningxian 寧縣, eastern Gansu Province)

Shannan 山南 (two Tang provinces)

Shanyin 山陰 (modern Shaoxing 紹興, Zhejiang Province)

Shaoxing 紹興 (Zhejiang Province)

Shichengfu 石城府 (Anhui Province)

Shixing 始興 (Guangzhou Province)

Taihang 太行 (mountains in Shanxi Province)

Taihu 太湖 (Lake Tai, Jiangsu Province)

Taishan 泰山 (Mount Tai, Shandong Province)

Taiyuan 太原 (Shanxi Province)

Tianjin 天津 (Hebei Province)

Tongzhou 通州 (modern Nantong 南通, Jiangsu Province)

Wangchuan 輞川 (Wheel Rim Creek, Shaanxi Province)

Wanshan 皖山 (Shining Hills, Anhui Province)

Wuge caotang 寤歌草堂 (Hut for Sleeping Alone and Waking to Sing; Bada Shanren)

Xiangfan 襄樊 (Hubei Province)

Xinchang 新昌 (Zhejiang Province)

Xinjian 新建 (modern Nanchang 南昌, Jiangxi Province)

Xinjiang 信江 (river in eastern Jiangxi Province)

Xiping 西平 (Gansu Province)

Xisaishan 西塞山 (West Pass Hill, near Wuxing 吳興, Zhejiang Province)

Xuancheng 宣城 (Anhui Province)

Xujiang 盱江 (river in eastern Jiangxi Province)

Yangzhou 揚州 (Jiangsu Province)

Yanling Xitai 嚴陵西臺 (Western Terrace of Yanling, Zhejiang Province)

Yanshan 鉛山 (county in eastern Jiangxi Province)

Yanta 雁塔 (Wild Goose Pagoda)

Youquan 由拳 (modern Jiaxing 嘉興, Zhejiang Province)

Yueyang 岳陽 (Hunan Province)

Yuhang 餘杭 (Zhejiang Province)

Zaifu shanfang 在芙山房 (Mountains Lodge amid the Lotus; Bada Shanren)

Zhenjiang 鎮江 (Jiangsu Province)

WORDS AND TERMS

Bada ti 八大體 (Bada style)

bei 碑 (stele)

Beidou 北斗 (Northern Dipper; Big Dipper)

Caodong 曹洞 (sect of Chan Buddhism)

cefeng 側鋒 (side of brush)

Chan 禪 (Zen)

chedian 掣顛 (control madness)

chun 椿 (cedar; *Cedrela sinensis, Juss.*)

dao 道 (the Way)

Dengshe 燈社 (Lantern Society)

fanbi 反筆 ("backward strokes")

fangcao 芳草 (fragrant grass)

fen 分 (divided)

fu xian 夫閒 (meaning uncertain)

gantang 甘棠 (a name for *tangli*, see below)

ganyu 感遇 (stirred, or moved, by experience)

gong 宮 (palace)

gongbu 工部 (Ministry of Works)

gu 骨 (bone)

gui'ai 蕘艾 (polygala and moxa; seal text of Bada Shanren)

haitang 海棠 (crab apple; *Chaenomeles lagenaria*, or *Malus micromalus*)

hao 號 (sobriquet; poetic name)

hefu 何負 (What promise did I break?—seal text of Bada Shanren)

hong 洪 (flood; broad, vast; abbreviated name for Nanchang?)

hua 化 (to transform)

hua 畫 (painting)

huangzhu 黃竹 (yellow bamboo)

ji 記 (account, record)

jie 階 (stairs, step; rank)

jiling 鶺鴒 (wagtail; *Motacilla chinensis*)

jin 筋 (sinew)

jinshi 進士 (advanced scholar degree)

jiu 舊 (old)

jun 郡 (commandery)

ke de shenxian 可得神仙 (immortality is achievable; seal text of Bada Shanren)

lin 臨 (to copy)

lü 驢 (donkey)

lüshi 律詩 (regulated verse)

mianman 縣蠻 (tender and low)

mu 摹 (to trace)

piao 漂 (to float, drift, be tossed about)

qin 琴 (zither, lute)

Shangqing 上清 (Highest Purity: a school of medieval Daoism)

shanshui 山水 (landscape; or hills and streams)

shaoyao 芍藥 (peony; *Paeonia lactiflora*)

sheshi 涉事 (involved in affairs)

shuhua tongyuan 書畫同源 (calligraphy and painting come from the same source)

tangli 棠梨 (sweet pear; *Pyrus betulifolia*)

tiexuepai 帖學派 (model text tradition)

tongku 慟哭 (to wail in anguish)

tushu 圖書 (charts, or pictures, and books; library)

wangsun 王孫 (princely descendant)

xie 斜 (slanting, leaning, tilted, oblique, sideways)

Xijiang Yiyang wangsun 西江弋陽王孫 (Descendant of Prince Yiyang of Jiangxi)

xinhua 心畫 (delineation of the mind)

xuan 萱 (day lily; *Hemerocallis fulva*)

yang kuang 佯狂 (to feign madness)

ye 也 (copula)

yi 矣 (emphatic particle)

Yiyang 弋陽 branch of the Ning 寧 princedom

youxiang 右相 (Minister of the Right)

yuanzhi 遠志 (great ambition)

yue 曰 (to say, be called)

yuzanhua 玉簪花 (Jade hairpin flowers: *Hosta sieboldiana*, or *Hosta plantaginea, Aschers*)

zheng 正 (upright, true; proper, correct; principal, chief)

zhi 制 (decree)

zhongfeng 中鋒 (brush tip)

zhongshu ling 中書令 (Director of the Secretariat)

zi 字 (courtesy name)

BOOK AND TEXT TITLES

"Ai wangsun" 哀王孫 (Alas, a prince!), by Du Fu (712–770)

Daodejing 道德經 (Book of the Way and its power), by Laozi (ca. 6th century B.C.E.)

Dongtian qinglu ji 洞天清錄集 (Pure records from the cavern heaven), by Zhao Xigu (ca. 1170–after 1242)

"Gantang" 甘棠 (Sweet pear), poem 16 in the *Shijing*

Huangtingjing 黃庭經 (Scripture of the Inner Radiances of the Yellow Court)

"Jiude song" 酒德頌 (Eulogy on the Virtue of Wine), by Liu Ling (died after 265 C.E.)

"Lanting ji xu" 蘭亭集序 (Preface to the Gathering at the Orchid Pavilion)

"Luoshen fu" 洛神賦 (Rhapsody, or prose-poem, on the Goddess of the Luo River)

Qingmen lügao 青門旅稿 (Notes on my travels), by Shao Changheng (1637–1704)

"Shengjiao xu" 聖教序 (Preface to the sacred teachings)

Shengmu tie 聖母帖 (Holy Mother Manuscript)

Shijing 詩經 (Classic of poetry)

Wenxian tongkao 文獻通考 (General history of institutions and critical examination of documents and studies), compiled by Ma Duanlin (1254–1323)

"Yangsheng lun" 養生論 (Treatise on nurturing life)

Yijing 易經 (Book of changes)

"Yufu ge" 漁父歌 (Fishermen songs), by Zhang Zhihe (ca. 742–ca. 782)

BIBLIOGRAPHY

ABBREVIATION

WSKQS for *Wenyuange Siku quanshu dianziban* 文淵閣四庫全書電子版 (The Electronic Version of *Siku quanshu* [Wenyuange edition], professional version 1.0). 163 discs. Hong Kong: Digital Heritage Publishing, The Chinese University Press, 1999.

CHINESE AND JAPANESE SOURCES

Bada Shanren Jinianguan 八大山人紀念館, ed. *Bada Shanren yanjiu* 八大山人研究 (Studies on Bada Shanren). Nanchang: Jiangxi renmin chubanshe, 1986.

Bai Juyi 白居易. *Bai Juyi ji jianjiao* 白居易集箋校 (Collected works of Bai Juyi, with notes and variants). Edited by Zhu Jincheng 朱金城. 6 vols. Shanghai: Shanghai guji chubanshe, 1988.

Bai Qianshen 白謙慎. "Bada Shanren huaya 'Shiyousan yue' kaoshi; fu Bada Shanren 'Yunchuang' yin xiaoji" 《八大山人花押『十有三月』考釋：附八大山人『芸窗』鈐小記》 (Interpretation of Bada Shanren's cipher-signature "Thirteenth month," with some notes on Bada Shanren's seal "Yunchuang"). *Gugong wenwu yuekan* 故宮文物月刊 (National Palace Museum Monthly) 133 (April 1994): 120–31. Reprinted in *Bada Shanren quanji* 八大山人全集 (Complete works of Bada Shanren). Edited by Wang Zhaowen 王朝聞. Vol. 5. Nanchang: Jiangxi meishu chubanshe, 2000.

———. "Bada Shanren wei Yan Ruoqu shu lian xiaokao ji qita" 《八大山人爲閻若璩書聯小考及其它》 (A brief study of Bada Shanren's couplet for Yan Ruoqu and other matters). *Gugong wenwu yuekan* 故宮文物月刊 (National Palace Museum Monthly) 109 (April 1992): 72–77.

———. "Cong Bada Shanren lin 'Lanting xu' lun Mingmo Qingchu shufa zhong de linshu guannian" 《從八大山人臨蘭亭序論明末清初書法中的臨書觀念》 (Bada Shanren's copies of the *Lanting xu* and the late-Ming to early-Qing concept of free copying). In *Lanting lunji* 蘭亭論集 (Collection of essays on the Orchid Pavilion). Edited by Hua Rende 華人德 and Bai Qianshen. Suzhou: Suzhou daxue chubanshe, 2000.

———. "Minmatsu Shinsho no shohō ni okeru itaiji shiyo no fūchō ni tsuite" 《明末清初の書法における異体字使用の風潮について》 (A study of the fashion of writing strange characters in late-Ming to early-Qing calligraphy). *Shoron* 書論 32 (2001): 181–87.

———. "Qingchu jinshixue de fuxing dui Bada Shanren wannian shufeng de yingxiang" 《清初金石學的復興對八大山人晚年書風的影響》 (The influence of the revival of the study of *jinshixue* in the early Qing on the late calligraphy of Bada Shanren). *Gugong xueshu jikan* 故宮學術季刊 (National Palace Museum Monthly) 12, no. 3 (April 1995): 89–124.

Ban Gu 班固 (32–92 C.E.). *Baihu tongyi* 白虎通義 (Comprehensive discussions in the White Tiger Hall). In *WSKQS*. Disc 92.

Bi Yuan 畢沅 (1730–1797), comp. *Jingxuntang fashu* 經訓堂法書 (Exemplary calligraphy in the Jingxuntang). 12 vols. China: privately published, 1789.

Chang Bide 昌彼得 et al., comps. *Songren chuanqi ziliao suoyin* 宋人傳奇資料索引 (Index to biographical materials on Song dynasty figures). 6 vols. Taipei: Dingwen shuju, 1973.

Chen Bangyan 陳邦彥 (1603–1647), comp. *Lidai tihuashi lei* 歷代題畫詩類 (Poems on paintings through the ages, by category). In *WSKQS*. Disc 157. Or Beijing: Palace edition, 1707.

Chen Ding 陳定 (17th century). "Bada Shanren zhuan" 《八大山人傳》 (The biography of Bada Shanren). In *Bada Shanren lunji* 八大山人論集 (An anthology of essays on Pa-ta-shan-jen). Edited by Wang Fangyu 王方宇. Vol. 1. Taipei: Guoli bianyiguan Zhonghua congshu bianshen weiyuanhui, 1984.

Chen Jie 陳玠. *Shufa ouji* 書法偶集 (Random notes on calligraphy). In *Pinglu congke* 屏廬叢刻 (Various writings published by Pinglu). Edited by Jin Yue 金鉞. Beijing: Beijingshi Zhongguo shudian, 1985.

Chen Shou 陳壽 (233–297 C.E.), comp. *Sanguo zhi* 三國志 (Record of the Three Kingdoms period, 221–280 C.E.). 5 vols. Beijing: Zhonghua shuju, 1959; 1973 edition.

Chen Yutang 陳玉堂, ed. *Zhongguo jinxiandai renwu minghao dacidian* 中國近現代人物名號大辭典 (Dictionary of given names and sobriquets for figures from recent and contemporary China). Hangzhou: Zhejiang guji chubanshe, 1993.

Cheng Qi 程琦. *Bada Shanren shuhua ji* 八大山人書畫集 (Collection of calligraphy and painting by Bada Shanren). Works in the Jinsong caotang 晉松草堂 collection of Cheng Qi.

Kyoto: Tōhō bunka kankōkai, 1956.

Conglin 叢林. *Bada Shanren hanmo ji* 八大山人翰墨集 (Collection of ink works by Bada Shanren). Beijing: Zhishi chubanshe, 1990.

Dong Qichang 董其昌 (1555–1636). *Xingshu shi "Shengmu tie" yice* 行書釋《聖母帖》一冊 (Album: Transcription of the "Holy Mother Manuscript," in running script). In *Shiqu baoji xubian* 石渠寶笈續編 (Catalogue of the Qing imperial collection of painting and calligraphy, second series [1793]). Compiled and edited by Wang Jie 王杰 (1725–1805) et al. Vol. 6. Taipei: Gugong bowuyuan, 1971.

Fan Ye 范曄 (398–445 C.E.), comp. *Hou Han shu* 後漢書 (History of the Eastern Han dynasty, 25–220 C.E.). 6 vols. Beijing: Zhonghua shuju, 1965.

Fang Xuanling 房玄齡 (578–648) et al., comps. *Jin shu* 晉書 (History of the Jin dynasty, 265–419 C.E.). 5 vols. Beijing: Zhonghua shuju, 1974.

Fushimi Chūkei 伏見沖敬. "Ō Gishi Kōfukuji danpi" 《王羲之興福寺斷碑》 (Wang Xizhi's "Half-stele of Xingfu Temple"). In *Shoseki meihin sōkan* 書跡名品叢刊 (Compendium of famous works of calligraphy). Vol. 73. Tokyo: Nigensha, 1969.

Gao Buying 高步瀛, comp. and annotator. *Tang Song wen juyao* 唐宋文舉要 (Essential prose of the Tang and Song dynasties). 3 vols. Hong Kong: Zhonghua shuju, 1985.

Gao Yong 高邕 (1850–1921), comp. *Taishan Canshilou canghua* 泰山殘石樓藏畫 (Paintings

in the collection of the Broken Stone Tower of Taishan). 40 vols. Shanghai: Xiling yinshe, 1926–29.

Ge Hong 葛洪 (284–364 C.E., or 254–334 C.E.). *Shenxian zhuan* 神仙傳 (Biographies of the immortals). In *WSKQS*. Disc 116.

Gugong shuhua tumu 故宮書畫圖錄 (Photo-catalogue of Chinese painting and calligraphy in the National Palace Museum, Taipei). Taipei: Gugong bowuyuan, 1991.

Guo Qingfen 郭慶藩 (1844–1896), comp. *Zhuangzi jishi* 莊子集釋 (Collected commentaries on the *Zhuangzi*). 4 vols. Beijing: Zhonghua shuju, 1961; 1978 edition.

Guo Zixu 郭子緒. "Bada Shanren shufa pingzhuan" 《八大山人書法評傳》 (An evaluation of Bada Shanren's calligraphy). In *Zhongguo shufa quanji 64. Qingdai: Zhu Da, Shitao, Gong Xian, Gong Qinggao* 中國書法全集 64。清代：朱耷、石濤、龔賢、龔晴皋 (Complete Chinese calligraphy 64. Qing dynasty: Zhu Da, Shitao, Gong Xian, Gong Qinggao). Edited by Guo Zixu et al. Beijing: Rongbaozhai chubanshe, 1998.

Guo Zixu 郭子緒 et al., eds. *Zhongguo shufa quanji 64. Qingdai: Zhu Da, Shitao, Gong Xian, Gong Qinggao* 中國書法全集 64。清代：朱耷、石濤、龔賢、龔晴皋 (Complete Chinese calligraphy 64. Qing dynasty: Zhu Da, Shitao, Gong Xian, Gong Qinggao). Beijing: Rongbaozhai chubanshe, 1998.

Hong Ye 洪業 (William Hung), comp. *Dushi yinde* 杜詩引得 (Concordance to the poems of Tu Fu). 3 vols. In Harvard-Yenching Institute Sinological Index Series, supplement 14. Beiping [Beijing]: Yenching University, 1940.

Hong Ye 洪業 (William Hung) et al., eds. *Zhou Yi yinde* 周易引得 (A concordance to the Yi Ching). In Harvard-Yenching Institute Sinological Index Series, supplement 10. Beiping [Beijing]: Yenching University Library, 1935.

Hu Yi 胡藝. "Bada Shanren xinkao" 八大山人新考 (New discoveries on Bada Shanren). In *Bada Shanren yanjiu* 八大山人研究 (Studies on Bada Shanren). Edited by Bada Shanren Jinianguan 八大山人紀念館. Nanchang: Jiangxi renmin chubanshe, 1986.

Hu Zhe 胡折 and Jin Ping 錦平. "Mei Geng nianpu" 《梅庚年譜》 (The chronology of Mei Geng). *Duoyun* 朵雲 (Art Clouds Quarterly) 53 (December 2000): 294–320.

Hua Rende 華人德 and Bai Qianshen 白謙慎, eds. *Lanting lunji* 蘭亭論集 (Collection of essays on Lanting). Suzhou: Suzhou daxue chubanshe, 2000.

Huang Du 黃篤. "Luo Mu nianpu" 《羅牧年譜》 (The chronology of Luo Mu). *Duoyun* 朵雲 (Art Clouds Quarterly) 25 (June 1990): 122–27.

Huili 慧立 (615–?) and Yancong 彥悰 (active mid- to late 7th century). *Datang da Ci'ensi Sanzang fashi zhuan* 大唐大慈恩寺三藏法師傳 (Biography of Tripitaka, the Teacher of the Law, of the Great Temple of Compassionate Grace of the Great Tang Dynasty). In *Taishō shinshū Daizō-kyō* 太正新脩大藏經 (The Taishō edition of the Buddhist Canon). Vol. 50. Tokyo: Taishō shinshū Daizō-kyō kanko kei, 1962.

Ji Yougong 計有功 (*jinshi* 1121), comp. *Tangshi jishi* 唐詩記事 (Tang poems and related anecdotes). In *WSKQS*. Disc 162.

Jiang Kui 姜夔 (ca. 1155–ca. 1235). *Xu shupu* 續書譜 (Sequel to the treatise on calligraphy). In *Yishu congbian* 藝術叢編 (Compendium of writings about art). Edited by Yang Jialuo 楊家駱. Vol. 2. Taipei: Shijie shuju, 1966.

Jiang Zhaoshen 江兆申. *Shuangxi duhua suibi* 雙溪讀畫隨筆 (Notes on viewing paintings in the National Palace Museum). Taipei: National Palace Museum, 1987.

Kokushi daijiten 國史大辭典 (Encyclopedia of Japanese history). 15 vols. Tokyo: Yoshikawa kobunsha, 1978–89.

Kong Shoushan 孔壽山, ed. *Tangchao tihuashi zhu* 唐朝題畫詩注 (Annotated Tang dynasty poems on paintings). Chengdu: Sichuan meishu chubanshe, 1988.

Li Fang 李昉 (925–996) et al., comps. *Taiping guangji* 太平廣記 (Miscellaneous records of the Taiping reign period, 976–83). In *WSKQS*. Disc 114.

———— et al., comps. *Wenyuan yinghua* 文苑英華 (Bright blossoms in the garden of literature, 987). Photolithographic copy of Ming edition. 6 vols. Beijing: Zhonghua shuju, 1966; 1990 edition.

Li Yanshou 李延壽 (active 618–676) et al., comps. *Nan shi* 南史 (History of the Southern Dynasties, 420–589). 3 vols. Beijing: Zhonghua shuju, 1975.

Liu Tao 劉濤, ed. *Zhongguo shufa quanji 19. Sanguo, Liang Jin, Nanbeichao: Wang Xizhi, Wang Xianzhi, juan er* 中國書法全集 19。三國兩晉南北朝：王義之、王獻之：卷二 (Complete Chinese calligraphy, volume 19. Three Kingdoms, Two Jin Dynasties, and Northern and Southern Dynasties: Wang Xizhi and Wang Xianzhi, part 2). Beijing: Rongbaozhai, 1991.

Liu Xu 劉昫 (887–946) et al., comps. *Jiu Tang shu* 舊唐書 (Old history of the Tang dynasty, 618–907). 8 vols. Beijing: Zhonghua shuju, 1975.

Liu Yiqing 劉義慶 (403–444 C.E.), comp. *Shishuo xinyu* 世說新語 (New account of tales of the world). In *Zhuzi jicheng* 諸子集成 (Compendium of works by famous masters). Vol. 8. Beijing: Zhonghua shuju, 1954; 1986 reprint.

Lu Fusheng 盧輔聖 et al., comps. *Zhongguo shuhua quanshu* 中國書畫全書 (Complete writings on Chinese calligraphy and painting). 14 vols. Shanghai: Shanghai shuhua chubanshe, 1992–99.

Lu Yaoyu 陸耀遹 (1771–1836). *Jinshi xubian* 金石續編 (Further studies in epigraphy). China: Shuangbaiyantang, 1874.

Lu Zengxiang 陸增祥 (1816–1882). *Baqiongshi jinshi buzheng* 八瓊室金石補正 (Studies in epigraphy). Beijing: Wenwu chubanshe, 1985.

Matsui Joryū 松井如流. "Kōfukuji danpi" 《興福寺斷碑》 (The half-stele of Xingfu Temple). *Shohin* 書品 83 (October 1957): 67–70; plates 1–28.

Meng Jiao 孟郊 (751–814). *Meng Dongye shiji* 孟東野詩集

(Collected poetry of Meng Jiao). Compiled by Song Minqiu 宋敏求 (1019–1079). In *WSKQS*. Disc 118.

Mu Tianzi zhuan 穆天子傳 (Travels of Emperor Mu). Commentary by Guo Pu 郭璞 (276–324 C.E.). In *WSKQS*. Disc 114.

Nakata Yūjirō 中田勇次郎. *Ri Yō, Chō Kyoku, Kaiso, Yō Gyō-shiki* 李邕、張旭、懷素、楊凝式 (Li Yong, Zhang Xu, Huaisu, and Yang Ningshi). In *Shodō geijutsu* 書道藝術 (The art of calligraphy). Edited by Nakata Yūjirō. Vol. 5. Tokyo: Chūō koronsha, 1976.

Ouyang Xiu 歐陽修 (1007–1072) et al., comps. *Xin Tang shu* 新唐書 (New history of the Tang dynasty, 618–907). 20 vols. Beijing: Zhonghua shuju, 1975.

Peng Dingqiu 彭定求 (1645–1719) et al., comps. *Quan Tang shi* 全唐詩 (Complete Tang poems, 1705). 25 vols. Beijing: Zhonghua shuju, 1960; 1985 edition.

Rao Zongyi 饒宗頤. "Chanseng Chuanqi qianhou qi minghao zhi jieshuo" 禪僧傳綮前後期名號之解說 (Interpretations of various pseudonyms of the Chan monk, Chuanqi). *Duoyun* 朵雲 (Art Clouds Quarterly) 15 (October 1987): 150–53. Reprinted in *Bada Shanren quanji* 八大山人全集 (Complete works of Bada Shanren). Edited by Wang Zhaowen 王朝聞. Vol. 5. Nanchang: Jiangxi meishu chubanshe, 2000.

———. "Zhilelou cang Bada Shanren shanshuihua ji qi xiangguan wenti"《至樂樓藏八大山人山水畫及其相關問題》(Landscape paintings by Bada Shanren in the Zhilelou collection and related issues). In *Ming yimin shuhua yanjiu taolunhui jilu*

明遺民書畫研究討論會記錄 (Proceedings of the symposium on paintings and calligraphy by Ming *i-min*). *Zhongguo wenhua yanjiusuo xuebao* 中國文化研究所學報 (Journal of the Institute of Chinese Studies) 8, no. 2 (December 1976): 507–15; English summary, 516–17.

Rui Tingzhang 芮廷章 (8th century), comp. *Guoxiu ji* 國秀集 (A poetry anthology, 744). In *WSKQS*. Disc 146. Or in *Tangren xuan Tang shi, shizhong* 唐人選唐詩，十種 (Tang poems selected by Tang compilers, ten examples). Vol. 1. Shanghai: Shanghai guji chubanshe, 1958; 1978 edition.

Sha Menghai 沙夢海. *Sha Menghai lunshu conggao* 沙夢海論書叢稿 (Collected discussions on calligraphy by Sha Menghai). Shanghai: Shanghai shuhua chubanshe, 1987.

Shao Changheng 邵長蘅. "Bada Shanren zhuan" 八大山人傳 (Biography of Bada Shanren). In *Bada Shanren lunji* 八大山人論集 (An anthology of essays on Pa-ta-shan-jen). Edited by Wang Fangyu 王方宇. Vol. 1. Taipei: Guoli bianyiguan Zhonghua congshu bianshen weiyuanhui, 1984.

Shen Tonglü 沈桐履. "Shishi Bada Shanren tihuashi"《試釋八大山人題畫詩》(Explanations of Bada Shanren's poems on paintings). In *Bada Shanren yanjiu* 八大山人研究 (Studies on Bada Shanren). Edited by Bada Shanren jinianguan. Nanchang: Jiangxi renmin chubanshe, 1986.

Shen Ye 沈野 (17th century). *Yin tan* 印談 (Talking about seals). In *Lidai yinxue lunwen xuan* 歷代印學論文選 (The study of seals through the ages,

selected texts). Edited by Han Tianheng 韓天衡. Hangzhou: Xiling yinshe, 1999.

Shen Yue 沈約 (441–513 C.E.), comp. *Song shu* 宋書 (History of the Liu-Song dynasty, 420–479 C.E.). 4 vols. Beijing: Zhonghua shuju, 1974.

Shoseki meihin sōkan 書跡名品叢刊 (Compendium of famous works of calligraphy). 208 vols. Tokyo: Nigensha, 1969–81.

Sugimura Kunihiko 杉村邦彥. *Kaiso Seibo chō* 懷素《聖母帖》(The "Holy Mother Manuscript" by Huaisu). In *Shoseki meihin sōkan* 書跡名品叢刊 (Compendium of famous works of calligraphy). Vol. 191. Tokyo: Nigensha, 1974.

Sun Chengze 孫承澤 (1592–1676). *Gengzi xiaoxia ji* 庚子消夏記 (Record of whiling away the summer in the *gengzi* year [1660]). China: n.p., prefaces 1755, 1761.

Sun Huanjing 孫寰鏡 (late 19th–early 20th century). *Ming yimin lu* 明遺民錄 (Records of Ming loyalists). Hangzhou: Zhejiang guji chubanshe, 1985.

Sun Weizu 孫慰祖. *Sun Weizu lunyin wengao* 孫慰祖論印文稿 (Sun Weizu's discussions on seals). Shanghai: Shanghai shudian, 1999.

Tangren xuan Tang shi, shizhong 唐人選唐詩，十種 (Tang poems selected by Tang compilers, ten examples). 2 vols. Shanghai: Shanghai guji chubanshe, 1958; 1978 edition.

Tian Rucheng 田汝成 (early to mid-16th century). *Xihu youlanzhi yu* 西湖遊覽志餘 (Sightseeing at West Lake, continued). In *WSKQS*. Disc 62.

Wang Bi 王弼 (226–249 C.E.). *Laozi Daodejing zhu* 老子道德經注 (Commentary to *The Way and its power*, by Laozi). In *Zhuzi jicheng* 諸子集成 (Compendium of works by famous masters). Vol. 3. Beijing: Zhonghua shuju, 1954; 1986 reprint.

Wang Chang 王昶 (1725–1806), comp. *Jinshi cuibian* 金石萃編 (Compiled comments on metal and stone inscriptions). China: Qingxuntang, 1805.

Wang Dingbao 王定保 (870–after 954), comp. *Tang zhiyan* 唐摭言 (Collected sayings from the Tang dynasty). In *WSKQS*. Disc 113.

Wang Fangyu 王方宇. *Bada Shanren fashu ji* 八大山人法書集 (Bada Shanren's calligraphy in the collection of Wang Fangyu). In *Mingjia hanmo: Zhongguo mingjia fashu quanji* 名家翰墨：中國名家法書全集 (Han Mo: Calligraphy of Famous Masters). Edited by Hui Lai Ping 許禮平 (Xu Liping). Vols. C9 and C10 (vols. 1 and 2, respectively). Hong Kong: Han Mo Xuan Publishing, 1998.

———. "Bada Shanren bingdian he yangkuang" 八大山人病顛和佯狂 (Mental illness and feigning madness in Bada Shanren). *Gugong wenwu yuekan* 故宮文物月刊 (National Palace Museum Monthly) 102 (September 1991): 16–23.

———. "Bada Shanren de shufa" 八大山人的書法 (The calligraphy of Bada Shanren). In *Bada Shanren lunji* 八大山人論集 (An Anthology of Essays on Pa-ta-shan-jen). Edited by Wang Fangyu. Vol. 1. Taipei: Guoli Bianyiguan Zhonghua congshu bianshen weiyuanhui, 1984.

———. "Bada Shanren de shu-

fa" 八大山人的書法 (The calligraphy of Bada Shanren). In *Bada Shanren fashu ji* 八大山人法書集 (Bada Shanren's calligraphy in the collection of Wang Fangyu). In *Mingjia hanmo: Zhongguo mingjia fashu quanji* 名家翰墨：中國名家法書全集 (Han Mo: Calligraphy of Famous Masters). Edited by Hui Lai Ping 許禮平 (Xu Liping). Vol. C10 (vol. 2). Hong Kong: Han Mo Xuan Publishing, 1998. Reprinted in *Bada Shanren quanji* 八大山人全集 (Complete works of Bada Shanren). Edited by Wang Zhaowen 王朝聞. Vol. 5. Nanchang: Jiangxi meishu chubanshe, 2000.

———. "Bada Shanren dui Wu Changshuo de yingxiang" 八大山人對吳昌碩的影響 (Bada Shanren's influence on Wu Changshuo). In *Bada Shanren lunji* 八大山人論集 (An anthology of essays on Pa-ta-shan-jen). Edited by Wang Fangyu. Vol. 1. Taipei: Guoli bianyiguan Zhonghua congshu bianshen weiyuanhui, 1984.

———. "Bada Shanren shi shi-jie" 八大山人詩試解 (Explaining the poetry of Bada Shanren). In *Bada Shanren lunji* 八大山人論集 (An anthology of essays on Pa-ta-shan-jen). Edited by Wang Fangyu. Vol. 1. Taipei: Guoli Bianyiguan Zhonghua congshu bianshen weiyuanhui, 1984.

———. "Bada Shanren shufa de fenqi" 八大山人書法的分期 (Periodization of Bada Shanren's calligraphy). In *Zhongguo shufa quanji 64: Zhu Da, Shitao, Gong Xian, Gong Qinggao* 中國書法全集 64：朱耷、石濤、龔賢、龔晴皋 (Complete Chinese Calligraphy 64: Zhu Da, Shitao, Gong Xian, Gong Qinggao). Edited by Guo Zixu 郭子緒 et al. Beijing: Rongbaozhai chubanshe, 1998.

———, ed. *Bada Shanren lunji* 八大山人論集 (An anthology of essays on Pa-ta-shan-jen). 2 vols. Taipei: Guoli bianyiguan Zhonghua congshu bianshen weiyuanhui, 1984.

Wang Shiqing 汪世清. "Bada Shanren de bingdian wenti" 八大山人的病顛問題 (The problem of Bada Shanren's madness). *Da Gong Bao* 大共報, July 1, 1984.

———. "Bada Shanren de jiaoyou" 八大山人的交游 (Bada Shanren's circle of friends). In *Bada Shanren quanji* 八大山人全集 (Complete works of Bada Shanren). Edited by Wang Zhaowen 王朝聞. Vol. 5. Nanchang: Jiangxi meishu chubanshe, 2000.

———. "Bada Shanren de jiaxue" 八大山人的家學 (The family education of Bada Shanren). *Gugong wenwu yuekan* 故宮文物月刊 (National Palace Museum Monthly) 96 (March 1991): 68–85.

———. "Bada Shanren de shixi wenti" 八大山人的世系問題 (The problem of Bada Shanren's genealogy). *Duoyun* 朵雲 (Art Clouds Quarterly) 27 (April 1990): 97–100.

———. "Qingchu huayuan bajia huamu xinian" 清初畫苑八家畫目系年 (Dated paintings by eight masters in the early Qing dynasty: part 3). *Xin meishu* 新美術 (New arts) 20, no. 3 (1999): 74–78.

Wang Zhaowen 王朝聞, ed. *Bada Shanren quanji* 八大山人全集 (Complete works of Bada Shanren). 5 vols. Nanchang: Jiangxi meishu chubanshe, 2000.

Wang Zidou 汪子豆, comp. *Bada Shanren shichao* 八大山人詩鈔 (Poetry of Bada Shanren).

Shanghai: Shanghai renmin meishu chubanshe, 1981.

———, comp. *Bada Shanren shuhua ji* 八大山人書畫集 (Collection of calligraphy and painting by Bada Shanren). 2 vols. Beijing: Renmin meishu chubanshe, 1981.

Wei Zhongju 魏仲舉 (late 12th–early 13th century), comp. *Wubaijia zhu Changli wenji* 五百家注昌黎文集 (Five hundred commentators on the works of Han Yu, preface 1200). In *WSKQS*. Disc 118.

Wei Ziyun 魏子雲. *Bada Shanren zhi mi* 八大山人之謎 (The riddle of Bada Shanren). Taipei: Liren shuju, 1998.

Xiao Hongming 蕭鴻鳴. *Bada Shanren yinkuan shuo* 八大山人印款說 (Interpretations of Bada Shanren's seals, studio names, and ciphers). Beijing: Beijing Yanshan chubanshe, 1998.

Xiao Tong 蕭統 (501–531), comp. *Liuchen zhu Wen xuan* 六臣註文選 (Literary selections, with commentaries by six Tang scholars). Reprint of Song woodblock edition. 2 vols. Taipei: Guangwen shuju, 1964; 1972 edition.

Yang Bojun 楊伯峻, comp. *Liezi jishi* 列子集釋 (Collected explanations of the *Liezi*). Beijing: Zhonghua shuju, 1979.

Yang Dianxun 楊殿珣. *Shike tiba suoyin* 石刻題跋索引 (Index of comments and colophons on stone inscriptions). Shanghai: Shangwu yinshuguan, 1957.

Yang Jialuo 楊家駱, ed. *Yishu congbian* 藝術叢編 (Compendium of writings about art). 36 vols. Taipei: Shijie shuju, 1962–67.

Yanta "Shengjiao xu" bei 雁塔《聖教序》碑 (Stele of the "Preface to the Sacred Teachings" at the Wild Goose Pagoda). In *Shoseki meihin sōkan* 書蹟名品叢刊 (Compendium of famous works of calligraphy). Vol. 10. Tokyo: Nigensha, 1959.

Yao Cha 姚察 (533–606) and Yao Silian 姚思廉 (died 637), comps. *Liang shu* 梁書 (History of the Liang dynasty, 502–557). 2 vols. Beijing: Zhonghua shuju, 1973.

Ye Dehui 葉德輝 (1864–1927). *Guanhua baiyong* 觀畫百詠 (One hundred poems on paintings I have seen). China: Yeshi Guangutang, 1917.

Yin Fan 殷璠 (active mid-8th century), comp. *Heyue yingling ji* 河嶽英靈集 (Collection of poems by eminent spirits of the rivers and mountains, 753). In *Tangren xuan Tang shi, shizhong* 唐人選唐詩，十種 (Tang poems selected by Tang compilers, ten examples). Shanghai: Shanghai guji chubanshe, 1958; 1978 edition.

Zeng Gong 曾鞏 (1019–1083). *Yuanfeng leigao* 元豐類藁 (Collected works of Zeng Gong). Compiled by Chen Shidao 陳師道 (1053–1102). In *WSKQS*. Disc 121.

Zhang Daqian 張大千 (1899–1983). *Dafengtang mingji* 大風堂名蹟 (Famous works in the Dafengtang collection of Zhang Daqian). 4 vols. Kyoto: Benridō, 1955–56.

———. *Dafengtang shuhua lu* 大風堂書畫錄 (Record of calligraphy and painting in the Dafengtang collection). China: privately published, 1943.

Zhang Geng 張庚 (1685–1760).

Guochao huazhenglu 國朝畫徵錄 (Records on painters of the Qing dynasty, preface 1739). In *Zhongguo shuhua quanshu* 中國書畫全書 (Complete writings on Chinese calligraphy and painting). Compiled by Lu Fusheng 盧輔聖 et al. Vol. 10. Shanghai: Shanghai shuhua chubanshe, 1992–99.

Zhang Junfang 張君房 (active 1008–1029), comp. *Yunji qiqian* 雲笈七籤 (Seven lots from the book bag of the clouds). In *WSKQS*. Disc 116.

Zhang Tingji 張廷濟 (1768–1848). *Qingyige tiba* 清儀閣題跋 (Inscriptions and colophons by Zhang Tingji). China: privately published (Ding family), 1891.

Zhang Yuzhang 張豫章 (active 1688–after 1709) et al., comps. *Yuxuan Ming shi* 御選明詩 (Poems of the Ming dynasty, selected by the Kangxi Emperor). In *WSKQS*. Disc 158.

Zhang Zining 張子寧 (Joseph Chang). "Bada Shanren shanshuihua de yanjiu" 《八大山人山水畫的研究》 (Researches on the landscape painting of Bada Shanren). *Gugong wenwu yuekan* 故宮文物月刊 (National Palace Museum Monthly) 97 (April 1991): 86–115. Reprinted in *Bada Shanren quanji* 八大山人全集 (Complete works of Bada Shanren). Edited by Wang Zhaowen 王朝聞. Vol. 5. Nanchang: Jiangxi meishu chubanshe, 2000.

———. "Bada Shanren zhi shanshuihua chutan" 《八大山人之山水畫初探》 (Preliminary discussion of Bada Shanren's landscape painting). *Duoyun* 朵雲 (Art Clouds Quarterly) 15 (October 1987): 143–49.

———. "Chen Yan xing 'Chen' ma?" 《陳琰姓『陳』麼》 (Was Chen Yan surnamed Chen?). *Gugong wenwu yuekan* 故宮文物月刊 (National Palace Museum Monthly) 134 (May 1994): 94–103.

Zhao Xigu 趙希鵠 (ca. 1170–after 1242). *Dongtian qinglu ji* 洞天清錄集 (Pure records from the cavern heaven). In *Yishu congbian* 藝術叢編 (Compendium of writings about art). Edited by Yang Jialuo 楊家駱. Vol. 28. Taipei: Shijie shuju, 1962.

Zheng Wei 鄭威 et al., eds. *Huang Daozhou moji daguan* 黃道周墨迹大觀 (Overview of Huang Daozhou's calligraphy). Shanghai: Shanghai renmin meishu chubanshe, 1992.

Zhongguo gudai shuhua jiandingzu 中國古代書畫鑒定組 (Group for the authentication of ancient works of Chinese painting and calligraphy), comp. *Zhongguo gudai shuhua tumu* 中國古代書畫圖目 (Illustrated catalogue of selected works of ancient Chinese painting and calligraphy). Vol. 4. Beijing: Wenwu chubanshe, 1990.

Zhou Shixin 周士心. *Bada Shanren ji qi yishu* 八大山人及其藝術 (Bada Shanren and his art). Taipei: Huagang shuju, 1970.

Zhu Anqun 朱安群 and Xu Ben 徐奔. *Bada Shanren shi yu hua* 八大山人詩與畫 (Poems and paintings of Bada Shanren). Wuchang: Huazhong ligong daxue chubanshe, 1993.

Zhu Yulong 朱玉龍, comp. *Wudai shiguo fangzhen nianbiao* 五代十國方鎮年表 (Chronology of regional administrative districts during the Five Dynasties and Ten Kingdoms period). Beijing: Zhonghua shuju, 1997.

ENGLISH LANGUAGE SOURCES

Acker, William R. B. *Some T'ang and Pre-T'ang Texts on Chinese Painting*. 3 vols. Leiden: E. J. Brill, 1954.

Bai, Qianshen. *Fu Shan's World: The Transformation of Chinese Calligraphy in the Seventeenth Century*. Cambridge, Mass.: Harvard University Asia Center, 2003.

Berkowitz, Alan J. *Patterns of Disengagement: the Practice and Portrayal of Reclusion in Early Medieval China*. Stanford: Stanford University Press, 2000.

Cahill, James. *Hills Beyond a River: Chinese Painting of the Yuan Dynasty, 1279–1368*. New York: Weatherhill, 1976.

———. "The 'Madness' in Bada Shanren's Paintings." *Ajia bunka kenkyu* アジア文化研究 (Asian culture studies) 17 (March 1989): 119–43.

Chang, Ch'ung-ho and Hans H. Frankel, trans. *Two Chinese Treatises on Calligraphy*. New Haven: Yale University Press, 1995.

Chen, Yu-shih. *Images and Ideas in Classical Chinese Prose*. Stanford: Stanford University Press, 1988.

Davis, A. R. *Tao Yuan-ming, a.d. 365–427: His Works and Their Meaning*. 2 vols. Cambridge and New York: Cambridge University Press, 1983.

———. *Tu Fu*. New York: Twayne Publishers, 1971.

Fong, Wen C. "Stages in the Life and Art of Chu Ta (a.d. 1626–1705)." *Archives of Asian Art* 40 (1987): 6–23.

———. "Tung Ch'i-ch'ang and Artistic Renewal." In *The Century of Tung Ch'i-ch'ang, 1555–1636*. Edited by Wai-kam Ho and Judith G. Smith. Vol. 2. Seattle: Nelson-Atkins Museum of Art in association with the University of Washington Press, 1992.

Fu, Shen C. Y. *Traces of the Brush: Studies in Chinese Calligraphy*. New Haven: Yale University Art Gallery, 1977.

Graham, A. C., trans. *The Book of Lieh-tzu*. London: John Murray, 1960; 1973 edition.

Gu, Bing. "Spontaneous Interpretation: An Album of Bada Shanren's Seal Script Calligraphy." *Orientations* 20, no. 5 (May 1989): 65–70.

Hay, Jonathan. *Shitao: Painting and Modernity in Early Qing China*. Cambridge: Cambridge University Press, 2001.

Ho, Wai-kam and Judith G. Smith, eds. *The Century of Tung Ch'i-ch'ang, 1555–1636*. 2 vols. Seattle: Nelson-Atkins Museum of Art in association with the University of Washington Press, 1992.

Hummel, Arthur W., ed. *Eminent Chinese of the Ch'ing Period*. 2 vols. Washington, D.C.: United States Government Printing Office, 1943.

Hung, William (Hong Ye). *Tu Fu: China's Greatest Poet*. 2 vols. Cambridge: Harvard University Press, 1952.

Knechtges, David R., trans. *Wen Xuan: or Selections of Refined Literature*. Compiled by Xiao Tong (501–531). 3 vols. Princeton: Princeton University Press, 1982–96.

Kodansha Encyclopedia of Japan. 9 vols. Tokyo and New York: Kodansha, 1983.

Kroll, Paul W. "Body Gods and Inner Vision: The Scripture of the Yellow Court." In *Religions of China in Practice*. Edited by Donald S. Lopez Jr. Princeton: Princeton University Press, 1996.

Ledderose, Lothar. *Mi Fu and the Classical Tradition of Chinese Calligraphy*. Princeton: Princeton University Press, 1979.

————. "Chinese Calligraphy: Art of the Elite." In *World Art: Theme of Unity in Diversity*. Edited by Irving Lavin. Vol. 2. University Park: Pennsylvania State University Press, 1989.

Lee, Hui-shu. "Bada Shanren's Bird-and-Fish Painting and the Art of Transformation." *Archives of Asian Art* 44 (1991): 6–26.

Lynn, Richard John. *The Book of Changes: A New Translation of the I Ching as Interpreted by Wang Bi*. New York: Columbia University Press, 1994.

Mather, Richard B., trans. *Shih-shuo Hsin-yü: A New Account of Tales of the World*. Comp. Liu I-ch'ing. Minneapolis: University of Minnesota Press, 1976.

Owen, Stephen. *The Great Age of Chinese Poetry: The High T'ang*. New Haven: Yale University Press, 1981.

Owen, Stephen, ed. and trans. *An Anthology of Chinese Literature: Beginnings to 1911*. New York: W. W. Norton & Co., 1996.

Ricci, Matteo and Nicolas Trigault. *China in the Sixteenth Century: The Journal of Matthew Ricci: 1583–1610*. Translated by Louis J. Callagher. New York: Random House, 1953.

Robinet, Isabelle. "The Book of the Yellow Court." In *Taoist Meditation: The Mao-shan Tradition of Great Purity*. Translated by Julian F. Pas and Norman J. Girardot. Albany: State University of New York Press, 1993.

Schlombs, Adele. *Huai-su and the Beginnings of Wild-cursive Script in Chinese Calligraphy*. Münchener Ostasiatische Studien, Band 75. Stuttgart: Franz Steiner Verlag, 1998.

Soper, Alexander C. *Textual Evidence for the Secular Arts of China in the Period from Liu Song through Sui*. Artibus Asiae Supplementum 24. Ascona, Switzerland: Artibus Asiae Publishers, 1967.

Spence, Jonathan. *The Search for Modern China*. New York: W. W. Norton & Co., 1990.

Strassberg, Richard E. *Inscribed Landscapes: Travel Writing from Imperial China*. Berkeley: University of California Press, 1994.

Waley, Arthur. *The Way and Its Power: A Study of the Tao Te Ching and Its Place in Chinese Thought*. London: George Allen & Unwin, 1934; 1965 edition.

Wang, Fangyu. "Bada Shanren's *Cat on a Rock*: A Case Study." *Orientations* 29 (April 1998): 40–46.

Wang, Fangyu and Richard M. Barnhart. *Master of the Lotus Garden: The Life and Art of Bada Shanren (1626–1705)*. New Haven: Yale University Art Gallery and Yale University Press, 1990.

Watson, Burton, trans. *The Complete Works of Chuang Tzu*. New York: Columbia University Press, 1968.

Watt, James C. Y. "The Literati Environment." In *The Chinese Scholar's Studio: Artistic Life in the Late Ming Period*. Edited by Chu-tsing Li and James C. Y. Watt. New York: The Asia Society Galleries, 1987.

CONCORDANCE

INDEX

Italicized page numbers refer to illustrations.

寶真儀麗設　遠　歸　祈　誰　障
祈禱請神貺略畜人用大原發益之積武獲
皆則有奇翁穎且廬衛詢玷邪雍闕那都
井之旨無諸恩鴬自晉宿惟將三若都郁
精奉車証森沙及場帝康運汝易志林
道佋玄元九聖不涼恭楊之道遘真官秘而兩
孤建況靈蹤子訊道從在义誰在郁即郁即
真禱儒也集棟与末項音文禱怒誰其典與
團碩德絡作义淮南亭石就家使禮部公
監軍女太原郡公道冠方隅勳崇南維
貞試沉而不朽乎頌声
貞元九年蕆之癸卣閏月廿有二日

聖母志念斂香無私私逐奉上清
燈列聖之位仙臨者靈感逐曲遍功道
延迎有真人劉之擁節蜂于于遠功劉
君名賣真此以聖母道之懷仙錄于合士仙
之校爵餌以真王所逐神儀夾瓊餘之胎
隆脩流郎遠慶後杜晃初者武列禮聖功
備悲不涯聽雲久之人生記之于曲圖搨慶
寬密仙駕降臨空自之臨名二女瑠虚同升
香沒空方息榮宗中以為中興凡瑞銘于其麗雷仙
日初照逐真士旋憧彩煥輝珠倫墨林
宮觀慶祥代因弘弘齋東陵聖乃家于遠廢
仙于東志忠東陵駕二女瑤升儁聖母家遠停